EDITED BY KATHARINE LOCHNAN

Drawing Attention

Selected Works on Paper from the Renaissance to Modernism
Art Gallery of Ontario

MERRELL
LONDON · NEW YORK

First published 2008 by Merrell Publishers Limited

Head office
81 Southwark Street
London SE1 0HX

New York office
740 Broadway, Suite 1202
New York, NY 10003

www.merrellpublishers.com

in association with

Art Gallery of Ontario
317 Dundas Street West
Toronto, Ontario, Canada M5T 1G4

www.ago.net

The Art Gallery of Ontario is partially funded by the Ontario Ministry of Culture. Additional operating support is received from the Volunteers of the Art Gallery of Ontario, the City of Toronto, the Department of Canadian Heritage, and the Canada Council for the Arts.

FRONT JACKET

LEFT:
A Standing Draped Youth, n.d. (detail)
Attributed to Agnolo di Domenico di Donnino
Silverpoint heightened with white on ochre prepared paper
(see pages 28–29)

RIGHT:
Grey Circle, 1923 (detail)
Vasily Kandinsky
Watercolour and ink on wove paper
© Estate of Wassily Kandinsky/SODRAC (2008)
(see pages 188–89)

BACK JACKET

Stormy Landscape with a Rainbow, c. 1824 (detail)
Joseph Mallord William Turner
Watercolour on wove paper
(see pages 140–41)

CONTENTS

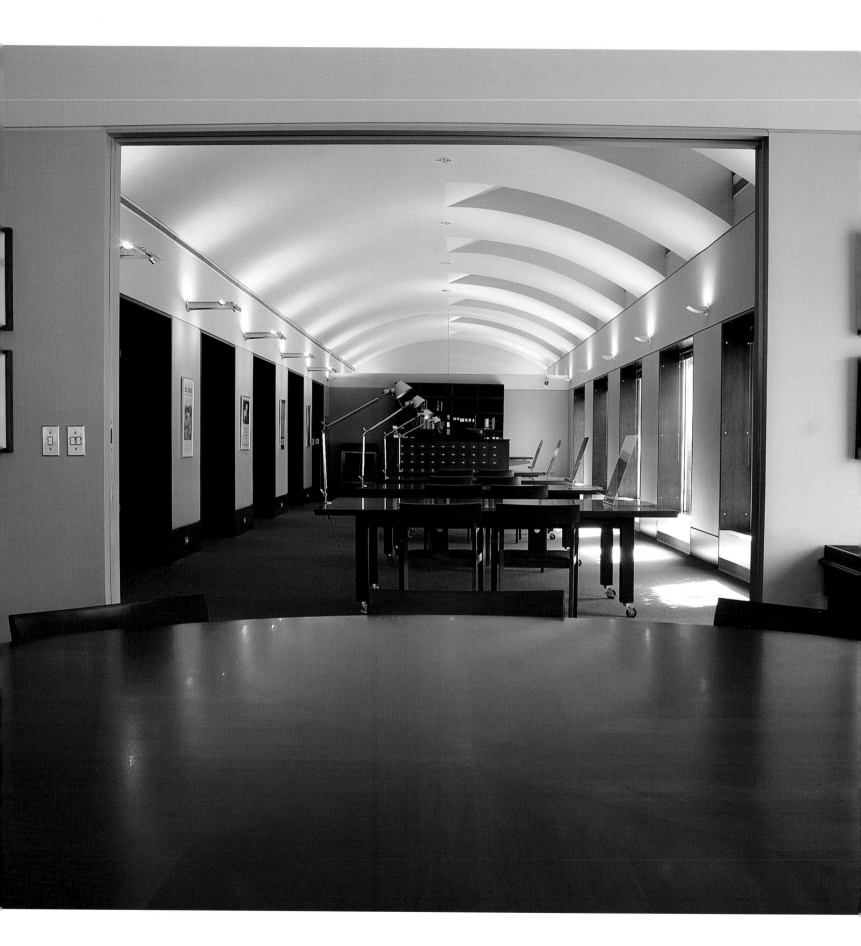

DIRECTOR'S PREFACE

Our objective has been straightforward from the outset: to demonstrate the Art Gallery of Ontario's commitment to acquisition and preservation at the highest level, and to highlight our one hundred greatest European and North American drawings. We have focused on a selection of works on paper that chronicle the evolution of drawing – including watercolour and pastel – from the fifteenth century to the mid-twentieth century, and from its origins in Italy to its growth in North America.

This publication – and the exhibition it accompanies – represents a milestone in the history of collecting drawings at the Gallery. It is the first time that highlights from our drawings collection have been brought together for an exhibition. We trust it demonstrates the excellence of a collection that we have built steadily over the last forty years with the encouragement of our collecting community.

This is the story of a community – great collectors, generous individual donors, government programs, and named family endowment funds that are committed to developing strength over time – uniting in common purpose. Taken together, their contributions express the confidence that a collection of drawings can provide insight into the history of art.

The late R. Fraser Elliott was a long-time supporter of the Gallery's ambitions to establish and build its reputation for the study of prints and drawings in Canada. His support culminated in two notable commitments in his final years: creating the position of senior curator of prints and drawings ably filled by Dr. Katharine Lochnan, the founding curator of prints and drawings at the Gallery; and the funding of this publication. Fraser believed in the sustaining value of research focused on the permanent collection, both for the purposes of documentation and encouraging new scholarship. We believe we have honoured Fraser's wishes in this publication, which compiles the work of thirty-three Canadian scholars who were invited to provide a fresh perspective on the highlights of our drawings collection.

We wish to express our gratitude to everyone who has supported our ambitions and has helped us realize our dreams. It gives us great pleasure to celebrate the expansion of the Art Gallery of Ontario's drawings collection for the benefit of our city, our province and our country.

Matthew Teitelbaum
Michael and Sonja Koerner Director, and CEO

ACKNOWLEDGEMENTS

This publication is the tangible outcome of four decades of contributions by many individuals including trustees, directors, curators, donors, sponsors, scholars and interns. It is through their combined efforts that we have managed to build, research, select and write about the collection of drawings at the Art Gallery of Ontario.

While our activities are made possible through the support of the federal and provincial governments, this handsome catalogue is the result of the philanthropic vision of the late R. Fraser Elliott (1921–2005). Born in Ottawa, Mr. Elliott enjoyed a long and exemplary career that combined his interests in business and law. After graduating with a degree in commerce in 1943 from Queen's University in Kingston, Ontario, he entered Osgoode Hall Law School in Toronto. He then proceeded to the Harvard Business School where he received a masters degree in business administration in 1947. He was called to the Ontario bar in 1946 and to the Quebec bar two years later.

In 1951 Mr. Elliott co-founded Stikeman Elliott, one of the most successful tax and corporate law firms in Canadian history. In addition, he invested early and wisely in high-tech industries. Firmly believing in the importance of private philanthropy, in 1985 he established the R. Fraser Elliott Foundation, which has been of immense benefit to arts organizations, universities and hospitals. While Mr. Elliott kept a low profile and never sought personal recognition, he was made a Member of the Order of Canada in 1980 and was named Outstanding Philanthropist of the Year 2003.

His avocation was collecting. An astute and quiet man, Mr. Elliott was attracted to works of art that were subtle and nuanced, preferring drawings to paintings. He was encouraged to start collecting European drawings in 1965 by David Carter, then director of the Montreal Museum of Fine Arts. The majority of his acquisitions were made over a thirty-year period from leading dealers in Montreal, New York, London and Toronto. His wife, Betty Ann, who shared his enthusiasm, was attracted to preparatory studies. Beautifully hung and carefully protected from daylight, their collection became a mecca for visiting scholars. Mr. Elliott's emotional attachment to the collection was clearly evident during his last years when he uncharacteristically declined all loan requests. He simply could not bear to be parted from his works.

Mr. Elliott placed his business and legal acumen at the service of museums and agencies responsible for building public collections. While in Montreal he was an active supporter of the Montreal Museum of Fine Arts. Following his move to Toronto in the mid-1970s, he served on and chaired the AGO's Board of Trustees, Acquisitions Committee, Old Masters Committee, and the Print and Drawing Collection Committee and its successors. He also set up and chaired the Art Gallery of Ontario Foundation. The federal government invited him to become the inaugural chair of the

Canadian Cultural Property Export Review Board, which has played a key role in the growth of museum collections through gift and repatriation.

Mr. Elliott believed that the collections that lie at the core of a museum are its most important asset. He believed that museums should encourage and assist private collectors within the community and harness their energies toward building a public collection. For this reason he became patron of the Master Print and Drawing Society of Ontario in the late 1980s. He also decided to leave his entire collection of eighty-one European drawings to the AGO. This constitutes the largest and most important gift of European drawings ever received by the Gallery.

In 2001 Mr. Elliott's endowment of a curatorship led to the re-establishment of the prints and drawings department. He believed in the importance of publishing the highlights of the collection and was keen to draw this area to national and international attention. Although he did not live to see the project completed, he followed its early stages with great interest and would undoubtedly be delighted with the results.

In addition, our thanks are due to the many generous donors whose names appear in the credit lines. We have benefited enormously from the activities of the Department of Canadian Heritage and the Canadian Cultural Property Export Review Board whose certification program, export controls and repatriation fund have encouraged gifting and ensured that a number of these drawings remained in Canada, including the Boucher (cat. 28), the van Gogh (cat. 23) and the Poynter (cat. 66).

This ambitious project could not have come to fruition without Sarah Parsons, now associate professor at York University, who assumed the part-time role of project manager for the first three years and helped to implement a strategic plan. She was assisted by Steven Stowell, Marvin Gelber Intern in 2004, who compiled research files on several drawings, and Jennifer Pearson, Laura Milligan and Peter McCormack, three interns from York University. Brenda Rix took over the coordination of the project from Dr. Parsons in 2006, and was aided by Lanie Treen, administrative assistant, and Ryan Whyte, Marvin Gelber Intern in 2007.

We set out to create an unconventional catalogue of master drawings that would include British, North American and twentieth-century European drawings, watercolours and pastels. A number of individuals assisted the curators in the final selection. We wish to thank David McTavish, of Queen's University, and Cara Dennison, of the Pierpont Morgan Library, New York, for assisting with the selection of Italian drawings; Odilia Bonebakker, doctoral candidate at Harvard University, for assistance with Dutch drawings; Kim Sloan, of the British Museum, for assistance with British drawings; and Anna Hudson, of York University, Toronto, for assisting with the selection of Canadian works.

Mr. Elliott believed in the seminal role of scholarly research in the intellectual life of the museum and was a great advocate of Canadian scholarship. To recognize the involvement of many individuals in the development of this collection, and to celebrate the Canadian contribution to international drawings scholarship, a team of Canadian writers was invited to join forces with AGO curators in putting together this publication. Spanning several generations, and working in Canada and abroad, they not only add their voices to the mix, but also employ a wide range of approaches to their subject matter.

We are especially grateful for the leadership demonstrated by Marvin Gelber and Walter Vitzthum without which the collection would never have been started (see "Drawing Conclusions"). Their initiative has been supported by generations of staff, including former AGO directors William J. Withrow, Glenn Lowry and Max Anderson, who oversaw the growth and development of the collection during their tenures,

and former curators, including Roald Nasgaard and Alan Wilkinson. We are grateful to John O'Neill, former senior paper conservator, and Martha Kelleher, former assistant curator of European art.

Sincere thanks are due to those colleagues who have supported this project and contributed entries: Dennis Reid, director of Collections and Research and senior curator of Canadian Art; Michael Parke-Taylor, acting curator of European Art; Brenda Rix, assistant curator of Prints and Drawings; Georgiana Uhlyarik, curatorial assistant, Canadian Art; and Joan Weir, paper conservator.

It would be impossible to acknowledge all of the individuals who have assisted contributors with information, but we would like to recognize the following: Hugh Belsey, Jaap Bolten, John Collins, Patrick Connor, Stephanie Dales, Sheila Danby, Martin Davis, Vivian Endicott Barnett, Alison Inglis, Jane Kallir, Michael Koortbojian, Elisa Korb, Dennis T. Lannigan, Rupert Maas, Terence Maloon, Gunther Thiem, William W. Robinson and William Worth Bracken.

We would also like to acknowledge the contribution of staff members Jill Cuthbertson, Lucie Chevalier, Catherine de Zegher, Karen Linauskas and Daniel Naccarato in the Exhibitions Department; John O'Leary in Exhibition Services; Margaret Haupt, Ralph Ingleton, Barry Simpson and Joan Weir in the Conservation and Collections Management Department; and Syvalya Elchen, Sean Weaver and Tanya Zhilinsky in the Photographic Resources Department. We are especially grateful to Craig Boyko for his photographs of the Marvin Gelber Print and Drawing Study Centre.

We would like to thank the publisher, Merrell, the staff of which has taken a personal interest in this project and worked closely with us to ensure that the publication would be lively and distinctive.

In closing, I would personally like to thank the director Matthew Teitelbaum for his support of collection-building activities in this area. His intervention was also critical in securing the Rosalba (cat. 14) and Boucher (cat. 28) drawings. I would like to thank Dennis Reid for his long-time advice and support. They have enabled this young department to flourish and to dare to dream of building an even greater collection in years to come.

Dr. Katharine Lochnan
Deputy Director of Research and The R. Fraser Elliott Curator of Prints and Drawings

DRAWING CONCLUSIONS

Katharine Lochnan

I N 1970 the Gallery published a thirty-two-page catalogue entitled *Master Drawings in the Collection of the Art Gallery of Ontario*. It was written by Dr. Walter Vitzthum (1928–1971) (fig. 1), a professor in the Department of Fine Art at the University of Toronto who was widely acclaimed as one of the greatest living drawings scholars. In June 1969, after being appointed to the Gallery's Old Masters' Committee, Dr. Vitzthum was allocated a small discretionary purchase fund. This modest, but auspicious, start led to the acquisition of a group of European drawings that constitutes the cornerstone of our collection. Copies of the catalogue were sent to his colleagues all over the world announcing its birth.

Dr. Vitzthum led a peripatetic existence reviewing drawings exhibitions for the leading scholarly art journals, *Master Drawings* and *The Burlington Magazine*. Following regular trips to Venice, where he kept an apartment, he would pass through London and Paris, visit dealers and arrange for drawings to be dispatched in plain brown wrappers. As the new curatorial assistant, it was my job to have them opened and photographed, and to insert the photographs into plastic sleeves in a black binder. Dr. Vitzthum *loved* photographs of drawings and, on returning from his travels, would routinely raid my binder. I was finally forced to glue the prints down to ensure that I could always present him with a complete reference set.

Although he occasionally purchased large, finished and firmly attributed drawings including the Panini (cat. 15), Silvestre (cat. 26) and Seydelman (cat. 42), the majority were preparatory sketches by members of the Neapolitan school, on which he was the leading expert. Most of the drawings he purchased were unattributed, not only making them affordable, but also giving him the opportunity to weigh their attributions and build on his growing corpus of Neapolitan drawings. Unattributed drawings challenged his superb connoisseurship skills and those of his scholarly friends, who relished the detective work involved in arriving at attributions in much the same way as others enjoy solving cryptic crosswords. He would routinely instruct me to send photographs to the eminent curators at the Metropolitan Museum, British Museum, Berlin Museum and Musée du Louvre – Jacob Bean, John Gere, Erich Schleier and Pierre Rosenberg – with whom he would share opinions.

Dr. Vitzthum always found more drawings than he could afford and soon began to encourage Marvin Gelber (1912–1990)[1] (fig. 2), a trustee of the Gallery, to build a personal collection. Whenever possible, Mr. Gelber would join Dr. Vitzthum in Europe and make the rounds of the drawings dealers. This genial collector took pleasure as the walls of his apartment began to fill up, installed blinds to protect the

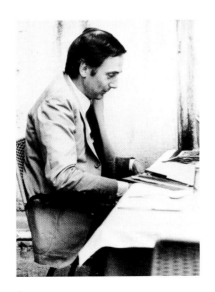

fig. 1:
Dr. Walter Vitzthum, c. 1970

13

drawings from daylight and invited visiting scholars up for drinks. When asked about the attributions, Mr. Gelber resorted to a list that he kept tucked underneath the sofa. As Dr. Vitzthum had hoped, these drawings, which include the beautiful Cavaliere d'Arpino (cat. 9), were later given to the Gallery, where they complement the other purchases.[2]

When I was hired in October 1969, the chief curator, Mario Amaya (1933–1986), an American who had lived in London for many years,[3] asked me to look after the collection of prints and drawings. My first job was to locate and assess the state of the collection and the storage facilities for works on paper. While framed drawings were kept in the paintings vault, unframed drawings were stored in old black Solander boxes[4] on shelves at the end of a dark basement corridor where they could only be viewed under one bare light bulb. Mr. Amaya agreed to make storage and study a priority, and within weeks we built our first print study room adjacent to the old paintings vault and boiler room beneath Walker Court (fig. 3).

A small rectangular room well lit with filtered fluorescent tubes, it contained a countertop, light table, shelves for the new acid-free Solander boxes, and bins for framed works. However modest, this facility represented a quantum leap forward. It was here that Dr. Vitzthum would come, with me at his elbow, to inspect the new arrivals. I remember how, on one occasion, he simultaneously lifted one eyebrow and the window of a mat and asked, "Is it a Bottani or a Batoni? What do you think?" Unfamiliar with his alarming rhetorical method, I panicked at the prospect of revealing that I had never heard of either. Fortunately he had the opportunity to debate attributions intelligently with two of his former students, Catherine Johnston and David McTavish.

In September 1970 I was invited to audit Dr. Vitzthum's graduate seminar. He assigned me the task of researching and presenting at his weekly classes one of the drawings he had acquired for the Gallery. After a brief trip to Italy at Thanksgiving, he returned looking pale and gaunt and, apart from his academic duties, spent most of his time closeted in the old library in Grange House with our learned librarian, Sybille Pantazzi (1914–1983) (fig. 4). Miss Pantazzi, who had always taken great interest in the prints and drawings collection and was its de facto curator, liked nothing better than assisting Dr. Vitzthum with his research.

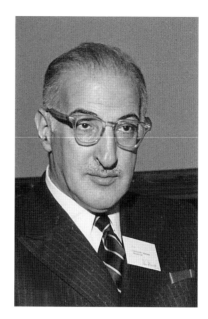

fig. 2:
Marvin Gelber, 1970

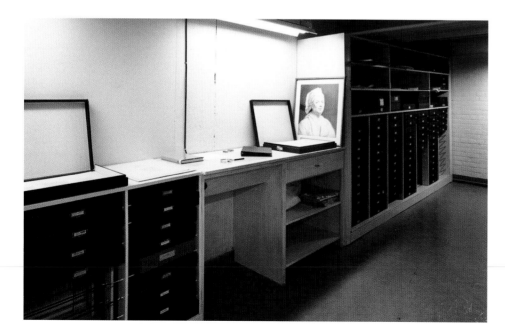

fig. 3:
Original AGO print study room, c. 1970

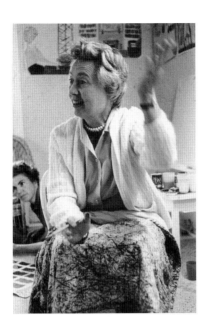

fig. 4:
Sybille Pantazzi, 1972
Photo: John Polyani

Dr. Vitzthum made a point of going through the binders of photographs in my little back office in Grange House. Focusing intently on each one, as if boring a hole through it with his eyes, he turned the pages slowly and dictated, as if in a trance, deattributions and reattributions one after the other. At the end of the term, he returned to Europe and, before we had time to change the records, we learned that he had collapsed and died of leukemia in a Paris hospital. His death at the peak of his career was a tragic loss to the field of Italian drawings scholarship and shocked colleagues, trustees, staff, students and friends all over the world.

The contribution made by Dr. Vitzthum in assembling the nucleus of our collection was subsequently described in his obituary by John Gere in *The Burlington Magazine* as "a model of intelligent acquisition on a small budget."[5] Dr. Vitzthum's concern to set the records straight before he died remains an important part of his legacy. His attributions continue to carry a great deal of weight, and he took pains to ensure that they would not mislead those who would one day follow in his footsteps.

Dr. Vitzthum encouraged Mr. Amaya to include major drawings shows in the exhibition program. The first of these, *Old Master Drawings from Chatsworth*, took place in 1970. It was beautifully installed on ochre walls in the E.R. Wood Gallery, and given a ducal setting by incorporating antique furniture and oriental rugs. Although he initiated a sequel, *French Master Drawings in North American Collections*, Dr. Vitzthum did not live to see it. Organized by Pierre Rosenberg, it opened in September 1972 and represented a milestone in the recognition of French master drawings. It included three of the French drawings that Vitzthum had bought for the Gallery, among them the Silvestre (cat. 26).[6]

———•——

Dr. Vitzthum's purchases for the Gallery built on pre-existing collections of British watercolours and Canadian and contemporary drawings. The British watercolours had been donated by William Bower Dalton (1868–1965), a British art potter who lived in Stamford, Connecticut. He was a friend of the Gallery's first director, Martin Baldwin (1891–1968). Whenever Baldwin went to visit, Mr. Dalton would slip a watercolour into his suitcase as a gift for the Gallery. He later began to purchase watercolours such as the Bonington (cat. 61) and had them sent directly to the Gallery.

Not surprisingly, the collection of Canadian drawings was strong, thanks in part to a large gift from the Canadian National Exhibition. In October 1969 it was decided that this area of the collection would fall under the newly created Canadian department, which has overseen its growth and development ever since. Contemporary drawings, which represent a chronological extension of the Canadian and European areas, were placed under the aegis of the Contemporary department, which, at that time, was responsible for all acquisitions dating after 1946. Although this publication is focused on the development of the European schools, the North American schools are inextricably linked to them. Because the boundaries between national schools all but broke down during the twentieth century, and the period defined as "contemporary" keeps shifting, we have included a few twentieth-century North American drawings in this publication.

The collection of modern European drawings was given a terrific boost in 1970 when, shortly before his death, Samuel J. Zacks and his wife Ayala made arrangements to bequeath their collection of European art to the Gallery. The drawings were interspersed with paintings on the high white walls of their Toronto penthouse, and included outstanding examples of the works of French impressionists,

postimpressionists, Italian futurists and Russian constructivists, many of which form the core of our modern collection. Among them are works by Renoir (cat. 38), Léger (cat. 85), Matisse (cat. 82), Dufy (cat. 84), Delaunay (cat. 77) and Lissitzky (cat. 80).

In May 1971 an exhibition of the Zacks collection opened at the Gallery. It was beautifully hung on walls painted subtle shades of rose, grey or pale yellow, created by mixing raw pigments into pots of paint under the supervision of the vivacious Mrs. Zacks. The entries on the drawings included in the catalogue, *A Tribute to Samuel J. Zacks from the Sam and Ayala Zacks Collection*, were written by Theodore ("Ted") Heinrich (1910–1981). Well-connected socially and a great friend of the Zacks family, he was widely regarded as the leading expert on drawings in Toronto.

An American, Dr. Heinrich had been a curator at the Metropolitan Museum, director of the Royal Ontario Museum, and head of the Visual Arts Department at York University. He brought to Toronto a very large personal collection of drawings from which he organized exhibitions. One of these was still circulating under the aegis of the Art Gallery of Ontario at the time of my arrival. The collection, which was broken up at auction following his death, contained some very fine sheets, among them a Bloemaert (cat. 19) and Romney (cat. 47).

—— ··· ——

Marvin Gelber was keen to build on Dr. Vitzthum's legacy. He continued to purchase Italian drawings and supported the creation of a prints and drawings department at the Gallery. As the Gallery was eager to find a Canadian candidate for the curatorship, and it was impossible to train for such a position in Canada, I was asked by the American-born chief curator, Richard Wattenmaker, who had succeeded Mr. Amaya in 1972, whether I would be willing to spend a year in a major print room to gain the requisite experience. After seeking advice, I asked to be sent to the British Museum (BM) in London. Mr. Gelber wrote to Sir John Pope-Hennessy, then director of the BM and a friend of the late Dr. Vitzthum, and I was accepted as a volunteer assistant in the Department of Prints and Drawings by the keeper, John Gere.

Upon arrival at the British Museum on 1 May 1975, I was issued a pass and a fistful of large and noisy keys on a long chain, and shown to a desk in the soaring two-storey Study Room. When I requested office supplies, a bearded man named Antony Matthews, who wore a necklace made of human bone, brought me a pile of BM stationery and half a dozen quill pens. Bemused by my startled expression, he explained that the quills were kept in stock for the keeper emeritus, Mr. Edward ("Teddy") Croft-Murray, whose desk was at a right angle to mine. When Mr. Croft-Murray arrived wearing an eighteenth-century vest and carrying an eighteenth-century cane, he greeted me jovially. Expressing great interest in the Art Gallery of Ontario, he told me that Dorothy Isabella Webb, daughter of Sir Edmund Walker (1848–1924), founder of the Art Gallery of Ontario, was a personal friend. I felt as if I had been shot back a couple of centuries!

My early lessons at Dr. Vitzthum's side in the inexact science of attribution convinced me that the most important asset for a curator was to develop a sense of quality and a "good eye." I immersed myself in the language of draftsmanship and, in an attempt to develop the intangible and mysterious skill of connoisseurship, looked closely at the drawings of the greatest masters. I quickly realized that the BM's collection was vast and that, even in a year, I would never be able to see all of it. Forced to choose between looking and reading, I decided on the former, with the result being

that I developed a holistic grasp of the history of drawing and an untutored visual literacy relatively unaffected by shifting tastes and fashions. Every morning for fourteen months I immersed myself in box after box, working my way steadily, school by school, century by century, around the gallery that overlooks the Study Room.

The confidence that came with the increasing ability to separate the wheat from the chaff was the most valuable possible preparation for curatorship. By the time I returned to Toronto in July 1976, the Study Room at the British Museum had become my professional home away from home. For years, I would return for a month at a time to collect my case keys and continue my endless journey through the boxes. The keeper John Gere, his successors and their assistants have all become friends and supporters who, to this day, take an active interest in the development of our collection.

Not all of my looking was done on-site. The need to develop the ability to deal with issues of authenticity was always hovering in the background. I was keen to learn not only the characteristics of the greatest "hands" but, wherever possible, the ability to distinguish between their works and those of their followers. Geoff Gibbons (an Australian Harold Wright intern at the BM) and I spent a memorable day in the library of Chatsworth House in Derbyshire looking through albums of drawings by Guercino (cat. 10) and his followers. Half a dozen great connoisseurs including Popham, Pouncey and Vitzthum had recorded their sometimes conflicting views on attribution in the margins. Deciding to take Dr. Vitzthum's attributions as our gold standard, we covered up all the annotations and tested one another to see whether or not we could tell the real Guercinos from the "Guercineschi." We were surprised at this game when the duke of Devonshire came striding into the library to greet his colonial visitors and ask our opinions of his drawings!

Before I returned from London, Dr. Wattenmaker recommended that I make the rounds of major Continental print rooms. With letters of introduction from Mr. Gere, I traveled to Stockholm, Berlin, Vienna, Dresden, Prague, Budapest, Montauban and Bayonne, meeting curators, looking at treasures, and continuing to build visual literacy.

———•••———

After arriving back in Toronto in July 1976, I assumed the newly created post of curator of Prints and Drawings. By 1976 the collection had outgrown the Print Room, and better space and storage equipment had again become a high priority. In 1977 the collection was moved into new, custom-made, metal cabinets in a dedicated basement vault. A small room was partitioned off to serve as a study room, and an attractive space was created by hanging tapestries over the cement-block walls, laying an oriental rug on the carpeted floor and installing a pair of marble-topped antique tables. Although it was not publicly accessible, this space served us well enough until the end of the 1980s.

My first concern was to ensure continuity in collecting Italian drawings with the assistance of a person who could understand the inherent logic of Dr. Vitzthum's selection and build upon it. I approached his former student David McTavish, who, having completed his Ph.D. at the Courtauld Institute, had taken up a teaching position at Queen's University in Kingston, Ontario. Dr. McTavish not only agreed to advise us on Italian drawings but, in 1981, published, in the catalogue *The Arts of Italy in Toronto Collections*,[7] many of the drawings acquired by the Gallery and Mr. Gelber on the advice of Dr. Vitzthum. He has continued to vet additions to Dr. Vitzthum's nucleus and has recommended purchases such as the Salviati (cat. 4). He has also

used the collection to teach generations of students, among them Graham Larkin and Odilia Bonebakker, who also served internships in our prints and drawings department. In this way the torch lit by Dr. Vitzthum continues to burn and to be passed on.

Given the aspirations of the Gallery, and the very late date at which we began to collect in this area, it was essential at the outset to take stock of the art market and develop a strategy that could be implemented during the fourth quarter of the twentieth century. We needed first to ensure that footings were in place in all the major schools of draftsmanship. Prices were escalating rapidly, and more and more drawings by major figures were disappearing forever off the art market into major museums.

In order to accomplish this task we needed a collection committee, serious purchase funds and the support of the collecting community. In 1978 the Board of Trustees gave the prints and drawings department permission to form a committee, and Dr. McTavish was invited to chair it. There was only one problem: it had no purchase funds. I had been given two pieces of advice: New York collector Stephen Spector had said, "Never buy a drawing you can't see across a crowded room!" and Dr. Wattenmaker had said, "Don't buy scraps!" That autumn, while visiting Agnews, the great art dealership in Old Bond Street, London, I was shown the superb series of Fragonard drawings for the Ariosto series and fell in love with *Charlemagne Leads Angelica away from Roland*, c. 1785 (cat. 30). It bore a very serious price tag and had been reserved by a leading French museum. It was just the sort of drawing we needed.

fig. 5:
R. Fraser Elliott, 1995

Having requested second refusal, I returned home with a photograph and showed it to Marvin Gelber. When Agnews got in touch to say that the drawing was still available, Mr. Gelber showed it to R. Fraser Elliott (fig. 5). A lawyer, businessman and collector of drawings who had recently moved from Montreal to Toronto, Mr. Elliott was chair of the Gallery's Acquisitions Committee. A man of few words, an active listener and an astute advisor, he sat me down and gave me my first lesson in high finance. Speaking slowly and carefully, he began by saying that he liked the drawing very much and thought we should buy it. I asked how he proposed we go about this. He said that my chairman should ask the chairman of the Old Masters' Committee, Marvin Gelber, if it would lend us the funds. "But," I replied, flabbergasted, "how would we ever repay our debt?" Fraser replied patiently, "Next year, when the Acquisitions Committee meets, your chairman should ask for a share of the purchase funds so that the Prints and Drawings Collection Committee can repay the Old Masters' Committee!" It took me a split second to realize that Mr. Elliott was proposing a brilliant strategy: if we were not to be placed in the same position the following year, we would have to request an allocation in excess of our very considerable debt. The Fragonard was the first drawing purchased by the new prints and drawings department and established, at the outset, a high benchmark of quality. From 1979–92 purchase funds were divided equally between collecting areas, making it possible to play a proactive role in implementing our strategy of purchasing important drawings by major hands.

In 1981 a hitherto unknown drawing by Vincent van Gogh, *The Vicarage at Neunen* (cat. 23), was consigned to Sotheby's Toronto. The auction house applied for an export permit under the Canadian Cultural Property Import and Export Act. I first learned of its existence when the permit arrived on my desk and immediately invited Prof. Bogomila Welsh-Ovcharov, a leading van Gogh scholar teaching at the University of Toronto, to look at the drawing and vet the attribution. When she saw it, she said that not only was it by van Gogh, but it showed his father's vicarage and, it would seem, his sister Elizabeth sitting on the porch. She was amazed to discover that

the drawing had been consigned to Sotheby's by a hitherto unknown nephew of the artist, Mr. Félix du Quesne, who lived in Québec. Elizabeth's son by a second marriage, he had inherited the drawing from his mother and brought it to Canada when he immigrated. It was one of the few works by van Gogh that had remained in the family. While visiting Sotheby's London, I saw an enlarged and backlit transparency of the drawing promoting a forthcoming sale. Believing strongly that it should remain in Canada, Dr. Welsh-Ovcharov and I recommended that its export be delayed. Sotheby's decided to put the drawing on the block in Toronto on 31 March 1982.

The Gallery began to put together a strategy. Unfortunately the repatriation fund of the Department of Canadian Heritage was depleted for the year, so we could not look for assistance from the federal government. Although we had a significant balance in the prints and drawings purchase fund, we were afraid that it would not be enough. A member of our collection committee, Dr. Martin Kosoy, agreed to bid on our behalf. Just before the sale started, Roald Nasgaard, then chief curator, authorized Dr. Kosoy to go one bid beyond our limit. Dr. Nasgaard, Dr. Welsh-Ovcharov and I sat at the back of the packed salesroom with our hearts in our mouths. Telephone bidders were hooked up, and the drawing was put on the block. The room was so packed and the bidding so fast and furious that we were unable to follow the increments and were not sure, when the hammer came down, what it had sold for or who had purchased it.

Anticipating this possibility, we had arranged to meet Dr. Kosoy outside the salesroom immediately afterwards. Emerging through a different exit, he found himself surrounded by bright lights and staring into a television camera while being congratulated by an interviewer as the new owner of the drawing! Waiting on the sidelines, we were elated when we realized that he had managed to secure it by going to the new limit authorized by Dr. Nasgaard. Other members of the press in the vicinity picked up variations on the story, and by morning there were three in circulation: (1) Dr. Kosoy had purchased the drawing for himself; (2) he had purchased it and immediately given it to the Art Gallery of Ontario; and (3) he had purchased it on behalf of the Gallery. The drawing was placed on display in a collection-in-focus exhibition organized by Dr. Welsh-Ovcharov and opened by Mr. du Quesne. Given the enormous leap in the prices of van Gogh drawings following that sale, this was, as we predicted, our one and only chance to purchase a work by this great artist.

During the 1980s the department's activity increased significantly. In addition to building the collection, we brought in or organized several exhibitions of drawings. These included John Murdoch's *Forty-Two Watercolours from the Victoria and Albert Museum* (1977), Andrew Wilton's *Turner and the Sublime* (1981), David Bindman's *William Blake: His Art and Times* (1983), Kim Sloan's *Alexander and John Robert Cozens: The Poetry of Landscape* (1986), Nigel Thorp's *The Glory of the Page: Medieval and Renaissance Illuminated Manuscripts from Glasgow University Library* (1987) and *Drawings by Holbein from the Court of Henry VIII: Fifty Drawings from the Collection of Her Majesty the Queen, Windsor Castle* (1988). These exhibitions gave the public the opportunity to see drawings of the highest quality, and built an audience for future drawings exhibitions.

———•——

However high profile, these exhibitions were only the tip of the departmental iceberg. In 1981 I was joined by Brenda Rix, who, as assistant curator of prints and drawings, made it possible to expand our activities. We worked away behind the scenes to build

up the collection so that we would one day be in a position to generate high-quality exhibitions of our own. She was replaced during maternity leaves by Kim Sloan (1984) and Michael Parke-Taylor (1987–92), both of whom made significant contributions to our budding department. Dr. Sloan wrote the catalogue *Preferred Places: A Selection of British Landscape Watercolours from the Collection of the Art Gallery of Ontario*, published in 1987. Mr. Parke-Taylor, who joined the European department in 1993, continues to play a leading role in the building of the twentieth-century drawings collection.

It was clear from the outset that the potential for growth would depend primarily on gifts and our ability to involve collectors in the process. It was very difficult to build a collection of old master drawings in Toronto during the 1960s and 1970s. Although the Blair Laing Gallery and the Jerrold Morris Gallery handled drawings from time to time, there were no galleries dedicated to drawings until the Gabor Kekko Gallery opened in Yorkville in 1976. Mr. Kekko cultivated a new group of collectors, among them Sidney Bregman and Frank and Marianne Seger.

I was eager to meet collectors, see their collections and hear their stories. There were those like Vincent Tovell who had inherited collections, those such as Dr. William Landmann who had brought them to Canada, and those such as R. Fraser and Betty Ann Elliott and Marjorie Bronfman who had secured professional advice in Montreal and bought from dealers in Paris, London and New York. I soon realized that most of them thought there were no other collectors of drawings in Toronto and they were keen to share their passion. I conceived the idea of forming a collectors' group. As luck would have it, Mr. Bregman had the same idea and, in 1986, offered to become the founding president of an organization we named the Master Print and Drawing Society of Ontario.

I got in touch with those who were actively building collections and invited them to the founding meeting. To these "collector members" we added "resource members" that included such academics as Dr. McTavish, such curators as Dr. Johnston, and such paper conservators as Dr. John O'Neill. A special program of activities was developed to meet the needs and interests of collectors in the group. Far from the centres of the international drawings world, most were not familiar with, or comfortable in, museum print rooms and did not know the curators, scholars or dealers who specialized in their areas of interest.

In 1987 we organized a trip to London under the leadership of Dr. McTavish. Marvin Gelber had fallen ill and was unable to participate; however, his brother, Arthur Gelber (1916–1998) (fig. 6), joined us. Although he maintained that he "knew nothing" about drawings, Arthur fell in love with a superb Annibale Carracci drawing (cat. 8). Dr. McTavish was conscripted to call me in California to find out whether, if Mr. Gelber were to purchase it, the Gallery would be willing to accept it as a gift. This was the beginning of Arthur Gelber's long and important involvement with prints and drawings. He carried the torch for his brother, Marvin, who was slowly losing his memory.

Mr. Elliott was far too busy to join the society, but his wife, Betty Ann, became a member and travelled to London with the group. Soon afterward Mr. Elliott invited me to lunch and told me that he had heard very good things about the trip from his wife, and thought the idea of developing collectors and engaging them in the process of collection-building was a good one. He wanted to help by ensuring that the program of lectures and trips continued without placing a strain on the Gallery's finances, and offered to make an annual donation to cover the hard costs. As a result

fig. 6:
Arthur Gelber, 1987

of the sponsorship of the R. Fraser Elliott Foundation, the society has flourished, its program continues, and we have received support and extraordinary gifts from its members over the past twenty-two years.

In the late 1980s the Gallery began planning for another phase of expansion, which was to contain a publicly accessible print room. On a trip to look at the recently completed Schwartz Graphic Arts Galleries at the Detroit Institute of Arts with Tom Payne and Bruce Kuwabara of Barton Myers Associates, I drew a diagram of an ideal prints and drawings facility on the back of an envelope. This was the starting point for Tom Payne's splendid design. It consisted of a series of rooms that deliberately referenced favourite spaces in prints and drawings facilities in sister institutions: the entrance through the octagonal Treasury was inspired by the Treasury at the Detroit Institute of Arts; the vaulted ceiling and huge windows of the Reception Room and Study Room by the Prints, Drawings and Photographs Study Room at the National Gallery of Canada; the two-tier storage vault by the British Museum's Prints and Drawings Students' Room; and the view from the Study Room by the Thomas Fisher Rare Book Library at the University of Toronto. Overlooking Grange Park, with its green lawn and spreading chestnut trees, the facility promised to be beautiful, functional and a model of its kind. All it needed was a sponsor.

One day I was invited by AGO director William J. Withrow to discuss the plans with Arthur Gelber. Comfortably seated in the Members' Lounge with a big smile on his face, Mr. Gelber asked whether I would have any objection to the idea of naming the new prints and drawings study centre after his brother Marvin. Of course, we were delighted. The Marvin Gelber Print and Drawing Study Centre opened in January 1993, and began to provide public access to the collections, as well as open houses, seminars, classes, workshops, lectures and clinics. Brenda Rix returned to her former post to supervise the Study Room, assisted by a dedicated group of volunteers. We have had, on average, 3,500 visitors a year for the past decade and a half.

During the 1990s the collection continued to grow strongly by gift and occasional purchase. In autumn 1997 a previously unknown drawing attributed to François Boucher, *Young Country Girl Dancing* (cat. 28), was consigned to Ritchies auction house in Toronto. I first heard about it from Alastair Laing, the leading Boucher drawings scholar, who was invited over from London to look at it. I had long hoped to find a really good Boucher, and Mr. Laing told me that if this drawing was indeed by Boucher, it was one of the artist's greatest sheets. My curiosity was piqued and, before hearing back from him, I went to see the drawing. I will never forget the visceral impact it made when it was set down for viewing on the seat of a chair. It struck me immediately as not only one of Boucher's largest, freshest and most beautiful drawings, but as one of the finest eighteenth-century French drawings I had ever seen. Executed in the exquisite *trois crayons* technique, the animated figure actually appeared to be dancing. As soon as Mr. Laing wrote to say that the attribution was right, I put together a strategy with Matthew Teitelbaum, who was then chief curator.

We were thrilled when a close friend, Nan Shuttleworth, stepped forward and offered to make a major contribution toward its purchase, enabling us to put together a serious bid. But as word began to spread around the drawings world, we heard that there was great interest abroad and that the drawing was likely to go for a record price. Our chances of being able to secure it appeared to be rapidly diminishing. On 3 December 1997 Esther Sarick, a member of the Master Print and Drawing Society of Ontario, bid on behalf of the Gallery, while Ms. Shuttleworth and I were on tenterhooks at the back. A bank of telephones was activated and the drawing placed on the

block. When the bidding reached $120,000 it slowed down and, for one wild moment, we thought it might stop within our range. However, it suddenly took off again like wildfire, and the incoming bids, shooting over our heads, resembled a Spitfire attack and continued without a pause until the drawing was finally knocked down at $450,000. Mrs. Sarick never even had a chance to raise her paddle. The bid established a new international record for the sale of a Boucher drawing. M. Rosenberg, by that time director of the Musée du Louvre, who had encouraged us to bid, was startled to read the next day on the front page of a French newspaper that a Boucher drawing had set a world record in Toronto.

We were down but not out. We had developed in advance a two-part strategy, realizing that if the drawing were knocked down to a foreign bidder, it would still require an export permit, and we would have one last opportunity to try to keep it in Canada. The Canadian Cultural Property Export Review Board endorsed the recommendation of the expert examiner, and the permit was delayed for the maximum period (six months). The Gallery then applied for a repatriation grant from the Department of Canadian Heritage. While the clock ticked, Mr. Laing and I performed "due diligence" by doing everything possible to reconstruct the history of ownership in compliance with the newly issued *Report of the American Association of Museum Directors (AAMD) Task Force on the Spoliation of Art during the Nazi/World War II Era (1933–1945)*. This was a major challenge as this spectacular drawing had never been reproduced in any medium, and we had only the scantiest information. Working primarily from labels on the back of the frame and the frame itself, we managed to piece together a history of ownership, which strongly suggested that the drawing had come to England in the 1840s. This process was completed in the nick of time, the grant was approved, and we contacted the successful bidder, the London dealers Hazlitt, Gooden and Fox. They were very understanding, if disappointed, and helped us to conclude the purchase. The drawing was published for the first time by Mr. Laing in his catalogue of Boucher drawings in 2003.[8] It was one of the largest, freshest and strongest sheets in the exhibition, and is considered today the most important European drawing in our collection.

By the end of the 1990s the collection was attracting increasing international interest. To celebrate the millennium we brought in two important drawings exhibitions, *From Michelangelo to Picasso: Master Drawings from the Collection of the Albertina, Vienna* and *Raphael and his Circle: Drawings from Windsor Castle*. The department was firmly established when R. Fraser Elliott stepped forward in 2001 to endow the curatorship.

———·—·———

The collection is as central to an art museum as a library is to a university. Although still very much a work in progress, our drawings collection has taken a quantum leap forward in strength, scope and depth over the past decade and a half. We have begun to put footings in place by acquiring iconic works by major figures. A vast jigsaw puzzle, the collection is now developing focus and coherence in certain areas. We have strengthened the northern schools, introducing greater scope and balance. Although our strides have been modest in the Dutch and German schools, they have been considerable in the British and French. With the prices of great drawings endlessly outstripping available purchase funds, we have forged ahead by seeking opportunities outside the epicentres of interest in the drawings market. We have avoided purchasing token works by major artists, focusing instead on works with intrinsic

artistic merit. Eschewing "scraps," we have acquired, for the most part, works that can be "seen across a crowded room."

This is the first publication to be devoted exclusively to the highlights of the drawings collection since Walter Vitzthum's slim catalogue of 1970. It has been very difficult to select one hundred works that provide insight into high points of the collection, when hundreds more clamour for inclusion! We were forced to draw the line before the arrival on site of some of the last great gifts of the late Kenneth Thomson (Lord Thomson of Fleet), among them six Rubens drawings and four by van de Velde.[9] This publication cannot possibly do justice to the drawings collection as a whole, which is ripe for in-depth investigation in the Italian, French, British and Canadian schools, as well as the international schools of the twentieth century.

The collection gains a new artistic voice with the addition of each new draftsman and, with each work, new ideas that greatly enrich the dialogue within and across media. While continuing to assess the strength of the collection according to conventional "schools" of drawing, we are now beginning to evaluate it for its ability to support thematic investigations that span geographic and chronological divides. In addition to being shown in dedicated prints and drawings galleries, drawings will be integrated with works in other media in the new permanent collection galleries.

It has taken centuries to build the greatest museum collections, most of which are rooted in pre-existing royal ones. Although no collection is ever "complete" and it is impossible today to aspire to build a collection of early Renaissance drawings in depth, our collection, like our country, has youthful vitality. It is developing its own subtle personality, and has now reached the age of majority.

If the effort made over the past four decades has provided us with a solid base on which to build, our greatest strength lies in the fact that our collection has emerged from the fabric of our community and represents the combined tastes and histories of many collectors and collections. As the community develops an increasingly multicultural profile and the institution grows, the drawings collection will not only develop greater depth and distinctiveness in the core European schools, but will branch out into new, unforeseen and, today, unforeseeable areas.

1. Mr. Gelber was a Member of Parliament for York South (1963–65); a delegate to the United Nations General Assembly; a member of the United Nations Economic, Social and Financial Committee; and head of the Canadian Mission to UNESCO at Geneva in 1967. He was involved with the Gallery in the 1960s and 1970s, becoming president of the board (1974–76) and chairman of the Old Masters' Committee (1973–83).

2. The drawings were given by Marvin Gelber's brother Arthur in 1989.

3. See Ihor Holubizky, "Versions II," *Lola*, no. 3 (Winter 1998): pp. 16–19.

4. The boxes were invented by Dr. Daniel Solander at the British Museum (where he worked from 1773 to 1782) for the storage of specimens. They are used today to store prints and drawings.

5. *The Burlington Magazine* 114, no. 835 (Oct. 1972): pp. 721–22.

6. See Pierre Rosenberg, *French Master Drawings of the 17th and 18th Centuries from North American Collections* (London: Secker and Warburg, 1972), cats. 73, 134 and 146.

7. David McTavish et al., *The Arts of Italy in Toronto Collections 1300–1800*, exh. cat. (AGO, Toronto, 1981–82).

8. Alastair Laing, *The Drawings of François Boucher*, exh. cat. (Frick Collection, New York, 2003; Kimbell Art Museum, Fort Worth, 2004), cat. 54, p. 151.

9. See Christie's London, 6–7 July 1987, lots 58, 59, 62 and 64; Christie's New York, 23 January 2002, lot 153; and Sotheby's New York, 25 January 2006, lots 11, 12, 13 and 16.

LIST OF CONTRIBUTORS

OB Odilia Bonebakker, doctoral candidate, Harvard University

CB Christine Boyanoski, independent scholar, Toronto

TB Thea Burns, Helen H. Glaser conservator, Weissman Preservation Center,
 Harvard University

SC Sonia Couturier, assistant curator, European and American Prints and Drawings,
 National Gallery of Canada

DWD Douglas W. Druick, Prince Trust Chairman, Department of Prints and Drawings,
 and Searle Chairman, Department of Medieval through Modern European Painting
 and Sculpture, Art Institute of Chicago

AE Adele Ernstrom, professor emerita, Bishop's University

GF Gerald Finley, professor emeritus, Queen's University

JGH John G. Hatch, associate professor, University of Western Ontario

AH Anna Hudson, assistant professor, Department of Visual Arts, York University

CJ Catherine Johnston, (retired) curator of European art, National Gallery of Canada

MK Martha Kelleher, independent scholar, Toronto

GK George Knox, professor emeritus, University of British Columbia

GL Graham Larkin, curator of European art, National Gallery of Canada

BL Bruce Laughton, professor emeritus, Queen's University

KL Katharine Lochnan, Deputy Director of Research and The R. Fraser Elliott
 Curator of Prints and Drawings, Art Gallery of Ontario

RL Rose Logie, doctoral candidate, University of Toronto

CM Catherine Mastin, senior curator of art, Glenbow Museum

DMcT David McTavish, professor, Department of Art History, Queen's University

MM Milijana Mladjan, research assistant, Art Gallery of Ontario

RN Roald Nasgaard, professor, Department of Art History, Florida State University

JO John O'Neill, assistant professor, Art Conservation Program, Queen's University

MPT Michael Parke-Taylor, acting curator of European art, Art Gallery of Ontario

SP Sarah Parsons, associate professor, York University

DR Dennis Reid, director of Collections & Research and senior curator of Canadian art,
 Art Gallery of Ontario

BR Brenda Rix, assistant curator, Prints and Drawings, Art Gallery of Ontario

MNR Myra Nan Rosenfeld, independent scholar, Toronto

DES Douglas E. Schoenherr, (retired) associate curator of Prints and Drawings,
 National Gallery of Canada

KS Kim Sloan, curator of British Drawings and Watercolours and Francis Finlay curator
 of the Enlightenment Gallery, Department of Prints and Drawings, British Museum

GU Georgiana Uhlyarik, curatorial assistant, Canadian art, Art Gallery of Ontario

JW Jennifer Watson, independent scholar, Hamilton

JWeir Joan Weir, paper conservator, Art Gallery of Ontario

BWO Bogomila Welsh-Ovcharov, professor emerita, University of Toronto

RLW Ryan L. Whyte, assistant professor, Department of Art, University of Toronto

THE CATALOGUE

1 AGNOLO DI DOMENICO DI DONNINO (Attributed to)

Florence 1466–1513 Florence

A Standing Draped Youth

Silverpoint heightened with white on ochre prepared paper
20.2 × 11.3 cm
Inscribed in brown ink on the verso: *63*
Gift from the estate of R. Fraser Elliott, 2005

The study of Italian drawings is a vast, multi-generational, scholarly jigsaw puzzle into which new pieces are constantly being fitted and old pieces re-fitted. Fifteenth-century drawings are rare, and advances depend on new evidence coming to light. This sheet was linked by Everett Fahy to a group of studies in the Uffizi and the British Museum attributed to Agnolo di Domenico di Donnino by Anna Padoa Rizzo.[1] They reflect a combination of the drawing styles of Filippino Lippi and Domenico Ghirlandaio, who, together with Botticelli, operated the three leading workshops in Florence in the late fifteenth century. They were all masters of the metalpoint technique.[2]

Giorgio Vasari wrote that when Michelangelo was ready to transfer his cartoons for fresco to the Sistine Chapel ceiling, he invited a group of Florentine artists including Donnino to Rome in order to learn their technique. When Michelangelo found their work unsatisfactory, he destroyed it and proceeded to paint the ceiling single-handedly.[3] Vasari describes Donnino as a "diligent worker…wasting all his time in making designs which he never carried out."[4]

Paper was still a relatively scarce commodity in the fifteenth century and was used in artists' workshops for small, detailed studies intended as models for projects. As they were never signed, the attributions are tentatively assigned based on patient detective work and the current state of scholarship. This begins with an attempt to associate a drawing with a securely attributed work, usually a painting. It also involves looking at clues embedded in the work itself – such as style, quality, technique, paper, watermarks and inscriptions – in the work's provenance, and in archival documents and other drawings of the period.

This sheet was executed using silverpoint on prepared paper, one of the most refined and beautiful quattrocento techniques. Apprentices were expected to master it before being introduced to other drawing media, because it demanded precision of handling and was impossible to correct. A coating consisting of ground bone, white lead, earth pigment and size was applied with a wide brush and burnished to create a smooth and even surface that would not interrupt the flow of the point. After the artist laid in the contours, shadows were created using diagonal lines and cross-hatching, and highlights were added using a brush and white gouache. Metalpoint oxidizes and darkens in air, making the lines more visible.

The study of anatomy was in its infancy at that time, and figures were generally depicted clothed. Florence based its prosperity on the manufacturing and trading of wool cloth. This study, which demonstrates the linear refinement of Florentine art, appears to have been made from a live model, and the drapery, which is typically Florentine, is not so much decorative as sculptural and naturalistic. This stylishly dressed and coiffed young man gathers his cloak up under his left arm to reveal well-turned ankles and nicely shod feet. Since contemporary secular subjects were unusual at that time, he may have been intended as an onlooker in a religious painting.

The drawing was purchased by R. Fraser Elliott on the recommendation of David McTavish. It is the first fifteenth-century metalpoint drawing on prepared paper to enter the collection. KL

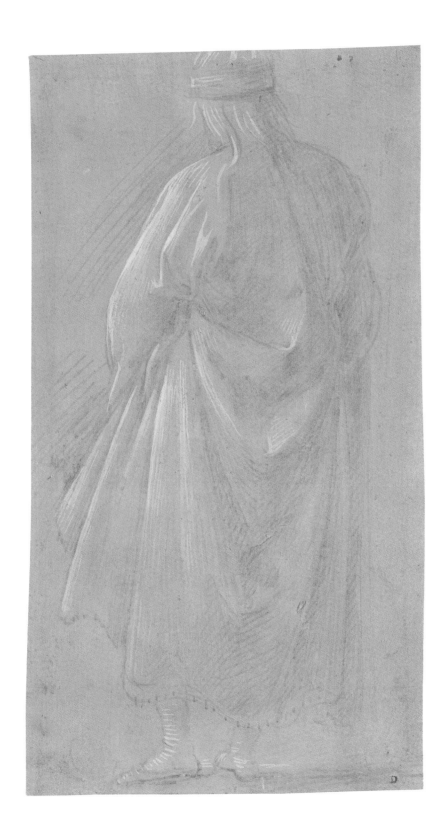

2 MICHELANGELO
Caprese 1475–1564 Rome

Studies of a Left Thigh and Knee, a Right Knee, and a Right Foot

Black chalk on laid paper
18.6 × 16.1 cm
Collector's stamp l.l.: Sir Joshua Reynolds (Lugt 2364)
The Thomson Collection, gift, 2003
2004/63

Michelangelo Buonarroti played a dominant role in Italian art during a career spanning almost three-quarters of a century. In Florence and Rome he created commanding works of sculpture, painting and architecture, but he first worked out his ideas in exploratory drawings, executed most often with painstaking care.

The human figure is at the very core of Italian draftsmanship. During the High Renaissance, artists like Leonardo da Vinci and Michelangelo prided themselves on their extensive knowledge of surface anatomy and on their precise rendering of the various parts of the human body, usually studied from a nude model. When producing a painting or sculpture, they made preliminary studies of a posed nude model in red or black chalk or, at times, in pen and ink.

Throughout his long career Michelangelo focused almost exclusively on the human figure. Although he lavished obsessive attention on most parts of human anatomy, he frequently devoted particular care to highly articulated areas such as the male torso, and to such details as shoulders, elbows and knees. On this sheet from relatively late in his career, it is the human knee that is most prominently featured in two of the three (or possibly four) individual studies.

At least as early as 1537, Michelangelo had trouble seeing clearly at close range, a condition that may have affected his later drawings.[1] This drawing is rendered in short, searching strokes of black chalk in various thicknesses and densities. In the study of the leg at the left, the analysis of bone, sinew and muscle is so immediate that it is almost as if he were penetrating beneath the skin, as in the study of a flayed body or *écorché*. In the central study some of the black chalk lines appear more tremulous, as they define and redefine the profile of the knee and the contour and shadow behind it. This detailed investigation stops abruptly just below the knee, as if the artist knew that further analysis was not required for the lower part of the leg in the finished work of art. As was first pointed out by Hugo Chapman, some of the same nervous linear quest to define anatomy is found in a drawing of a male torso, formerly in the Gathorne-Hardy collection,[2] that has been called "one of Michelangelo's last anatomical drawings."[3]

The most utilitarian of draftsmen, Michelangelo almost certainly made the studies of human legs with a specific purpose in mind, but his precise intentions are no longer known. Unfortunately, none of the details can be exactly related to any of the artist's other known works, although the angle of the left leg is one that he employed throughout his career, and the right knee seen from behind also appears in some of his pictorial work.[4]

Late examples of similarly posed legs can be found among Michelangelo's black chalk sketches for the figure of Christ in *Entombment* and in *Christ Expelling the Money-changers*, usually dated to the 1550s.[5] Given the nervous handling of the black chalk in all these drawings – characterized by energetic but short, broken strokes – such compositions perhaps supply the best context for the Toronto drawing, but again it should be emphasized that there is no conclusive connection with any of them. DMcT

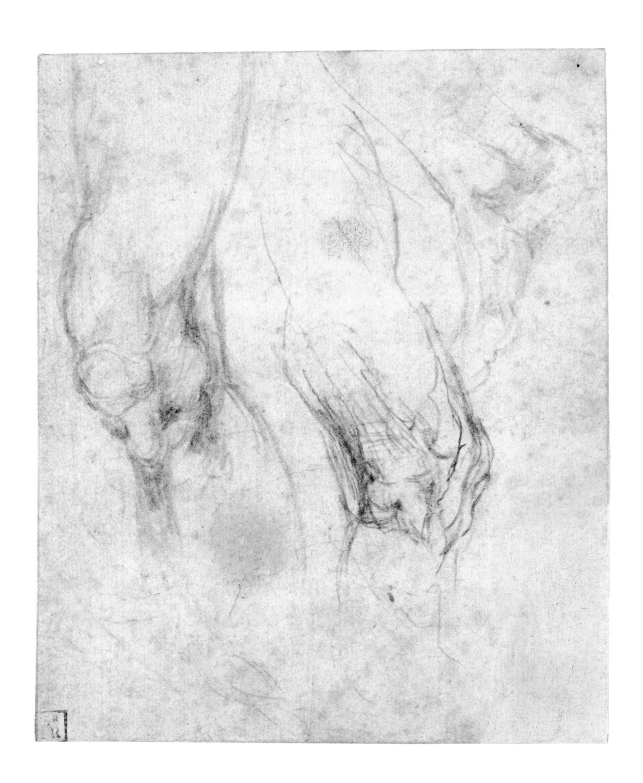

3 GIULIO ROMANO

Rome c. 1499–1546 Mantua
Study for the Toilet of Psyche (recto);
Study for Psyche Bathing (?) (verso), c. 1520

Pen and brown ink over traces of black chalk on laid paper
20.6 × 13.7 cm
Inscribed in pen and brown ink l.l.: *Pirino dl Vago*
Gift of Louise Comfort, Ottawa, 1986
86/246.1–2

This delightful double-sided sheet, which was discovered in the 1980s in a Canadian private collection, has prompted much scholarly comment. Generally agreed to be one of Giulio Romano's earliest extant drawings, it provides tantalizing evidence about the relationship between Romano as a precocious pupil and his great master, Raphael. It also gives clues to the unresolved mystery of the execution of one of Raphael's most enchanting late works – the fresco decorations in the garden loggia of the new villa (now called Villa Farnesina) built for the wealthy banker Agostino Chigi on the banks of the Tiber River in Rome.

The vault of the garden loggia depicts scenes of the love of Cupid and Psyche in heaven; however, the famous episodes that take place on earth are entirely missing. It is likely that the terrestrial scenes, which would inevitably have included the toilet of Psyche, were planned but never completed.[1] Although the ceiling decorations were finished by January 1519, no further work appears to have been done, and both Raphael and Chigi died the next year.[2] Romano was Raphael's principal heir and quickly rose to prominence as an artist and architect in his native Rome and, from 1524 onward, Mantua in northern Italy, where he remained an employee of the Gonzaga court for the rest of his life.

Executed with a fine-nibbed pen, the drawing shows a nude woman with faintly indicated attendants, a barking dog and what appear to be pieces of jewellery.[3] After experimenting with the position of the figure, the artist reinforced the preferred pose with short pen strokes. The jerky contours, together with the curvilinear internal modelling, are characteristic of many pen and ink drawings by Romano. If the line found here is more hesitant than usual, it probably indicates youthful inexperience.

The seated nude reappears as the central figure in a drawing by Alberto Alberti (1526–1598) that was probably copied from a lost drawing by Raphael for one of the unexecuted Farnesina frescoes (fig. 1).[4] Two of Psyche's nude attendants in the Alberti drawing are closely related to a figure study by Raphael in Edinburgh and a copy after a lost Raphael drawing in the Louvre.[5] Their existence proves that Raphael was working on the subject of the toilet of Psyche.[6] It is likely that the master made a rough sketch (now lost) of the entire arrangement of figures, then asked his pupil, Romano, to explore the pose of the protagonist.

The verso represents a standing nude female figure bathing in a round tub attended by putti, a subject not directly connected with any other work by Romano.[7] Once again the artist reinforced the contour lines of the upper part of the central figure. Both the figure and pose indicate the influence of classical sculpture, in particular the chaste *Venus Pudica.*

DMcT

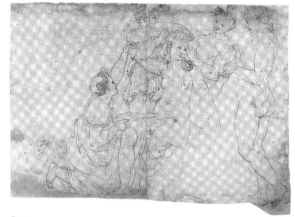

fig. 1:
Alberto Alberti (after Raphael)
The Toilet of Psyche
pen and brown ink, pencil
29.3 × 41 cm
Istituto Nazionale per la Grafica, Gabinetto Nazionale delle Stampe, Rome
(F.N.2838)

4 FRANCESCO SALVIATI

Florence 1510–1563 Rome

Lamentation over the Dead Christ, c. 1540

Brown ink and wash, over traces of black chalk, heightened with white gouache on laid paper
24.1 × 16.1 cm
Collector's mark in black ink l.l.: *G*
Purchase, 1981
81/4

Francesco Salviati, a pre-eminent painter and draftsman working in the mid-sixteenth century, received his early artistic training in Florence. First apprenticed as a goldsmith, he later entered the studio of sculptor Baccio Bandinelli. During this period Salviati also befriended biographer and fellow artist Giorgio Vasari.[1] Salviati worked for two years in the atelier of painter Andrea del Sarto. In 1531 the young artist, then known as Francesco de' Rossi, was invited to Rome to study at the expense of an early patron, Cardinal Giovanni Salviati, from whom he took his name.

Although he is best known for his large-scale frescoes, such as those at the Palazzo Vecchio in Florence and the Palazzo Farnese in Rome, Salviati also created designs for tapestries, metalwork, mosaics and festival backdrops. His disparate corpus is united by an assured sense of *disegno* and a proclivity for experimentation indicative of a restless, creative mind. Deemed exceptionally learned by his peers, Salviati moved easily within sophisticated intellectual and literary circles, even though his temperament was notoriously difficult. Unable to secure a fixed patron, he frequently travelled between Florence and Rome in pursuit of commissions. Salviati's work also took him to northern Italy, Venice and France.

This depiction of a Lamentation, as David McTavish has suggested, appears to have served as a preparatory composition for an altarpiece made for the Corpus Domini Church in Venice (c. 1540).[2] The drawing is not entirely consistent with the final painting and departs from it in a number of respects.[3] This does not indicate that the two works are unrelated, however, for a more experimental approach to preparatory studies is consistent with prevailing artistic practices at the time. Sometimes referred to as "mannerism," the period following the High Renaissance fostered a highly self-conscious artistic culture of visual quotation. A vast repertory of figure types and motifs was perpetually reworked and revisited; this approach included both the repetition of extant models from within one's own oeuvre as well as the appropriation of those found elsewhere.[4]

The unusual pose Salviati selects for the figure of Mary, with her hands outstretched before her in a gesture of anguish, appears to have been inspired by Dürer's *Small Passion* woodblock print of the Lamentation (c. 1509–10). The angel that bears the Instruments of the Passion recalls medieval devotional images devised to inspire meditation upon Christ's suffering and crucifixion. Isolated by an ambiguous bank of clouds, which effectively divides the image into two counterpoised registers, the hovering angel's curiously blunt, frontal presentation evokes types found in classical and Byzantine mosaic (Salviati had a demonstrable interest in this medium and even took it up in his later years).[5] Salviati's pictorial inventiveness would have been appreciated for its evocation of multi-layered, spiritual truths through a fluid and unorthodox synthesis of image types. RL

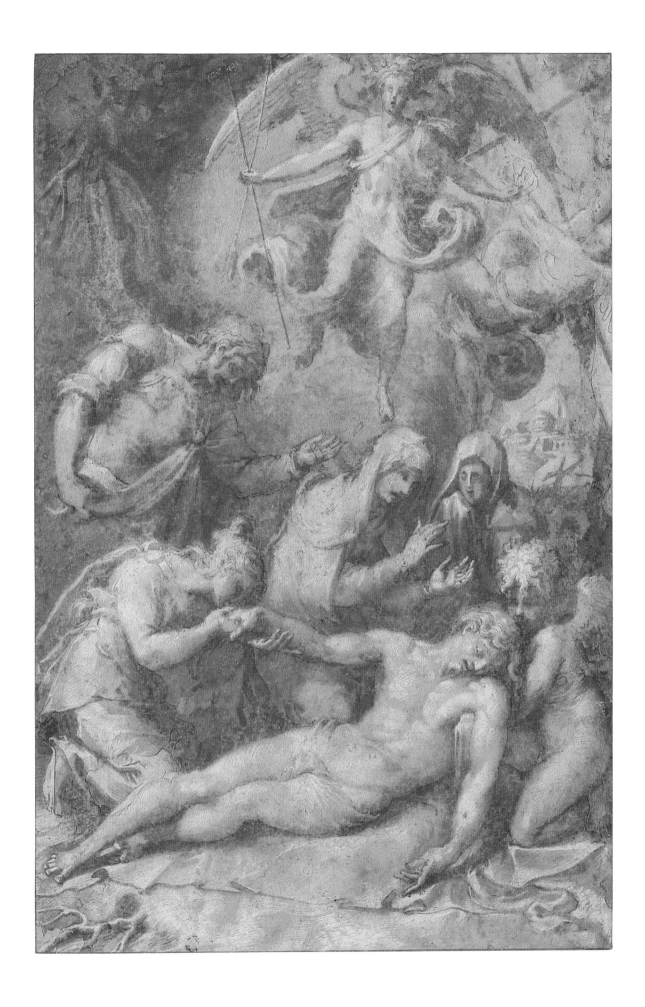

5 AURELIO LUINI

Milan c. 1530–1593 Milan

St. John the Baptist in a Landscape

Pen and brown ink and wash, heightened with white, over black chalk, on blue paper
25.0 × 16.2 cm
Inscribed on verso: *Denys Calvert*
Gift of Frank and Marianne Seger, 2001
2001/60

This highly pictorial representation of St. John the Baptist in a landscape typifies sixteenth-century draftsmanship in northern Italy, where the soft modelling and tender sentiment of Leonardo da Vinci, who had lived in Milan for many years, left an enduring influence. Aurelio Luini was the son of the Milanese painter Bernardino Luini (c. 1480/1485–1532), who is said to have been a pupil of da Vinci's, and Aurelio is himself reported to have owned drawings of grotesque heads by the great master from Florence.[1]

In typical fashion, Luini here combines pen-and-ink, brush and white heightening on blue paper to produce a strikingly atmospheric and painterly effect. Since the composition is fully resolved, and the execution is unusually finished, Luini may have intended the drawing as an independent work of art, or else as the final study for another work that has not been traced. Despite the high degree of finish, however, certain changes in the design are still visible, such as the two positions for the head of the lamb.

This devotional image of John the Baptist as the precursor of Jesus Christ is interpreted in an entirely naturalistic manner. Surrounded by a notably benign landscape representing the wilderness, St. John the Baptist is clad in camel skin (Matthew 3:4 and Mark 1:6) and points with his right hand to the symbolic Lamb of God – John's own phrase in acknowledging Jesus Christ, *Ecce Agnus Dei*, as related in the Gospel of John, 1:29. In his left hand John holds another of his attributes, the reed cross that just as unmistakably alludes to the ultimate sacrifice of Christ. And lastly, the spring of water gushing from the rock at the left relates to John's vocation of baptizing in the wilderness and of preaching the baptism of repentance for the remission of sin (Mark 1:4).

Luini's adoption of a format that fully integrates the standing saint in an extensive landscape, with a cliff to one side, suggests the effects of a pervasive North Italian tradition of picture-making, one that embraces not only da Vinci but also Titian. DMcT

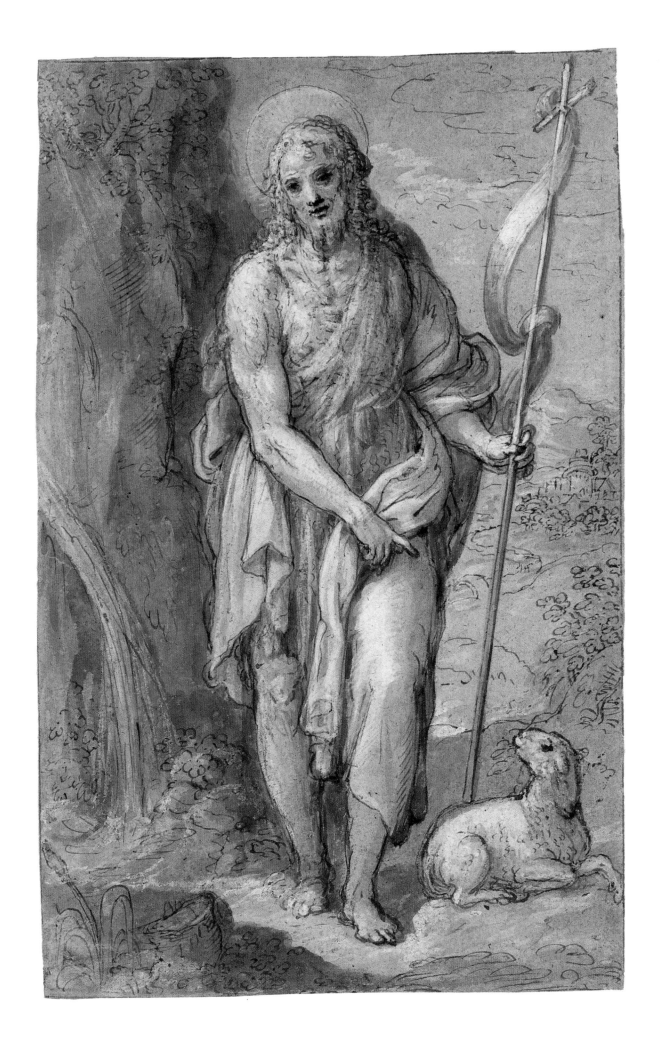

6 GIOVANNI BATTISTA NALDINI

Fiesole 1537–1591 Florence

Study of a Kneeling Youth, Looking to the Left (recto);
Studies of Drapery and a Bust-Length Youth (verso)

Red chalk, partly squared in black chalk, outlines indented with a stylus (recto);
red and black chalk (verso) on laid paper
26.8 × 19.0 cm
Inscribed in black chalk: *Murillo/1617–1682*
Collector's mark in black ink l.r.: W. Mayor (Lugt 2799)
Gift from the estate of R. Fraser Elliott, 2005
2005/236.1–2

As a draftsman, Giovanni Battista Naldini extended the vaunted Florentine tradition from the mid-1500s until almost the end of the century. He trained with the celebrated Florentine mannerist Jacopo da Pontormo (1494–1557) from about 1549 until 1556 and was also adopted by him. At the same time, Naldini carefully studied the work of Andrea del Sarto, and the influence of del Sarto's red chalk drawings is just as apparent as Pontormo's on Naldini's own draftsmanship. After Pontormo's death in 1557, Naldini completed his artistic education by moving to Rome, where he studied the works of Raphael and his followers, as well as the remains of classical antiquity.

After returning to Florence in about 1562, he joined Giorgio Vasari's circle and participated in a succession of Medici commissions. These included decorations for the marriage of Francesco I de' Medici and Giovanna d'Austria in 1565, and paintings in 1570–71 for Francesco's Studiolo in the Palazzo Vecchio.

Following a long-standing Florentine precedent, Naldini routinely executed red chalk drawings from posed models, who were most often young studio assistants. These studies, of which this is a typical example, were part of a well-defined procedure for the preparation of figures in paintings. In the vigorous use of chalk and angular description of drapery, the drawing reflects Naldini's admiration for del Sarto's red chalk studies, although the younger artist's application of chalk is freer and less analytical. Also typical of del Sarto is the diagonal hatching outside the figure, which in this case does not so much heighten the relief of the figure as unite it with the surrounding atmosphere.

The pose suggests that the figure was ultimately to represent a person kneeling in adoration or making a presentation, but the final destination of the figure has yet to be discovered. A related sheet of studies by Naldini in Berlin implies that the figure itself was of some prominence, and that the artist was taking no chances with the pose.[1] In the Berlin drawing, the same youth is studied in the nude and his arms are shown in a different position. In going to the trouble to do a nude study in addition to a draped one, Naldini was following the advice propounded by Leon Battista Alberti, the influential fifteenth-century Florentine writer and architect, in his treatise of 1435 on painting.[2] The procedure of carefully working from posed models was indeed more faithfully observed in Florence than elsewhere. While the model in the Toronto drawing is a young man, the personage in the finished work of art may not have been male, or even young, since Naldini, like many other sixteenth-century artists, typically used male studio assistants to pose as models, regardless of whether the figure was to be masculine or feminine in the finished painting.[3]

DMcT

7 FEDERICO ZUCCARO

Sant'Angelo in Vado 1540/42–1609 Ancona

Seated Youth with his Arms Raised, c. 1568

Black and red chalk on laid paper
24.0 × 19.0 cm
Watermark: fleur-de-lys inside double circle (similar to Heawood 1636–37)
Gift from the estate of R. Fraser Elliott, 2005
2005/268

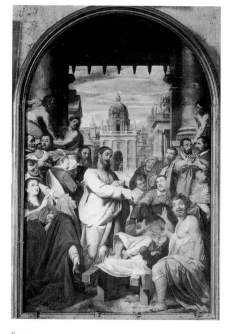

fig. 1:
Federico Zuccaro
Christ's Miraculous Raising of the Son of the Widow of Nain,
altarpiece for the cathedral of Orvieto,
commissioned 1568.
Museo dell'Opera del Duomo, Orvieto

A prominent artist of the Counter-Reformation period, Federico Zuccaro painted in many parts of Italy and as far afield as Holland, England and Spain. In theory and practice he emphasized good draftsmanship, and he produced an abundance of carefully executed drawings. Later in life he espoused the cause of art theory, leading the movement to reorganize the Accademia di San Luca (the academy for artists in Rome), and writing books on the visual arts.

At one time believed to be an anonymous copy after a lost drawing by Pontormo,[1] this dramatic study of a youth is now recognized as a typical example of Zuccaro's red and black chalk figure drawings.[2] Evidently drawn from life, the study emphasizes the young man's attitude of surprise – sitting up with his long-fingered hands raised, mouth open, and wide eyes staring toward the upper right. The pose appears to have been derived from a black chalk drawing of a young satyr by Zuccaro's elder brother Taddeo,[3] who had taught Federico as a teenager, and who died prematurely in 1566. As usual, Federico's drawing, with its diagonal hatching and precise contours, is more perfunctory than Taddeo's pictorial treatment.

The original purpose of the Toronto drawing is not known, but the figure is related to that of a youth who has just been brought back to life, depicted in an altarpiece by Zuccaro that was commissioned in 1568 for the cathedral of Orvieto (fig. 1).[4] The altarpiece depicts Christ's miraculous raising of the son of the widow of Nain, recounted in the Gospel of St. Luke (7:11–16): "And [Jesus] said, Young man, I say unto thee, Arise. And he that was dead sat up, and began to speak."

A number of preliminary drawings for the altarpiece survive, attesting to the care with which Zuccaro prepared his composition. Initially he chose a more restrained pose for the son, with his hands reverently clasped before his chest, as seen in compositional drawings in the British Museum and the Albertina.[5] In the painting he is shown in a more supine position, but in an animated pose roughly similar to that found in the Toronto drawing. However, the drawing shows the youth gazing to the upper right (away from Christ) and illuminated in the opposite direction from the painting, which suggests that the Toronto study may have been created independent of the Orvieto commission and was simply reused by Zuccaro as convenient inspiration for the resurrected son in the altarpiece.

DMcT

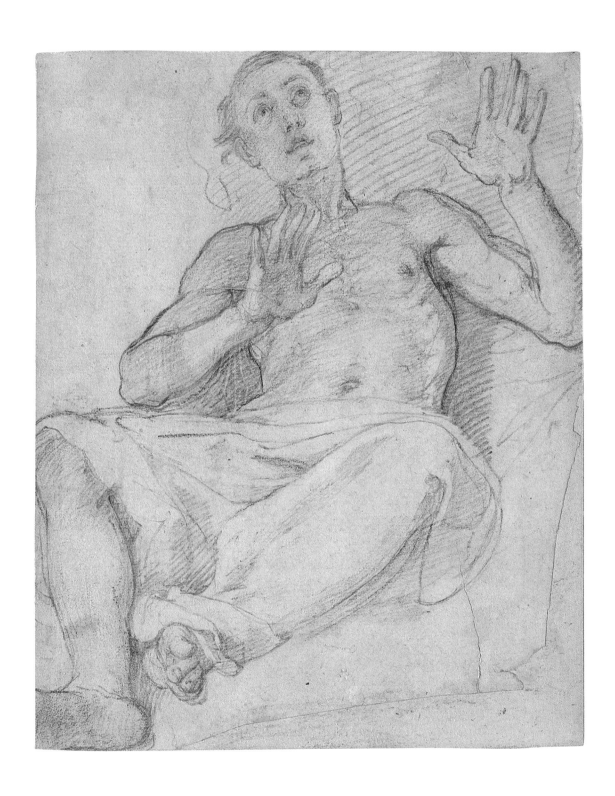

8 ANNIBALE CARRACCI

Bologna c. 1560–1609 Rome

Studies for the Hand of an Angel Holding a Violin Bow (recto);
Study for the Figure of St. Jerome Reading (verso), c. 1585

Charcoal and white chalk on blue laid paper
28.3 × 40.8 cm
Gift of Arthur Gelber, 1988
88/338

In their search to enliven painting in the last decades of the sixteenth century, the Carracci assiduously made drawings after the great artists of northern Italy, especially after Correggio and the Venetians. In the early 1580s they founded an academy in Bologna, initially intended to train assistants to aid them with their fresco commissions as well as with their ever-increasing activity in supplying altarpieces for the churches in that city. Drawing was the primary focus, whether in the studio from plaster casts and live models or in the streets of the city and the surrounding countryside. With the call to Rome in 1595 to paint frescoes in the Farnese Palace, Annibale proved the outstanding artist of the family, projecting and achieving over the next ten years a mythological ceiling decoration of great complexity rivaling the major fresco decorations of the Renaissance. Thousands of drawings were created in the process, eagerly sought by collectors and now mostly to be found at Windsor Castle and at the Louvre.

Since it came to light in 1987, this drawing has been justly celebrated. The hands on the recto are life-sized studies for the hand of the angel in the upper left of Annibale Carracci's early altarpiece of the Baptism, commissioned for the Church of San Gregorio in Bologna late in 1583 and delivered in 1585 (fig. 1). The use of rich black chalk highlighted with white chalk on blue paper attests to Carracci's study of Venetian drawings, while most of the surviving figure studies for the same altarpiece are in red chalk and reflect Correggio's preference for this medium, much emulated in Carracci's early drawings. Among these are the well-known study in the British Museum for the torso and head of an angel seen from below at the right of the composition and one in the Louvre of the kneeling boy raising his shirt in preparation for his own baptism in the Jordan. To these and others initially conceived as protagonists in the composition, but not used in its final realization, can be added a study for the approaching family group in the far right of the picture, recognized by the present writer in the early 1990s and recently published in the catalogue of drawings at Stockholm.[1]

The figure of Jerome on the verso (fig. 2) connects with a painting of the saint, today in the collection of the Banca dell'Emilia Romagna in Modena, which was attributed to Carracci in the 1960s, although this attribution was later queried. The drawing therefore confirms the early attribution to Carracci. In the soft application of rich black chalk, the drawing can also be compared with two studies for figures in a scene in the Palazzo Fava frescoes that are today at the National Gallery of Canada. CJ

fig. 1:
Annibale Carracci
The Baptism of Christ, 1585
San Gregorio, Bologna
Photo: Alinari/Art Resource, NY

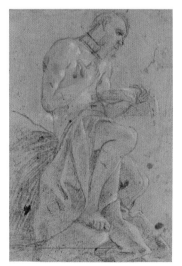

fig. 2:
Annibale Carracci
Study for the Figure of St. Jerome Reading
(verso of *Studies for the Hand of an Angel*),
c. 1585
charcoal and white chalk on blue laid
paper
28.3 × 40.8 cm
Art Gallery of Ontario, Toronto, gift of
Arthur Gelber, 1988 (88/338)

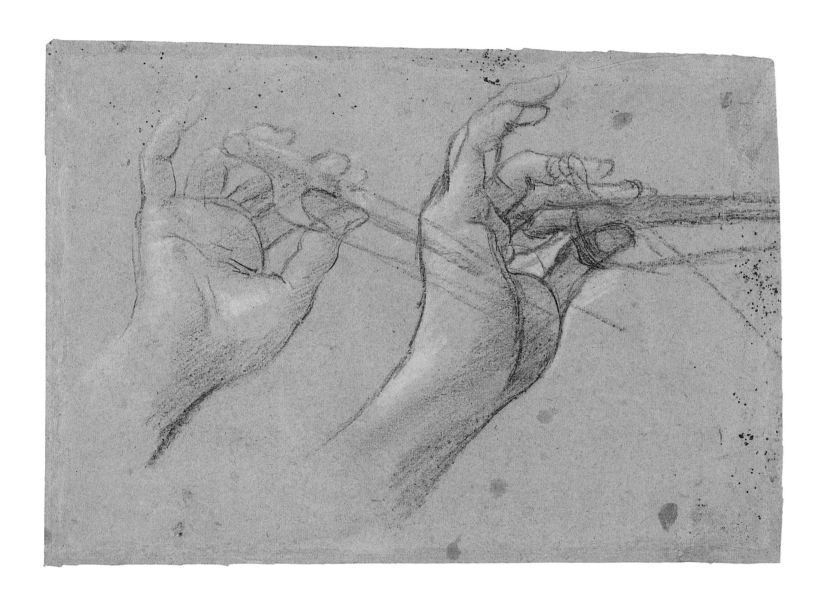

9 GIUSEPPE CESARI called CAVALIERE D'ARPINO

Arpino (near Sora) 1568–1640 Rome
Study of a Standing Male Nude, c. 1595

Red chalk on laid paper
26.1 × 14.6 cm
Inscribed in brown ink l.r.: *Testa*
Gift of Marvin Gelber, 1989
89/1

Considered a prodigy by his contemporaries, Giuseppe Cesari called Cavaliere d'Arpino began his career in Rome at the age of fourteen and soon became the most celebrated and sought-after artist of his day. D'Arpino's ability to design ambitious, large-scale painting cycles for papal and aristocratic circles eventually earned him a near-monopoly over Rome's most prestigious commissions. His successful coordination of the decorative program for the baptistery and transepts of San Giovanni in Laterano, the Pope's Episcopal church, inspired Clement VIII to bestow him with the papal title of *Cavaliere di Cristo*. The highly coveted charge of designing mosaics for the cupola of St. Peter's (1603–12) also fell to d'Arpino.

D'Arpino is often viewed as something of a transitional figure, for his career bridges the artistic periods referred to as late Roman mannerism and the early baroque. Unlike his immediate predecessors, who prized esoteric and formal complexity, d'Arpino's concern for compositional clarity harks back to the classicizing idealism of High Renaissance models. Scholarly focus upon the careers of Caravaggio and the Carracci, early baroque artists less renowned than d'Arpino in their day, has since marginalized his oeuvre. Yet d'Arpino's continuous employment over nearly six decades attests to the sustained esteem in which his work was held by his contemporaries, despite subsequent vicissitudes in taste.

This red chalk study of an athletic male nude is a consummate example of d'Arpino's skill as a draftsman. Once considered a work by Pietro Testa on the basis of an old inscription, the drawing has since been correctly reattributed.[1] D'Arpino's patent admiration for both Raphael and Michelangelo is evident here. In particular, the figure's pose recalls that of the latter's *Dying Slave* (c. 1513–16).[2] Both the drawing and its paraphrased source share a manifest engagement with the expressive possibilities of contrapposto, yet d'Arpino creates an even greater sense of bodily torsion by reversing and exaggerating the stance of his figure's legs. The strain apparent upon the figure's features, a departure from the more languid attitude evinced by Michelangelo's sculpture, recalls the famed expression of anguish on the face of Laocoön, the central figure in the late Hellenistic sculptural group that provided sixteenth-century artists with the superlative model of tragic pathos.[3]

Herwarth Röttgen suggests that the AGO drawing may be linked to a commission d'Arpino completed for the church of S. Bastianello alli Mattei o dei Merciari.[4] This proposal is based upon a description of a now-lost St. Sebastian painting from Giovanni Baglione's *Vite de' pittori, scultori, architetti* (1642). Röttgen draws a parallel between the AGO nude and a d'Arpino sheet in the Uffizi that depicts a figure in an almost identical pose. This second drawing is unambiguously a representation of the saint, tied to a tree and pierced with arrows.[5] It is thus possible that *Study of a Standing Male Nude* was also a preparatory drawing for just such a martyrdom scene.[6] Sixteenth-century art theorists regarded the exploration of the human form as the highest application of an artist's skill and *diligenza*. D'Arpino offers a subtle interpretation of the body's communicative potential through a nuanced synthesis of esteemed artistic prototypes. RL

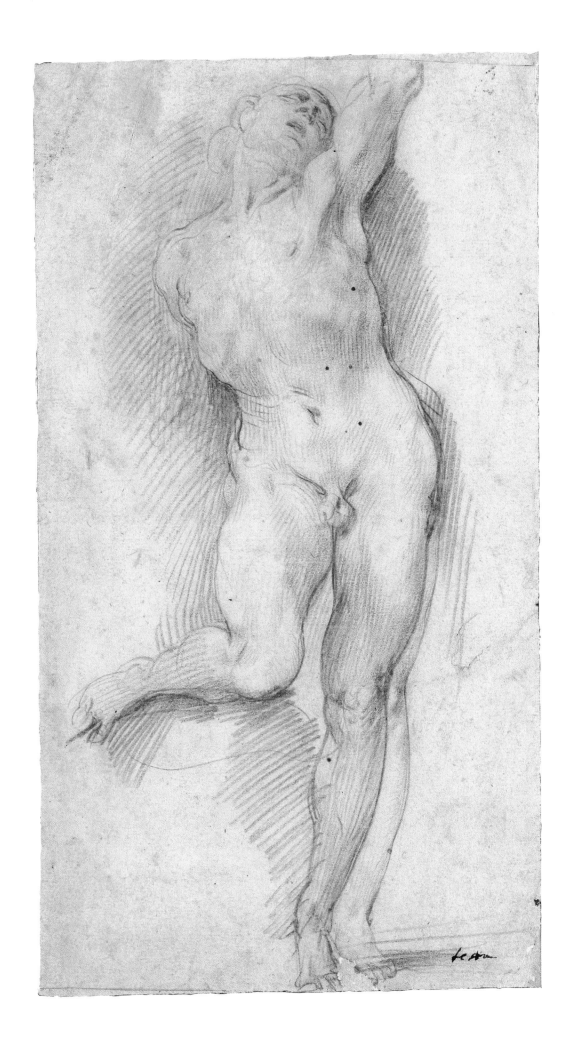

10 GIOVANNI FRANCESCO BARBIERI called GUERCINO

Cento 1591–1666 Bologna

A Witch, Two Bats, and a Demon in Flight

Pen and brown ink and brown wash on laid paper

11.7 × 25.7 cm

Inscribed in ink (verso): *Vechia streia donata/bruta incuperosa* (?, or *vien perosa?*), and by a different hand,

22-10-; laid down on a sheet inscribed in pen: *G.D.* and *D*, and in pencil: *Leonardo da Vinci*

Collector's mark: armorial mark (not in Lugt)

Watermark: deer and antlers contained within a circle (Heawood 18)

Purchased as a gift of the Trier-Fodor Foundation, 1986

86/194

Giovanni Francesco Barbieri, nicknamed "Guercino" due to his squint, was a major figure in Italian painting during the first half of the seventeenth century. He was born in Cento, on the agricultural plain known as the Val Padana, which stretches from Bologna to Venice, and spent the greater part of his life there.

Guercino was first influenced by Ferrarese artists and by the Carracci family of Bologna, who recorded scenes of daily life as a means to introduce a greater naturalism into their representations. When he travelled to Rome at the behest of the Bolognese pope, Gregory XV Ludovisi (r. 1621–23), he was influenced by the chiaroscuro paintings of Caravaggio. Following the demise of the pontiff, Guercino returned north, but sensing Guido Reni's domination of the artistic scene in Bologna, he only transferred there at the latter's death in 1642.

A virtuoso draftsman, Guercino favoured pen and ink when working out his religious or mythological compositions, frequently adding wash for dramatic effect. In addition, he was clearly engaged with the rural culture of his native district. Many drawings recording the antics of peasants were made simply as ends in themselves with no painting in mind. From this evolved his interest in caricature, in which category belong several drawings of witches, including the sheet under discussion. The Toronto drawing shows a witch with ape-like features, while the drawing at Windsor Castle describes a woman with vague expression, a long, refined nose, a rope around her neck and a tall cylindrical hat.[1] Both sketches are decorated with flying devils carrying tridents, such as those featured at the left of the witch depicted here. She wears a hairnet gathered in front in the form of a spider's web, a detail that seems to be repeated in a drawing in Warsaw of a witch blowing at a candle.[2] These drawings tend to be whimsical rather than sinister and may, in the present case, relate to a specific personality with whom the artist was familiar, for the inscription on the verso seems to refer to an old witch named Donata who was ugly and may have come from Perugia.[3] In any case, it is difficult to imagine Guercino dabbling in the occult, and he appears instead to make reference, with gentle humour, to a certain subculture found in Italian life of the period.

The thin white paper Guercino employed for such drawings has been lined, in this case, with a second sheet, making an exact reading of the inscription difficult. The unusual shape suggests that it was originally mounted in an album on a page with other drawings.

CJ

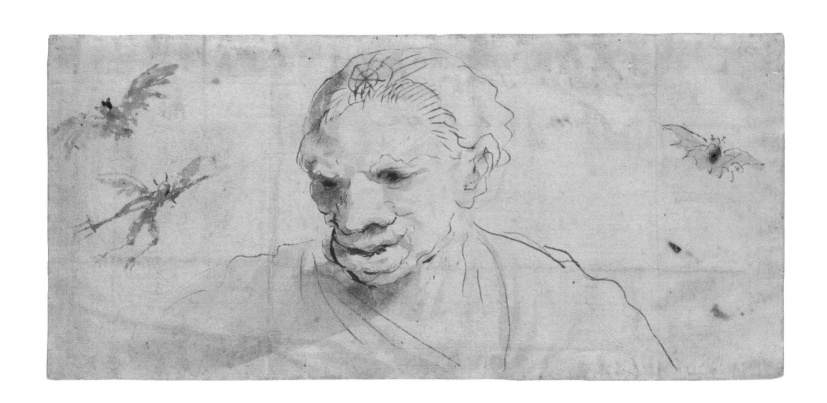

11 PIETRO BERRETTINI called PIETRO DA CORTONA

Cortona 1596–1669 Rome

Tobias and the Archangel Raphael

Black chalk on laid paper
23.6 × 16.7 cm
Inscribed in pen and brown ink l.r.: *P. de Cortona*
Purchased in memory of Dr. Walter Vitzthum, 1971
71/1

Both as a painter and as an architect, Pietro da Cortona enjoyed a commanding position in Rome and Florence from the 1620s until the 1660s. His outstanding accomplishments helped shape the high baroque style in Italian art.

This carefully composed drawing shows Tobias and the archangel Raphael, with walking sticks in their right hands, striding through a lush landscape. Typical of Cortona's style are the towering trees with criss-crossing trunks and arching, leafy boughs; the billowing cumulus clouds overhead; and the supple draperies that ripple over the young bodies of the travelling companions, helping to harmonize them with their setting.

The story comes from the Book of Tobit in the Old Testament Apocrypha. In order to collect money owed his righteous but blind father Tobit, Tobias embarks on a journey into Media guided by an unknown companion who turns out to be the archangel Raphael. At the Tigris River, Tobias catches a fish that is shown here hanging from his left hand. In the biblical account the fish is cooked, but Raphael counsels Tobias to save the fish's gall as it can be used to heal blindness (Tobit 6:8). When Tobias and Raphael eventually return from their journey, the gall is applied to Tobit's eyes, and his sight is restored.

The name Raphael means "medicine of God," and as an archangel, Raphael is the chief of all the guardian angels.[1] Cortona never painted the subject of Tobias and Raphael, but he did paint a large canvas of the guardian angel, now in the Galleria Nazionale (Palazzo Corsini) in Rome, for Pope Alexander VII (Chigi) in 1656.[2] When this drawing appeared at auction in 1971, Walter Vitzthum pointed out its close relationship with a slightly larger black chalk study in the Royal Collection at Windsor for *The Guardian Angel*, commissioned by Alexander VII.[3] The composition and setting are very similar. For this reason, the Toronto drawing was also thought most likely to date from the mid-1650s.

Jörg Merz discovered that the AGO drawing was the source for two rare engravings, one by J.B. Bonacina (fig. 1), who made a number of prints after Cortona and his circle, beginning about 1650, and one by François Cassart.[4] The vertical framing lines at the left probably indicate his attempts to compress the overall composition – a goal partly realized in the two prints. For stylistic reasons, Merz dates the drawing to the late 1640s.[5] The AGO drawing, which then evolved into the closely related but more generic *Guardian Angel*, may be Cortona's earliest known representation of a subject described by Milton as "Raphael, the sociable spirit that deigned to travel with Tobias."[6] DMcT

fig. 1:
J.B. Bonacina after Pietro da Cortona
Tobias and the Archangel Raphael
(*Angele Dei qui custes es mei...*)
engraving, 21.8 × 15.8 cm
Albertina, Vienna (HB XV, I Nr. 72 bzw. 71)

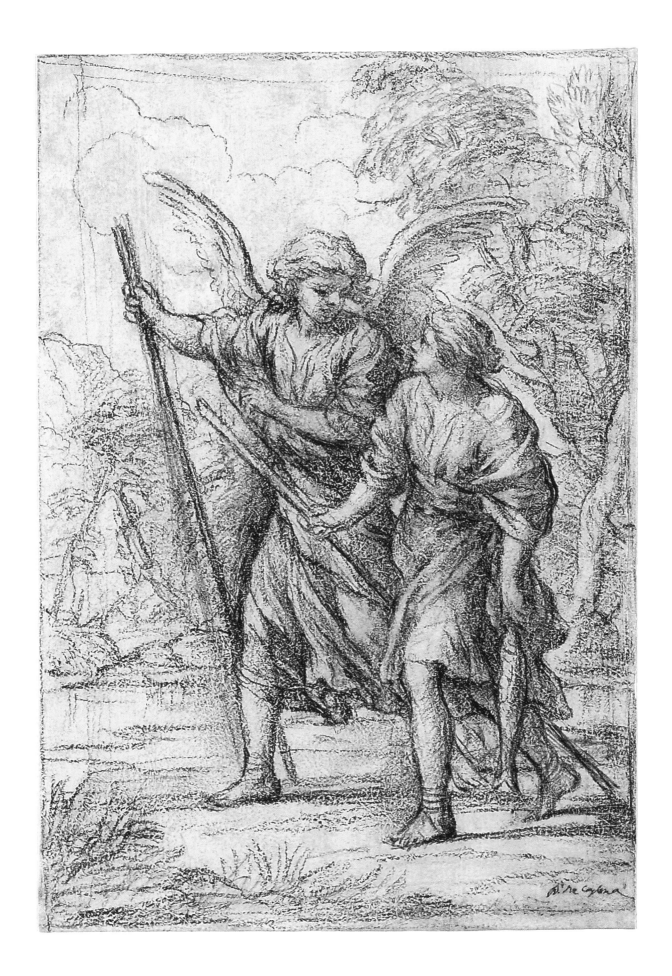

12 BALDASSARE FRANCESCHINI called IL VOLTERRANO

Volterra 1611–1689 Florence
Studies for the Head of the Virgin (recto);
Right Arm and Hand (verso)

Red chalk with traces of white chalk heightening (recto); black chalk (verso) on laid paper
26.8 × 39.9 cm
Purchased as a gift of the Betty Ann Elliott Fund and the Master Print and Drawing
Society of Ontario, 1991
91/150

Baldassare Franceschini's drawings survive in large quantities, attesting to his prolific practice and the esteem of collectors. The majority are figure studies usually executed in chalk and, as in this example, frequently showing more than one alternative for a specific pose or facial expression.

Born in Volterra, hence his nickname "Il Volterrano," Franceschini moved to Florence while still a teenager. He completed his training there with local artists and soon began to win commissions from such illustrious patrons as the Medici. He also travelled extensively to Rome (probably in 1641 and then in 1652), Parma and Venice (in 1640, 1652 and 1662). In Parma he was especially attracted to paintings by Correggio, and made detailed copies of his vast fresco decorations in the dome of the cathedral.[1] So extensive was Correggio's influence that Volterrano was called "the Correggio of the Florentines."[2]

These red chalk studies of the Virgin are preparatory to Volterrano's frescoes in the enormous dome over the tribune of Santissima Annunziata, a major Florentine church in which Volterrano had worked on several occasions. Commissioned in 1676 on the advice of Grand Duke Cosimo III, the frescoes were executed between 1680 and 1683 after problems in erecting the gigantic rotating scaffold had been resolved.[3] A brief indication of the circular device may be included at the lower right of the Toronto drawing. Volterrano devised the iconographic program, which features the Holy Trinity and the Virgin Mary – who is about to be crowned queen of heaven – clouds and angels, and significant personages from the Old and New Testaments. Filippo Baldinucci, the biographer of Florentine artists, gives a full account of the cupola frescoes and describes the female protagonist as "the very pure mother Mary and always immaculate Virgin, who genuflects with humility . . . looking at once devout and joyous,"[4] which is an apt description of the Toronto drawing. Executed at a dizzying height and entirely by torchlight, the frescoes represent Volterrano in his full maturity and are among his last major undertakings (fig. 1).

Correggio's influence can be clearly seen in the interpretation of the Virgin's face – ecstatically upturned with dark, emphatic eyes and shaded cheek, upper lip and neck, inspired perhaps by Correggio's figure of Eve on the frescoed dome of Parma cathedral. Perhaps Volterrano knew Correggio's drawings of Eve, for the Virgin at the right of the Toronto drawing is strikingly similar to Correggio's red chalk study of Eve in the Louvre.[5] In an earlier multi-figured sketch in Vienna, Volterrano represented Mary with her head inclined demurely to the lower left, but with her arms crossed at her breast as in the Toronto drawing.[6] The pose may have been inspired by Correggio's memorable image of Mary in the *Coronation of the Virgin*, painted in 1522 for the apse of the San Giovanni Evangelista, Parma. The influence of Correggio may be detected in Volterrano's sensuous use of red chalk, although his application of the medium is not normally as soft, and is more linear, with distinctly splintered strokes and slashing diagonal hatches. DMcT

fig. 1:
Baldassare Franceschini called Il Volterrano
L'Assunzione della Vergine Maria
fresco in cupola of Santissima Annunziata, Florence
Photo: Scala/Art Resource, NY

13 SALVATOR ROSA

Naples 1615–1673 Rome
A Poet Seated by a Tree, c. 1640

Pen and brown ink on laid paper
16.7 × 10.8 cm
Gift from the Volunteer Committee Fund, 1977
76/216

Salvator Rosa was a follower of the great Neapolitan baroque artist Jusepe de Ribera (1591–1652).[1] Intriguing aspects culled from Rosa's personal life, combined with his prolific production, led to his posthumous Romantic celebrity. Poetry figured prominently in his life as well and, in addition to his satirical publications, often infused the art of his paintings and works on paper.

Forced to flee Rome after his brazen public affront of Gian Lorenzo Bernini, he settled in the city of Florence. There he founded a small society of local literati who, meeting regularly in his house during the 1640s, dubbed themselves the Academy of the *Percossi* (the Smitten). Absurd, ironic names were commonly given to these learned societies that abounded throughout Italy in the seventeenth century, presumably to humble the intellectual pretensions of their highbrow members. During that period Rosa wrote the first three of seven scathing satires, *Musica*, *Poesia* and *Pittura*, and executed many landscapes and figure drawings. As a writer-cum-draftsman he was at his best in pen and ink, and this enigmatic sheet, executed in a style that comes closer to his etchings, showcases his mastery of line.

He has depicted a pensive poet who, holding a stylus in one hand, a book in the other and notes on his lap, sits nestled against a sturdy tree trunk, fully immersed in the act of writing. Rosa himself was drawn to early Cynic and Stoic notions of retreat to nature, which instead of a particular practice or abstract body of knowledge was more a lived philosophy. Like this lone scribe, he did manage on occasion to get away to the countryside villas of friends in Tuscany in search of creative inspiration. There he drew first-hand the rocks and trees that were used to shelter the stock figures that populate his landscape paintings. Yet this sort of escapism, a withdrawal from the corruption of urban life, was often a relished pastime or fantasy rather than a reality for Rosa. An artist in popular demand, his work was highly sought after by European rulers, among them Queen Christina of Sweden. This drawing can be traced back to her prestigious collection.[2]

Although the identity of the sitter remains a mystery, the nobly philosophical figure is a quiet study of the artist-poet as genius. The strong sense of presence and the pose are suggestive of other known portraits; however, the facial features are more generic.[3] The poet is crowned with conifer twigs, likely cypress, rather than the more customary, delicate leaves of laurel or ivy. Resembling a liberty bonnet, further topped with symbolic sprigs of mourning, it is perhaps representative of the poet's (as well as Rosa's) persistent meditation on moral, even macabre, matters – a search for freedom from the existential, material world.

Throughout his career Rosa self-consciously strove to cultivate a figure for himself as a serious rather than sentimental painter-philosopher. He has secured his status as the object of scholarly interest, and fulfilled his longing to be honoured with more than one crown. MM

14 ROSALBA CARRIERA

Venice 1675–1757 Venice

Portrait of a Woman

Pastel on blue laid paper
31.0 × 25.0 cm
Watermark: "IV" (18th-century Dutch?)
Purchased as a gift from Mrs. Walter Gordon, 1995
94/308

The pastel portraits of the renowned Venetian artist Rosalba Carriera are highlights of European rococo draftsmanship. Kings and aristocrats vied with Grand Tourists to sit for this extraordinary woman who created uncanny likenesses exploiting the subtle physical properties of pastel.

Carriera's pastels privilege an aesthetic of pleasurable illusion intimately linked to her materials. Powder makes up and depicts sitters' faces, engaging viewers in a refined, endless interplay between deception and reality, and reflecting ideas current in the sophisticated circle of art lovers around the wealthy Parisian collector Pierre Crozat (1661–1740), ideas expressed in Carriera's correspondence and developed by Roger de Piles (1635–1709), who wrote: "Painting is only make-up (fard), its essence is to deceive, and the greatest deceiver in this art is the greatest painter."[1]

The delicate, fragile pastel portrait was admired for its freshness and lightness, powdery skin and soft, velvety matte texture, characteristics, too, of the made-up human face. In the AGO work, a thick layer of moistened pastel fills in irregularities in the paper much in the way cosmetics smooth out skin blemishes.

The international elite sat for Carriera in her studio by the Grand Canal. Martin Folkes described a visit in 1733: "I was here extreamly [*sic*] well entertained with a great number of fine portraits some of my acquaintances very like."[2] Sitters selected a pose from portraits on display in the gallery of her house. Format was normally restricted to the bust or the head and shoulders, placed in a neutral but airy space close to the picture plane. This privileged the made-up face and echoed the elite's exploitation of cosmetics to control facial expression and convey only attractive messages.

This fresh and jewel-like portrait of a yet unidentified female sitter exploits the formal characteristics of eighteenth-century Venetian painting: free, open technique, virtuoso execution and appealing colour. This rich image, remarkable for dazzling textures, exquisite details and seamless finish, is flawlessly worked. No preliminary sketches survive. Examination with infrared reflectography uncovers schematic outlines that locate the sitter's shoulders and neckline beneath the pastel layer. Carriera blocked out the major areas of light and dark and enlivened the face with colour.

This portrait is worked on blue paper, which provided a soft fibrous surface that caught and held the dry pastel particles. The pattern of the antique laid papermaking mould and the watermark "IV" are visible in transmitted light. This mark, widely appropriated by European papermakers as a mark of quality, originated as the initials of the French papermaker Jean Villedary. Carriera's pastel portraits were mounted to wood strainers, placed in ornate gilt frames like oil paintings, and hung on walls. TB

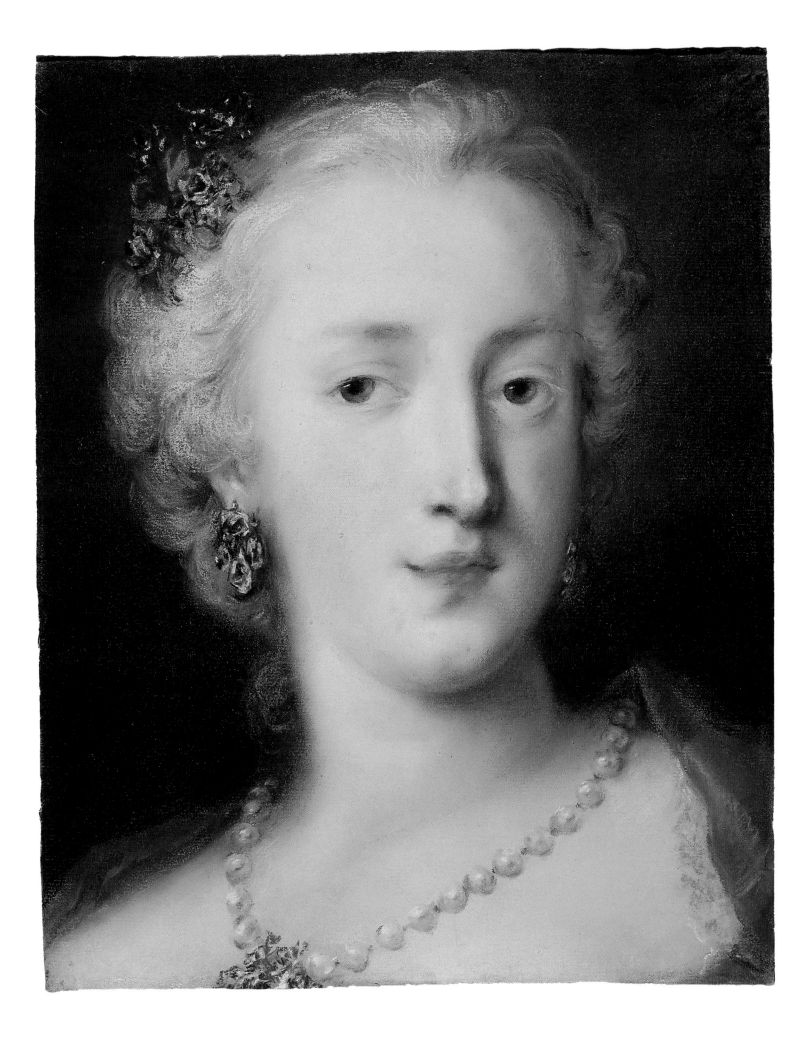

15 GIOVANNI PAOLO PANINI

Piacenza 1691–1765 Rome

Roman Ruin with Figures, 1728

Pen and brown ink and grey wash over black chalk on laid paper
68.3 × 45.4 cm
Inscribed in brown ink l.l.: *I.P. Panini/Rome/1728*
Gift from the Junior Women's Committee Fund, 1971
70/147

In 1711 Giovanni Paolo Panini left his native Piacenza for Rome to further his artistic studies after having spent three years collaborating with fellow architect and decorative painter Ferdinando Bibiena. A commission to decorate several rooms in the villa of Cardinal Giovanni Patrizi in 1718 affirmed Panini's growing professional reputation. That same year he was elected to the Congregazione dei Virtuosi al Pantheon, and in the following to the Accademia di San Luca. Panini would also later serve as an instructor at the Académie de France in Rome. A versatile artist, he moved easily between drawing, oil painting and decorative fresco. In addition, Panini's practice encompassed designs for church furnishings, stage sets and ephemeral festival architecture.

As early as 1716 Panini demonstrated an aptitude for producing "view" paintings (known by the Italian term *vedute*). Avidly pursued by Dutch and northern émigré artists working in late-seventeenth-century Rome and Venice, this type of picture took the local architectural and topographical surrounding as its principal subject. Panini's ability to depict sites with speed and accuracy inspired members of the elite to request his services in creating documentary paintings (*vedute reale*) for the commemoration of festivals, ceremonies and the visits of dignitaries.

Many of Panini's works, including this drawing, are *vedute ideate*, or inventive *cappricci*, rather than *vedute* proper. These consist of an imaginative array of monuments presented within a convincingly unified space (cf. Kobell, cat. 41). Although Panini's draftsmanship engages with a high degree of precision and perspectival accuracy (certainly the result of his early training in architecture and stage design), the picturesque and atmospheric qualities of his approach always remain in evidence. Quite large in size and refined in its degree of finish, the present state of this drawing represents its final and intended form, rather than serving as a preparatory study.[1]

The educated eighteenth-century travellers who ventured to Rome (one of the foremost destination points on the Grand Tour) were the primary market for this type of image; English tourists in particular were avid collectors of Panini's work. This drawing is an accomplished example of Panini's facility for redeploying a vast repertoire of archaeological prototypes. Both the striated sarcophagus, with its lion and double portrait, and the towering, Bacchus-like sculpture loosely resemble actual monuments. Likewise, the crumbling columns and entablature recall the temple fragments scattered along the Via Sacra of the Roman campo. Although Panini's figures wear vaguely historicizing garb, the degree of overgrowth and decay in their environs corresponds to how Rome would have appeared to an eighteenth-century spectator. The drawing thus conflates a speculative rumination upon daily life in the classical past with the physical manifestation of its present state, creating an ambiguous sense of temporality. The denizens of this antique landscape gesture casually to one another, engage in quotidian activities and assume an air of sociable collusion. They also demonstrate a marked degree of attentiveness to the monuments that surround them. Panini thus seems deliberately to thematize the act of looking and in particular the sense of wonder that such archaeological splendour engendered for both his imagined viewers of antiquity and the spectators of his own day. RL

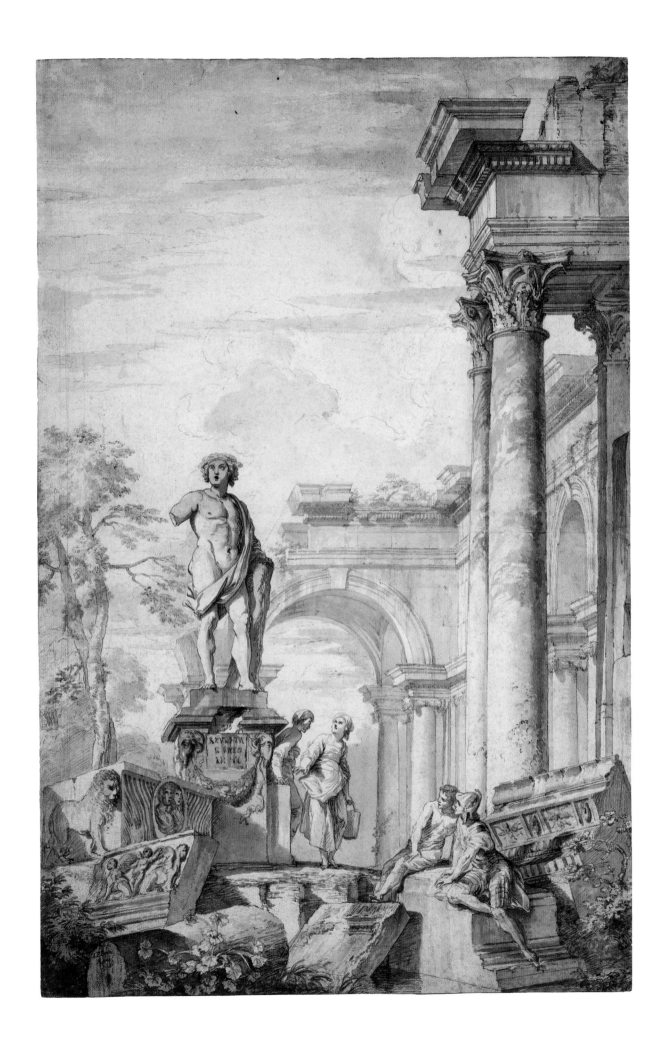

16 GIAMBATTISTA TIEPOLO

Venice 1696–1770 Madrid

A Reclining Male Nude, 1745

Black chalk with traces of white chalk on blue laid paper
30.5 × 41.6 cm
Watermark: animal or bird above the letters "ROSA"
Gift from the estate of R. Fraser Elliott, 2005
2005/259

Giambattista Tiepolo is the leading history painter of eighteenth-century Italy. He worked for palaces and churches from Madrid to St. Petersburg; he was a prolific and brilliant draftsman and was active as an etcher. Of the nearly 1,500 chalk drawings from the Tiepolo studio, one-third are studies by Giambattista, many linked with his paintings; one-third are studies by Domenico, mostly linked with his paintings; and one-third are studio copies. This handsome study was made on a folio sheet of blue paper, the same size as the Tiepolo sketchbooks in Venice and St. Petersburg.[1] It was preparatory to an important figure, perhaps representing heresy, falling out of the lower part of the ceiling fresco of the Church of the Scalzi in Venice, painted by Giambattista between April and November 1745.[2] The ceiling was destroyed in the Austrian bombardment of October 1915.[3]

Drawings of this kind represent an important stage in the development of the design of a fresco or canvas, between preliminary rough studies in pen and wash on white paper, and oil sketches, or modelli, and the final execution. Although known from an early part of Giambattista's career,[4] they take their characteristic form with the frescoes of Ca' Labia in the summer of 1744[5] and the ceiling of the Scalzi in 1745. Broadly, they show Giambattista following a type of drawing established by Veronese.

Such studies were preserved with care in the Tiepolo studio, and were used again when appropriate. Thus we find this figure recurring in the frescoed ceiling of the Palazzo Canossa in Verona of 1761,[6] and in the ceiling of the throne room of the Royal Palace at Madrid in 1764.[7]

There has always been controversy as to whether such drawings as these should be regarded as original studies by Giambattista, or as copies after them, presumably by his son Domenico. This element of doubt was still expressed in the catalogue of the exhibition at Cambridge in 1970.[8] Only in the course of a study of the mass of chalk drawings at Stuttgart in that year, in which both Giambattista and Domenico are well represented, did it become clear that such a drawing as this must be claimed as a study for the fresco by Giambattista himself. This position was first presented at the exhibition held at Stuttgart later in 1970. Against the background of a study of all the chalk drawings, the full publication of the Tiepolo chalk drawings in 1980 established clearly the distinction between the hands of Giambattista, Domenico and the studio copyists.[9]

Armand-Louis de Mestral de Saint-Saphorin (1738–1806) was a Swiss gentleman whose family took its name from the village of Saint-Saphorin, on the north side of the Lake of Geneva, to the east of Vevey. He served the King of Denmark in various diplomatic posts, including a mission to Madrid in 1774. There, it seems, he acquired a considerable group of Tiepolo drawings directly from the studio. At his death, his collection of drawings passed by descent to Édouard de Cérenville (1843–1915) and René de Cérenville (1875–1968) of Lausanne, who bequeathed the remains of the collection to the Musée Jenisch at Vevey.[10]

GK

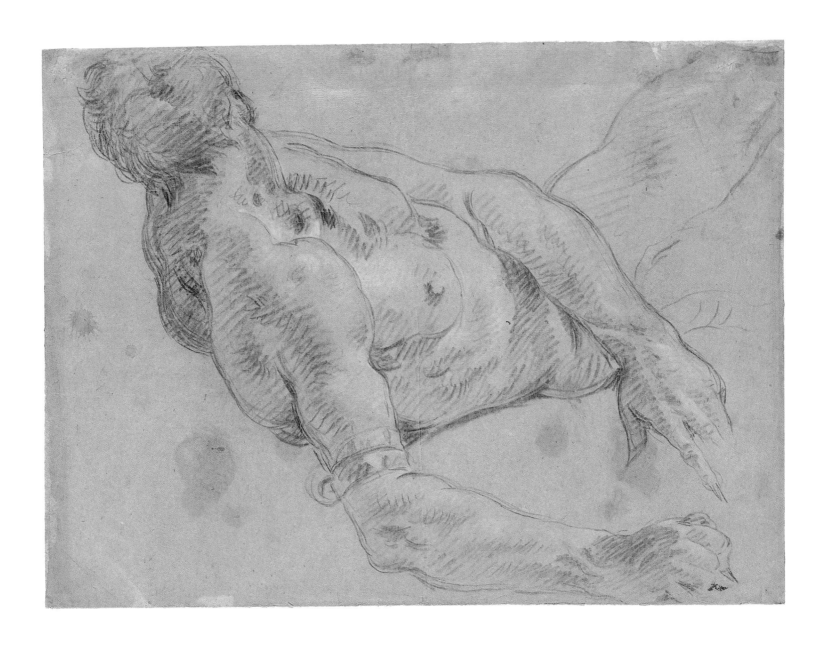

17 GIOVANNI DOMENICO TIEPOLO

Venice 1727–1804 Venice

Satyrs and Satyresses in a Landscape

Pen and brown ink and brown and grey washes on laid paper
17.5 × 27.6 cm
Watermark: "CZ" (?)
Signed in ink l.r.: *Dom. Tiepolo f*
Inscribed on verso: *415*
Purchase, 1989
89/11

Domenico Tiepolo worked in the shadow of his father Giambattista, but from the beginning he developed a clearly defined style of his own, with an enthusiasm for popular religious themes and genre subjects. Like his father, he was also very active as a draftsman and an etcher. The present sheet forms part of an extensive series of approximately 140 drawings that constitute nearly ten per cent of his known pen drawings. They do not appear to have been commissioned, and seem to have been made in a single creative impulse. They remained together until after Domenico's death in 1804.[1]

The male and female satyrs of Domenico Tiepolo are benign denizens of the countryside, kinsmen of the great god Pan, living on good terms with their human neighbours. A small admiring group of these, properly dressed – as they nearly always are in these drawings – edge into the scene on the left side. The story of Pan and Syrinx has given satyrs a bad name, but those of Domenico's works do not rape nymphs, although female satyrs are sometimes carried off by centaurs. Even so, their relations with the centaurs are also on the whole peaceful and friendly. Animistic creatures, half man and half goat, they play out human passions and feelings in a fabulous setting, without the equivocal embarrassment of human nakedness. They bridge the great divide between the mundane and the divine, and bring a touch of Arcadia to the Venetian countryside.

Satyrs populate some of the earlier paintings of Tiepolo's father, Giambattista (cat. 16); in an early canvas, *Apollo and Marsyas*, painted for Ca' Sandi about 1725,[2] and in three overdoors painted around 1742 as part of the decoration of a room in Ca' Dolfin a Rialto.[3] These small oval canvases show female satyrs relaxing in a landscape. Four of Giambattista's etchings of the early 1740s show a satyr family in a landscape.[4] Satyrs, male and female, *en grisaille*, form an important decorative element in several ceilings by Giambattista, especially those in the Palazzo Clerici in Milan,[5] in Ca' Rezzonico[6] and Stra,[7] for which there exist a number of fine drawings. The female satyr in our drawing is closely related to these reclining figures on cornices and overdoors.[8]

Apart from this large series of drawings, Domenico's main essay in this genre is found in the frescoes of the Stanza dei satiri in Ca' Rezzonico,[9] dated 1771.[10] The relationship of the drawings to the frescoes is fully explored by Cailleux,[11] and one may suppose that the drawings as well as the frescoes may well have been the result of a prolonged *villeggiatura* in the summer following his return from Madrid in November 1770.[12] The female satyr in our drawing appears in reverse in these frescoes.[13] GK

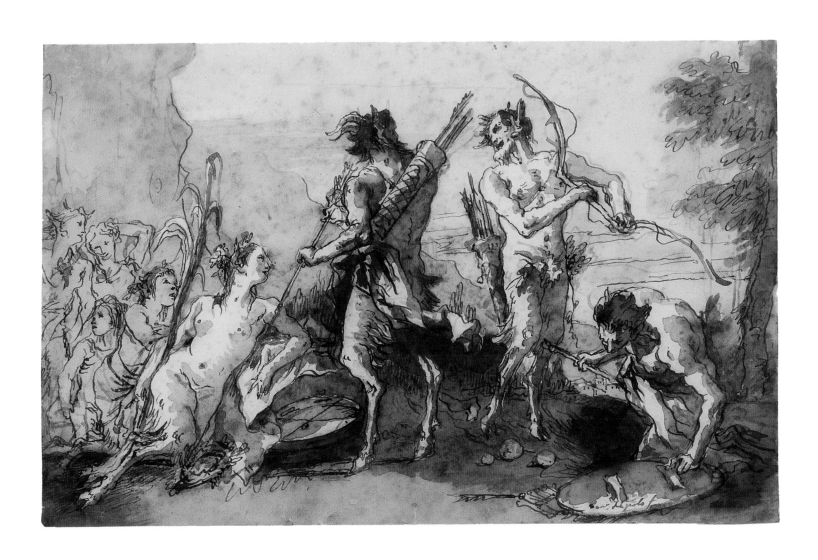

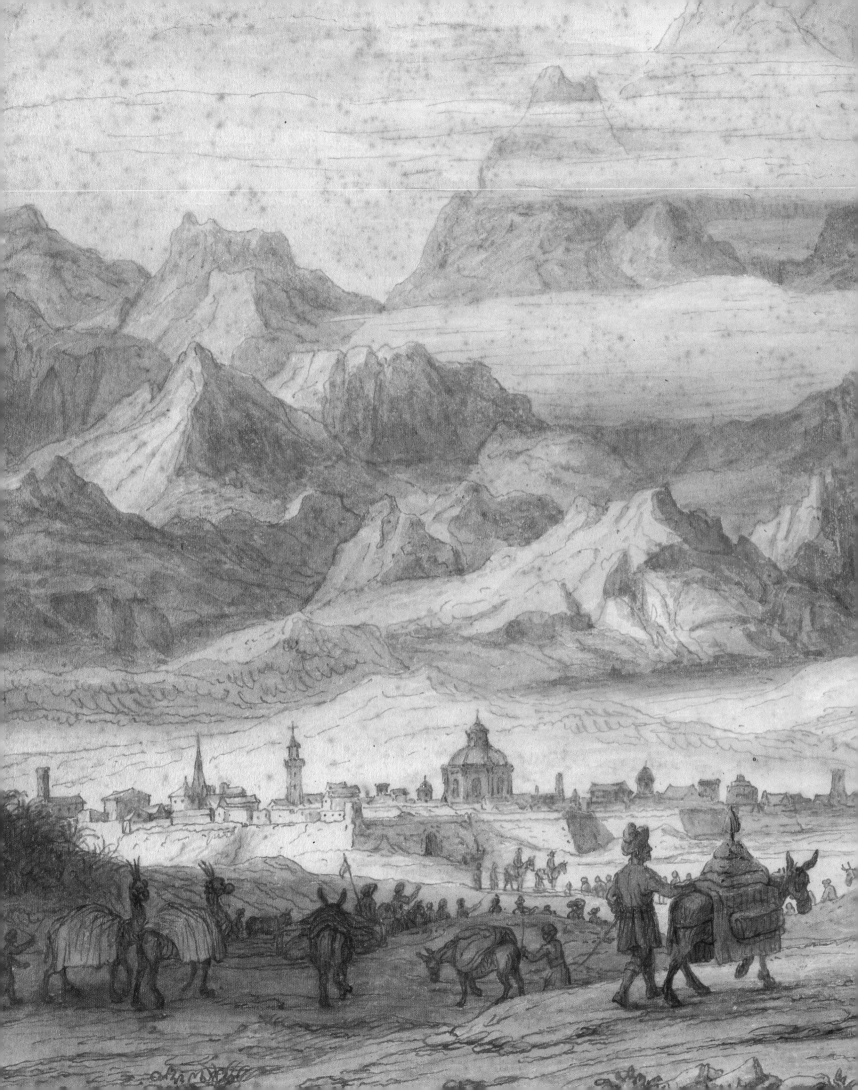

18 MASTER OF THE EGMONT ALBUMS

Flemish painter, active in Italy, late 16th to early 17th century

St. Cecilia and the Heavenly Chorus, c. 1580–1600

Black chalk, pen and brown ink on laid paper
36.4 × 28.8 cm
l.l.: illegible inscription in brown ink;
Inscribed in brown ink l.r.: *M 3 L*
Gift of Marjorie Bronfman, 2001
2001/230

Few draftsmen constitute a greater enigma to historians of Netherlandish art than the artist known as the Master of the Egmont Albums. Despite several attempts, there is still no consensus on the artist's identity.[1] This name has been given to a diverse body of ink and chalk drawings executed in a mannerist style and employing vigorous draftsmanship. If nothing else, we can at least be certain that the artist was familiar with Netherlandish and Italian stylistic currents of the last few decades of the sixteenth century.

This attribution was first assigned in 1958 to four pen and ink drawings from the albums of the first Earl of Egmont (1683–1748).[2] Since then, about two dozen sheets have been attributed to the same hand, of which *St. Cecilia* is one of the largest and most dynamic.[3]

In addition to the steady flow of northern artists to Rome, prints made the work of leading Italian and northern mannerist artists accessible throughout Europe.[4] Although the style and technique suggest the influence of the Utrecht painter and draftsman Anthonis Blocklandt, who travelled to Rome in the 1570s, other sources have also been noted, particularly the Roman artist Taddeo Zuccaro.[5] Interestingly, later inscriptions on several sheets attribute these drawings to a wide variety of artists, including Pordenone, Tempesta, Hans von Aachen and Frans Francken II. An inscription on the mount of this drawing attributes it to Rubens's master Otto van Veen. The range of these attributions attests to the international influence of Italian stylistic currents during the late sixteenth century.

St. Cecilia exhibits the master's characteristic style and pen technique: strong, agitated parallel hatching, small faces and flat, attenuated forms. However, the composition, with its semicircular sweep of angels and perspectival recession, departs from the shallow chaos of the master's furious battle scenes at Yale and Munich. The opening to a vista at one side occurs in other drawings associated with the master, such as the *Nativity* at Yale and *The Good Samaritan* at the J. Paul Getty Museum.

Although there is a long artistic tradition of depictions of the virgin martyr St. Cecilia, dating back to the late fifth century, representations with the organ originate in the fourteenth century. They appear to have been inspired by the legend that while the musicians played at her wedding, she sang to God only in her heart ("*cantantibus organis illa in corde suo soi domino decantabat*"); the words *cantantibus organis* were evidently misinterpreted.[6] Here the artist has depicted St. Cecilia playing a portative organ while an angel works its bellows. Our drawing is unusual in that pictures of the saint by Netherlandish mannerists – for example, Hendrick Goltzius – typically show only a few musicians.[7] However, an idiosyncratic approach to subject matter has been noted in other sheets by the artist.[8] St. Cecilia was frequently depicted in the late sixteenth century, and in 1585 when the Academy of Music opened in Rome, she was chosen as its patron saint.

A sketchier drawing with similar dimensions and black chalk shading in the Kupferstichkabinett, Dresden, presents a variation on the subject in reverse (fig. 1).[9] The relationship between them is unclear. One may have been designed for a print. OB

fig. 1:
Master of the Egmont Albums
St. Cecilia and the Heavenly Chorus
pen and brown ink and black chalk
35.1 × 28.4 cm
Kupferstichkabinett, Staatliche Kunstsammlungen, Dresden (C 1976-184)

19 ABRAHAM BLOEMAERT

Gorinchem 1566–1651 Utrecht

The Judgment of Paris, c. 1592

Pen and brown ink and grey wash over traces of black chalk on laid paper
40.5 × 51.5 cm
Purchased with the assistance of Frank and Marianne Seger, 1984
84/37

With an artistic output that spanned the period from about 1590 to 1650, Abraham Bloemaert was one of the most prolific and influential Dutch artists of the Golden Age. *The Judgment of Paris* is a compositional design for a painting that was severely damaged in a New York fire in 1954.[1]

The painting, which M. Roethlisberger called "a mannerist composition *par excellence*," is datable to about 1592 on the basis of its stylistic proximity to the signed and dated painting *Apollo and Daphne* (formerly in Breslau).[2] The Toronto drawing is a brilliant example of Bloemaert's drawings of mythological and biblical subjects from his earliest period of activity.[3] It is also one of the first Dutch compositions of the classical mythological theme popular in sixteenth-century Italy and Flanders.

Paris, a Trojan shepherd, was instructed by Mercury to judge a beauty contest between three goddesses: Juno, shown in profile; Minerva, in the center; and Venus, accompanied by Cupid. Tempted by Venus's promise of the hand of Helen, the most beautiful of women, Paris awarded Venus the golden apple. The ensuing abduction of Helen, wife of the king of Sparta, provoked the Trojan War. The contest is witnessed in the left foreground by Diana and seven nymphs, and in the right foreground by the river god Xanthus and satyrs. In the clouds, putti play above Venus's chariot. Bloemaert drew inspiration from the famous print of the subject by Marcantonio Raimondi, incorporating the motif of the river god at lower right, the seated position of Paris and the general pose of Minerva (fig. 1).[4] In the early seventeenth century, Bloemaert's composition directly inspired a number of painted versions by his close Utrecht associate Joachim Wtewael.[5] Bloemaert himself would return to the subject in a painting of 1636 in his later classicist style.[6]

The twisting, muscular figures, decorative elements and compositional arrangement of the Toronto drawing register Bloemaert's inventive and lively engagement with the late-mannerist aesthetic influenced by Bartholomeus Spranger and current in Haarlem in the last decades of the sixteenth century. The engravings of Hendrick Goltzius, especially the 1590 *Judgment of Midas* and the magnificent 1587 *Wedding of Cupid and Psyche* after Spranger, provided a source for the exaggerated foliage and elaborate coifs and for the boldly gesturing figures that frame the composition.

The use of *repoussoir* figures and the relegation of the protagonists to a sunlit middle ground accorded with Karel van Mander's principles for narrative compositions outlined in his *Den Grondt der Edel vry Schilder-Const* (Foundations of the Noble and Free Art of Painting) of 1604. He derived these principles from Italian art, particularly that of the Zuccaro brothers in Rome. According to a seventeenth-century description, van Mander painted a lost *Judgment of Paris* with satyrs, nymphs and a river god in a landscape.[7] Although the Judgment of Paris does not appear in Ovid, van Mander included a moralizing commentary on the story in his *Wtlegghingh op den Metamorphosis* (Explanation of the Metamorphosis) of 1604. This didactic text seems to have inspired the unprecedented interest in scenes from Ovid by Dutch artists in the last decade of the sixteenth century.[8]

OB

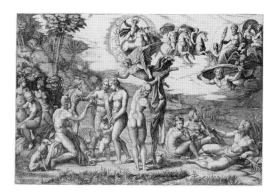

fig. 1:
Marcantonio Raimondi after Raphael
The Judgement of Paris
c. 1510–20
engraving
29.1 × 43.7 cm
The Metropolitan Museum of Art, New York, Rogers Fund, 1919 (19.74.1)
Digital image: The Metropolitan Museum of Art, New York

REMBRANDT HARMENSZ. VAN RIJN

Leiden 1606–1669 Amsterdam

A Quack, c. 1637

Pen and brown ink on laid paper
10.2 × 8.6 cm
Gift from the estate of R. Fraser Elliott, 2005
2005/246

This exuberant sketch of a quack doctor peddling his false remedies is one of several amusing studies of street entertainers, actors and mountebanks that Rembrandt executed in the late 1630s.[1] In a few rapidly penned lines, this extraordinary characterization exemplifies Rembrandt's theatrical ability. Wearing an old-fashioned mantle and tall cylindrical hat, the wily charlatan leans forward emphatically and counts off his wares. A similar quack doctor, complete with a parrot on his shoulder, appears in a drawing in Berlin, gesturing slyly to a crowd from a makeshift stage propped with a table, a Chinese parasol and a poster (fig. 1).[2]

Itinerant quack doctors were a popular subject in the art and literature of the Netherlands during the seventeenth century. Images of mountebanks hawking their elixirs to a gullible crowd satirized foolishness and deceit. The theatrical characterization of the quack derived from sixteenth-century farces, which focused on his flamboyant trickery rather than the public's naivety.[3] In this drawing, Rembrandt focuses less on social satire than on the exploration of dramatic performance. Not surprisingly, our sheet is closely related thematically to Rembrandt's group of drawings of lively actors from the *commedia dell'arte* (Italian improvisational comedy).[4] Indeed, the quack's fantastic costume, including a "baton" hanging from his belt – which also appears in the Berlin drawing – resembles the dress of actors in the *commedia dell'arte*, especially the figure of "Pantalone," whom Rembrandt also represented in another drawing of the same period, now in Hamburg.[5]

Aside from allowing him to explore the depiction of theatrical figures, the subject of the quack may also have resonated with Rembrandt on another level. The characterization of the artist as a deceiver was common in Dutch literature of the sixteenth and seventeenth centuries. Similar to how the quack's profession involved tricking the public with his illusive remedies, the artist playfully deceived the viewer with his pictorial illusions. A painting by Gerard Dou, a pupil of Rembrandt, draws an analogy between the artist and the quack: in a window behind the quack's stage is a self-portrait, suggesting in pictorial terms that both practise a form of skilled deception.[6]

Rembrandt's draftsmanship is generally characterized by an animating energy and penetrating observation, but it was specifically in the 1630s that he explored possibilities for activating figures through the rapid handling of his pen. The present drawing exhibits the spontaneity and fluidity of his other pen drawings from the mid-to-late 1630s. The stage backdrop is briefly indicated with three vertical lines, while the quack's shadow appears as a speedy zigzag stroke from the half-dry pen. To emphasize his forward motion, Rembrandt added a few bold strokes over the initial contours with the broader edge of the quill pen. Typical of Rembrandt's draftsmanship is the way in which a single abbreviated mark – for example, the two-shaped stroke under the quack's hand in both this work and the Berlin sheet – serves no other purpose than to emphasize movement.[7] The taut facial profile, which captures the charlatan's expression with a powerful economy of means, also appears in other drawings of the same period.[8] OB

fig. 1:
Rembrandt Harmensz. van Rijn
The Quack
c. 1637–38
pen and brown ink, corrections in white
20.0 × 14.7 cm
Kupferstichkabinett, Staatliche Museen, Berlin
(5268)

21 LAMBERT DOOMER

Amsterdam c. 1623–1700 Amsterdam

Noah's Ark on Mount Ararat, a Camel Train outside the City of Yerevan in the Foreground, c. 1690

Pen and brown ink and brown, grey and yellow washes on laid paper
26.7 × 41.0 cm
Watermark: "I H S" surmounted by a Latin cross with "PB" below
Inscribed on verso: *De stat urwan of erwan leggende aen den voet vant geberchte Ararath of aen het/ Lantschap Meden omtrent de Kaspische See op de scheydinge van Armenien/en meeden en Parse. de Arche noo stat noch boven op den Berch*
Collectors' marks: Cornelis Hofstede de Groot (Lugt 561); C.R. Rudolf (Lugt 2811b)
Purchase, 1978
78/98

Large coloured landscape drawings such as this dreamy scene by Lambert Doomer, one of the most characteristic and prolific of Dutch topographical draftsmen, exemplify the pictorial quality of many Dutch seventeenth-century drawings. Doomer was one of many Dutch artists to travel across Europe sketching famous sites. In the studio, he used these travel sketches to create large finished drawings, which he sold to collectors who purchased them as complete works of art in their own right. They are characterized by the application of atmospheric washes of subtly different tones overlaying sensitive pen work.

This is an extraordinary sheet, fantastic and monumental in its composition, and is best understood as an idealized topographical landscape. The subject has inspired much speculation. As in many of his accurate topographic views, an autograph inscription on the verso precisely identifies the scene as the city of Yerevan, now the capital of Armenia and a popular tourist destination. The exotic train in the foreground and the ancient boat on top of the mountain suggest that this episode is drawn from the Old Testament story of Noah's Ark. The inscription on the verso translates: "The city of Yerevan at the foot of Mount Ararat, in the landscape of Media around the Caspian Sea at the border of Armenia, Media and Persia." Following popular opinion, Doomer added, "Noah's Ark still lies at the top of the mountain." Indeed, a small ark sits atop the cloud-lined peak.

The Holy Land fascinated the Dutch in the seventeenth century: they saw themselves as the spiritual descendants of the ancient Israelites and called Amsterdam "the new Jerusalem." The drawing resembles the imaginative biblical illustrations of the engraver Jan Luiken (1649–1712) published in the early eighteenth century.

Although his other topographical drawings are based on sites that he visited, there is no evidence that Doomer travelled east. There is a smaller version of the same composition, in reverse, by the Dutch topographical and landscape draftsman Willem Schellinks (1623–1678) (fig. 1).[1] The artists were travel companions in France in the 1640s, and they both produced drawings for a collector of local and biblical topographical views, Laurens van der Hem (1621–1678).[2] The exact relationship between the two drawings is unknown. However, since Doomer's work probably dates from the early 1690s, when he made a number of idealized landscapes, it is later than that of Schellinks, who died in 1678.[3] Schellinks apparently did not travel to the area either, and he may have consulted a printed model.[4]

OB

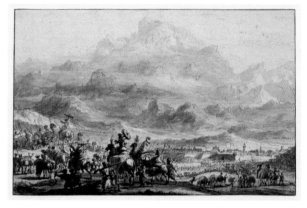

fig. 1:
Willem Schellinks
Noah's Ark on Mount Ararat, a Camel Train outside the City of Yerevan
graphite, pen and brown ink, brown wash
18.3 × 28.6 cm
Kupferstichkabinett, Staatliche Museen, Berlin
(4348)

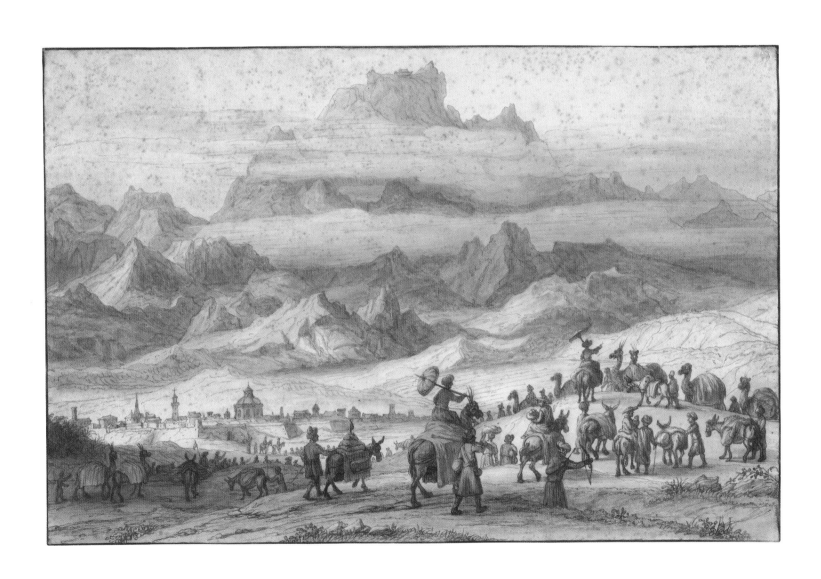

22 ADRIAEN VAN DE VELDE

Amsterdam 1636–1672 Amsterdam

Seated Old Man, c. 1660–71

Red chalk, traces of black chalk, on laid paper
28.2 × 20.5 cm
Signed in red chalk l.r.: *A.v.d.Velde fe.*
Gift of Dr. and Mrs. Gilbert Bagnani, 1988
88/149

Painter and etcher of sunlit pastoral scenes with herdsmen and cattle, Adriaen van de Velde made dozens of chalk drawings from models in the studio in preparation for the figures in his finished works. Although he died when he was only thirty-five, he was one of the most gifted observers of the human figure, and he was regularly asked to paint staffage in works by other landscape artists. This chalk drawing of an old man in a cloak holding an upturned hat appears to depict a model posing as a beggar. It is a superb example of van de Velde's distinctive studies and beautifully demonstrates his technical mastery and ability to endow figures with a convincing sense of individuality.

The directness of this study was achieved by van de Velde's skilled evocation of light and shadow. With precise chalk strokes and sensitive use of the white paper, he was able to suggest a nuanced play of light over the form. In contrast to the delicate strokes defining the face and folds of the cloak, van de Velde characteristically set off the figure from the background with broader parallel hatching. The curious lines that traverse the figure may be the result of putting the chalk drawing together with a blank sheet in a press, creating an offset image on the latter called a counterproof. Although there is no known counterproof of this work extant, van de Velde frequently made use of this practice, which gave him an easy record of the figure in reverse that increased his stock of studies.[1]

Most of van de Velde's drawings of live models date from the 1660s, when the figures play a larger role in his landscapes. In addition to his numerous chalk studies of younger women and men in the poses of herdsmen and milkmaids, he also sketched cows and sheep in the countryside, and he frequently drew from nude models in the studio. His preparatory method was much more thorough than other Dutch artists, such as Rembrandt, who rarely made direct preliminary studies. By contrast, van de Velde usually began a painting by making a rough sketch of the composition, followed by studies of models in specific poses for the principal figures and, finally, a detailed compositional drawing.[2] Over half of his more than forty surviving figure studies can be related to finished works.[3] His method, especially the practice of drawing nudes, may have been influenced by the example of the French Academy.

Another drawing of the same model, taken from a different angle, is in Cambridge, Massachusetts (fig. 1). In both drawings the man's right hand rests on his left knee. Interestingly, the man appears to have a foot disorder, possibly flat feet, which is visible in both drawings. Van de Velde used the figure in the Cambridge sheet for his painting *Mercury and Battus*, which is signed and dated 1671 (National Museum, Prague).[4] However, so far our drawing has not been connected with a painting or other finished work. OB

fig. 1:
Adriaen van de Velde
Seated Old Man
charcoal and white chalk on paper
59.8 × 41.4 cm
Fogg Art Museum, Harvard University Art Museums,
Cambridge, Massachusetts, inv. no. 1957.221

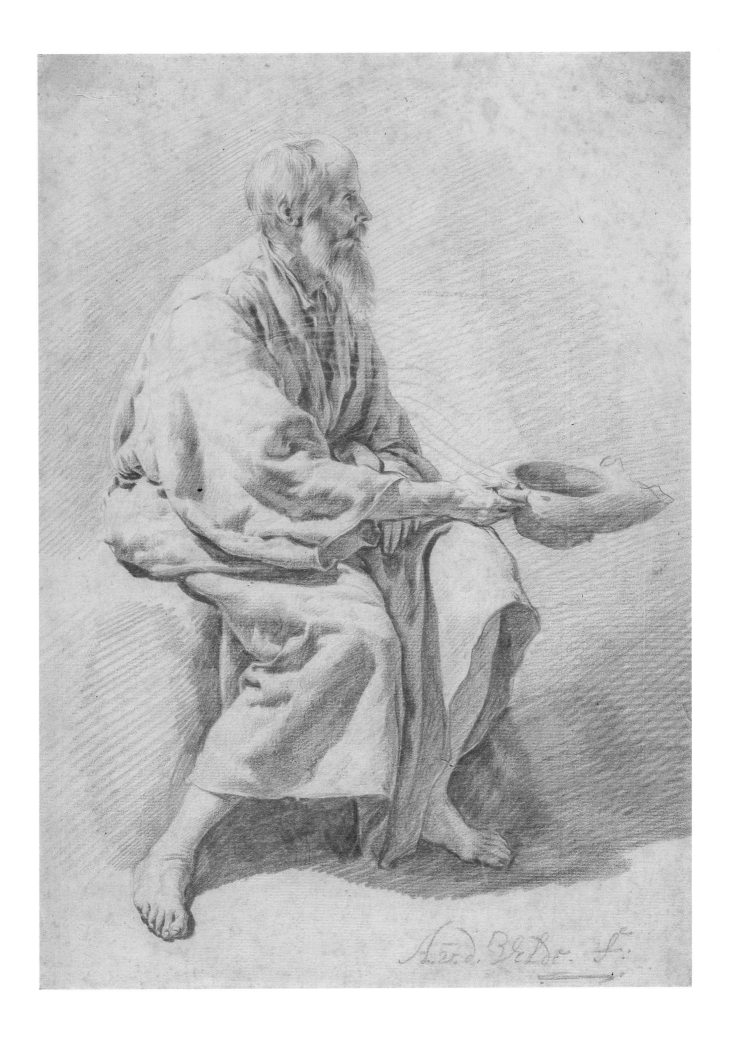

23 VINCENT VAN GOGH

Zundert 1853–1890 Auvers-sur-Oise

The Vicarage at Neunen: Seen from the Back,
with the Artist's Studio on the Right, c. 1884

Graphite, pen and brown ink, brown wash, heightened with white on wove paper
25.6 × 37.8 cm
Purchased with proceeds from the Annual Giving Fund, 1982
81/556

This drawing is inextricably linked to Vincent van Gogh's psychological relationship with his family as well as his artistic experiments in Holland.

On 4 August 1882 van Gogh's father, the Reverend Theodorus van Gogh, was transferred to the remote Brabant village of Neunen where, as the newly appointed Dutch Reformed minister, he settled with his family into the old vicarage. Built in 1776, it was situated in the vicinity of his Calvinist church.

The small extension to the right of the house in this view from the garden enclosed the laundry and storage shed that had been converted into van Gogh's combined living quarters and studio by the end of December 1883. Here he began work on the *Weavers* and Brabant peasant themes that later culminated in his watershed painting *The Potato Eaters*. He made this drawing in April 1884, five months after arriving in Neunen. A photograph (fig. 1) attests to his faithful observation. The drawing is related to several other studies depicting the vicarage and its garden.[1] In November 1885 he made a related study of the façade and a lugubrious moonlit view of the garden, probably in memory of his father's death.

In the first edition (1910) of her biography, *Personal Recollections of Vincent van Gogh,* Elizabeth Huberta van Gogh recalled that her brother made a view of the vicarage garden as a means of expressing his feelings of estrangement from the traditional and conservative lifestyle of his family and their social standing. She wrote: "This displeasure is fully expressed in the otherwise beautiful lithograph-like drawing of the parental house seen from the rear of the garden. Of this old-fashioned, somewhat overly groomed house with its friendly, well-cared-for garden he has made a haunted house, overgrown with wild grass even as the trees are whipped to one side by the wind. Of the two unidentified figures it cannot be said what they are doing."[2]

After leaving Neunen in November 1885, van Gogh continued to produce a series of psycho-biographical studies representing his *atelier-résidence* in France. These works recall in spirit his earlier studies of the vicarage. In this context, *Vicarage at Neunen: Seen from the Back of the Artist's Studio* can be considered a seminal source for van Gogh's iconic *The Yellow House*, painted in 1888 in Arles.

Although Elizabeth Huberta did not identify the female figure on the porch, it must represent one of the artist's sisters – Anna, Wilhelmien or Elizabeth – who resided in the household while their mother recuperated from a broken thigh bone. It is likely that the figure is Elizabeth, as she was the first owner of the drawing. It was purchased at auction by the Art Gallery of Ontario after having been consigned by a hitherto unknown nephew of the artist, Félix du Quesne, Elizabeth's son by her second husband. Mr. du Quesne had inherited the drawing after his mother's death in 1936 and brought it with him when he immigrated to Canada. He lived in Québec. BWO

fig. 1:
Photograph from the garden of the vicarage at Neunen, taken mid-twentieth century, of the structure built in 1776.
Photo: Courtesy of Bogomila Welsh-Ovcharov.

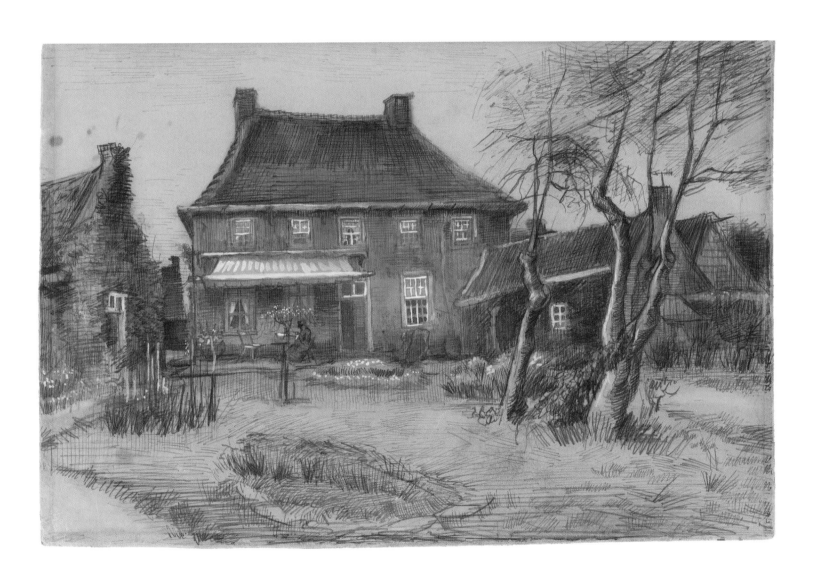

77

24 DANIEL RABEL

Paris 1578–1637 Paris

Grotesque Musician from the Ballet du Sérieux et du Grotesque, 1627

Watercolour, pen and brown ink, over black chalk, with gold and silver highlights, on laid paper
30.7 × 20.9 cm
Inscribed in graphite u.r.: *19*; inscribed in ink u.r.: *Musiciens du/Crotesque [sic]/trouillat/ou/M.d musiq*
Purchased as a gift of the Trier-Fodor Foundation, 1986
86/192

The designs from the workshop of Daniel Rabel,[1] an accomplished printmaker and *ingénieur du roi* for King Louis XIII (r. 1610–43), are practically the only visual evidence for French court ballet in this period. Until recently Rabel's known costume designs comprised an album of elaborate drawings showing figures or groups in three ballets dating between 1625 and 1632, and thirteen etchings illustrating the commemorative booklet (*livret*) for a performance in 1617.[2] In the mid-1980s the known corpus was greatly expanded with the discovery of some two hundred working drawings for costumes, mainly attributable to Rabel himself.[3] The AGO now owns forty of these drawings including the present sheet.[4] As Margaret McGowan notes, they are clearly "working drawings from which costume, hat and boot makers, jewellers, embroiderers and so on, wrought creations intended to astonish the Court by their richness and (often) by the bizarre nature of their designs."[5]

Despite more dignified beginnings in previous decades, French court ballets under Henri IV (r. 1589–1610) and Louis XIII (r. 1610–43) often consisted of disparate entrées of bizarre characters, in the manner of the *commedia dell'arte* performances by travelling Italian players. Even in the more ambitious burlesque ballets, the verse tends to be mediocre, the sets rudimentary and the themes devoid of any plot continuity.[6] The costumes, however, are invariably lavish and abundant signifiers of courtly magnificence. In France male and female roles alike were danced by the men of the court. Indeed, Louis himself is known to have taken the stage as a coat snatcher, a ridiculous soldier, a grotesque Persian scholar and an old Gallic woman in the train of a princess.[7] Such sexual, generational and economic cross-dressing seems less strange when one recognizes that these performances are a form of carnival reversal. The noble dancers' legitimate identities are expressed straightforwardly in the magnificent *grand ballet* traditionally closing the performance.[8]

The present design sheet shows a masked figure playing a triangle, dressed in a ludicrous costume with alternating sections of intense colour.[9] The details, from the flag-pierced hat to the variable-length toes, are amusingly asymmetrical. Rabel playfully underscores the character's musical role by trimming the scalloped upper garment with gold bells and adding a cymbal or gong to his chest. Characteristically, real gold and silver are applied over the watercolour for such details.

The inscription at upper right (*Musiciens du Crotesque [sic]*) helps us relate this drawing to the *Ballet du Sérieux et du Grotesque* (1627), to which we can ascribe numerous other designs with varying degrees of confidence.[10] This ballet was danced by Louis XIII and his courtiers in the Louvre and the Hôtel de Ville in February 1627, with the main verses by René Bordier, and music by Antoine Boësset.[11] At one point the *livret* includes a verse for "the grotesque [one] followed by music," with no description of instruments or other trappings.[12] Elsewhere there is mention of a *sérénade des grotesques* danced by the king and others – including, perhaps, the obscure Trouillat intended in the inscription at upper right. In the *livret* the grotesque serenaders are described as playing hurdy-gurdies, trumpets marine and other exotic instruments, but there is no mention of the triangle seen here.[13]

GL

19.

25 JACQUES STELLA

Lyon 1596–1657 Paris

The Presentation of Jesus to Simeon in the Temple, c. 1638–42

Quill pen, brush, iron gall and black ink, grey, gold and white transparent wash,
over black chalk and stylus underdrawing on laid paper
36.1 × 26.5 cm
Watermark: a cardinal's hat, the coat of arms of Armand-Jean du Plessis, cardinal, duc de Richelieu
(1585–1642)
Purchase, 1988
88/75

Jacques Stella, Nicolas Poussin (1594–1665) and Simon Vouet (1590–1649) were amongst the founders of the classical style in French painting during the reign of King Louis XIII (r. 1610–43). On his return from Italy to Paris in 1634, Stella became a painter both to the king and to his prime minister, Cardinal Richelieu.[1] Jacques Thuillier considered Stella's altarpiece *Jesus in the Temple, Found by His Parents* (1640–42), for the right transept of the Noviciat des Jésuites in Paris, to be an avant-garde work,[2] more classical in style than the baroque altarpieces that Poussin and Vouet executed contemporaneously for the main altar and the altar of the left transept of the same church.[3]

The style of the monumental, sculpturesque figures with restrained emotions in this drawing corresponds closely to that of the figures in Stella's altarpiece. The twisted Corinthian columns in the backgrounds of both works are an allusion to the eight twisted marble, late-antique columns in the piers of the crossing of St. Peter's in Rome, which were believed to have come from the Temple of Solomon in Jerusalem.[4] Stella actually depicted the twisted columns of Gian Lorenzo Bernini's (1598–1680) bronze *Baldacchino* in St. Peter's (1624–33) in the Art Gallery of Ontario's drawing, since he added a gold wash of iron gall ink over the grey wash to indicate that the columns were made of bronze.

This highly finished drawing is part of a series of twenty-two scenes of the life of the Virgin that the artist left to his niece, the engraver Claudine Bouzonnet-Stella. The drawings remained together until 1986–87, when they were sold at auction.[5] An approximate date of between 1638 and 1642 for the drawing in the AGO can be established by the coat of arms of Cardinal Richelieu in the watermark in the paper support.[6] This same coat of arms appears on the base of the throne of the Virgin in the engraved frontispiece by Pierre Daret of *L'instruction du chrétien par monseigneur l'éminentissime cardinal-duc de Richelieu* (Paris, Imprimerie royale, 1642). The preparatory drawing for this frontispiece by Stella is similar in style and technique to this drawing at the AGO.[7] Between 1638 and 1642 Stella designed several other frontispieces for the Imprimerie royale (founded by Richelieu).[8] Stella's series of drawings of the Virgin was probably intended to be published by the Imprimerie royale as a small book of devotion.[9] The commission for Stella's series was probably never carried out, and Stella may have continued to work on this project in the later 1640s after the death of Cardinal Richelieu.[10] The series was not printed until the eighteenth century, when it was etched twice, once in 1756 by Felice Polanzani, and a second time by Alessandro Mocchetti. Pinholes throughout the AGO drawing were used for transfer in the preparation of Polanzani's etching.[11] MNR

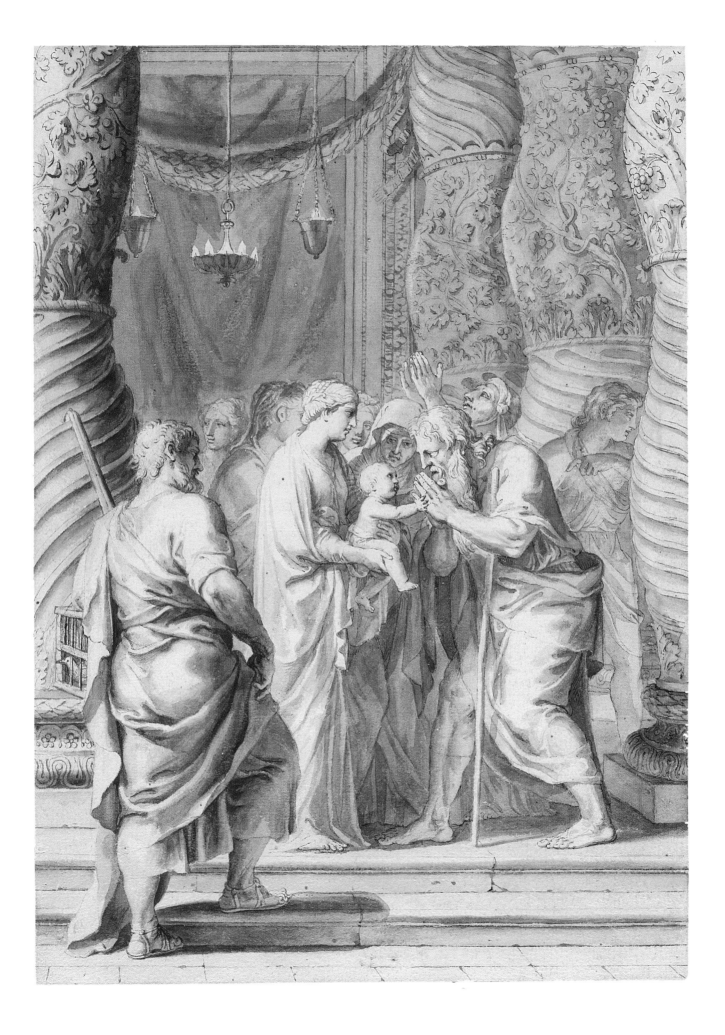

26 ISRAËL SILVESTRE

Nancy 1621–1691 Paris

View of Venice from the Campanile of San Giorgio Maggiore, c. 1664

Brush, grey ink, grey, grey-brown and blue ink washes, over metalpoint underdrawing
on vellum laid down at the borders
17.7 × 47.9 cm
Collector's mark (verso) l.l.: Sir Bruce S. Ingram, Chesham (Lugt 1405a)
Purchase, estate of William N. McIlwraith, 1969
69/29

Israël Silvestre, like Claude Lorrain (1600–1682) and Jacques Callot (1592–1635), was from Lorraine. Silvestre left Nancy during the Thirty Years' War (1618–48) and made three trips to Italy, in 1638–41, 1643 and 1653. He was named *graveur ordinaire du roi* in 1664. His task as principal etcher to King Louis XIV (r. 1643–1715) was to depict the royal palaces, court festivals and cities of the kingdom of France. Silvestre's panoramic views are indebted to the etchings of Callot and had an influence on Canaletto (1697–1768) and Gaspare Vanvitelli (1652–1736).[1]

Walter Vitzthum pointed out that this view of Venice was based on earlier fifteenth- and sixteenth-century views found in printed travel books. Silvestre adopts a bird's-eye view of the Bacino di San Marco, as had Erhard Reeuwich in his woodblock view of Venice, published in Bernhard von Breydenbach's *Peregrinationes in Terram Sanctam* (Mainz, 1486).[2] In this unfinished drawing, Silvestre depicts in the foreground, along the Bacino di San Marco and the Riva degli Schiavoni, from left to right, the Palazzo Giustinian-Morosini, the Church of San Moisè before its façade was renovated in 1668, the Fonteghetto della Farina (the Grain Exchange) and the Granari di Terranova (the Grain Warehouses) before they were replaced by the gardens of the Royal Palace in the nineteenth century, the Zecca (the Mint), the Libreria (the Library), the Torre dell'Orlogio (the Clock Tower), the Piazetta and the Doge's Palace with the domes of San Marco seen behind its roof. To the right he outlined in grey ink with a brush the Ponte della Paglia, the Prigióni (the Prisons), which had been completed in 1614, and the Palazzo Dandolo. In the distance, to the left, the Church of Santa Maria dei Frari and, at the horizon, the Dolomite mountains are depicted.[3]

In 1935, when it was sold at auction, this drawing was part of a collector's album, not a sketchbook (as many authors have assumed), since it contained various finished drawings by Silvestre of different sizes, dates and media. This is the only drawing on vellum and the only view of Venice.[4] In spite of its spontaneous quality, it was probably not executed *en plein air*, as Jacques Thuillier first suggested. Since it was executed on vellum, a support not used for drawing outdoors in the sixteenth and seventeenth centuries, it must have been made by Silvestre in his workshop in the Louvre. Silvestre may have executed this drawing on vellum in order to make a manuscript version of a printed travel book for King Louis XIV. In 1664 he made copies on vellum for the king of a suite of etchings of a festival at Versailles, *Les plaisirs de l'île enchantée*. The vellum album, now in the Bibliothèque Nationale in Paris, bears a dedication to the King.[5] In doing so, Silvestre was carrying on an earlier tradition. Jacques Androuet du Cerceau (1520–1586) made a copy on vellum (British Museum) of his etched album of royal palaces, *Les plus excellents bastiments de France* (Paris, 1575–79).

<div align="right">MNR</div>

27 CHARLES-JOSEPH NATOIRE

Nîmes 1700–1777 Castel Gandolfo

The Park at Arcueil, 1748

Pen with brown and grey ink and wash, black chalk and red chalk,
heightened with white on faded blue laid paper
24.3 × 33.4 cm
Inscribed in brown ink l.l.: *C. Natoire 1748*; l.r.: *Arqueil*
Purchase, 1987
87/35

Charles-Joseph Natoire studied from 1723 to 1730 at the French Academy in Rome, where he developed an interest in landscape and genre subjects from Nicholas Vleughels, the director. Vleughels did much to encourage landscape drawing by taking his students on sketching expeditions into the countryside around Rome.

Following Natoire's return to Paris he rivalled Boucher (cat. 28) for royal commissions. However, his drawings were also in demand. When sketching after nature became popular at the beginning of the 1740s, he went to draw in the park at Arcueil, which was already a favourite destination of a group of artists that included Boucher and, most notably, Jean-Baptiste Oudry (1686–1755).

Located just to the west of Paris, the park and gardens of the Château d'Arcueil, which had been laid out by Anne-Marie-Joseph de Lorraine, Prince de Guise, were considered the most beautiful in France. In 1747, following the death of the Prince de Guise, they were put up for sale, and the park, with its terraces, flights of steps, allées, parterres and trellises, was neglected and gradually reclaimed by nature. Natoire and his contemporaries found this overgrown landscape picturesque, poetic and poignant.

Of the fourteen drawings Natoire made at Arcueil, only three have come to light.[1] The view selected appears to be the same as one chosen by Oudry in 1744.[2] Although the relatively shallow perspective suggests a theatrical rather than a natural setting,[3] the subject matter, asymmetrical arrangement of the elements of the composition, and the picturesque details are indicative of the growing interest in naturalism, which led to romanticism.

While the subject recalls the aristocratic *fêtes champêtres* of Antoine Watteau (1684–1721), the inclusion of naturalistic peasants and animals owes more to the Dutch and Flemish tradition. It encapsulates references to the life cycle, to fecundity, nurturing and harvesting, as lovers flirt, a child plays with its mother, and gardeners water plants and prune trees. Baskets and panniers await the fruits of the autumnal harvest. Such Arcadian fantasies appealed to aristocrats who, since Watteau's day, had sought refuge from the stifling etiquette of Versailles in country pavilions. By mid-century, Oudry's peasants had replaced Watteau's aristocrats.[4]

Executed rapidly, Natoire's drawings are delicate and unassuming and have "*une fragilité d'instantané*" that lends them their special charm.[5] In this drawing, rendered on buff coloured paper, the artist used a favourite combination of brown and grey ink applied with pen and brush together with black, red and white chalk. He drew attention to the changing colour of the leaves by drawing a wet brush over red chalk to create pink wash. This poetic touch draws attention to autumnal subtexts of mellowness and melancholy.

Natoire was appointed director of the French Academy in Rome in 1751. He left behind his brilliant career in Paris and remained in Italy for the rest of his life. There he taught the next generation of French artists, which included Fragonard (cat. 30) and Robert (cat. 31). He also did much to stimulate an interest in and appreciation for landscape drawing by making it part of the curriculum. KL

28 FRANÇOIS BOUCHER

Paris 1703–1770 Paris

Young Country Girl Dancing, c. 1765–70

Black, red and white chalk and stump on buff laid paper
46.2 × 29.2 cm
Purchased as a gift of the Salamander Foundation and the Marvin Gelber Fund with the assistance
of the Department of Canadian Heritage under the terms of the Cultural Property Export and Import
Act, 1998
98/129

Although Watteau, Fragonard (cat. 30) and Boucher have long been considered the three greatest painters and draftsmen of the eighteenth-century French school, it was François Boucher whom the brothers Goncourt singled out as "one of those men who typify the tastes of a century, who express it, personify it, and incarnate it."[1] His drawings epitomize the elegance and prettiness of the rococo style, and his subjects, the aristocratic predilection for the flirtatious and risqué.

Boucher was the favourite artist and art teacher of Mme de Pompadour, mistress of Louis XV, who made him king's painter in 1765. By framing and hanging his drawings on her wall she stimulated the fashion for collecting and displaying drawings as works of art. Sadly this practice has also ensured that many of Boucher's drawings are rubbed and faded.

This drawing is exceptional for the exquisite delineation of costume and the vitality, rhythm and movement of the figure. The head of the girl is anticipated in Boucher's *Study of a Female Head*, c. 1749, in the Louvre (Inv. no. 24764). Boucher was intimately aware of the texture of fabrics and construction of dress, being himself a costume designer. Until 1851 this drawing remained with its pendant, *A Shepherdess Looking Upwards* (fig. 1), which entered the Manchester Art Gallery. When the drawings are juxtaposed, the girls appear to be dancing together.

The sudden appearance of this drawing on the Toronto art market in 1997 created a wave of excitement and controversy. Unsigned and never before reproduced, it was attributed to Boucher by Alastair Laing,[2] who wrote, "One searches in vain – in this or any period – for a drawing of comparable scale or finish."[3] It is a superlative example of the rococo technique of *trois crayons*, a combination of black, red and white chalk on buff or blue paper. Colin Bailey wrote, "Highly finished and powerfully rendered figure drawings such as this sheet are extremely rare in his *oeuvre*. The work . . . is exceptional in its quality, its state of preservation, and its degree of finish."[4]

The subject matter reflects the tastes and attitudes of the nobility during the last years of the *ancien régime*. Far from representing the grinding poverty of the peasantry, this romantic fantasy reflects the sentiments expressed in the writings of Jean-Jacques Rousseau and anticipates the pastime of Marie-Antoinette, wife of Louis XVI, who enjoyed masquerading as a milkmaid at her rustic farm, Le Hameau, in the garden of Versailles. This political schizophrenia indicates the extent to which the royal house was fatally out of touch with the Third Estate, just as art critics and reformers railed in vain against the persistence of rococo taste. The critic La Font de Saint-Yenne had fired the first serious critical salvo against rococo style and subject matter in 1747.[5] With the outbreak of revolution in 1789, it finally fell out of favour. KL

fig. 1:
François Boucher
A Shepherdess Looking Upwards
black chalk touched with red chalk and heightened
with white on buff paper
48.1 × 29.4 cm
Bequest of George Beatson Blair, Manchester Art Gallery
(1947.126)

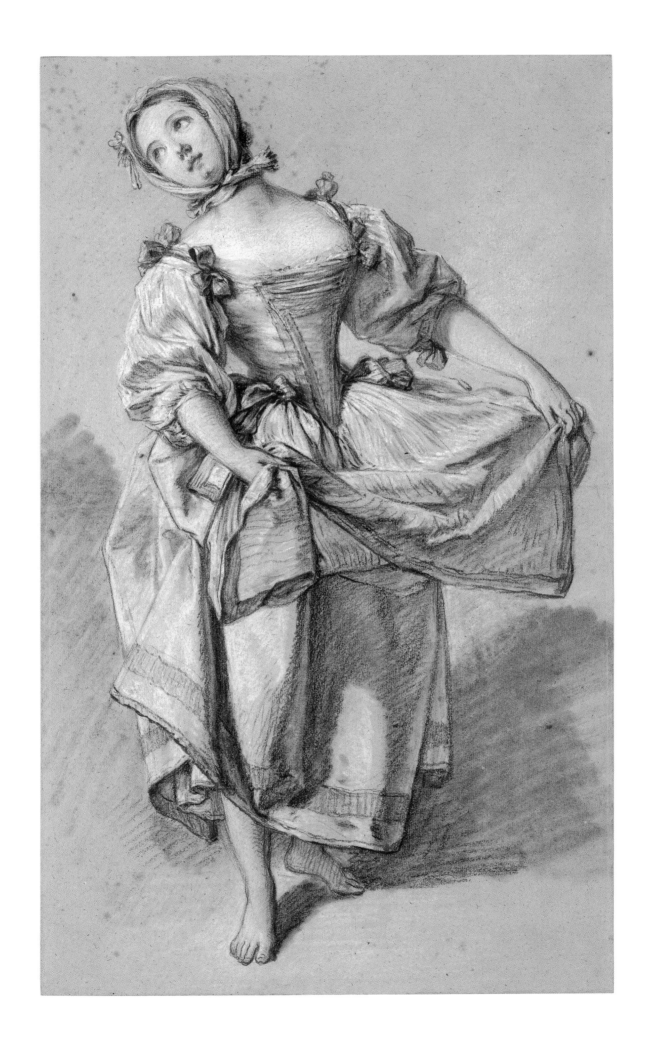

29 CHARLES MICHEL-ANGE CHALLE

Paris 1718–1778 Paris

The Ruins of the Temple of Antoninus and Faustina in Rome, 1740s

Black and white chalk on buff laid paper
30.4 × 47.4 cm
Purchased as a gift of Robert and Phyllis Couzin, 2005
2005/5

As crumbling vestiges of the past, ruins offer a fusion of knowledge and imagination. Over the centuries the ancient monuments in the Roman Forum, or rather their derelict remains, have inspired hundreds of studies by writers and artists, locals and foreigners alike, because of their picturesque and historical significance.

The eighteenth-century French draftsman Charles Michel-Ange Challe was no exception. A pupil of François Lemoyne and François Boucher, Challe first trained as an architect. However, rather than construct brick-and-mortar buildings, he turned his attention to devising elaborate festival ephemera and architectural fantasies. No doubt these early experiences contributed to his official appointment later in life as *dessinateur de la chambre et du cabinet du roi* – designer of royal festivities.[1]

After winning the Prix de Rome in 1741 Challe became a pensioner of the French Academy from 1742 to 1749. Influenced by fellow pensioners such as Hubert Robert (cat. 31) and his close friend, the great Roman engraver Giovanni Battista Piranesi (1720–1778), Challe looked to the city's rich imperial heritage for his subject matter. This included one of its best-preserved and revered romantic landmarks, the Temple of Antoninus and Faustina in the Forum Romanum. With archaeological excavations just getting underway at this time, the second-century shrine remained one of the most visible sites, its surroundings largely concealed beneath thirty to forty feet of debris and cow dung.

Situated on the Via Sacra, the temple was one of the noblest buildings in Republican Rome. It was erected in 141 CE and dedicated by the Senate to the memory of the Empress Faustina, and to her loving husband, Emperor Antoninus Pius, after his death. Like others in the Forum, the pagan temple had been transformed by the eleventh century into a Christian church dedicated to San Lorenzo in Miranda. By the time Challe made this drawing the building had undergone restoration and destruction: its sculptures had been pulverized to make powdered lime, its exterior side chapels demolished, and its marble steps and facing appropriated for papal beautification projects, among them St. Peter's Basilica. The uniform cut marks on the upper portions of the columns, shown in the drawing, are silent scars.[2]

The distinctive Corinthian colonnade and massive masonry walls of the *cella* are depicted from a low, easterly vantage point and fill most of the picture space. The Temple of Vespasian and Titus, with its three monumental fluted pillars, can be seen in the background. As in the engravings of Piranesi, the staffage serve largely to enhance the imposing scale of the ruins; but the tone is different. It has been tempered from the highly dramatic to the serene. And, aside from a few stray brambles, the setting appears unfinished rather than overgrown and ruined. Challe depicted the hexastyle temple as it appeared at the time, although he did make notable omissions. He has excluded the elaborate frieze with griffins and candelabra from the fragmented entablature. The ornate baroque façade, immediately behind the portico, has been shed as well in order to focus attention on the austerity of the antique remains.[3]

Challe's stunning sketches bear the hallmarks of the drawings made in situ by students of the French Academy in Rome who, using chalk on large pieces of paper, applied the rococo style to classical subjects. MM

30 JEAN-HONORÉ FRAGONARD

Grasse 1732–1806 Paris

Charlemagne Leads Angelica away from Roland, c. 1785
Illustration for *Orlando Furioso* Canto 1 (6–9) by Ariosto

Black chalk and brown wash and traces of graphite on laid paper
40.0 × 46.0 cm
Purchase, Walter C. Laidlaw Endowment, 1978
77/207

The natural heir to the rococo style that flourished during the first half of the eighteenth century, the work of Jean-Honoré Fragonard is distinguished by its sensuality. A virtuoso artist, he willingly put his talents at the service of a private collector clientele with a taste for amorous subjects, while never forgetting his beginnings as a history painter.

Fragonard's drawings are as diverse in subject as they are in style and technique. He handled black and red chalk with remarkable precision, gouache and watercolour with great finesse, at the same time demonstrating great subtlety in his wash drawings – as we can see in this sheet.

This drawing illustrates the opening scene of *Orlando Furioso*, a poem by Ludovico Ariosto published in 1516. Characterized by a complex plot and fantastic scenes, it interweaves amorous conquest and religious conflict. This epic, in which the Christian knight Roland wins the heart of Angelica, a pagan oriental beauty, inspired at least 177 drawings by Fragonard in the 1780s. Of the forty-six verses, only the first sixteen were employed, suggesting that the project may have been more ambitious at the outset.

From the sixteenth to the nineteenth centuries, episodes from Ariosto's poem captured the imagination of many artists; after 1773 and throughout the 1780s, the theme reached the height of popularity in French engraved illustration.[1] Although the final intention of Fragonard's sheets remains unknown, it is tempting to think that they were designed for a series of engravings. However, these vague renderings in which black chalk and wash are mixed together to create pictorial effects could only have been transferred to copper with considerable difficulty. Despite the uncertainty surrounding the circumstances that gave birth to these images, Williams observed that they reveal an artist at the height of his powers: "The sense of composition is certainly that of a mature artist who is graced with rich power of narrative invention, control over his media, and confidence in his draftsmanship."[2]

Seznec believes that the scene corresponds with the episode in which Ruggiero and Astolpho visit Logistilla (canto 10, 65); however, a recent reinterpretation by Dupuy-Vachey has identified iconographic elements that point to a completely different episode.[3] Bewitched by the charms of the sorceress Angelica, Roland decides to take the oriental beauty to the West. Meanwhile this daughter of the emperor of China becomes the object of desire of Renaud, Roland's cousin. Concerned by the disturbance resulting from their rivalry, Charlemagne decides to send Angelica away. To win back the hand of his lady love, Roland is required to prove himself by killing the largest number of infidel troops in battle.

Instead of interpreting this passage literally, Fragonard employed symbolism. He created a mysterious and evocative scene in which legendary and allegorical figures are interspersed. In the foreground, with a diadem perched on her head, the haughty Angelica is led by Charlemagne. The personification of the Wisdom of the emperor appears in a cloud below an angel with outspread wings and, turning toward Roland (left background), points upward toward a coronation by Victory.[4] SC

31 HUBERT ROBERT

Paris 1733–1808 Paris

View of the Vaulting of St. Peter's Taken from an Upper Cornice, c. 1763

Red chalk on laid paper in an 18th-century mount
33.5 × 45.0 cm
Purchase, 1984
83/312

Hubert Robert was one of the finest draftsmen of the eighteenth-century French school. A fellow student of Jean-Honoré Fragonard (cat. 30), he studied at the French Academy in Rome under the directorship of Charles Natoire (cat. 27). Students were encouraged to make *plein air* sketches of classical and Renaissance monuments around the city. Robert's reputation is largely based on his red chalk drawings, which describe light and texture with such sensitivity that they are sometimes confused with those of Fragonard. This sheet was probably made a year after he completed his studies in 1762. He was able to find the financial support to remain in Rome until the summer of 1765.

St. Peter's Basilica was not only the greatest late-Renaissance monument, but also a primary tourist destination. Its overwhelming scale and didactic program were calculated to inspire awe in believers and non-believers alike. This extraordinary view was made looking toward the crossing and Michelangelo's dome. This was positioned directly above the high altar and the subterranean tomb in the Roman cemetery that, from early Christian times, has been identified as that of St. Peter. Part of the Latin inscription on the drum of the dome is visible: "ORUM + TV ES PETRUS ET SUPER HANC." The complete inscription may be translated "Thou art Peter and upon this rock I shall build my Church and to you I will give the keys to the Kingdom of Heaven."[1] This quotation has long been used to support the claim to primacy by the bishop of Rome and, more recently, papal infallibility.

This crisp, fresh sheet would have appealed to Grand Tourists and to those with a taste for sublime subjects. Robert situates the viewer on the cornice running around the base of the coffered vault and emphasizes the vastness of the space by including workmen on the opposite side of the nave. They appear to be climbing a ladder to hang or take down the draperies used to cover the decoration during Lent.[2] The artist situates the viewer close to the edge of the cornice alongside contemporary viewers who peer over the edge into the abyss, inducing a feeling of vertigo and the delicious terrors of the sublime.

Robert reveals his familiarity with the etchings of Piranesi, whose workshop was located directly across the via del Corso from the French Academy. The device of the arch used to dramatize and frame views, and the exaggerated disparity of scale between figure and architecture, are found in Piranesi's views of Rome. The poses of the crouching figures, the precariousness of the ladder and the feeling that if we were to take one tiny step to the right we would tumble over the edge of the precipice recall the nightmare environments found in Piranesi's most famous series, the *Carceri (Prisons)*, which had been reworked in the second edition that appeared in 1761. The etchings were hugely popular with Grand Tourists, and Robert's drawing may have been intended to capitalize on their popularity. KL

32 PIERRE NARCISSE GUÉRIN

Paris 1774–1833 Rome

Clytemnestra Urges Aegistes to Kill the Sleeping Agamemnon, c. 1817

Pen and ink, watercolour and gouache on laid paper
26.7 × 21.7 cm
Collector's mark l.l.: Georges Danyau (Lugt 720)
Purchase, 1989
89/376

Following the outbreak of the French Revolution in 1789, the "frivolous" rococo style, which had been under attack since mid-century, finally gave way to the "virtuous" neoclassical manner. This spartan linear style, inspired by Greek and Roman art, was combined with stern classical subjects laced with contemporary political subtexts. These were designed to play a didactic and moralizing role, subjugating passion to reason and sacrificing individual interests to the common good.

This is the most finished in a series of preliminary sketches of figures and compositional ideas for Pierre Narcisse Guérin's painting *Clytemnestra* (fig. 1). The differences between the drawing and the painting are more telling than the similarities. Executed in an agile pen line with liquid brown washes of various densities,[1] the drawing has a freshness, vitality and dramatic intensity not found in the saccharine painting with its "chromolike smoothness and finish."[2] The narrative flow of the action moves from right to left in the drawing, perhaps to imply hesitation on the part of Clytemnestra. The symbolism is heightened in the drawing, where the composition is divided into three vertical zones through the application of light, medium and dark washes. These serve to indicate the moral character of the dramatis personae: the unwitting husband, Agamemnon, is bathed in light; the scheming lover, Aegisthus, is barely visible in the dark; and the prevaricating Clytemnestra is trapped in the shadow that falls between them.

This extraordinary drawing demonstrates Guérin's debt to Jacques-Louis David, the leading painter of the revolutionary period, who went into exile in Brussels in 1816 following the Bourbon Restoration. In subject and style it stands at the cusp of the transition from neoclassicism to romanticism: reason is ruled by passion, and passion by evil, an inversion of the neoclassical didactic program. It constitutes the first glimmerings of the romantic style and sentiment that Guérin would pass on to his brilliant pupils Géricault and Delacroix (cat. 34), the leaders of the French romantic movement.

The use of silhouetted poses, dramatic gestures, graduated lighting and receding parallel planes are all theatrical conventions of the age. When the painting was exhibited at the Salon of 1817, Guérin was accused of reproducing, even caricaturing, theatrical productions.[3] It is very likely that the concept was inspired by productions of Aeschylus's tragedy *Agamemnon*. A very successful one was staged in Paris in 1797 by L.-N. Lemercier, starring Guérin's friend Talma, the leading tragedian of the day.[4]

Offered the position of director of the French Academy in Rome in 1816, Guérin finally accepted in 1822. He bequeathed the drawings for this painting to his pupil Guillaume Bodinier (1795–1872) in 1833. Although the majority were sold in his posthumous sale in 1873,[5] Bodinier's widow withheld a group of the drawings, which she gave to the Louvre in 1874.[6]

KL

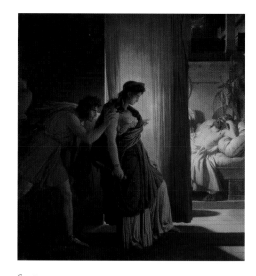

fig. 1:
Pierre Narcisse Guérin
Clytemnestra Hesitates Before Striking the Sleeping Agamemnon
1817
oil on canvas
342.0 × 325.0 cm
Musée du Louvre, Paris (5185)

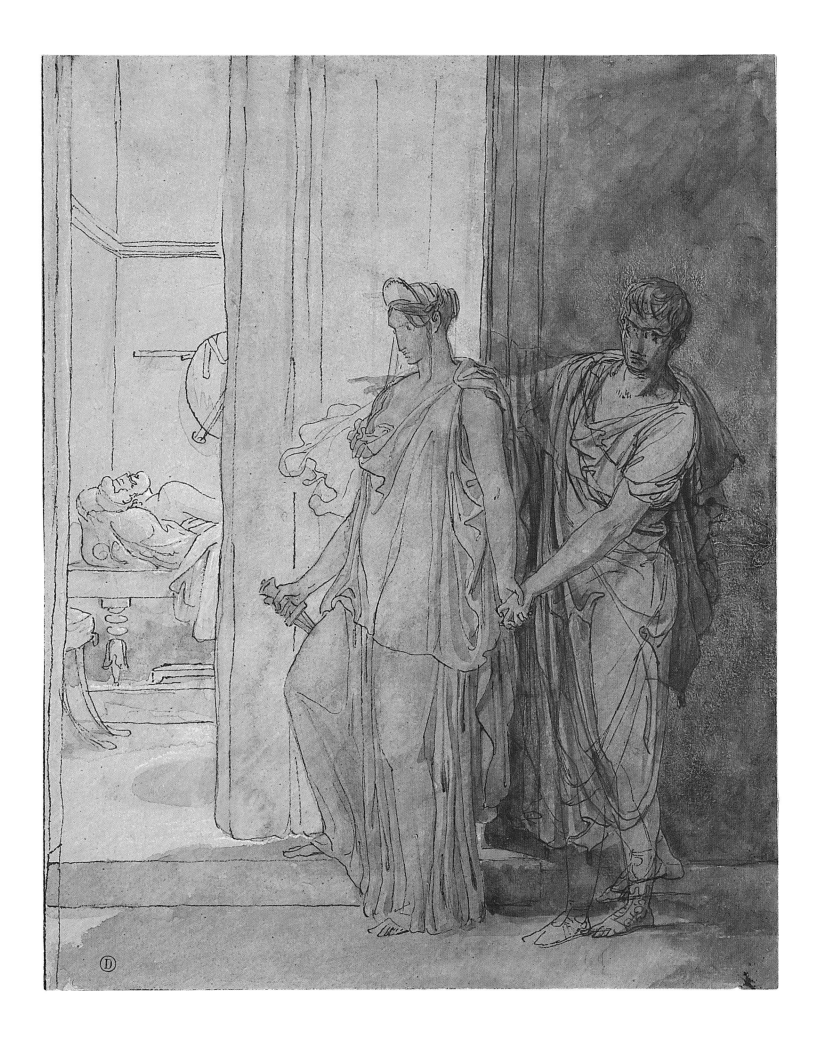

33 JEAN-AUGUSTE-DOMINIQUE INGRES

Montauban 1780 –1867 Paris
Study of a Drapery

Graphite with white chalk on laid paper
16.8 × 18.2 cm
Artist's stamp in blue ink l.r.: (Lugt 1477)
Gift from the estate of R. Fraser Elliott, 2005
2005/224

Jean-Auguste-Dominique Ingres was the leader of the French neoclassical school that was seen then and now as the polar opposite to the romantic school led by Delacroix (cat. 34). These two great figures, who defended the primacy of "line" and "colour" respectively, continued to have a major impact on French art until the end of the nineteenth century.

Ingres's style and studio practice, modelled on that of Raphael (see Giulio Romano, cat. 3), included making preparatory drawings for figures, drapery and composition. Ingres believed that line is the visual correlative to the intellect, and that "drawing is the probity of art."

He studied under the neoclassical artist Jacques-Louis David, the leading painter in France during the Revolution and Empire. Although Ingres won the Prix de Rome in 1802, he did not leave the French Academy until 1806. He remained in Rome until 1820. His work was strongly influenced by Roman antiquities, especially carved friezes: this can be seen in the shallow pictorial space, horizontal distribution of figures, profile forms, emphasis on silhouette and elegant contour lines that characterize his work.

In 1812 Ingres painted the first of two versions of *Virgil Reading the Aeneid to Augustus* (fig. 1) inspired by a phrase in the *Aeneid* (Book VI, *Tu Marcellus eris*). It was made for General Miollis, an admirer of Virgil, and hung in the Villa Aldobrandini in Rome in 1835. Ingres reacquired it and almost destroyed it by first extending, then amputating, the canvas. After the painting entered the Musée des Augustins, Toulouse, it was "finished" by his pupil Pichon. As a result, the preliminary drawings and the reproductive engraving made by Charles-Simon Pradier in 1832 are key to understanding the artist's original intention. Between 1812 and 1847 Ingres made another version of the painting, now in the Musées royaux des Beaux-Arts de Belgique, which incorporated significant changes.

Referring to the first version, Georges Vigne pointed out that Ingres's "excessively meticulous preparatory work, which resulted in numerous preliminary studies, tended to drain his final compositions of vitality. Hence the preference so often expressed today for his sketches which are freer and more spontaneous."[1] This sensitive study for the right hand and drapery worn by Livia captures the texture, pattern of folds, and fall of light and shadow. The pose of the figure, and the horizontal emphasis of the attenuated folds, recall the semi-recumbent women found on the lids of Etruscan and Roman sarcophagi.

This drawing was given to the AGO with another study for the same painting, *Study for the Portrait of Livia* (fig. 2), with which it may once have been framed.[2] These were both acquired by Edgar Degas (cat. 37) in the sale that followed Ingres's death in 1867.[3] Degas was a great admirer of Ingres, and his early work owes a debt to him. Related preparatory studies for the painting are to be found at the Musée Ingres in Montauban, the National Gallery of Canada[4] and the Fogg Art Museum.[5] KL

fig. 1:
Jean-Auguste-Dominique Ingres
Tu Marcellus eris: Virgil Reading Book VI of the Aeneid to Augustus
1811
oil on canvas
30.7 × 32.6 cm
Musée des Augustins, Toulouse
Photo: Bernard Delorme

fig. 2:
Jean-Auguste-Dominique Ingres
Study for the Portrait of Livia
graphite with traces of white chalk heightening, brown ink on translucent paper
15.2 × 19.3 cm
Art Gallery of Ontario, Toronto, gift from the estate of R. Fraser Elliott, 2005 (2005/223)

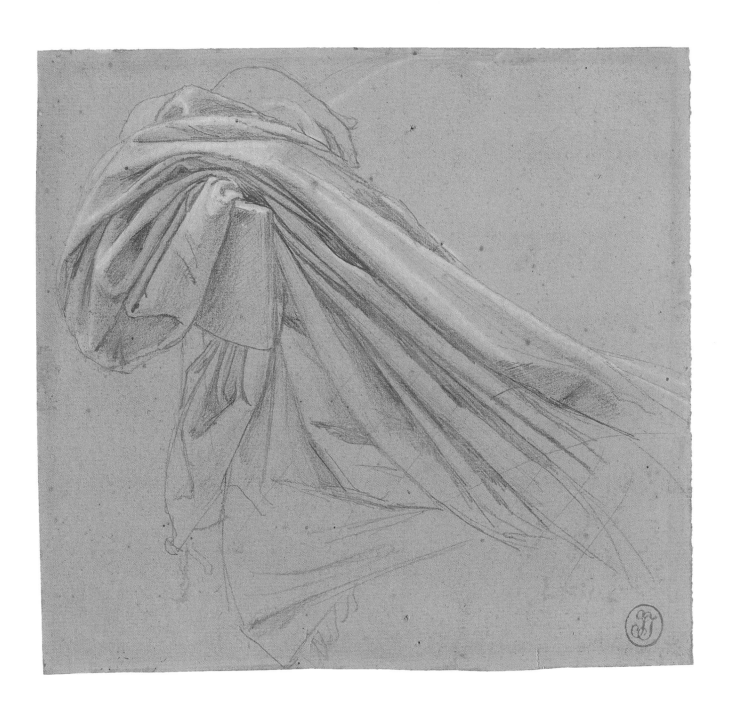

34 EUGÈNE DELACROIX

Charenton-Saint-Maurice 1798–1863 Paris

The Bride of Lammermoor, c. 1826

Watercolour and gouache over graphite on wove paper
19.2 × 26.3 cm
Inscribed by Frédéric Villot on verso in ink: *par Eug. Delacroix (sujet de la fiancée de Lammermoor) aquarelle passée à l'huile (vers 1826) FV*
Purchase, 1980
80/83

Eugène Delacroix was the leader of the French romantic school that challenged the classical tradition of Ingres. While Ingres believed in the primacy of line over colour, Delacroix believed in the primacy of colour over line, seeing it as the visual correlative to the emotions.[1]

During the wave of anglophilia of the 1820s, English art and literature, especially the novels of Sir Walter Scott, were all the rage in Paris. In 1825 Delacroix travelled to England with his friend Richard Parkes Bonington (cat. 61) and visited Scott at Abbotsford. He was attracted to the British technique of watercolour, and it is possible that this highly finished work was inspired by the English mania for assembling watercolour albums.[2] After returning to Paris, Delacroix and Bonington shared a studio and worked on small romantic paintings in the cramped, medievalizing "style troubadour."

In 1826 Delacroix was undergoing a difficult emotional and artistic transition. He was "overwhelmed with sadness and boredom," suffering from feelings of "misanthropy and melancholy" and found himself "painting everything in gloomy tones"[3] and attracted to "violent episodes . . . enveloped in a gloomy veil." He aspired to create "a totally new kind of painting which would involve tracings from nature," would make "the most simple poses interesting by using a variety of foreshortenings," be "mobile rather than defined" and rely on " resonances of colour" to communicate feeling.[4]

Delacroix read Scott's *The Bride of Lammermoor*, which was translated into French in 1823.[5] He identified personally with Ravenswood, Lucy Ashton's lover, and depicted himself in the role. Tricked by her mother into believing that Ravenswood had abandoned her, Lucy agreed to marry the Lord of Buclaw instead. Discovering her mother's duplicity, she stabbed her husband on their wedding night. Hearing a cry upstairs, Colonel Ashton rushed from the wedding feast to discover the door of the bridal chamber blocked by the body of the bridegroom. One of the wedding guests spotted "something white in the corner of the great old-fashioned chimney of the apartment . . . the unfortunate girl, seated, or rather crouched like a hare upon its form – her head-gear disheveled; her night-clothes torn and dabbled with blood, her eyes glazed, and her features convulsed into a wild paroxysm of insanity. When she saw herself discovered, she gibbered, made mouths, and pointed at them with her bloody fingers, with the frantic gestures of an exulting demoniac."[6]

The subject combines elements of rape, murder and insanity, and reveals the artist at the moment when he emerged as the leader of the French romantic movement. The disfiguration of the human form, awkward foreshortening and ambiguous spatial relationships found here wreak havoc with classical ideals and perspective, giving this brutal image extraordinary psychological power. It anticipates Delacroix's controversial *Faust* lithographs of 1827, long considered the apogee of the Romantic movement.[7]

There is a related drawing (fig. 1) that follows the outlines of the composition closely while omitting the door and the figure appearing around it. It is tempting to think that the drawing may be an experiment of the kind referred to in Delacroix's journal entry. KL

fig. 1:
Eugène Delacroix
The Bride of Lammermoor
graphite on paper
22.0 × 33.0 cm
Private collection, France

35 JEAN-FRANÇOIS MILLET

Gruchy 1814–1875 Barbizon

Women Carrying Loads of Dried Grasses at the Entrance to a Village
(recto);
Sketch of the Plain of Chailly (verso), early 1850s

Charcoal, chalk and watercolour on laid paper
39.9 × 28.4 cm
Signed in black chalk l.r.: *J.F. Millet*
Purchased with the assistance of the Department of Canadian Heritage
under the terms of the Cultural Property Export and Import Act, and
with donations from AGO members, 1990
90/2

Before settling in Barbizon, where this drawing was made, Jean-François Millet had spent over ten years struggling to make his name in Paris. He had arrived there in 1837 with a scholarship from Cherbourg to study at the École des Beaux-Arts. After experiencing mixed success he returned to Cherbourg to make a precarious living as a portrait painter. He returned to Paris in 1841, and just as he was beginning to gain recognition at the Salon, his young wife died of consumption, and probably starvation.

Millet retreated to Le Havre until a public sale of his works enabled him to return to the capital in 1845 with a new companion, Catherine Lemaire. This time he was befriended by several artists of the Barbizon group, including Diaz, Barye, Daumier and Théodore Rousseau – all Republicans. By the outbreak of the February Revolution in 1848, Millet had begun to paint peasant subjects in a new style of social realism. The worsening political situation in 1849 caused him to retreat to the country village of Barbizon on the edge of the forest of Fontainebleau. There he settled for the rest of his life, living in a simple rural style with Catherine and their growing family, selling his work through a Paris agent.

Scenes of rural life enjoyed increasing popularity with Parisian collectors who yearned for escape from the constrictions and competitiveness of the city. Millet saw peasant life as symbolic of purer modes of living in earlier times, which involved a stoic, heroic acceptance of fate. The two heavily laden figures are shown entering the village of Barbizon. Their slow, measured tread and expressionless faces reflect the withdrawn mood into which Millet had lapsed. Because the forest is behind them, their loads have been wrongly interpreted as brushwood, and the drawing was acquired with the title *Les ramasseurs de bois mort*. However, the correct title, *Femme[s] portant des faix d'herbes à l'entrée d'un village*, appeared in the artist's retrospective exhibition in 1887, indicating that these were loads of grass.

Although Millet eventually achieved considerable renown, when this drawing was conceived his struggle for recognition – he called it a combat, a grinding of gears – was at a low ebb, and he seemed to have identified himself with the essential sadness of the peasant's lot. He almost certainly made the drawing from memory, and executed it in black and white. At an unspecified time, perhaps several years later, Millet added watercolour washes and touches of coloured chalk to make the image more saleable. It is slightly ironic that the man who first bought this work in the 1860s, Émile Gavet, was himself a successful industrialist.

Following its acquisition by the AGO, the backing was removed and an unfinished landscape sketch was discovered on the verso depicting the agricultural plain of Chailly, located on the other side of the village. Millet loved it as much as the forest. BL

J. F. Millet

36 FRANÇOIS BONVIN

Paris 1817–1887 Saint Germain-en-Laye

A Woman Knitting, 1861

Charcoal and stump on laid paper
42.1 × 31.4 cm
Signed and dated in charcoal l.l.: *F. Bonvin 1861*
Watermark: "Van der Ley" and complex figure (18th-century Dutch)
Purchase, 1985
85/83

François Bonvin was one of the young painters in the circle of Gustave Courbet who met at the Brasserie Andler. In the late 1840s they declared themselves "realists" – a general term meaning that their pictures were both eminently tangible and a reflection of contemporary life. By 1861, when this drawing was made, Bonvin had established a reputation after some years of struggle. The influential critic W. Bürger (alias Théophile Thoré) wrote of him in that year: "M. Bonvin ought to have come after Millet and Courbet, for he has certain affinities with both. He is also a master, in his own restricted field."[1] In fact Bonvin was a contemporary of both Millet and Courbet, but his subjects were less rural than Millet's, and his painting less aggressively sensual than Courbet's. By 1861 he was exhibiting regularly at the Paris Salon, and he also had a private market for such highly finished drawings as this.

It would be hard to guess from this drawing that the artist was of a passionate disposition and had recently entered into a second marriage to a woman much younger than he – not the present model! Although his young wife inspired him to do some of his best work, she had begun to lead him quite a dance. But most of Bonvin's genre drawings of this period are quite unromantic. They relate to the principles discussed by Courbet and his circle over the previous decade, and expressed in a "Realist Manifesto" prefacing Courbet's notorious exhibition of 1855 in which he claimed to represent the appearance of his own epoch without the encumbrance of "art for art's sake."

Bonvin's drawing technique was quite similar to Courbet's, using either charcoal or black chalk with a full range of tones from white to almost black, giving a strong effect of chiaroscuro. This image of a woman seated by a window, who pauses in her work of knitting to reach for a pinch of snuff in a tiny box beside her, shows no signs of erasure or correction. The artist's control over his medium expresses the fall of light from the broadest contrasts to the smallest details such as the ball of wool on the floor. Executed without drama, this is a contemplative work that raises a domestic pursuit to the level of art. Champfleury, a young novelist and art critic who was also a member of Courbet's circle, noticed early on that Bonvin had affinities with Chardin, the great painter of genre and still life in the previous century. Bonvin's quiet figure also harks back to Rembrandt (cat. 20), yet maintains a contemporary air of naturalism, signifying the aesthetic of the age just before the young impressionists arrived on the scene in Paris. Bonvin was not unaware of coming changes, and was broad-minded: in 1859 he had opened his studio to an exhibition of "refusés" from the Salon that included Whistler and Fantin-Latour.

The fine quality laid paper on which this drawing is executed was likely from old stock, for the watermark, visible through the model's apron in the lower part of this image, indicates that it was made from a mould manufactured in 1765. BL

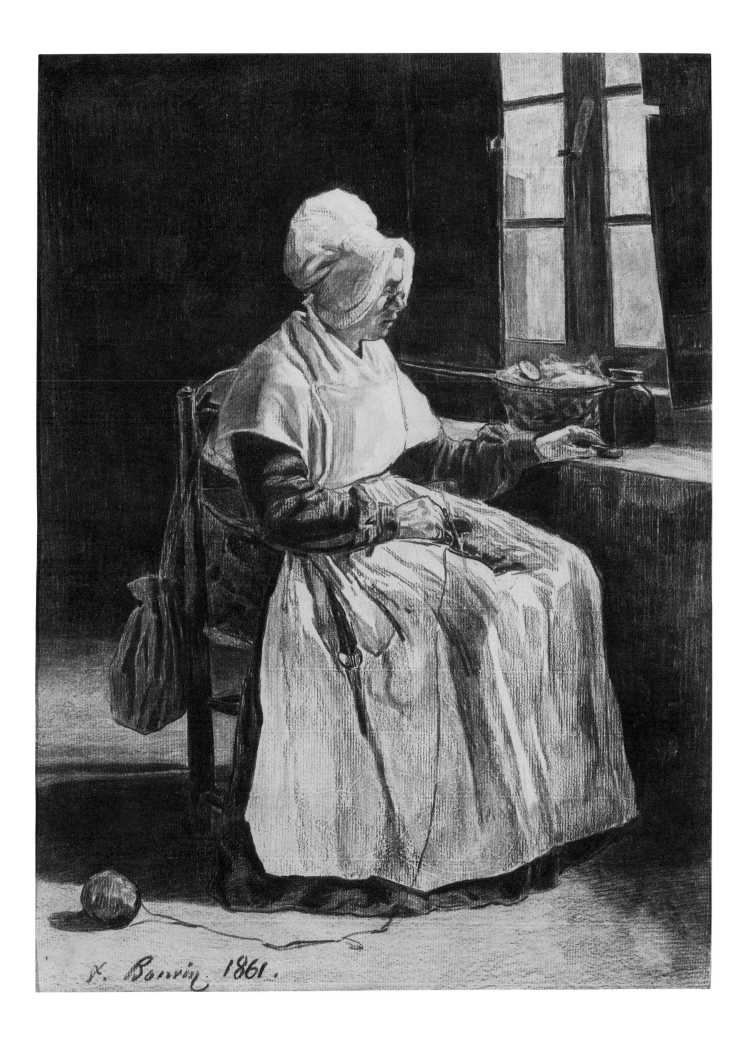

X. Bourin. 1861.

37 EDGAR DEGAS

Paris 1834–1917 Paris

Portrait of a Woman, c. 1881–85

Pastel over graphite on laid paper
30.8 × 23.7 cm
Studio stamp in red l.l.: *Degas* (Lugt 658)
Gift of Vivian and David Campbell, 1991
91/59

In the late 1850s Edgar Degas joined the circle of young realists that surrounded Gustave Courbet in Paris. Throughout his prolific sixty-year career, he experimented tirelessly with unconventional combinations of media and techniques, working in oil, charcoal, pastel, pencil, wax modelling, printmaking and photography. But his work as a draftsman and his belief in the power of drawing to capture the essence of the subject were central to his artistic activities. Indeed, draftsmanship had been the basis of Degas's early training. When the contents of his studio were inventoried after his death in 1917, it was discovered that the graphic work, which included this striking portrait, provided a comprehensive continuum of his artistic endeavours.

Degas executed some of the most penetrating portraits of the nineteenth century. His uncompromising contemporary images stripped away the idealizing conventions employed by other artists during this period. Portraiture was a major subject area for the artist, accounting for almost one-fifth of his oeuvre. He was particularly interested in women and approached all of his female subjects – whether laundresses, ballet dancers, bathers or relatives – with impartiality. He explored the range of facial types and personalities of his fellow Parisians. He applied modern physiognomic theories espoused by such writers as Joris-Karl Huysmans (1848–1907) to his depictions of family members, friends and anonymous models.

The severe face of this older woman exemplifies the realist style with its insistence on conveying the appearance of immediacy through deliberate observation. The artist focuses on the commanding visage and formidable character of his sitter. From the angularity of the narrow face, with its flesh tightly pulled across the cheekbones, to the grim set of the mouth, Degas effectively renders the forceful personality of the woman. This intense and self-contained image avoids all reference to the context or identity of the bourgeois sitter. At a time when respectable bourgeois women were expected to be exemplary wives and mothers, this woman appears resentful and disdainful of such restrictive conventions as she unflinchingly faces the viewer. The psychological intensity and pinched face of the sitter recall the disturbing woman on the left in *The Bellelli Family* (1858–67, Paris, Musée d'Orsay). In both cases, the viewer feels confronted and uncomfortable.

Degas was one of the greatest exponents of the medium of pastel and did much to spread its popularity in the second half of the nineteenth century. Pastel enabled him to combine line with colour, to work rapidly and to make the changes to his compositions that were an important part of his working method. This drawing is composed of a series of rich layers of pastel with some smudging to suggest shadows such as those defining the sitter's cheekbones, deep-set eyes and jawline. Degas did not rely solely on the thickly applied pastel for texture but also took advantage of the uneven pattern of the laid lines of the paper. He appears to have restricted his palette to livid and sombre colours to set the mood and reinforce the severity of his depiction. MK

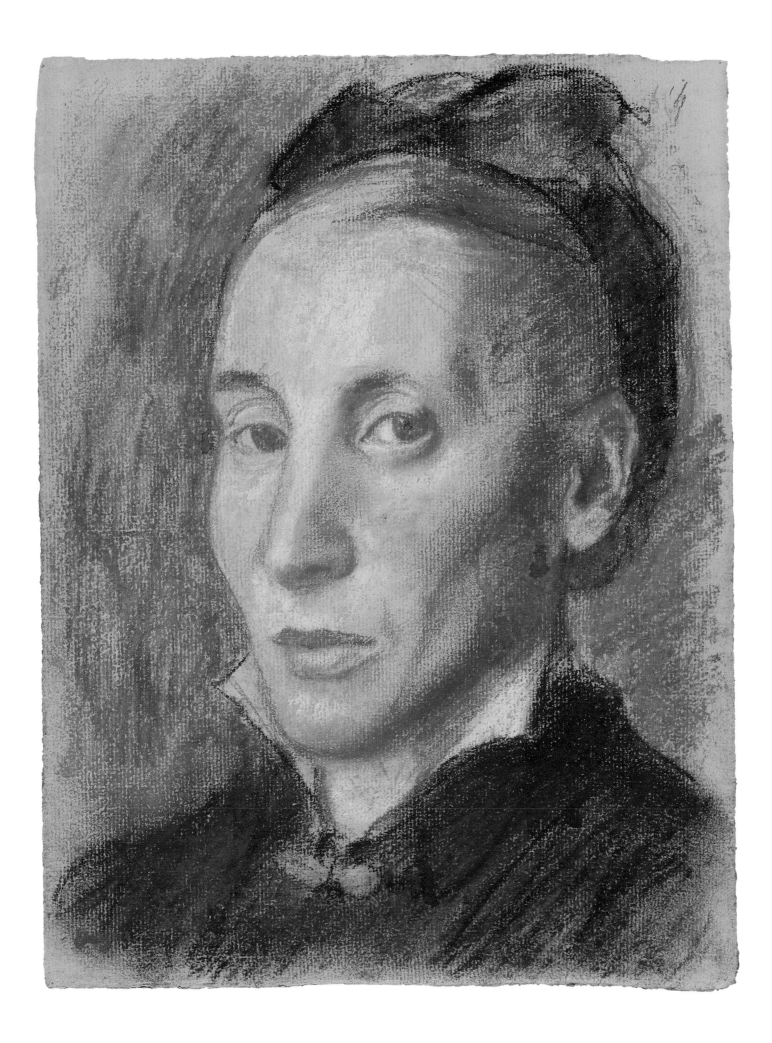

38 PIERRE AUGUSTE RENOIR

Limoges 1841–1919 Cagnes
Studies for Mother and Child, c. 1885

Red and white chalk on buff laid paper
55.2 × 66.3 cm
Signed in blue pencil l.r.: *Renoir*
Gift of Sam and Ayala Zacks, 1970
71/309

Pierre Auguste Renoir was deeply influenced by Ingres (cat. 33), who saw himself as a follower of Raphael. In 1881 Renoir travelled to Italy with his model Aline Victorine Charigot, a seamstress who worked in Montmartre. After their marriage in 1890, the couple referred to this trip as their honeymoon. It was in Italy that Renoir found in Raphael's paintings of the Madonna and Child the quintessential image of motherhood.[1]

In September 1885 they visited Aline's birthplace, Essoyes, in the Aube (southern Champagne) with their first child, Pierre, born on 21 March. Renoir was proud of Aline's peasant roots and her naivety, and saw her in her country clothes, wearing a straw hat on her head and nursing their baby, as the "natural woman."[2] In his deeply personal interpretation of the Madonna and Child theme he found his new artistic direction.

Departing from earlier practice, Renoir made many preparatory drawings, some of which were executed in red and white chalk. Their charm and prettiness, together with his choice of medium, demonstrate the artist's interest in French rococo drawings, particularly those of Boucher (cat. 28). The roughly applied white chalk recalls the surface of the frescoes he had admired in Naples.[3]

This drawing is related to two others that could have been made during the same sitting, *Motherhood. Mother Nursing her Child* (1885)[4] and *Nursing Composition with Two Infant Heads* (1886).[5] The Toronto drawing appears to be the first in which Renoir captured the pose of the baby holding its foot, which is repeated in the other two works. He based three later oil paintings on the pose in the 1886 drawing.[6]

When Berthe Morisot visited Renoir early in 1886, at 87 rue Laval in Paris, she saw "on an easel, a drawing in red pencil and in chalk of a young mother nursing her child, charming in its grace and subtlety. Since I admired it, he showed me a series of them with the same model and almost in the same position. He is a first-class draftsman: all these preparatory studies for a painting would be interesting to show to the public, which generally imagines that the Impressionists work in a free and easy manner. I don't think that one can go further in the rendering of form."[7]

The Toronto drawing was owned by Renoir's dealer, Ambroise Vollard, and was used to make a heliogravure, *Trois Esquisses de Maternité*.[8] It was printed by Henri Clot and published by Lucien Vollard.[9] Some of the black lines appear to have been reinforced on the copperplate. It had been previously identified as an original lithograph by the artist.[10]

KL

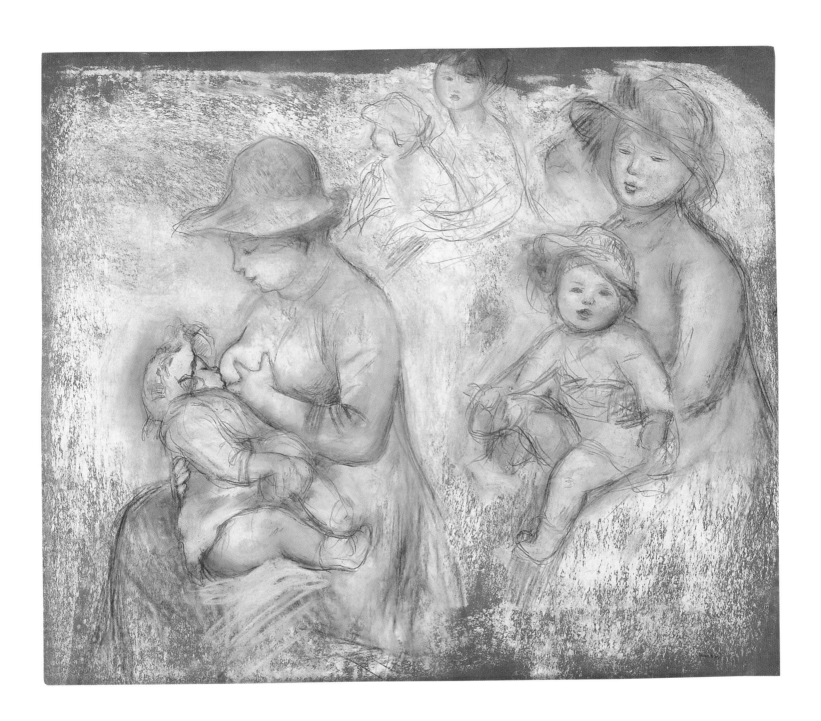

39 LÉON-AUGUSTIN LHERMITTE

Mont-Saint-Père 1844–1925 Paris
Watering the Garden, 1900

Pastel on wove paper mounted on canvas
34.0 × 43.7 cm
Signed and dated l.l.: *Lhermitte 1900*
Gift of Mr. and Mrs. H.C. Cox, 1926
809

After universal suffrage was introduced in France in 1850, peasants were no longer viewed as potential revolutionaries when depicted in works of art. Instead, they were seen as conservatives who exemplified the work ethic, preserved traditional values and contributed to the stability of the nation.[1]

Léon-Augustin Lhermitte, who valued rural life, spent most of his time in Mont-Saint-Père, on the banks of the Marne. His works reflected the sentiments of those who regretted the impact of industrialization and the inevitable "march of progress" on the countryside. In 1887 he illustrated a book by André Theuriet, *La Vie Rustique*, which was designed to record some of the agricultural practices and aspects of rural life that were rapidly disappearing.[2] The author was careful to avoid the pitfalls of idealizing or sentimentalizing his subject matter. He described the lifestyle of peasants as intimate and isolated, their days spent largely in the company of plants and animals, with the exception of market days and Sundays.

Pastel had been rapidly growing in popularity since the 1860s after it became a favorite medium of Degas (cat. 37) and his fellow impressionists. It was the perfect graphic medium for artists who prized spontaneity, worked from nature and wanted to break down the boundaries between drawing and painting. Pastels are portable, dry, available in a full range of colours, and can be used to replicate the effects of oil paint. Applied to textured papers, pastel can imitate the broken brushwork of the impressionists or be rubbed to create the ethereal effects and dreamlike quality sought by the symbolists. Pastels were classified, collected, framed and exhibited as if they were oil paintings.

Lhermitte has long been known and admired for his pastels. He used the medium to capture a vanishing way of life and project a vision of "great peace and harmony."[3] The woman watering a row of leeks in her cottage garden is engaged in the type of timeless, repetitive activity that not only connected the peasant to the earth but was seen by Lhermitte as ennobling and deeply spiritual. A member of the Catholic revival of the 1890s, Lhermitte saw in the raising of plants and animals a sacramental quality.

His work combines both documentary and poetic elements. The documentary component comes from direct observation and photographs, and the poetic from his own experience and sensibility. He used the method of Lecoq de Boisbaudran, who recommended that artists work from memory in order to synthesize their visual and imaginative approach to their subjects. Lhermitte was associated with the impressionists even though he declined Degas's invitation to exhibit with them in 1879.

Lhermitte is still an underestimated artist. His work was greatly admired by van Gogh (cat. 23), who said in 1884, "When I think of Millet or Lhermitte, I find a modern art as potent as the work of Michelangelo or Rembrandt."[4] KL

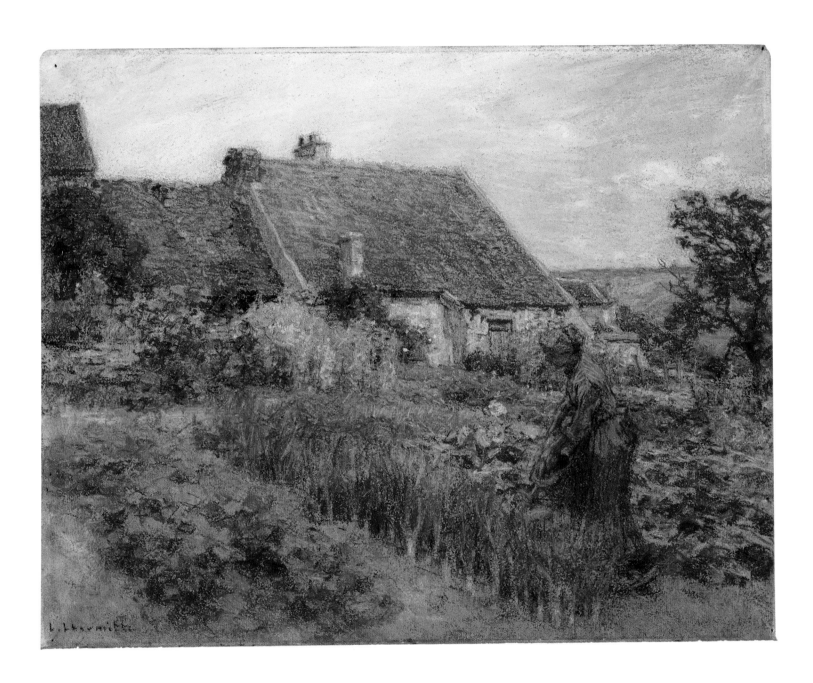

40 PAUL GAUGUIN

Paris 1848–1903 Atuona, Marquesas Islands
Tahitian Girl in Pink Pareu, 1894

Gouache and watercolour transfer on laid paper
24.6 × 14.8 cm
Gift of Vincent Tovell in memory of his parents Harold and Ruth Tovell, 1999
99/45

fig. 1:
Paul Gauguin
Tahitian Girl in a Pink Pareu
gouache, watercolour and ink on coarse-fibred
paper
24.4 × 23.5 cm
The Museum of Modern Art, New York, The
William S. Paley Collection (SPC12.1990)
Digital image © The Museum of Modern
Art/Licensed by SCALA/Art Resource, NY

fig. 2:
Paul Gauguin
Tahitian Girl in Pink Pareu
1894
gouache and watercolour transfer on ivory laid paper
27.5 × 26.6 cm
The Art Institute of Chicago, gift of Walter S. Brewster (1949.606)
Photo: © The Art Institute of Chicago

fig. 3:
Paul Gauguin
Tahitian Girl in a Pink Pareu
1894
gouache and watercolour transfer on laid paper
29.9 × 19.4 cm
The Art Institute of Chicago, gift of Edward McCormick Blair
(2002.237)
Photo: © The Art Institute of Chicago

Paul Gauguin, along with Cézanne, van Gogh and Seurat, is credited with breaking with the impressionist aesthetic and leading art in new directions in the late nineteenth century.

This gouache and watercolour transfer, featuring a young Tahitian wearing the dress that European missionaries had imposed on the islanders, belongs to the remarkable body of works on paper that Gauguin produced in France between August 1893, when he returned from his first Tahitian sojourn, and July 1895, the date he again set sail for the South Pacific. The works were undertaken with the aim of making the paintings the artist had brought back from Tahiti better "understood."[1]

Tahitian Girl in Pink Pareu offers insight into how Gauguin pursued suggestive visual effects through a highly original handling of the little-practiced technique of monotype. The customary approach, which Edgar Degas (cat. 37) had recently followed, was to make a design with printer's ink on a metal plate that was then run through the printing press. Gauguin's variation involved offsetting watercolour or gouache designs made on paper or on glass onto paper. He placed a dampened sheet over the original design and then exerted pressure with an implement such as the back of a spoon. Since the moisture in the paper acted partially to dissolve the water-based medium, the original design was thus transferred in reverse to the paper. The technique allowed the painter to pull two or even three variant impressions of a basic design, despite the singularity indicated by the monotype appellation.[2]

In the case of the monotypes printed from drawings and liquid media on glass, the printing matrix – the design on glass – disappeared or was discarded. There are only a few instances in which the gouache-on-paper designs that were used as matrices survived. Among these are the Elliott monotype (fig. 1), and two other cognate impressions: one with the profile of the young man seen at lower right of the drawing (lower left in the transfer) (fig. 2), and another in which the profile is consciously edited out (fig. 3), as in the Elliott sheet.

Comparison of these four works is an object lesson in Gauguin's procedures and aims. Partially products of chance – like the impressions he pulled of his woodcuts – Gauguin's monotypes exhibit a visual suggestiveness he could not readily achieve in paintings or drawings. Their blurriness makes their imagery seem ephemeral, representations less of present experience than of distant memories on the verge of fading away. The stuff of dream – evocative, mysterious – they embody Gauguin's belief that "the essence of a work [is to be] unsubstantial and out of reach."[3] DWD

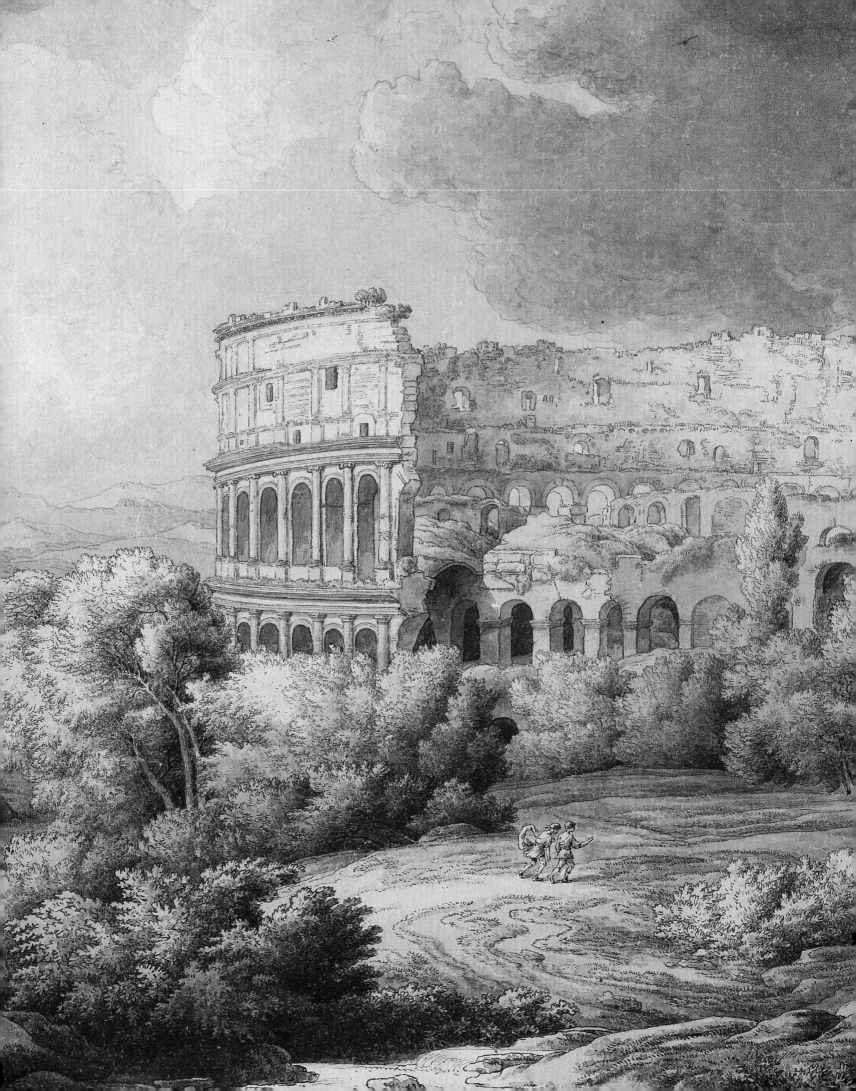

41 FRANZ INNOCENZ KOBELL

Mannheim 1749–1822 Munich

Colosseum, c. 1780

Pen and black and brown ink and wash over traces of black chalk on laid paper
33.6 × 47.0 cm
Purchased as a gift of the Master Print and Drawing Society of Ontario Purchase Fund, 2004
2004/13

Despite the many obstacles that stood in his way following the premature death of his parents, Franz Kobell was determined to become an artist. He received some training from his older brother Ferdinand, who believed trees to be "the soul of landscape."[1] After Kobell attended the Mannheim Drawing Academy, Prince Elector Carl Theodor gave him a pension enabling him to go to Rome from 1778 to 1784. There he joined the growing international community of artists that, by this time, included the German artist Seydelman (cat. 42).

In Rome, Kobell devoted himself to the study of the city's great monuments and the surrounding countryside. He began to produce large drawings executed in pen, ink and wash that were greatly appreciated by his contemporaries. Capriccios of Roman ruins were in vogue, and this drawing is composed of ruins brought from different parts of Rome and its vicinity, including the Colosseum, the Pyramid of Cestius and the Ponte Lucano (see cat. 15). At that time the Colosseum was still half filled with dirt and rubble, and its state of decay inspired meditation on the passing of worldly glory, evoking feelings of melancholy in the viewer.

Kobell situates these ruins in a romantic landscape that includes the volcanic peaks of the Alban Hills south of Rome. The deciduous trees owe a debt to the idealized views of the Campagna by Claude Lorrain and Gaspard Dughet, whom Kobell greatly admired. It was in part through the study of their works that he developed his own landscape drawing style.

This subject has an allegorical subtext. In the centre of the composition a pair of young gladiators, locked in conversation, appear unaware of the crumbling monuments or the storm brewing overhead. This can be linked to the German Sturm und Drang movement, symbolized in literature and art by a youthful genius who fought for freedom from the rules of the existing order. This inevitably involved conflict with authority, ensuring that the path ahead would be filled with storm and stress.

This movement precipitated a raging debate from 1770 to 1784. Pitting nature against reason, Sturm und Drang opposed the Enlightenment and its aesthetic counterpart, neoclassicism, seeking to replace decorum with passion and imitation with imagination. Johann Wolfgang von Goethe, its leading proponent, was a great admirer of the drawings of Franz Kobell, and wrote to Kobell's brother in 1780 asking him to order a dozen drawings from Franz and requesting that "he should draw them at least partially from nature, and then finish them as he wishes."[2] This drawing answers that description.

In 1780 Kobell was named court artist. He returned to Germany four years later and settled near his patron, Prince Elector Carl Theodor, in Munich, where he was joined by other members of his artistic family. He remained so passionate about drawing that he called for a pencil and paper on his deathbed. KL

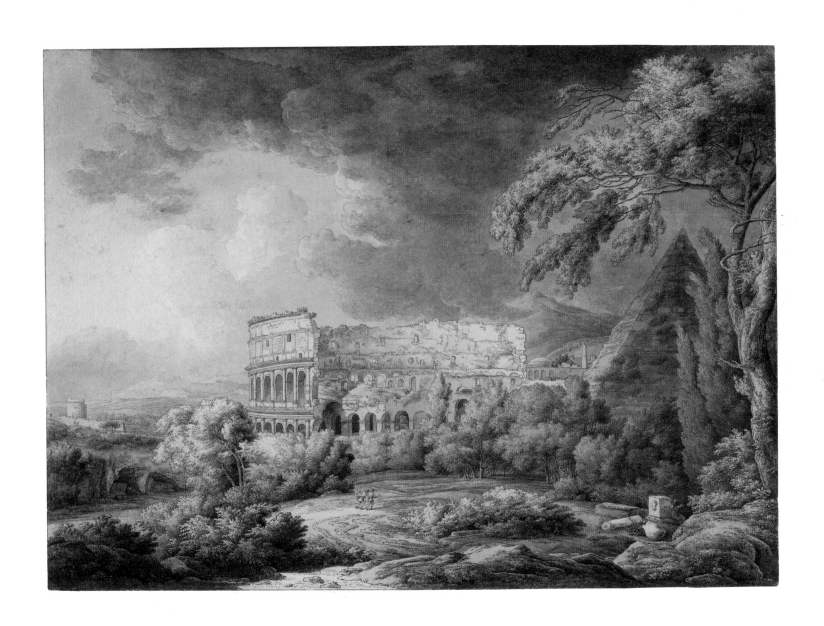

42 JOHANN CRESCENTIUS SEYDELMAN

Dresden 1750–1829 Dresden

Portrait of a Man, 1777

Sepia wash on laid paper
52.1 × 45.7 cm
Inscribed: *Rome 1777*
Watermark: "HONIG & ZOONEN" (Heawood 3344–45?)
Purchase, Peter Larkin Foundation, 1968
67/38

Born in Dresden, Johann Crescentius Seydelman studied at the Dresden Academy under Giovanni Battista Casanova and Bernardo Bellotto, Canaletto's nephew and pupil. In 1772, at the age of 22, Seydelman was awarded a pension by the elector of Saxony that enabled him to go to Rome to complete his artistic training. In doing so, he followed in the footsteps of two illustrious predecessors, the painter Anton Raphael Mengs (1728–1779) and the classical scholar Johan Joachim Winckelmann (1717–1768).

Seydelman arrived in Rome at a time when artists from many countries were converging on the city. They debated the ideas of the Enlightenment in studios and cafés in the vicinity of the Piazza di Spagna, where English nobles on the Grand Tour purchased art and antiquities for their residences. Art students looked to Grand Tourists for income and made works on paper with this in mind.

Mengs had preceded Seydelman in Rome. He had arrived in Dresden in 1741, and was appointed first painter to the elector of Saxony in 1749. In 1855 he met Winckelmann, the father of archaeology, in Rome. They shared a mutual enthusiasm for classical antiquity from which they derived their aesthetic theories. These ideas were incorporated into Mengs's paintings and Winckelmann's writings.

The History of Ancient Art, 1764, by Winckelmann was hugely influential in the dissemination of the neoclassical style that swept away the frivolity of the rococo.[1] He maintained that the principal goal of art was to project feelings of "noble simplicity and sedate grandeur."[2] It was believed that by studying the art of Greece and Rome, artists would find a timeless and immutable beauty that would give their works the desired qualities of truth, purity, nobility and honesty.[3]

Seydelman entered the studio of Mengs after his arrival in Rome in 1772, four years after the death of Winckelmann. He was commissioned by some of the leading Grand Tourists to make sepia drawings after great Italian masters. He was aware of the art of Fuseli (cat. 48) and his circle, who were among his contemporaries in Rome. Seydelman is credited with introducing the use of sepia washes, and developed a reputation for large portrait drawings such as this one. His sitters included his teacher Giovanni Battista Casanova (1722–1795) and Friedrich August IV, Kurfurst von Sachsen. Although the sitter in this drawing has not been identified, it seems likely, given the informality of his dress, that it may be the artist himself or a close friend. In this work, Seydelman seamlessly combines naturalism and classicism: the sitter appears to be simultaneously drawn from nature and carved in marble, like a classical portrait bust. While employing the linear clarity and shallow picture space characteristic of neoclassicism, the drawing's decorative calligraphy and the angularity of the drapery recall German art of the sixteenth century.

Seydelman returned to Dresden the year after Mengs's death in Rome in 1779. He was appointed professor of drawing at the Dresden Academy, becoming a member in 1782. He married an Italian artist and returned to Rome several times during the course of his career. KL

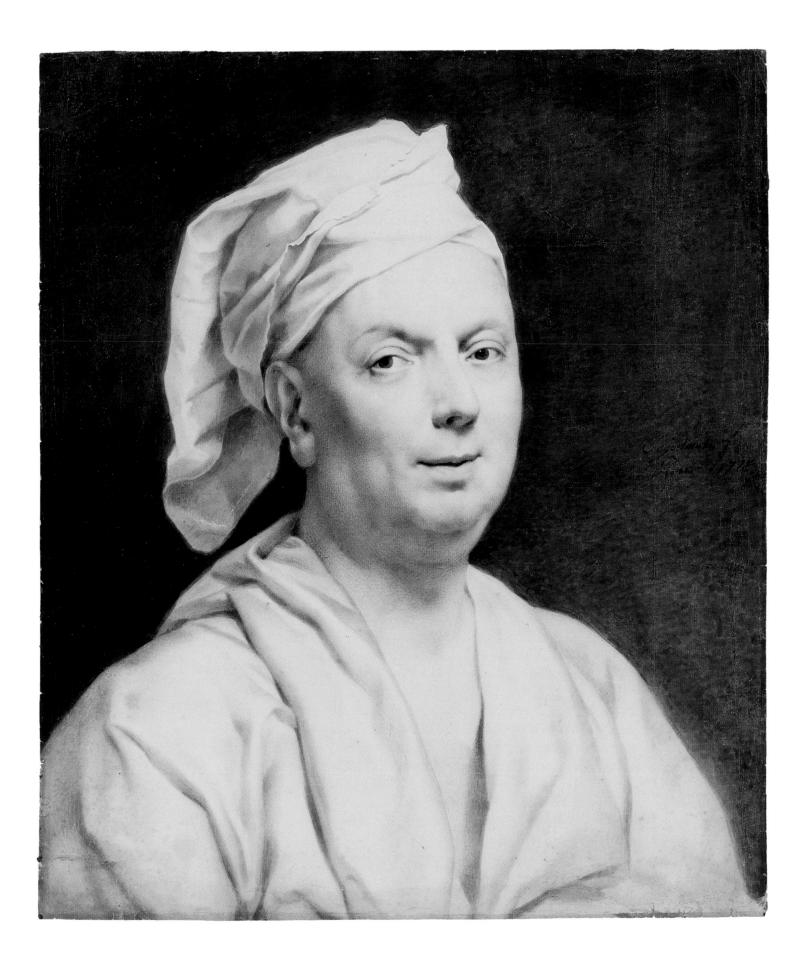

43 JOHANN CHRISTIAN REINHART

Hof, Bavaria, 1761–1847 Rome

In the Park of the Palazzo Chigi, Ariccia, 1818

Graphite and black chalk on laid paper
48.2 × 63.8 cm
Signed and dated l.r.: *C. Reinhart/Roma/1818*
Watermark: "IV"
Purchased as a gift of the Marvin Gelber Fund, 2005
2005/16

Johann Christian Reinhart, a leading German romantic artist, studied theology before beginning art studies in Dresden. In 1785 he met, and was greatly influenced by, the poet Friedrich Schiller, leader of the German romantic movement following Goethe's conversion to neoclassicism. In 1789 Reinhart was given a pension by the duke of Sachsen-Meiningen that enabled him to go to Rome, where he remained for the rest of his life.

Between 1770 and 1800 landscape assumed increasing importance as a subject in German art. The way in which the landscape was depicted, and especially the trees within it, became part of a philosophical debate in artistic circles. Supporters of neoclassicism opposed supporters of romanticism over the concepts of the ideal versus the real and the universal versus the particular. Reinhart espoused a romantic point of view and did not believe that there was such a thing as an ideal or universal landscape.

In 1795 Reinhart met Karl Ludwig Fernow (1763–1808), who dedicated a chapter, "Über die Landschaftsmalerei," to the artist in his three-volume publication *Römische Studien* (c. 1806–08). Fernow maintained that there is no such thing as an ideal tree, only distinct types of trees. He urged artists to study natural forms and emphasize their "peculiarities." He believed that the image should activate "the emotional and moral impulse of the soul" of the viewer before the details of the composition began to attract the viewers' attention. In this superb sheet, Reinhart met all of these requirements.

This is one of a group of large drawings that were executed in the wild and uncultivated park of the Palazzo Chigi near Lake Albano in the Alban Hills south of Rome.[1] On one level this is a scientific study of oak trees, igneous rocks and ground cover, and on another it is infused with the ideas of the Sturm und Drang movement that sought analogues in nature to human passions and emotions. Enhancing the raw beauty of the Creation through meticulous delineation, the artist also underlines the tenacity required by the ancient trees in order to survive in this inhospitable volcanic terrain. The vital forces of nature find expression in the gnarled limb with its grasping "hands" and the roots that glide, like giant serpents, down the boulder-strewn hillside in their search for soil. The drawing provides a springboard for meditation on life's stresses and strains and the passage of time.

Reinhart was admitted to the Accademia di San Luca in 1813. Greatly admired in his native land, he was given a yearly pension by King Ludwig I of Bavaria in 1825. On the occasion of his fiftieth year in Rome, the artist was made an honorary member of the Munich Academy and awarded the title of Bavarian court painter. KL

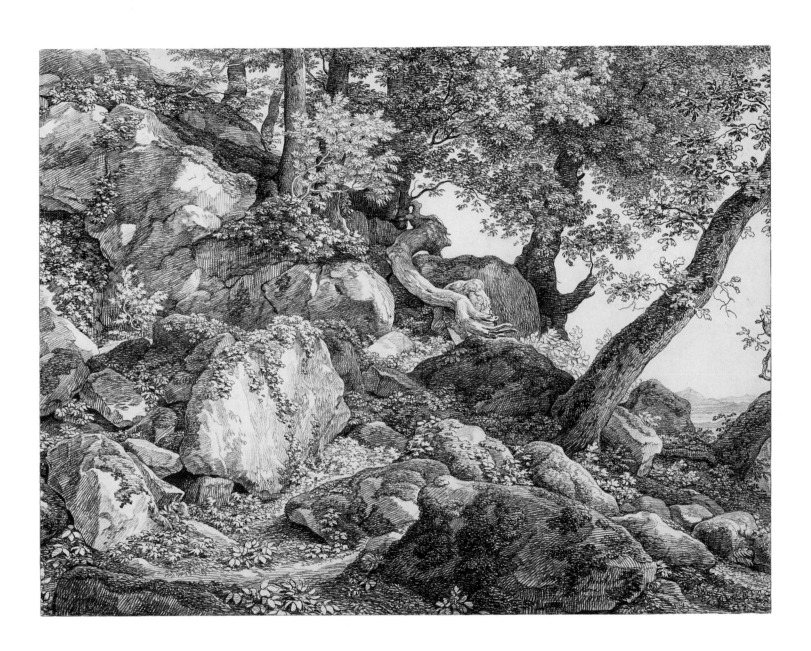

44 ADOLPH FRIEDRICH ERDMANN VON MENZEL

Breslau, Silesia (now Wrocław, Poland) 1815–1905 Berlin

Head of a Young Man, 1893

Graphite and stump on wove paper
21.0 × 13.0 cm
Signed and dated l.l.: *A.M. 93*
Purchase, 1985
85/270

In 1830 Adolph Menzel moved from his native Silesia to Berlin and, with the death of his father two years later, was obliged to take over the family lithography business. This trade provided a living for himself, his mother and siblings and offered an opportunity to develop his skills as a draftsman and printmaker. Largely a self-taught artist, he made his name as the illustrator of the life and times of Frederick the Great.

Menzel once remarked, "My artistic creativity began as soon as I was able to hold a piece of chalk."[1] A consummate and prolific draftsman, his lifelong passion for drawing and his commitment to becoming a successful artist are demonstrated by more than 6000 extant drawings and approximately seventy-five sketchbooks that are now housed in the Kupferstichkabinett, Berlin.[2] He is known to have kept his pockets filled with small sketchbooks, ready to seize every opportunity to record his impressions of the world around him.

In 1875 Menzel completed his monumental canvas on a modern realist industrial theme, *The Iron Rolling Mill* (Nationalgalerie, Staatliche Museen zu Berlin). In keeping with his usual working process for multi-figured oil paintings, this extraordinary composition was developed through a multitude of separate studies in pencil. He seldom produced an overall compositional sketch or cartoon for a canvas, but worked directly from individual studies and from memory. One historian has described this process as "intricate and complex" and "very much like creating a montage of fragments from reality."[3]

By the mid-1890s Menzel devoted himself to drawing (mostly with graphite) and to close-range realistic studies of (mainly older) individuals and, occasionally, small groupings of figures. His drawing became more painterly, as evidenced by his increased use of shading with stump. The carpenter's pencil became his preferred drawing implement and, in combination with stump, created a kind of photographic accuracy through a range of textures and modulated grey tones.

Head of a Young Man dates from the last decade of Menzel's career and is one of his many studies of heads or half-length figures seen from unexpected vantage points. Observed from below, the young man appears to have been caught in a fleeting moment, with eyes half closed as he raises or lowers his left arm. The close-up point of view, the careful finish of the drawing and the way the figure has been cropped to fill the sheet give the work a disarming snapshot quality and suggest that this is not a quick, on-the-spot sketch but a deliberately posed, autonomous work of art.[4] Attention has been focused on the sensitively rendered face and the sitter's haughty, enigmatic expression, indicating the artist's desire to explore the inner life of his subject. The sitter may have been one of the paid models who posed for the artist during his later years, although these were mostly poor older men. This smartly dressed and slightly dissipated young man was possibly a student or someone the artist encountered on a visit to the theatre.

During the last two decades of his life, Menzel received many awards and honours in Germany and was much admired by fellow artists. Edgar Degas owned one of his drawings and is quoted as calling Menzel "the greatest living master."[5] BR

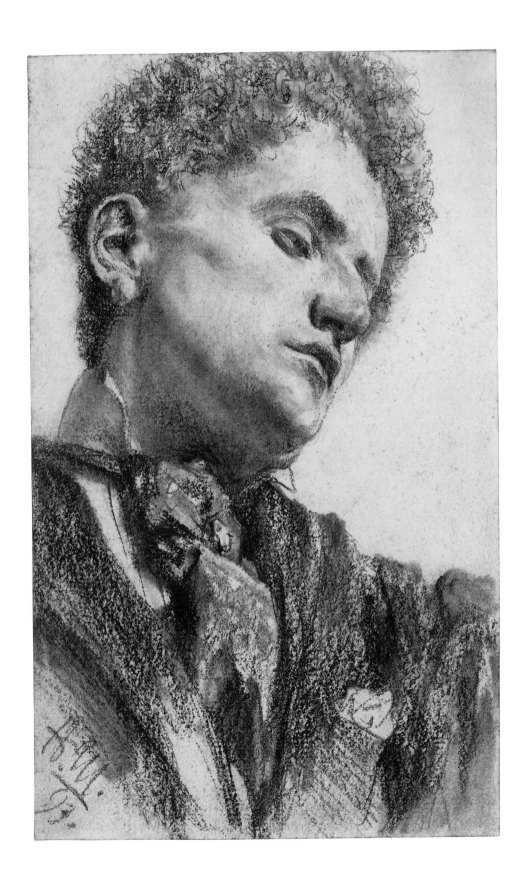

45 KÄTHE KOLLWITZ

Königsberg 1867–1945 Moritzburg (near Dresden)
Tavern in Königsberg (recto);
Studies of Women's Clothing (verso), 1890–91

Nagel/Timm 51
Pen and black ink and grey wash on wove paper
24.8 × 32.8 cm
Signed in graphite l.r.: *Käthe Kollwitz*
Purchase, 1983
83/258

Given that Käthe Kollwitz's art is autobiographical, rooted in socialism and essentially figural, an image of an empty room, such as *Tavern in Königsberg*, is atypical and rare. This early study dates to 1890 or 1891, a period that the artist spent in her hometown of Königsberg. By this time she had completed her training at the Berlin Women's Art Union and with private instructors in Königsberg and Munich. Her outstanding ability to draw had been recognized by her teachers, who encouraged her to give up painting and pursue a career in drawing and printmaking. Kollwitz admired the technical innovations of Max Klinger's prints and his ideas about the imaginative potential of the graphic arts. While in Berlin in 1884 she saw his series *Ein Leben (A Life)*, and was excited by the socially biting subject matter and naturalistic, literary content of his imagery.

fig. 1:
Käthe Kollwitz
Szene aus Germinal (Scene from Germinal)
1893
Klipstein 21, Knesebeck 19
etching
23.9 × 52.8 cm
Kupferstichkabinett, Staatliche Museen, Berlin
© Estate of Käthe Kollwitz/SODRAC (2007)

Along with other German artists, Kollwitz was attracted to the works of French naturalist writers, particularly to the controversial writings of Émile Zola. His novel *Germinal*, the story of a young miner who incited his fellow workers to strike, had caused a sensation when it was published in 1885. In 1888–89, while studying in Munich, Kollwitz belonged to a group of young artists who were given the task of illustrating the "fight" or "struggle" theme. Kollwitz chose the scene from Zola's story "where two men fight in the smoky tavern over young Catherine."[1] She subsequently planned a series of prints associated with Germinal, made a couple of trial etchings and completed one ambitious plate for the series, *Scene from Germinal* of 1893 (fig. 1).[2] The drawing *Tavern in Königsberg* is a preparatory study for these prints.

Although the room in the drawing is empty, there is a sense that it has been recently vacated. In fact, this sailors' tavern in Königsberg usually bustled with nightlife. Kollwitz obtained permission from the owner to draw the venue in the mornings when it was quiet and safe.[3] In keeping with her early preference for pen and ink, the linear detail has been freely sketched, with cross-hatched details reflective of her current work in etching. Broad tonal areas of grey have been loosely washed in to create a haunting and mysterious mood. In the related etching, the artist reduced the large empty foreground, choosing a narrow horizontal format.

Kollwitz was apparently attracted to *Germinal*'s love triangle involving Catherine and her two suitors. In other narrative prints and drawings of the 1890s she similarly focuses on the tragedies of victimized heroines in novels and plays.[4] At the same time, these stories almost invariably portray the lives of working-class subjects and can be seen as the first manifestations of her lifelong fascination with the plight of lower-class women.

Kollwitz would return to the "fight in a tavern" theme ten years later in at least two drawings and another print of 1903–04.[5] The room in these later works bears a marked resemblance to the one in *Tavern in Königsberg*, and it is tempting to speculate that Kollwitz had pinned the earlier study to the wall of her Berlin studio (suggested by the cluster of pinholes in the top centre of the sheet), making it available for ongoing reference and inspiration.

BR

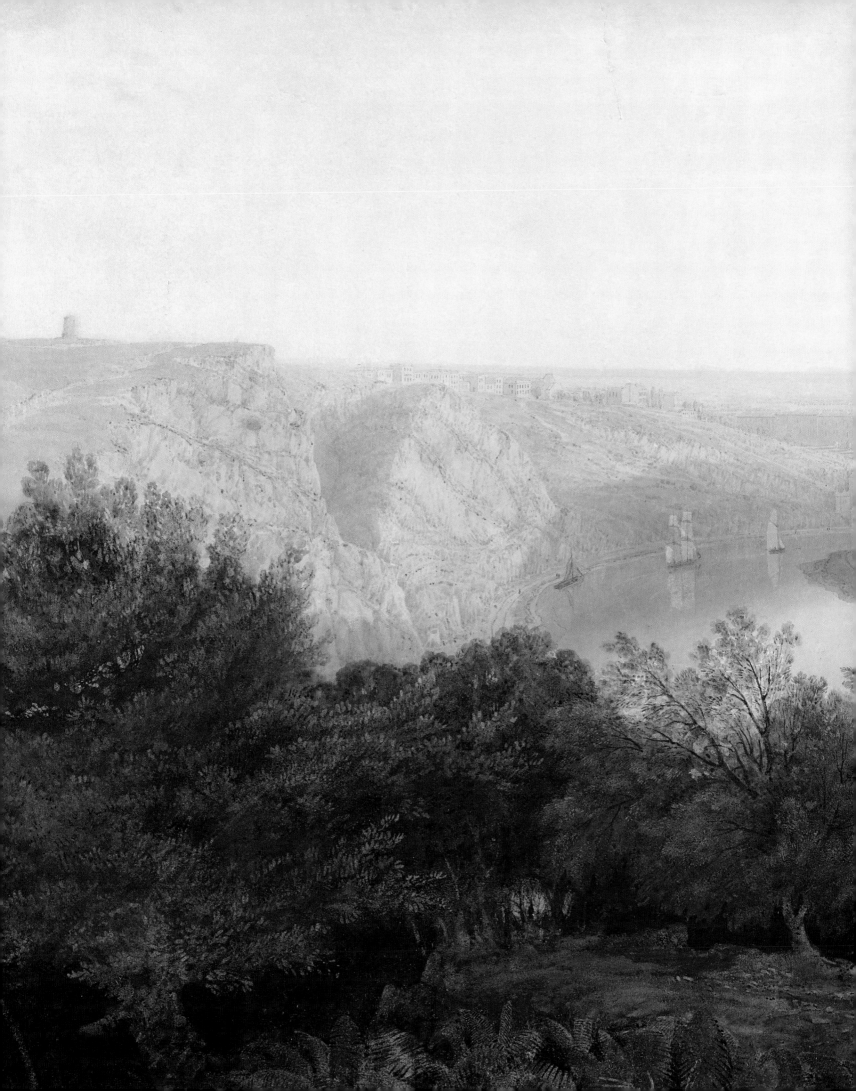

46 THOMAS GAINSBOROUGH

Sudbury, Suffolk 1727–1788 London

Wooded Landscape with Herdsman and Cattle, c. 1775–80

Black chalk and grey-black washes, heightened with white gouache on laid paper
28.0 × 36.7 cm
Purchase, 1985
85/272

Although Thomas Gainsborough is known as one of the great portrait painters of the British school, he had a lifelong passion for landscape drawing. For the most part he worked on his drawings in the evenings by candlelight, using tabletop models. As W.H. Pyne describes, "He would place cork or coal for his foregrounds, make middle grounds of sand and clay, brushes of moss and lichens, and set up distant woods of broccoli."[1] He moved these elements around on the tabletop. Thus Gainsborough composed his landscapes, adapting and changing nature to suit his imagination. He was a gifted and original draftsman, concerned with his materials. By the time of this drawing, he typically used chalk, washes and white highlighting, as he was interested in chiaroscuro and light effects. Gainsborough clearly prized these drawings, for Sir Henry Bate Dudley noted that he rarely parted with them, and then only as "*gifts* to very particular friends, or select persons of fashion."[2] The present sheet is one of eight that may have been given to the Spencer family of Althorp.

As Gainsborough's style evolved, his handling became freer and more rapid, yet his work retained elements of the Dutch landscapes that inspired his early years, as well as the rhythms of the French rococo. Some of his compositions reflect the classicism of Claude Lorrain. Others reveal his interest in the picturesque, an interest he shared with its leading proponent William Gilpin. Gilpin wrote, "*Roughness* forms the most essential point of difference between the *beautiful*, and the *picturesque*."[3] Apparently Gainsborough, with his ruined castles, rugged cliffs and hills, and broken ground, was one of the earliest to adopt picturesque principles. The picturesque was an element in the growth of romanticism and exercised a major influence on the next generation of artists, among them J.M.W. Turner (cat. 53).

Gainsborough used drawing primarily to develop ideas for paintings rather than as preparatory studies. As John Hayes and Lindsay Stainton point out, the present sheet relates to Gainsborough's canvas *Wooded Landscape with Figures in a Country Cart* from c. 1777–78, on loan to the National Museum Wales.[4] While the main compositional elements are the same, there are changes, such as the substitution of donkeys for the cows, and the addition of a cart and figures. Interestingly, *Woody Lane with Market Cart* at the Sudley Art Gallery in Liverpool has cows at the left like the drawing.[5] Extra figures in the more complex painted composition emphasize the nostalgic mood of Gainsborough's mature landscapes, and they have sometimes been regarded as a commentary on the plight of the rural poor.

JW

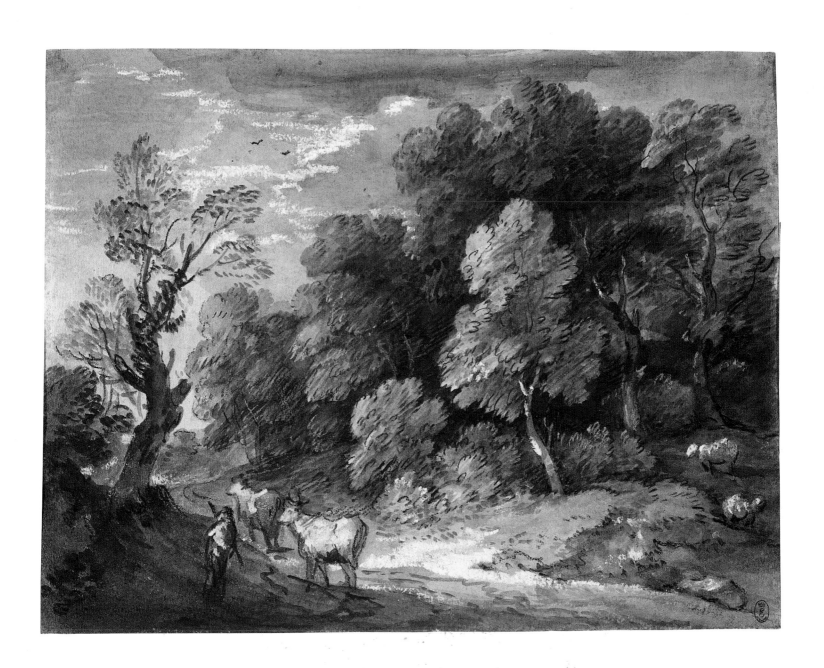

47 GEORGE ROMNEY

Beckside, Lancashire 1734–1802 Kendal, Cumbria

John Howard Visiting a Prison or Lazaretto, 1790–92

Pen, brush, black and grey wash, traces of black chalk and graphite on laid paper
30.0 × 41.9 cm
Gift of T.A. Heinrich, 1980
80/98

While George Romney is well known as a painter of portraits, his chief interest in later life
was history painting. He made numerous drawings from both contemporary and histori-
cal literature. This is one of nearly five hundred drawings depicting the great prison
reformer John Howard (1726–1790).[1] Romney's interest in Howard dates from 1779
when he contributed the frontispiece to William Hayley's *Ode to Howard*, published in
1780.[2] Although Romney also planned a portrait, Howard refused to sit, disliking worldly
honours. Romney then conceived the idea for "one or two large pictures," according to
his son, "representing . . . those scenes of human wretchedness which . . . Howard [could
have seen] in his perilous visits to the Lazzarettos [*sic*] and prisons abroad."[3] Howard's
death in 1790 renewed interest in his achievements.

Howard had inspected and published the horrifying conditions and many abuses of
prisons in England and Wales, foreign prisons and, in 1789, the lazarettos or leper houses
of Europe. His extensive travels took him as far as Russia, where he died from camp fever.
From his writings we know that he was particularly disturbed by the practice of binding
prisoners, confining men and women together, and keeping them in dark, underground
cells, details that are incorporated into this sheet.

Romney's many Howard drawings range from sketchbook studies in graphite to large
compositions in pen with dramatic use of wash, as here. His bold chiaroscuro, flowing
lines and simplified forms, together with his interest in the horrors of his subject, bear wit-
ness to his creative years in Rome, 1773–75. There he participated in an artistic circle that
centred on Henry Fuseli (cat. 48). In this milieu Romney evolved a new style and turned
to new subject matter. He portrays Howard in a dramatic confrontation with the jailer,
towering at the left with a key. Howard was a contemporary hero who sought freedom
and justice against the backdrop of the French Revolution. Romney was close to some of
the political radicals of his time, such as Tom Paine, and apparently followed political and
social events with interest. As Victor Chan notes, "Romney saw the opportunity of
expanding the realm of history painting and transforming traditional prison iconography
into a romantic allegory of concern for human misery and helplessness."[4] The drawing
effectively illustrates Romney's grounding in neoclassicism and, at the same time, reveals
him as a precursor of romanticism. JW

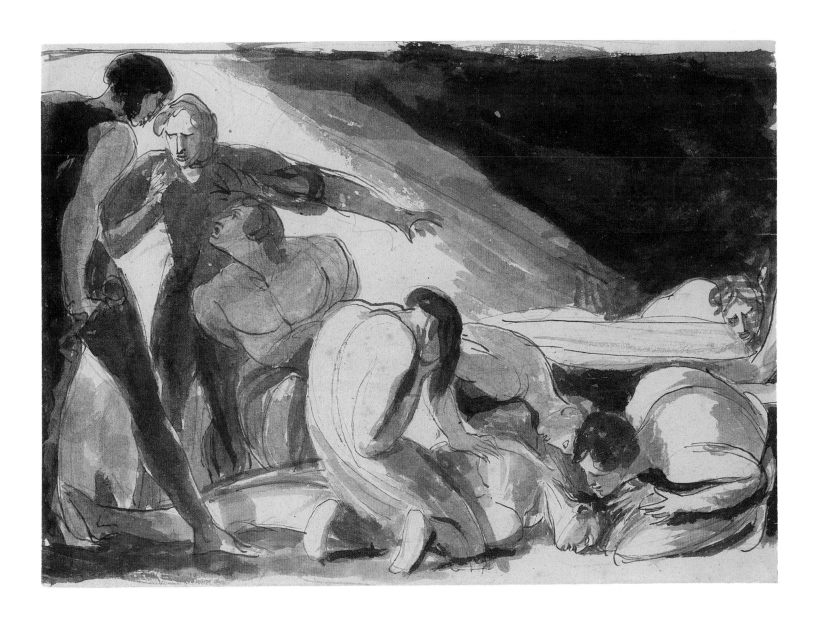

48 HENRY FUSELI (born JOHANN HEINRICH FÜSSLI)

Zurich 1741–1825 Putney Hill

A Standing Nude Figure, Seen from Behind (recto and verso)

Pen and brown ink on laid paper
31.0 × 19.2 cm
Watermark: "Britannia"
Purchased in memory of Alan Flacks, 1995
94/309

Henry Fuseli was one of the most significant of the early romantic artists. His distinctive and idiosyncratic style exercised an influence on the imagination and vision of draftsmen and artists in Britain and across Europe. In Fuseli's hands, the fluid neoclassical line evolved into a mannered and distinctive style.

After coming to England from Switzerland in 1764, Fuseli met Joshua Reynolds, president of the fledgling Royal Academy, who encouraged him to pursue his talent for drawing. From 1770 to 1778 he lived in Rome where he became the most original and influential member of a circle of international artists that included George Romney (cat. 47) and Thomas Kerrich (cat. 49).

Romantic artists often studied the flayed (*écorché*) human figure and combined their knowledge of musculature with an interest in physical deformity, distortion, metamorphosis and evil. This progression is demonstrated here by comparing the slightly more naturalistic drawing on the verso to the fantastic figure on the recto whose devilish pointed ears and menacing musculature convey a sense of demonic power and strength. This arrogant muscular figure seen from behind was probably inspired by the figure of the executioner in Andrea del Sarto's *Beheading of St. John the Baptist* in the Scalzo in Florence. Here, however, it turns into a monstrous satanic creature drawn from Fuseli's notoriously vivid imagination.

A prolific draftsman, Fuseli employed this motif frequently, notably in a sketch that served as the basis for a pen and wash drawing by his young friend and admirer William Blake, who later engraved it as *Fertilization of Egypt* (fig. 1). The engraving, showing Anubis, the dog-headed god of the Nile, praying to the star Sirius for rain, was commissioned by Erasmus Darwin to illustrate his epic poem *The Botanic Garden* in 1791. However, it was in the guise of Satan in *Paradise Lost* for Fuseli's Milton Gallery of the 1790s that this figure really came into its own. Fuseli created a series of drawings and studies, including this one, through the 1780s and 1790s in preparation for his enormous painting of the magnificent figure of the rebellious Satan, rising from the fiery lake and summoning his legions (*Satan After his Fall, Addressing the Rebel Angels*, Stratfield Saye, Hertfordshire, duke of Wellington, England).

This drawing may have belonged to Fuseli's great friend and patron Dr. James Carrick Moore (1762–1860), whose father Dr. John Moore may have met the artist in Rome. James Moore's eldest daughter, Harriet Jane Moore (1801–1884), owned *A Midsummer Night's Dream* (Tate Britain) in which a fairy standing in the upturned palm of Bottom is depicted in this pose. She also owned three albums of Fuseli drawings, some of which were gifts from the artist and others purchased by her after his death. The "Roman album" went to the British Museum, but the other two, covering most of his career and a wide range of subjects, were sold by Christie's in 1973 (6 March) and 1992 (14 April) and were later broken up. This sheet comes from the album sold in 1992 that contained another almost identical sheet.

KS

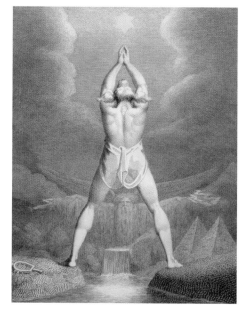

fig. 1:
William Blake after Henry Fuseli
Fertilization of Egypt
illustration in Erasmus Darwin, *The Botanic Garden*, part 1,
1791, p. 127
etching and engraving
15.4 × 19.6 cm
British Museum, London

49 THOMAS KERRICH

Dersingham 1747–1828 Cambridge

Portrait of William Heath M.A., Fellow of Magdalene College, 1777

Red and black chalk on laid paper
44.4 × 30.4 cm
Inscribed in brown ink on verso: *William Heath M.A./Fellow of Magdalen College, Cambridge/T. Kerrich delin/M.C.C. May 1777*
Purchased with donations from AGO members, 1990
90/132

Ordained in the Church of England, the Reverend Thomas Kerrich served as vicar of his father's parish of Dersingham in Norfolk and was a prebendary (recipient of a stipend) of Lincoln Cathedral and, from 1812, Wells Cathedral. In 1797 he became principal librarian of Cambridge University. His position in the church provided him with an income and leisure time to pursue his artistic and scholarly interests. Like many eighteenth-century clerical gentlemen, he was a scholar, amateur artist, antiquary, scientist and collector.

Although Kerrich studied at art academies, he never intended to become a professional artist. Drawing was seen as a useful pursuit for a gentleman, particularly a natural philosopher such as Kerrich. He was also an accomplished miniaturist, recorder of medieval monuments, an etcher and one of the first lithographers. He is comparatively little known because his hundreds of drawings remained together in the hands of his descendants until they were dispersed through two sales that took place at Sotheby's London in 1989 and 2000.

When Kerrich graduated from Magdalene College, Cambridge in 1771, he was elected to a four-year travelling scholarship. He visited and studied briefly at various academies and was awarded a medal for drawing at the Academy of Painting in Antwerp. After six months in Paris, he settled in Rome for two years where he may have moved in the company of Fuseli and his circle, which included Romney. Like many other members of the circle, he used himself as a subject and produced many extraordinarily intense and strange self-portraits, most notably one from 1774 recently acquired by the National Portrait Gallery, London (inv. no. NPG 6531).

The portrait drawings made in Cambridge of friends and acquaintances following Kerrich's return are executed on a grand scale using the continental medium of coloured chalks in an extraordinary range of textures. Although at first they appear more traditional in composition and style, they have a freshness and directness, one might even say a realism and intensity, that distinguish them from the work of other professional portraitists of the time. This is particularly evident in the romantic nature of this rather effete, wan and bloodless portrait of the Reverend William Heath. Some of Kerrich's portraits of his Cambridge friends were engraved by the brothers George and John Facius, including the portrait of his fellow antiquary, the Reverend William Cole, now in the British Museum.

Little is known about the Reverend William Heath. The Cambridge alumni records (published in Venn's *Alumni Cantabrigienses*) indicate that he was the son of Lewis Heath of Newcastle, Staffordshire, and attended Repton School before being admitted to Magdalene in June 1769 at the age of eighteen. He received his BA in 1773 when he was ordained a deacon at Peterborough, and his MA in 1776 when he was made a priest and a fellow of the college. He was curate of Chesterton in Cambridgeshire from 1779 and rector of St Michael's in Longstanton in Northamptonshire from 1781 to 1782, after which all records of him cease. KS

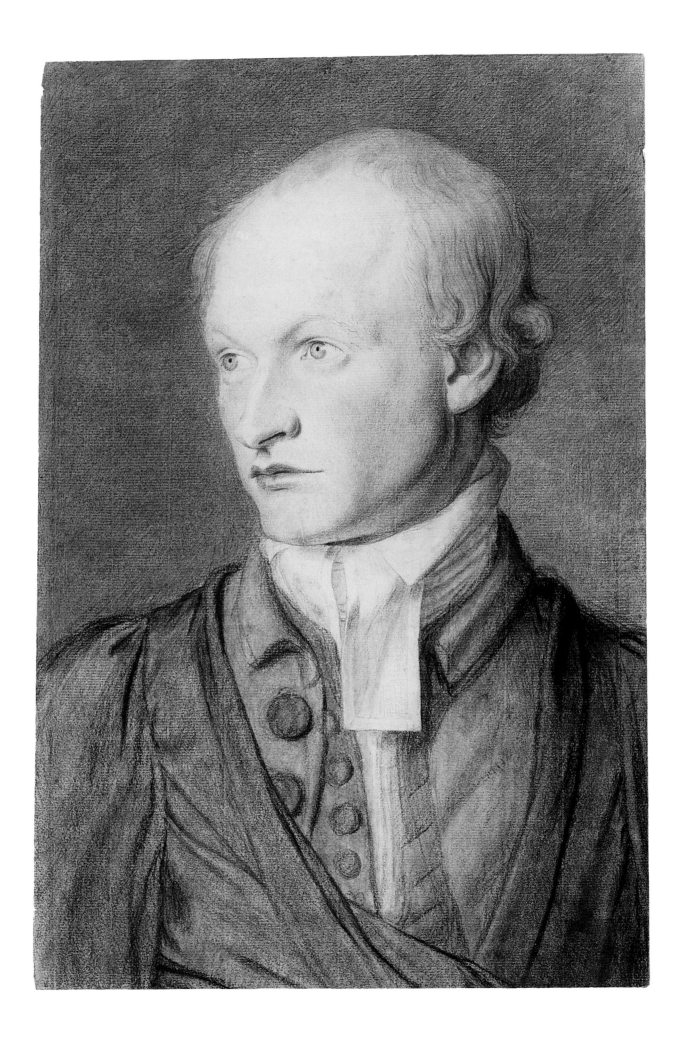

50 JOHN ROBERT COZENS

London 1752–1797 London

The Lake of Albano and Castel Gandolfo, c. 1778

Watercolour over graphite on wove paper
36.5 × 52.8 cm
Gift of Midland Bank Canada, 1986
86/197

According to John Constable, John Robert Cozens was "all poetry . . . the greatest genius that ever touched landscape." He was the son of the artist Alexander Cozens (1717–1786) who was described by his patron, the wealthy and eccentric young romantic, William Beckford, as being "as full of systems as the universe." As a drawing master to the sons and daughters of George III as well as to Beckford and other young members of the nobility and gentry, Alexander Cozens was well placed to further his son's career. However, John Robert's work was very different. Where Alexander's landscapes came from his imagination and elaborate systems, John Robert, as Henry Fuseli reported, "followed the arrangements of nature, which he saw with an enchanted eye, and drew with an enchanted hand."[1]

In 1776 John Robert Cozens accompanied the young classical scholar, connoisseur and collector Richard Payne Knight on his Grand Tour. On his arrival at the Caffè degli Inglesi in Rome – the English coffeehouse – Cozens was greeted by a number of artists from home, Fuseli among them. In the light and atmosphere of Italy, he left behind the sombre palette inherited from his father and made views in Rome and the surrounding Campagna employing picturesque compositions and a palette of greens and blues inspired by the great French landscape artist Claude Lorrain. Cozens developed new techniques of painting with brush strokes over pale washes applied broadly, building up his image through modelled forms.

In April 1777 Cozens drew in the Alban Hills south of Rome, which since ancient times had been a summer retreat from the torrid city. Here he depicts the papal palace, Castel Gandolfo, perched on the northern rim of the caldera of Lake Albano, an ancient volcanic crater. The palace is bathed in late afternoon sunlight, rays shining through the trees on the left silhouetting the rim of the hillside. This view was based on a pencil sketch in an album that was later purchased by the great British architect Sir John Soane. It was so popular that Cozens produced at least ten versions for clients, each with its own distinctive poetic light and mood. John Robert had learned from his father that composition and light could be used to evoke specific emotions that were deemed to have a beneficial effect on the viewer and even on society. Cozens's poetic watercolours have often been described as "mysterious," "melancholic," "pastoral" and "serene."

The feelings aroused by Cozens's watercolours have led them to be described as very early examples of romantic sensibility. But it is doubtful that Cozens was aware of the "romantic movement." He was by all reports a solitary artist and, in the early 1790s when he appears to have become mentally ill, was placed under the care of Dr. Thomas Monro. The physician, himself an amateur and patron of the arts, paid J.M.W. Turner (cat. 53) to make copies of Cozens's works, which had a formative influence on Turner's interpretation of sublime and evocative scenery. KS

51 JOHN FLAXMAN

York 1755–1826 London

Paternal Affection

Pen and ink and grey wash over graphite on laid paper
30.5 × 24.5 cm
Purchase, 1980
80/84

John Flaxman studied with his father, a cast maker, before entering the Royal Academy Schools. There he was strongly influenced by the study of Greek vase painting and the flowing linear drawing style of his friend and fellow student William Blake. Before leaving the Academy in 1775, Flaxman began to work as a modeller for Josiah Wedgwood and was responsible for some of the latter's most memorable ceramics.

Flaxman left for Italy in 1787, inspired by the work of Fuseli and his circle in Rome. Their characteristically fluid, often elegantly spare compositions assisted Flaxman in his search for a linear style that was capable of conveying emotions and sentiment expressed through the face and body. He once wrote that an artist should "observe attentively the actions of people . . . in any way that affects the passions or affections, to consider their countenances, the Contour of their figures and draperies . . ."[1]

While in Italy, Flaxman's study of the antique and the works of early-fourteenth-century Italian masters inspired him to begin to design book illustrations that were to become some of his best-known and most influential works. He employed a simple and elegant outline style to depict episodes from the Bible, Aeschylus, Homer, Dante and Milton. After his return to London he applied this style to sculpture, becoming one of the leading exponents of neoclassicism in Britain. He continued to work on illustrative schemes, among them a series of drawings entitled *Acts of Mercy* that included such subjects as *Feed the Hungry*, *Protect the Fatherless* and *Maternal Compassion*. These were published posthumously.

Flaxman's "Hindu" sketchbook (Fitzwilliam, Cambridge) contains drawings made around 1800 after Moghul miniatures, which he clearly admired for their elegance and linearity. He was also inspired by paintings by Arthur William Devis, who had worked for the East India Company. The subject of this haunting image of a seated man wearing a turban and staring straight ahead while tenderly holding a sleeping (or dead) child remains a mystery. While the title would suggest a connection to the *Mercy* series, it is not certain whether this was assigned by the artist or a subsequent owner. The subject suggests a relationship to a funeral monument designed by Flaxman for the raja of Tanjore (Calcutta, erected 1807), but the turban is that of a Moghul from central or northern India, and quite different from those found in his known monuments.

The pyramidal form of the composition is direct and powerful. Its simple monumentality calls to mind the drawings of Blake. However, the frieze-like quality and use of pen and wash are typical of the neoclassical style of not only Blake, but also Fuseli (cat. 48), Romney (cat. 47) and many other draftsmen throughout Europe at this time. KS

52 THOMAS ROWLANDSON

London 1756–1827 London

After Dinner, c. 1805

Pen and brown, vermilion and grey ink and watercolour over graphite on wove paper
on original mount
23.4 × 36.7 cm
Purchase, 1937
2450

After Dinner is an excellent example of Thomas Rowlandson's work from the first decade of the nineteenth century. The leading social satirist in Britain, Rowlandson was also a prolific and talented draftsman who, by this stage in his career, had developed a highly sophisticated technique using several colours of ink combined with yellow, green, pink and blue watercolour. The decorative effect was further enhanced by his thin, elegant line, which was probably inspired by the refined linear technique of the neoclassical artist John Flaxman (cat. 51).

The neoclassical style, then in its heyday, is evident in the architectural ornament of the room and in Rowlandson's women, who become less voluptuous around 1800 and wear the fashionable empire-style dresses and feathered headgear of the period. Rowlandson nevertheless retains an atmosphere of rococo frivolity and exposes the foibles of a society governed by rules of decorum that covered all aspects of social life including dress, gesture, topics of conversation and gender relations.

In the years 1807 and 1808 Rudolph Ackermann published numerous etchings by Rowlandson under the general title of *Miseries*. The inspiration came from the humorous "dialogues" of James Beresford and his book *The Miseries of Human Life*, first published in 1806.[1] *After Dinner* was used as the model for *Miseries Personal* (fig. 1), one of the larger prints in the series published in 1807. Dinner parties were a popular form of entertainment. The inscription describes a frustrated hostess "after dinner" when her husband and his friends linger over drinks in an adjacent room instead of joining the ladies for coffee.

Rowlandson's depiction of the moment when the men rejoin the women strips away the veneer of polite society. Everything is topsy-turvy. The hostess is clearly dismayed by the rowdiness and lewdness of the tipsy gentlemen who bear down upon the women. Coffee is spilled, propositions made and deals transacted. The children rolling on the floor are oblivious to the antics of their elders.

Rowlandson frequently depicted pretty, but impecunious, young women harnessed to unattractive but wealthy old men. The licentiousness of the period was epitomized in the lifestyle of the prince regent, and the couple on the left recalls Rowlandson's portrait from the 1790s of *Mrs. Fitzherbert and the Prince of Wales* (Museum of Fine Arts, Boston), in which the enamoured prince gazes longingly up into the face of his mistress.

Variations in the etching suggest that it was created for a different market than the more refined watercolour. The line is broadly etched, the hand-colouring is vivid; in addition, the poses of the figures are more awkward, the facial expressions less telling, coffee now splashes down the vest of a portly man, and the little boy's genitals are exposed. The scene has been transformed into a full-blown burlesque. This comparison is revealing, and emphasizes the difference between Rowlandson the draftsman and Rowlandson the printmaker.

BR

fig. 1:
Thomas Rowlandson
Miseries Personal
1807
hand-coloured etching
28.0 × 38.5 cm
Beinecke Rare Book and Manuscript Library,
Yale University, New Haven, Conn.

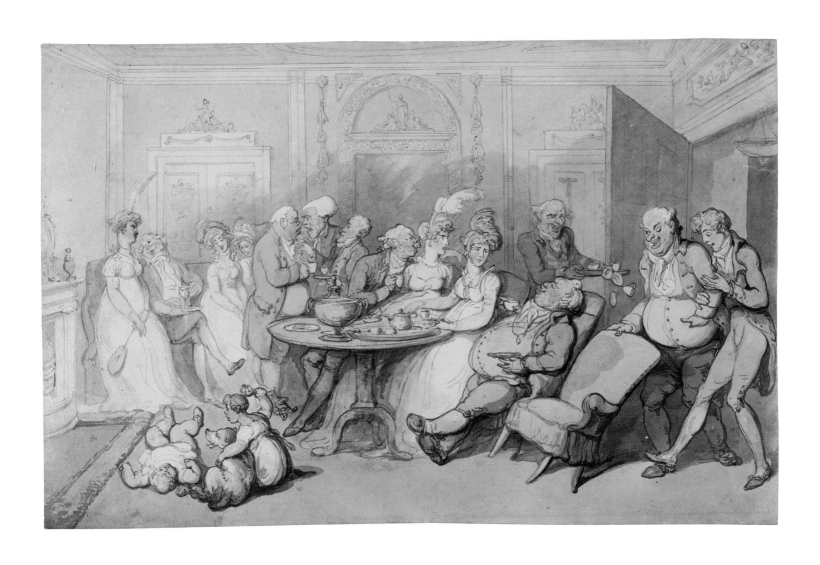

53 JOSEPH MALLORD WILLIAM TURNER

London 1775–1851 Chelsea

Stormy Landscape with a Rainbow, c. 1824

Watercolour on wove paper
19.6 × 27.0 cm
Purchased in memory of Alan Flacks, 1999
99/522

Joseph Mallord William Turner, the leading landscape painter of the romantic era, was a daunting talent and one of the most renowned artists of the nineteenth century. He adopted the watercolour medium early in his career when learning to paint topographical subjects. He gradually liberated himself from the strictures of the eighteenth-century topographical genre and distanced himself from conventional codified methods of painting in watercolour. This allowed him to explore fresh emotional terrain and to introduce a freedom of approach and a range of heightened colour that stunned and mystified both his colleagues and his audiences.

Turner, like his contemporary, the landscape painter John Constable (cat. 54), fully understood that the appearance of nature constantly changes. This sheet demonstrates the free and energetic handling of Turner's mature watercolour style. In this fresh and unfinished work, the artist captures and dramatizes the sublime effects of a passing storm. The impulsive, broken brushwork, with its range of greys suggesting misty land and turbulent sky, is complemented by the defined arc of the luminous rainbow cutting a momentary bright swath through the gloom, promising, it would seem, better weather.

At the time this watercolour was painted, Turner was investigating the science of colour and light. Indeed, in 1822, shortly before this work was created, he declared his interest in the possibility that through optics he could increase the brightness of his landscapes. He had heard of recent optical experiments by the physicist David Brewster, who had concluded that there were only three prime colours in the spectrum – red, yellow and blue – not seven as Newton had postulated. This lent legitimacy to what Turner and other artists had long believed, and reinforced their conviction that all hues in nature derive from these three.[1]

The rainbow in Turner's watercolour is similar to those in his other works in that it is composed of these three primary colours, not the full spectral sequence. A broad band of pale yellow is enclosed on its outer edge by a line of red and, on its inner side, by one of blue.

This sheet is related to drawings identified by Turner as "Colour Beginnings," many of which date from between 1820 and 1830. It was probably executed as an *aide-mémoire*, a rapidly limned exploratory study that he could later consult. Although it has the incomplete character of a work created on the spot, it likely was not. Turner usually prepared watercolours in the privacy of his studio or at his lodgings when travelling.

The sketchbook (now dismantled) that originally contained this sheet was given by the artist in 1836 to his patron, close friend and sketching companion, H.A.J. Munro, the Scottish landowner whose developing artistic talent Turner gently encouraged.

Stormy Landscape with a Rainbow is one of a relatively small number of drawings by the artist not held by the Turner Bequest, Tate Britain, London.[2] GF

54 JOHN CONSTABLE

East Bergholt, Suffolk 1776–1837 Hampstead
Bow View of H.M.S. Victory in the Medway, 1803

Graphite on laid paper
25.5 × 20.5 cm
Watermark: post horn
The Thomson Collection, gift, 2003
2004/65

Like his contemporary, J.M.W. Turner, John Constable exercised a transforming influence on French art and is seen as a precursor of French romanticism and impressionism. Unlike Turner, however, he never left England and was devoted to the study of the scenery in the vicinity of his birthplace, East Bergholt, in Suffolk. His interest in working from nature and portraying meteorological effects led him to be dubbed a "naturalist."

Constable has long been admired for the unparalleled freshness and brilliance of his small but sprightly pencil sketches.[1] Drawings and paintings of marine subjects are, nevertheless, relatively rare in his work. He made his only sea voyage in late spring of 1803, on board the *Coutts*, an East Indiaman travelling from Chatham to Deal. He wrote to his friend John Dunthorne, "I was nearly a month on board, and was much employed in making drawings of ships in all situations."[2] He made approximately 130 drawings at this time, including a group now in the Victoria and Albert Museum.[3] In their spontaneity and economy of line, they have been compared in style and subject to the masterful pencil drawings of the seventeenth-century Dutch marine artist Willem van de Velde the Younger.

Constable reported to Dunthorne on 18 April 1803 that "when the ship was at Gravesend, I took a walk on shore to Rochester and Chatham. At Chatham I hired a boat to see the men of war, which are there in great numbers. I sketched the 'Victory' in three views. She was the flower of the flock, a three decker of (some say) 112 guns. She looked very beautifull [*sic*], fresh out of Dock and newly painted. When I saw her they were bending the sails – which circumstance, added to a very fine evening, made a charming effect."[4]

HMS *Victory* is one of the most celebrated battleships in history. Originally launched in 1765, by 1803 it had just gone through a three-year refit. Already the flagship at several naval triumphs, its most celebrated moment at the Battle of Trafalgar, the defining British naval victory of the Napoleonic Wars, was still two years away. Of the three sketches Constable made from different angles, this "bow view" most vividly suggests the majesty and monumental presence of the ship, which fills the sheet vertically and towers over a smaller boat below.[5]

A few days after completing the three sketches of the *Victory* (fig. 1), Constable was forced to flee and abandon his drawings when the *Coutts* ran into a storm. They were, fortunately, retrieved and used as studies for the watercolour *His Majesty's Ship, Victory, Capt. E. Harvey, in the Memorable Battle of Trafalgar, between Two French Ships of the Line*, exhibited at the Royal Academy in 1806 (fig. 2). They subsequently disappeared once again and only turned up recently in the collection of a descendant of the artist.[6] BR

fig. 1:
John Constable
Stern View of H.M.S. Victory in the Medway
1803
graphite on laid paper
25.5 × 20.5 cm
Art Gallery of Ontario, Toronto, The Thomson Collection, gift, 2003 (2004/66)

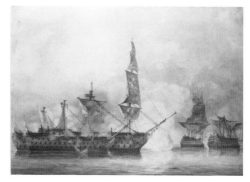

fig. 2:
John Constable
His Majesty's Ship, Victory, Capt. E. Harvey, in the Memorable Battle of Trafalgar, between Two French Ships of the Line
1806
watercolour
51.5 × 73.5 cm
Victoria and Albert Museum, London (169-1888)

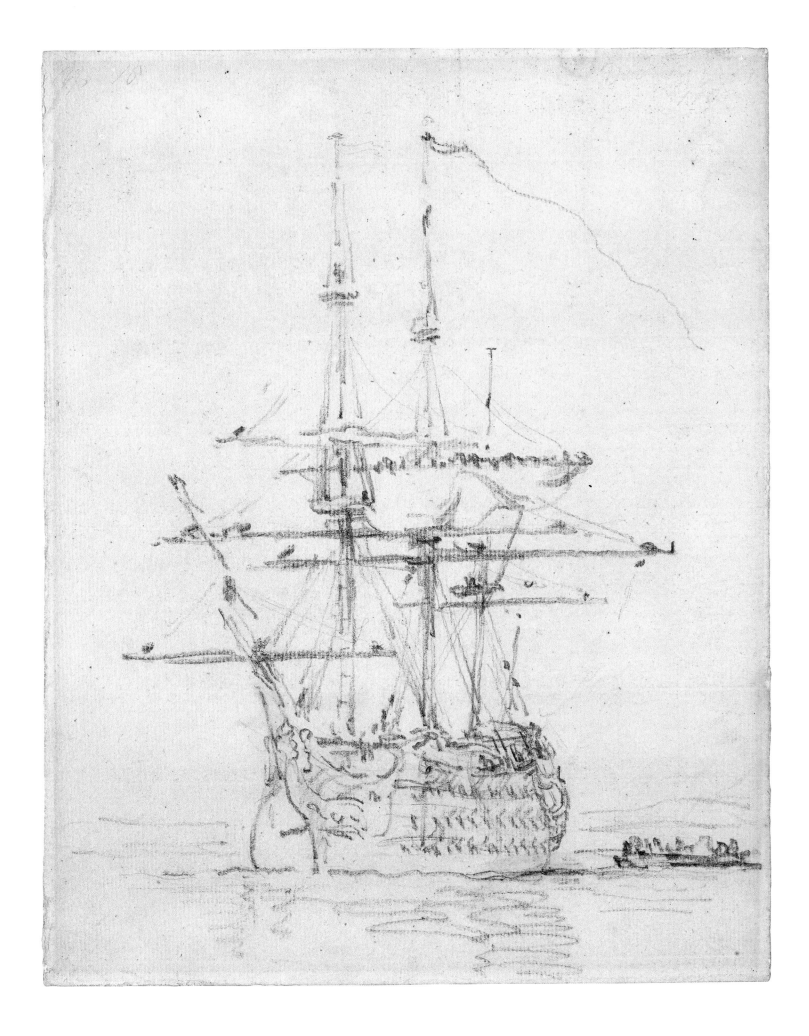

55 JOHN SELL COTMAN

Norwich 1782–1842 London

Rustic Cottage, c. 1810

Watercolour over graphite on wove paper
30.2 × 24.5 cm
Signed l.l.: *J.S.Cotman*
Inscribed l.r.: *847*
Purchased in memory of Alan Flacks, 1989
88/174

A leading figure in British watercolour of the romantic era and of the Norwich school, John Sell Cotman is increasingly valued today both for his *Greta* drawings of 1805–08 in which naturalism verges on arabesque, and for his originality of style in which flat washes take on an architectural finality. Following a series of disappointments in London, he was drawing master in his native Norwich from 1806 to 1812.

Scenes with cottages, often derelict yet without suggesting misery, were favoured by British artists who engaged with the aesthetic of the picturesque. Such themes also spoke to the nationalist and inward-looking political climate of Britain during the Napoleonic Wars, when continental travel was all but impossible. Domestic subjects, as in the present drawing, were frequently exhibited by the Norwich Society of Artists.

Although this cottage is generic to the region in its lath-and-plaster construction, tiled roof and brick chimney stacks, its representation nevertheless borders on fantasy. Against the structure's blond face, a curious tribune rests unevenly on a porch roof unsupported by posts or brackets. Theatrical, seemingly without purpose, it frames an opening through which fabric on a line appears as a crimson wash, its angle mimicking that of a door standing ajar to the left. On the right, beside a wherry's sail, a trapezoidal wash of blue braces the slant of the cottage, set off above by massed foliage. By including a girl whose profile is invisible, and who appears to rock another person, the work seems poised between familiarity and detachment.

Cotman adopted a scheme recently introduced by the London publisher and drawing school proprietor, Rudolph Ackermann. Cotman's proposal to personally deliver and supervise the copying of his drawings was a novelty in Norwich. By 5 July 1809, according to Cotman's press announcement, the first six hundred drawings were ready to circulate by subscription.[1]

Cottage scenes recur in Cotman's circulating collection. Numbered 847, the Toronto watercolour appears to be close in date to number 823, *Fisherman's Cottage, Thorpe*, in the British Museum (BM; Inv. no. 1902.5.14.25). Also made in Thorpe, a suburb of Norwich, its ladder-like stairs – which cast a stile-shaped shadow – and its quirky asymmetrical gable invite comparison with the BM drawing.[2]

Cotman's impulse toward the fantastic as it was translated into colour in domestic subjects at this time may argue for his affinity with the Venetian settecento. Harmonies of yellow, red and blue, with such fancies as the vacant tribune, might find their nearest correspondence in the fantasies of a Marco Ricci or Domenico Tiepolo. Cotman may have remembered seeing eighteenth-century Venetian paintings among the Orleans pictures in London in 1798–99, or subsequently in private collections. AE

56 PETER DE WINT

Hanley, Staffordshire 1784–1849 London

An Oxcart on a Country Road, c. 1820

Watercolour and gouache over graphite with scraping out on wove paper
33.7 × 47.2 cm
Purchase, 1983
83/255

Peter De Wint was a leading figure in the evolution of British watercolour, renowned for his picturesque landscapes and technical innovation. He was a prolific artist, had many students and followers, and rarely signed and dated his works, claiming that his style was unique and that his works were "signed all over."[1] The chronology of his development has yet to be fully unravelled.

De Wint's father, a doctor, hoped that his son would follow in his footsteps. Peter, however, was "determined to become an artist, having, from earliest childhood, been passionately fond of drawing."[2] As a young man he was apprenticed to the prominent engraver John Raphael Smith. Recognizing that De Wint's talents lay outside the field of engraving, Smith released him after four years in exchange for eighteen oil paintings. After going to the Royal Academy schools, De Wint was drawn into the circle of Dr. Thomas Monro and became familiar with the watercolours of both J.M.W. Turner and Thomas Girtin. Dr. Monro was a noted collector, connoisseur and mentor to a generation of young watercolour painters. De Wint's debt to Girtin may be seen in his sweeping panoramas and muted colours applied with broad, fluid brush strokes.

Like his friend Constable (cat. 54), De Wint preferred rural subjects. He was particularly fond of the Midlands and toured Staffordshire and Lincolnshire in search of picturesque views, often selecting rustic, unkempt woodlands and fields into which he inserted genre elements. Both the subject matter and the composition of *An Oxcart on a Country Road* bring to mind the paintings and drawings of De Wint's predecessor Thomas Gainsborough (cat. 46), whose work he would have seen exhibited in London by 1810.[3] The bird's-eye view of a small wagon winding its way down the side of a hill is a subject and format frequently employed by Gainsborough.

This sheet demonstrates De Wint's distinctive hand and mature style. As Kim Sloan has observed, "The unelevated subject, the introduction of the cart on the road, and the careful working with broken and dragged brush strokes over areas of solid wash, are all De Wint's signature."[4] Employing his characteristically muted palette, the artist has created a sense of atmosphere and luminosity, in part by sponging and scraping away paint with the end of his brush. The spontaneity of this watercolour is typical of De Wint, who was able to capture both the appearance and the feeling of the natural landscape.

De Wint was much admired by his contemporaries, including Constable, who purchased one of his watercolours, and Samuel Palmer (cat. 62), who made a note to himself in 1850 to seek a "new style . . . instead of aiming at finish . . . Try something like the solid BLOCKS of sober colour in De Wint."[5] BR

57 BENJAMIN ROBERT HAYDON

Plymouth 1786–1846 London

Head of a Young Man

Black chalk heightened with white gouache on buff wove paper
37.8 × 30.4 cm
Purchased with funds donated by AGO members, 1991
91/151

Benjamin Robert Haydon remains one of the most complex and tortured figures in nineteenth-century art. He was a passionate romantic, fought the art establishment and finally killed himself in despair after losing a competition for the design of a mural for the Houses of Parliament.

A devoted classicist, Haydon aspired to revive history painting in Britain. He was convinced that this could only be accomplished by studying anatomy like the Ancients and the masters of the Renaissance. He spent two years at the Royal Academy under the tutelage of Henry Fuseli (cat. 48) and others, and countless hours drawing after the Raphael cartoons in the Royal Collection and the newly arrived Elgin Marbles. While this head does not match any of those in the Elgin, its angular features and hard surface effect may have been inspired by the experience of drawing cold marble by candlelight in the Egyptian Hall in Piccadilly.

Although Haydon's arrogant and eccentric personality and his overly ambitious projects made him a target of mockery,[1] he was much admired as a draftsman. His powerful grasp of anatomy can be seen in this meticulously sculpted head. The heroic nobility he so desperately sought can be found in the arresting facial expression, which bears a striking resemblance to the figure of "hatred" in Charles Le Brun's widely used text on the passions. Haydon's drawing and Le Brun's illustration share the features of an intense stare, closely knit eyebrows and a tense, lowered, closed mouth. The pose of a head turned over the right shoulder is another similarity.[2] The finish of the Haydon head, with its flying locks, unnatural torsion and dramatic highlights, stands in marked contrast to the slightly sketched torso.[3]

Haydon often used his own face as the basis for his ideal figures. This head – with its long, slightly hooked nose, wavy hair, high forehead, wide eyes and strong cheekbones – closely resembles his own as well as a drawing for the head of Macbeth (c. 1809–11) based on his own face. By 1840, however, Haydon was no longer the handsome youth depicted here, and he would have had to work from early sketches rather than from life.

This is thought to be a preparatory drawing for one of the artist's large-scale historical paintings. Kim Sloan has suggested a possible link with the head of Uriel in *Uriel and Satan* (1845).[4] SP

58 WILLIAM TURNER of OXFORD

Black Bourton 1789–1862 Woodstock

Bournemouth Common, 1830s–1840s

Watercolour, gouache and gum arabic over graphite on wove paper
34.5 × 35.9 cm
Signed l.r.: *W. Turner: Oxford*
Inscribed on verso: *Bournemouth Common Wm Turner*
Purchase, 1985
85/77

William Turner left Oxford in 1804 for London, where he was apprenticed to the leading teacher of watercolour, John Varley. After being acclaimed by his master and voted a full member of the Old Watercolour Society in 1808 at the age of eighteen, he returned to Oxford, where he spent the rest of his life teaching. He adopted the nickname "of Oxford" to distinguish himself from his famous contemporary J.M.W. Turner (cat. 53), and continued to submit works for exhibition to the Old Watercolour Society in London.

Turner became known for landscape watercolours executed on his travels throughout the British Isles. He first visited the area around the Isle of Wight and Bournemouth in 1835. Situated on the south coast of Dorset, the seaside town was just beginning its mete-oric rise as a tourist destination. The rugged coastline was split by deep ravines, called chines, which opened out onto the sea, and the shore consisted of a wild stretch of heath that followed the sweeping curve of Poole Bay.

This work belongs to a group of watercolours executed between 1830 and 1840 that are exceptional for their careful observation of nature and bright colour. The minutely delineated shrubbery in the foreground would have greatly appealed to the leading art critic, John Ruskin (cat. 64), who commended Turner's truth to nature and became his principal advocate.[1] Here Turner employed his glorious and distinctive combination of blues, pinks and mauves[2] and gave the watercolour surface sparkle by finishing it with brilliantly coloured strokes of gouache.[3]

Close observation of nature is central to this work and is underscored by the inclusion of the standing and reclining figures who observe ships on the horizon. This leisure activ-ity reflects the transformation of the local economy as railways and hotels began to bring tourists in increasing numbers to the seaside town. Partly subsumed by haze, the ships, under steam and sail, draw attention to the larger world of trade and commerce, the phe-nomenal growth of which connected Britain to the farthest-flung corners of the globe at the height of the Victorian age. It is through such associations that Turner of Oxford gave his landscape subjects greater significance.[4]

Although Turner began as a member of the first generation of British watercolourists, he was preoccupied by the questions that interested the most progressive artists of the Victorian era. He abandoned the eighteenth-century landscape conventions and created long panoramic views that have more in common with early photography. He daringly placed his horizon line halfway up the picture space and constructed his composition parallel to the picture plane. The superimposition of gouache in the foreground over transparent wash in the background creates a sense of recession.

By abandoning one point perspective and moving toward a bi-dimensional picture space, Turner of Oxford anticipated the Pre-Raphaelite landscapes of the 1860s[5] and the aesthetic landscapes of James McNeill Whistler and his followers, such as Philip Wilson Steer. KL

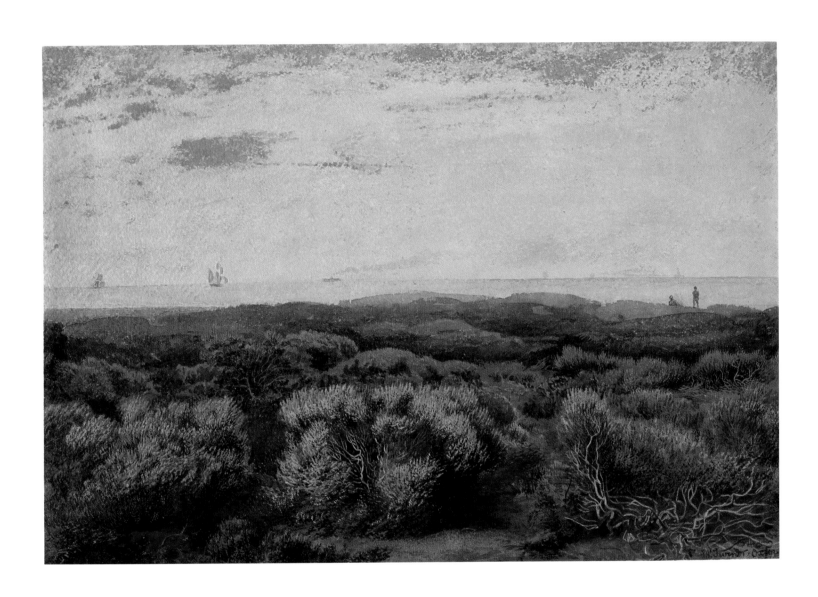

59 JOHN LINNELL

London 1792–1882 Redhill

Eve Offering the Forbidden Fruit to Adam, early 1830s to 1835

Pen and brown ink and watercolour heightened with body colour over graphite on wove paper
20.9 × 16.2 cm
Purchased as a gift of the estate of Esther Gelber, 1986
86/189

John Linnell was assisted by Benjamin West in entering the Royal Academy schools in 1805, where his teachers included Flaxman (cat. 51), Turner (cat. 53) and Fuseli (cat. 48). The son of a frame maker, Linnell employed oil paint sparingly because of the cost, and used watercolour as an aid to oil painting.

In 1811 Linnell underwent a religious crisis and left the Anglican Church for the Baptist Church. His system of belief was based on William Paley's *Natural Theology*, in which nature is seen as God's creation, and its organizational design as proof of God's existence. He sought to create a contemporary Protestant iconography by setting biblical subjects in the English countryside and gave his landscapes a spiritual dimension through heightened realism and visionary intensity.

After meeting William Blake in 1818, Linnell spent hours debating religious issues with him. He helped Blake financially by commissioning engravings and purchasing his drawings and watercolours. He also took a promising young artist, Samuel Palmer (cat. 62), under his wing and mentored him from 1822 to 1824 before finally introducing him to Blake. In 1825 Linnell purchased three of Blake's *Paradise Lost* watercolours,[1] which so deeply impressed Palmer that, in 1826, he made an oil sketch of *Adam and Eve* incorporating Blakean figures.[2] Linnell's introduction of Palmer to Blake inspired the formation of a group of visionary landscape artists called the Ancients, who settled at Shoreham in Kent and looked to Blake as a leader.

After Palmer moved to Shoreham, Linnell commissioned him to make detailed watercolours after nature. The most remarkable featured the "magic" apple trees that turned Shoreham into a veritable Garden of Eden in spring. Linnell loved Shoreham and visited three times in 1828–29 to sketch with Palmer.[3] In 1835 their relationship terminated abruptly when Palmer told Linnell that he had fallen in love with his daughter Hannah. Although Linnell had originally encouraged this romantic attachment, he was a stern patriarch and unable to let go of his daughter. His rejection of the young couple inaugurated a family feud that persisted for at least two more generations.

This watercolour, dated c. 1835, may be linked to Palmer's announcement. It is full of thinly veiled biographical details. The Garden of Eden resembles Shoreham, and the apple tree those found in Palmer's celebrated gouaches of 1829–30. Adam's head resembles Palmer's[4] and his full-length profile pose with hand outstretched recalls Blake's figure of God in *The Creation of Eve* that Palmer had so greatly admired in Linnell's collection.[5]

By the 1860s Linnell was one of the foremost landscape painters in Britain. He scarcely parted with his studies in oil or watercolour, and prized this one. On 10 December 1860 it was sent on approval to the brothers Louis and C.F. Huth. Louis wrote the next day, "My brother wishes me to say that he admires your drawing of Adam & Eve very much, but that he cannot afford to give the price asked."[6] The drawing was returned to the artist on 15 December. KL

60 FRANCIS DANBY

near Wexford, Ireland 1793–1861 Exmouth, Devon

The Avon Gorge with Clifton and the Hotwells, Bristol, c. 1820

Watercolour and body colour over graphite on wove paper
44.7 × 80.5 cm
Purchased in memory of Alan Flacks, 1997
97/180

Although Francis Danby was born in Ireland, travelled to Scandinavia and lived in London, he is best known for his central role in the Bristol school of artists. This consisted of a small group of professionals and amateurs who began, around 1820, to meet in each other's houses to draw and converse. They undertook sketching expeditions in the vicinity of the spectacular Avon Gorge that Fuseli considered "the finest scenery in the Kingdom, sublime &c."[1] Inspired by its combination of picturesque woods and downs and spectacular views, Danby used his professional training to pursue inventive ways of depicting the Gorge, prompting other members to follow suit.

This large panoramic watercolour, with its extraordinary palette and meticulous, almost surreal detail, is one such work. As Andrew Wilton has noted, in this and similar watercolours and oils, Danby "combines breadth of vision with the ability to invent ravishing detail – the two ships passing in the shadow of the rock, for example – so that the scene is presented with a vivid realism that makes the natural drama breathtaking."[2] The ships, sailing upriver toward Bristol, are just about to pass the Hotwells (a spa on the edge of the river) below Windsor Terrace. On the left the evening sun catches the tower, and on the right, the upper slopes of Nightingale Valley. Once a snuff mill, the tower was used after 1828 as a studio by William West, another member of the Bristol school. There he installed a panoramic camera obscura that is still in working order. Isambard Kingdom Brunel's great Clifton Suspension Bridge was erected across the gorge at this point a few decades later.

In this watercolour the woods in the foreground almost obscure the panoramic sweep of the gorge. The trees, rocks and bracken are executed with a variety of techniques – sponging, dabbing out and the use of gum arabic – to achieve effects not matched until the emergence of the Pre-Raphaelite landscapists forty years later. The detailed recording of the geology of the cliffs also anticipates their work, particularly the watercolours of their mentor John Ruskin (cat. 64). Like Ruskin's works, Danby's watercolour celebrates and inspires meditation upon the wonders of the Creation.

This work was painted during an era in which large-scale watercolours employing deep colour and, at times, gouache, competed with oil paintings. It was designed to be hung on the wall rather than stored in a portfolio like smaller works. The sky has faded slightly as a result of light exposure, a common problem with such watercolours.

Danby later lived in London, exhibiting enormous history paintings that competed with the spectacular works of John Martin at the Royal Academy. Yet it was his earlier watercolours and smaller oils of the picturesque and sublime landscape around Bristol that endeared him to local artists and patrons, and that constitute his legacy to the British school of landscape painting. KS

61 RICHARD PARKES BONINGTON

Arnold 1802–1828 London

Dutch Fishing Vessels near the French Coast, 1825

Watercolour over graphite with scraping out on wove paper
23.9 × 17.8 cm
Signed and dated l.r.: *RPB 1825* (cropped)
Gift of W.B. Dalton, Stamford, Connecticut, and the United Kingdom, 1961
60/12

Richard Parkes Bonington was one of the leading exponents of British watercolour and a key player in the artistic exchange that flourished between England and France in the wake of the Napoleonic Wars.[1] Born near Nottingham, he moved with his family to Calais in 1817. Although he died of tuberculosis just days before his twenty-sixth birthday in September 1828, his artistic output was prodigious.

Bonington studied in Calais under Louis Francia, who had trained in Britain and encouraged the young man's preference for watercolour and for marine subject matter. In 1818 Bonington moved to Paris, making it his home base. There he met the young French artist Eugène Delacroix while copying old master paintings in the Louvre.[2] By the early 1820s Bonington was an accomplished watercolourist, oil painter and lithographer, with a wide repertoire of subjects including landscape and marine views, picturesque representations of medieval architecture, and scenes from British history and literature.

In July of 1825, to escape the unbearably high temperatures in Paris, Bonington went to one of his favourite retreats on the coast near Dunkerque and Saint-Omer, where he was joined by fellow artists, probably including Delacroix. *Dutch Fishing Vessels near the French Coast* was painted at this time.[3]

The subject and unusual vertical format of the watercolour suggest the artist's familiarity with Dutch marine painting and battleship images in vertical formats by the famous van de Velde family who had worked in England a century earlier.[4] In addition, Bonington may have been thinking of J.M.W. Turner's paintings of ships, which he had seen in London that same summer in the collection of Walter Fawkes.[5]

As spontaneous and "on-the-spot" as his watercolour appears, Bonington was aware of compositional devices traditionally used in marine paintings. The image assumes a low vantage point, creating the sense that the viewer is in a small boat looking up at the ship. Seagulls flying over the foreground waves lead the viewer's eye into the scene. The low horizon line and another ship shown in the middle distance give a sense of depth, and most of the space is given over to the moving sky and clouds and the principal fishing vessels.[6]

Starting with the slightest of pencil sketches, Bonington displayed his versatility by employing both wet washes and a dry brush to create texture and atmospheric effects. His ability to suggest the swell of the sea, the wind, spray and fleeting sunlight give this work a freshness and naturalism that was rivalled only by Turner (cat. 53) before the advent of impressionism. In 1861 Delacroix wrote, "No one . . . has possessed that lightness of touch which, especially in watercolours, makes [Bonington's] works a type of diamond, which flatters and ravishes the eye, independently of any subject and any imitation."[7] BR

62 SAMUEL PALMER

London 1805–1881 Redhill

Sunset, c. 1879

Watercolour, gouache and egg tempera over graphite, heightened with gum arabic,
with scraping out on wove paper, laid down on pasteboard
15.7 × 24.5 cm
Signed in watercolour l.r.: *S. PALMER*
Inscribed on verso of mount in graphite: *Never suffer the card board to/be thinned
by taking away the paper/from the back. S.P.*
Purchase, 1979
79/44

A turning point in Samuel Palmer's early career occurred in 1822, when he met John
Linnell (cat. 59), an artist thirteen years his senior who became his mentor first and ulti-
mately his domineering father-in-law. An even more profound epiphany took place two
years later when Linnell introduced Palmer to the visionary poet and artist William Blake,
whose little wood-engraved landscapes for Thornton's *Pastorals of Virgil* (1821) had
a major influence on his art. Soon Palmer was the leader of a group of Blake's young
disciples, including George Richmond and Edward Calvert, who paradoxically called
themselves "Ancients" and found their "Valley of Vision" at Shoreham in Kent (around
1825 to 1835).

Profoundly religious, saturated with literature, under the spell of Blake and ec-
statically responsive to nature, the young Palmer recorded, mostly on paper, one
extraordinary vision after another during his magical years in Shoreham. After such
a sustained burst of creativity, as intense as van Gogh's shorter stay at Arles and Saint-
Rémy – both artists became famous for their starry nights – one either shoots oneself, as
van Gogh did, or comes down to earth, lowers the expressive temperature and continues
painting very well indeed, as Palmer did for almost another fifty years.

During his honeymoon visit to Italy in 1837–40, Palmer was already producing
watercolours that featured many of the same compositional elements found forty years
later in *Sunset*: a darkened foreground with figures and animals receding into the dis-
tance, light glinting on a pool of water, a framing tree silhouetted at the right, turrets and
buildings in the middle ground, and the whole bathed in the light of a sunset sky.[1] Such
pictures belong to the grand classical tradition of British landscape, which derived from
the seventeenth-century French artist Claude Lorrain, whom Palmer revered, and culmi-
nated with J.M.W. Turner (cat. 53), whom Palmer admired. For the rest of his life, Palmer
was a card-carrying member of this distinguished tradition of idyllic pastoral landscape,
choosing watercolour and etching as his preferred media and becoming a staunch mem-
ber of both the Old Water-Colour Society and the Etching Club.

The last decades of the artist's life were devoted to two projects very near his heart:
watercolours suggested by passages from Milton's *L'Allegro* and *Il Penseroso* (fig. 1), and
drawings and etchings illustrating his own translation of Virgil's *Eclogues*. What these
works have in common with *Sunset* is that they are all landscapes of the mind, idealized
visions of nature composed according to the Lorrain or Turner pastoral tradition, not top-
ographical depictions of real places. The large Milton watercolours are bravura exhibition
pieces in which Palmer pushed the medium to the very limits, employing a complex mix-
ture of techniques seen also in *Sunset* with its darkly glowing colours, elegiac mood and
striking sky effects. In fact, Palmer became notorious for the "chromatic madness" of his
sunsets and sunrises.[2] The crescent moon, appearing in the sky in the upper left corner,
had been a favourite motif since his Shoreham days. DES

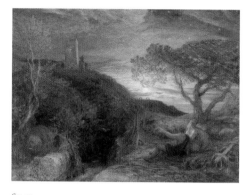

fig. 1:
Samuel Palmer
The Lonely Tower
1867–68
watercolour and body colour
51.0 × 70.5 cm
Yale Center for British Art, New Haven, Conn.,
Paul Mellon Collection (B1977.14.147)

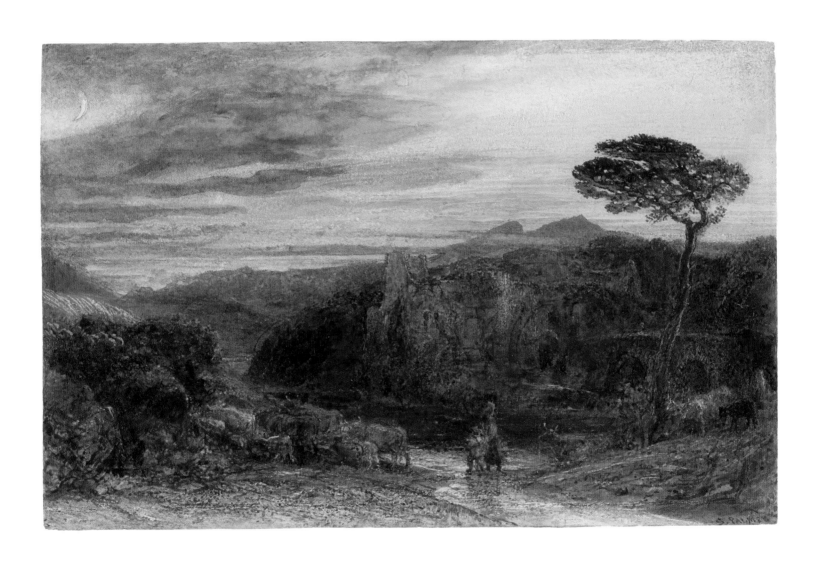

63 DANIEL FOWLER

Champion Hill 1810–1894 Amherst Island, Ontario

Cactus, 1875

Watercolour and graphite on wove paper
48.8 × 34.8 cm
Signed and dated l.r.: *D. Fowler 1875*
Gift of Sir Edmund Osler, 1918
596

Fowler studied watercolour in England in the early 1830s under James Duffield Harding, John Ruskin's drawing master, before emigrating to the Province of Canada in 1843. He purchased a farm, "The Cedars," on Amherst Island, which is situated on Lake Ontario. After a hiatus of more than a decade, Fowler began painting in earnest in 1858.

Drawing inspiration from the works he saw in his youth, Fowler frequently employed the rich palette and popular subjects seen in Victorian watercolour society exhibitions: dead game, landscapes and flower studies. A close observer of nature, he combined science with art to reveal the beauty he found in it. He would search Amherst Island for a perfect bloom to paint, returning to a chosen site each day until his painting was complete.

At this time, public and private conservatories (or glasshouses) were growing in popularity in Britain and the colonies, reaching a peak during the second half of the nineteenth century. Plant-hunting expeditions filled the new glass and iron structures with rare and tropical species that were arranged, according to fashion, in increasingly naturalistic settings.[1] Fowler travelled regularly to Toronto for exhibitions, including those of the Ontario Society of Artists and the Royal Canadian Academy of Arts. These trips also provided him with the opportunity to visit Toronto's Horticultural Gardens (renamed Allan Gardens in 1901). There he was able to indulge his Victorian penchant for exotic plants. It was, in fact, an associate of George Allan, prominent Toronto businessman Sir Edmund Osler, who gave this watercolour to the Gallery.

The artist chose to paint the cactus on more than one occasion, beginning in 1873. Each time he delighted the critics, who lauded "his brilliant depiction of a cactus in full flower."[2] His method of layering transparent and opaque watercolour, based on the technique developed by the British watercolourist William Henry Hunt, gives *Cactus* its corporeal succulence.

This is one of the most sensual Canadian watercolours of the nineteenth century. It accurately details the night-blooming *Selenicereus grandiflorus*, a cactus distinguished by its fragrant blossoms that unfold after sunset and last only a single night. The bowl-shaped flowers, with salmon-coloured sepals and white petals, branch from the plant's climbing ribbed stems. It grows wild in thickets in rocky woods in Jamaica and Cuba, but is also found throughout Central and South America.

The artist presents *Cactus* in a vaguely "natural" setting, as if he had stumbled upon this horticultural gem in the woods at dusk, just as the sky was turning from indigo to black. The blooms, exploding over a darkened and abstracted background, are compellingly exotic. The painting conveys Fowler's Victorian imagining of "New Worlds" and their natural wonders waiting for artistic exploration. AH

64 JOHN RUSKIN

London 1819–1900 Brantwood

Study of a Feather, Flanked by Two Studies of a Gentian, 1875

Watercolour over graphite, heightened and corrected with opaque white,
on three conjoined sheets of wove paper, laid down
16.2 × 24.2 cm (overall)
Inscribed in graphite *l.l.*: *5 May 1875. drawn by J. Ruskin/1* [circled] *a lesson in form./*
2 [circled] *a lesson in colour./3* [circled] *sketch of feather.*; each panel numbered in graphite,
left to right: *1; 3; 2* [all circled]
Purchased in memory of Alan Flacks, 1991
91/118

John Ruskin, author of *Modern Painters* (1843–60) and *The Stones of Venice* (1851–53), champion of J.M.W. Turner (cat. 53) and the Pre-Raphaelites, and leading art critic of the Victorian age, was also a brilliant draftsman. Throughout his life he believed that everyone should be taught drawing, like arithmetic. To draw was to see, to learn and to love.

In 1854 Ruskin became drawing master at the Working Men's College in London, where he taught ordinary labouring men. When he was appointed first Slade professor of fine art at Oxford in 1869, he set up the Ruskin Drawing School there to teach every student. Following the publication of his book *The Elements of Drawing* in 1857, there was such a demand for private lessons that he had to hire an assistant. For home visits he charged five shillings a lesson, plus omnibus fare. The thirty-nine-year-old Ruskin originally met Rose la Touche, the ten-year-old girl with whom he fell hopelessly in love, through such a home visit. Correspondence courses could also be taken through the mail at two shillings a letter. Sample drawings would be sent to the student to copy and return by mail for a written critique.[1]

In this watercolour Ruskin demonstrated three steps in his progressive method by pasting three sheets together to form a mini drawing lesson for some unknown pupil. Bits of nature easily accessible to his students provided the subject matter. The neophyte was advised to begin with a stone from the road or garden: "Now if you can draw that stone, you can draw anything . . ."[2] Soon he or she would progress to leaves, one of Ruskin's favourite subjects. Flowers and feathers, however, were for more advanced students. Since shading without lines was Ruskin's preferred way of drawing, the pupil was asked to copy, as "a lesson in form," the gentian in monochrome grey wash (sketch 1). With practice the pupil could produce beautiful drawings in chiaroscuro, but mastery of colour required a lifetime's commitment. Sketch 2, "a lesson in colour," demonstrated what was eventually possible. In sketch 3, apparently of a shuttlecock composed of a piece of cork with feathers stuck in it, Ruskin showed first, on the left, how to lay in the form of the feather in beige and grey washes, and then, on the right, how to finish it minutely.

The gentian was one of Ruskin's favourite flowers, covering his beloved Alps in spring with its sky-blue colour. Although he wrote about it frequently, this is a rare, possibly unique depiction of it in his surviving oeuvre. He delighted in microscopically observed studies of feathers – kingfishers', hens', pheasants' and peacocks'. Such ardent attention to the tiny details of nature is a trait Ruskin shared with and admired in the Pre-Raphaelites. In view of the fact that Rose la Touche died on 25 May 1875, only twenty days after he made these sketches – sending him into paroxysms of grief and ultimately madness – one is tempted to read the triptych as an image of the fragility and transience of life. DES

5 May 1875. drawn by J. Ruskin
① a lesson in form.
② a lesson in colour.
③ sketch of feather.

65 EDWARD BURNE-JONES

Birmingham 1833–1898 Fulham, London

Ariadne, c. 1867

Watercolour and gouache with opaque white, heightened with gum arabic on wove (?) paper,
laid down to millboard (cover of Roberson and Company's "Solid Sketch Book"
with blue cloth covering still attached [label on verso of millboard])
39.9 × 22.1 cm
Inscribed in gouache u.r.: *ARIADNE*
Purchased in memory of Alan Flacks, 2007
2007/8

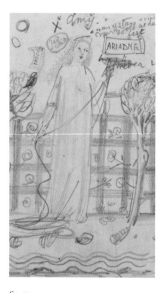

fig. 1:
Edward Burne-Jones
*Chaucer's Legend of Good Women:
Sketch Design for Needlework* (detail)
1863
pencil
26.6 × 36.2 cm
Birmingham Museums and Art Gallery
(1904P13 [56])

In choosing watercolour as his primary medium for the 1860s, Edward Burne-Jones was
following the practice of his friend and mentor Dante Gabriel Rossetti in the preceding
decade, explaining that the only lesson he had ever had was watching Rossetti paint
a watercolour.[1] In this way the torch was passed from a leading member of the original
Pre-Raphaelite Brotherhood to a leading member of the second generation. Burne-Jones
adopted both Rossetti's technique of opaque watercolour or gouache (the opposite of
fluid, transparent watercolour) and his figural subjects from literature (the opposite
of traditional landscape). When Burne-Jones began showing these unconventional works
at the Old Water-Colour Society in 1864, they provoked a storm of hostility, but critics
had to admit that they possessed an undeniable poetry unique to themselves.[2]

As fellow students in Oxford, Burne-Jones and William Morris discovered Chaucer,
who would remain a lifelong favourite.[3] In *The Legend of Good Women* the father of English
literature told the tales of ten classical heroines who had been "martyrs" for love. Burne-
Jones's first Ariadne (now lost)[4] was designed for a set of *Good Women* tiles (1861–62) for
the newly founded Morris, Marshall, Faulkner and Company. The same theme was also
proposed as an embroidery project for Ruskin in 1863, and a rough compositional draw-
ing shows Ariadne in the same pose as the present watercolour (fig. 1).[5] Like a Christian
saint with her attribute, Ariadne is depicted holding the ball of thread that she gave The-
seus so he could escape from the labyrinth, and standing on the wave-swept shore of the
island of Naxos, where he abandoned her. A watercolour of *Theseus and Ariadne*
(1861–62) is recorded, but its relationship to the present work is unknown.[6] When Burne-
Jones painted the large watercolour of another "Good Woman," *Lucretia* (1867), he
repeated the Ariadne pose and drapery, changing her attribute to a sword (fig. 2).[7] Com-
pared to the finished *Lucretia* with its title in real gold, *Ariadne* has the appearance of
a sketch, contributing to its undoubted charm. Burne-Jones gave it to Euphrosyne Ionides
Cassavetti, a member of the art-loving Greek community in London who became one of
his important patrons in 1866. Since many of her commissions involved portraits of her
daughter, Maria Zambaco, with whom he was to conduct a passionate love affair, it is
probable that he tried to reflect her features in *Ariadne*, an ancient Greek role model for
a beautiful but doomed modern Greek lady.[8]

In 1861 Burne-Jones painted a watercolour for Ruskin entitled *A Harmony in Blue*,
and indeed *Ariadne* could have been called *A Nocturne in Blue and Silver*, anticipating, as
it does, the formal concerns and colour harmonies of the "art for art's sake" aesthetic
movement of the 1870s.[9] When Whistler and Burne-Jones exhibited together at the open-
ing of the Grosvenor Gallery in 1877, they were hailed as leaders of the new
aesthetic craze.[10] Chaucer, in fact, related his story as a dream, and through these colour
harmonies Burne-Jones has hauntingly captured Ariadne in a veiled reverie. DES

fig. 2:
Edward Burne-Jones
Lucretia
1867
watercolour, body colour, pastel and gold on
paper laid on canvas
136.8 x 68.5 cm
Birmingham Museums and Art Gallery,
bequest of J.R. Holliday (1931P61 [B495])

66 EDWARD JOHN POYNTER

Paris 1836–1919 London
The Snake Charmer, 1866

Watercolour and gouache over graphite, heightened with gum arabic, on wove paper
45.3 × 32.6 cm
Inscribed in brown watercolour l.r.: *18 EJP 66*
Purchased with the assistance of the Department of Canadian Heritage under the terms of the Cultural
Property Export and Import Act, with the assistance of Sheldon Fish, and as a gift in memory of Alan
Flacks, 1995
95/127

After the birth in the mid-nineteenth century of Pre-Raphaelitism, which was violently anti-academic, the Royal Academy attempted to reassert its traditional leadership role in British art with the emergence of classicism in the 1860s, led by such future Royal Academicians as Frederic Leighton, Lawrence Alma-Tadema and Edward John Poynter. For Leighton and Poynter, both of whom would become presidents of the Royal Academy, the idealized nude figure was central to their art, which sought to recreate the glories of ancient Greece and Rome, often on a grand scale, in their ambitious history paintings.

As an academic artist trained in France, where his equivalent was Gérôme, Poynter had been preoccupied since the early 1860s with ancient Egyptian subjects, both in his book illustrations for *Dalziel's Bible Gallery* and his oil paintings. For three years he had been working on *Israel in Egypt*, which created a sensation at the Royal Academy in 1867. While completing this large historical machine, he got the idea of excerpting the figure of the dancing Nubian in the lower-right corner. Changing him from black to white, from male to female, from outside to indoors and from oil to watercolour, Poynter transformed him, with some adjustments of the head and arms, into *The Snake Charmer*. He retained the bright diagonal lighting that now illuminates the dark interior and casts dramatic shadows of the dancer on the floor.

Because the exhibitions of London's Royal Academy overwhelmingly favoured oil paintings, relegating watercolours to a limited and subordinate space, and because the two watercolour societies showed work only by their members, Poynter and Simeon Solomon (cat. 67) were among a group of serious watercolour artists who founded the Dudley Gallery in 1865 as an exclusive venue for watercolours, open to all without membership. It proved a great success and attracted many artists in the vanguard of the aesthetic movement before the Grosvenor Gallery opened in 1877. *The Snake Charmer* was Poynter's major exhibit at the Dudley in 1867. It was very appropriately located in the Egyptian Hall, a little bit of Luxor on Piccadilly. Rivalling an oil painting in its meticulous technique and finish, it received generally favourable reviews from the critics.

Living around the corner on Gower Street, Poynter could easily pop into the British Museum, a kind of visual encyclopedia for artists, where he sketched the granite lion for *Israel* and found the famous Egyptian stool with inlay that appears in the right background and again in a modified form to the left of the snake charmer.[1] Poynter's Egyptian pictures find a close parallel in the work of the Dutch artist Lawrence Alma-Tadema, whose *Pastimes in Ancient Egypt* won a gold medal at the 1864 Paris Salon and who would settle in London in 1870. As Egyptomania waned in popular taste, both artists would soon abandon the Nile for Greece and Rome.

This work remains in its original frame, which was designed by the artist. DES

67 SIMEON SOLOMON

London 1840–1905 London
Profile Head, 1890s

Watercolour and body colour on wove paper
27.2 × 21.5 cm
Purchase, 1980
80/85

Even as a student in the Royal Academy schools, Simeon Solomon had allied himself with the artistic rebels of the day, the Pre-Raphaelites. Soon he attracted the attention of Dante Gabriel Rossetti, the centre of a group of young disciples who would form the second generation of Pre-Raphaelites, including Edward Burne-Jones (cat. 65). For a time, Solomon became an intimate member of this circle, but tragic circumstances were soon to overtake him.

On 11 February 1873 Solomon and George Roberts were arrested in a London public urinal and charged with attempted buggery and indecent exposure, an event that ominously anticipates Oscar Wilde's trial and punishment more than two decades later. Wilde was, in fact, an admirer of Solomon's art and owned a number of his works. Although Roberts was sentenced to eighteen months' hard labour, Solomon got off with a fine of one hundred pounds.

The career of the precocious Jewish artist, however, who had exhibited at the Royal Academy and Dudley Gallery and had been a friend of Rossetti, Burne-Jones and Swinburne, was over, as far as proper Victorian society was concerned. Rejecting help from his family, Solomon chose the life of a vagrant, alcoholic and dissipated. Ironically he found a kind of refuge in the St. Giles Workhouse, just as another social outcast, Richard Dadd, found it in the madhouse; they were both free at last to be themselves and pursue their art unfettered by normal social constraints. Miraculously, considering the circumstances of their production, Solomon continued to make watercolours and drawings almost until the end of his life. The fact that Frederick Hollyer photographed for public sale more than two hundred of Solomon's drawings, including many late works, indicates that there was a considerable market for these icons of "the love that dare not speak its name."

Before 1873 Solomon's art moved from Old Testament scenes and illustrations of Jewish life and customs toward more Hellenic subjects like Bacchus or poetic allegories, often with homoerotic overtones. After 1873 by far the most common theme in his art was the androgynous head, either singly, as here, or paired with another – all showing sensuous, melancholy and introverted figures in a poetic dream world that is the artist's trademark. Solomon's sources for these heads may be traced through Burne-Jones to Leonardo, whose enigmatic, sexually ambiguous figures, shrouded in mysterious *sfumato*, had been so memorably described by the artist's friend Walter Pater in his famous essay "Leonardo da Vinci" (1869), collected in *The Renaissance* (1873). Solomon's late heads are usually executed in coloured chalks or, like this example, in layers of body colour or gouache built up with stippling and hatching. Untitled, unsigned and undated, the present work seems to have been produced toward the end of his life, probably in the 1890s. The head does not have any of the usual attributes that would allow identification as Christ or Apollo or an allegory. Although the artist-vagrant could scarcely have been aware of it, these now widely appreciated drawings belong to the same late-nineteenth-century pan-European tradition of symbolism as the work of Redon, Moreau and Khnopff. DES

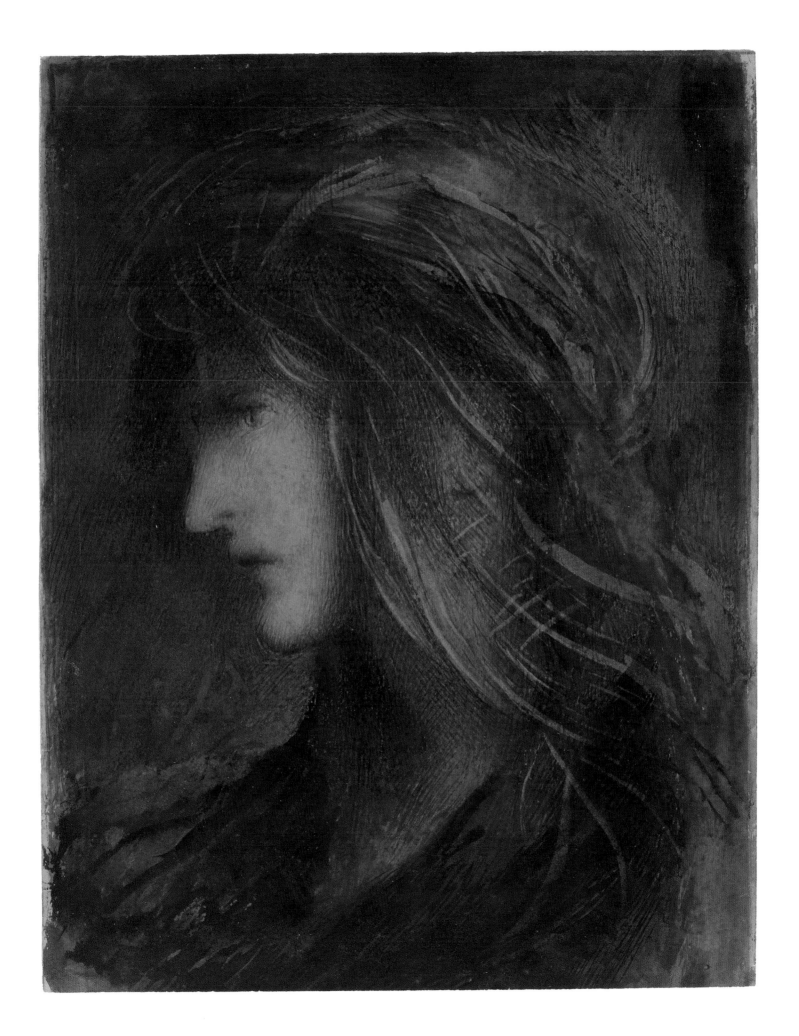

68 HELEN ALLINGHAM

Swadlincote 1848–1926 Haslemere

The Dairy Door, Farringford, Lord Tennyson's Home

Watercolour, gum arabic and scraping out on wove paper
27.8 × 21.7 cm
Purchased in memory of Alan Flacks, 1991
91/5

Helen Patterson attended the Royal Academy schools and the Slade School of Art in London and became a professional illustrator. She married the Irish poet William Allingham in 1874. Their artistic and literary circle included William Morris, John Ruskin (cat. 64) and the Pre-Raphaelites.

William introduced his young wife to the great poet laureate Alfred, Lord Tennyson. The Allinghams visited the Tennysons at their summer house at Farringford, a secluded and beautiful spot on the Isle of Wight. Tennyson loved rural life and, when he got up from his desk, would walk to the coast or work in the garden or fields. His surroundings were a constant stimulus to his imagination, and it was there that he wrote most of his best-known poems.

After the death of her husband in 1889 when she was only forty-one, Allingham's watercolours became the main source of family income. From Easter 1890, the Tennysons invited her to Farringford for holidays.[1] The watercolours of the house and garden represent a pinnacle of her career. Tennyson took great pleasure in watching her at her work. She later demonstrated her gratitude by producing a volume of colour reproductions of watercolours entitled *The Homes of Tennyson*, published in 1905.

Tennyson loved the kitchen garden, where "flowers encroach everywhere among the vegetables, and the apple trees rise amidst a parterre of blossom."[2] He visited it every morning "to read his meteorological gauges, and to prune and dig amongst the tree roses, for he was an avid gardener."[3] Helen found the green doorway, which always stood open[4] between the kitchen garden and dairy farm, so "pretty" that she painted it twice,[5] and used it here to frame the view of the delightful path that passed in front of the half-timbered dairy, just visible over the high brick wall.

Allingham's love of detail, her clear bright palette and ecstatic vision of nature follow in the tradition of the "Ancients," the Pre-Raphaelites and John Ruskin. The shift of focus in this work from hard to soft demonstrates her knowledge of photography and her appreciation of the aesthetic effects achieved by Julia Margaret Cameron, Tennyson's neighbour. Cameron asked Allingham to pose for her.

Allingham's work epitomized the much-reviled aesthetic of "prettiness" that was a Victorian reframing of the eighteenth-century idea of the "picturesque." Her jewel-like palette and idealized rural views evoked nostalgia for a vanishing way of life and spoke to contemporary concerns about urban pollution and the despoliation of the countryside. Her appreciation for vernacular architecture impressed adherents of the Arts and Crafts movement, leading to the acquisition and restoration of country cottages and gardens. Her name is synonymous today with images of thatched cottages flanked by perennial beds of the kind that were so greatly admired by her friend, the leading garden designer Gertrude Jekyll.

Allingham's vision of a simple life close to nature provided inspiration and a touchstone for renewal. Reproductions were carried to the farthest corners of the British Empire where they came to epitomize, for emigrants, the values of the life left behind. Her work has never been more popular, or more frequently reproduced, than it is today. KL

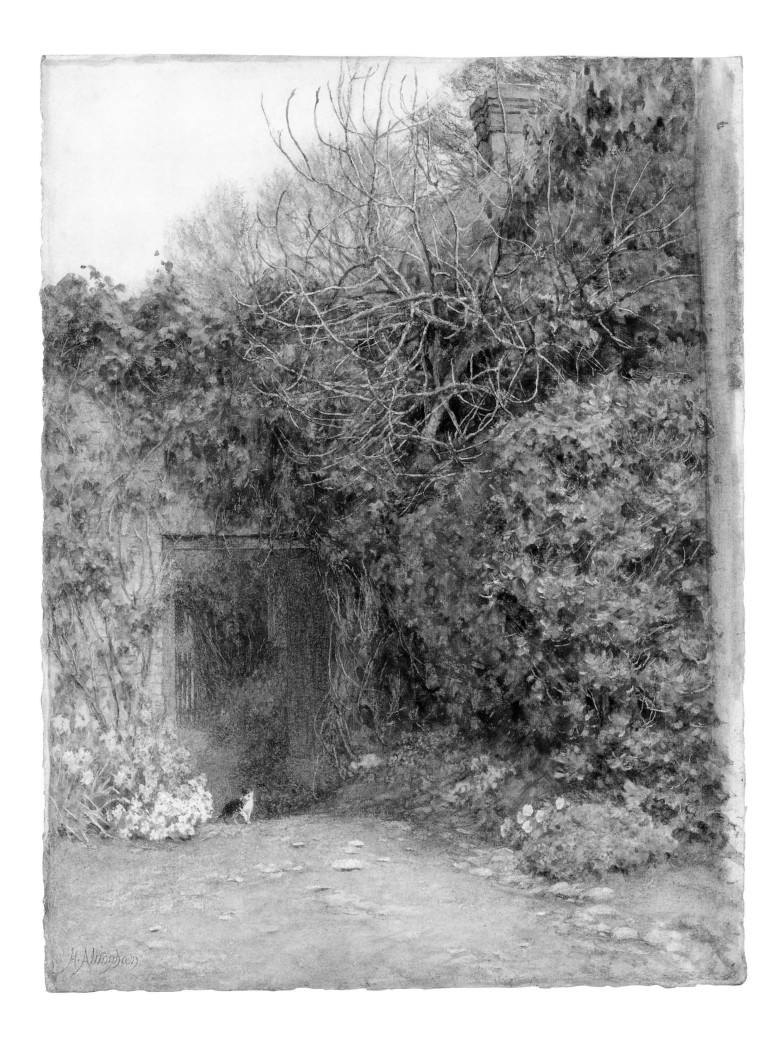

69 PIET MONDRIAN

Amersfoort 1872–1944 New York

Farm at Duivendrecht, c. 1905–07

Charcoal and stump on laid paper
46.4 × 60.0 cm
Purchase, Laidlaw Foundation, 1962
62/13
© 2008 Mondrian/Holtzman Trust c/o HCR International Virginia, US

This sensitively rendered charcoal drawing has now has been identified as representing the farmhouse called "Weltevreden." The building was located at Duivendrecht, near Amsterdam, an area that was lined on its periphery with farm complexes. Around 1905, when this drawing was executed, Duivendrecht was not so much a community as a *polder* belonging to the municipality of Ouder-Amstel. The original farmhouse was destroyed prior to World War II.[1] Robert Welsh has identified from a photograph (fig. 1) the house and its surrounding irrigation ditches and trees and the three elements – architecture, flora and the water surface – that attracted and held the artist's attention. The photograph looks back toward Amsterdam, whereas Piet Mondrian's numerous representations isolate the farmhouse and its surrounding trees against the meadows lying to the east.

This charcoal drawing represents the final compositional study for a painting dated 1905.[2] The light and shadow effects found in the large drawing provided the evening atmosphere for the finished painting.[3] In 1905 Mondrian rendered on numerous occasions and in various media the Weltevreden farm, which appears to have been a favourite subject.[4] A number of pencil drawings remain in a sketchbook depicting detailed studies of the barn, and two others probably represent the trees in the orchard of the site. The artist produced the subtle shading effects by extensive use of stumping on the charcoal drawing. For the drawing and the finished oil version Mondrian depicted the scene from the same unusual angle, from a close-up view. However, for his finished versions dating to pre-1912 he decided not to show the full reflection of the farm building. Several versions of the theme exist that are widely held to have been executed after Mondrian returned to the Netherlands from his first period of residence in Paris (1912–14).

The pre-1912 sketches as well as others that are now lost suggest Mondrian's *plein air* recording of the *Farm at Duivendrecht*. Yet as Welsh noted, although the drawing remains essentially naturalistic in setting, remembrances of the tonal, *plein air* style of the Hague impressionists "are less important to the Toronto drawing than the task of extracting a strong structural design from an otherwise picturesque scene."[5]

It is apparent that Mondrian's aim was rather to reduce nature to its principal horizontal and vertical components. By suppressing architectural detail and granting the same scale and definition to its mirror image as to the "real" farmhouse, the artist endows the composition with a feeling for the ordered definition of nature. The dominant features lie in the division lines between horizontal water and land and the stark vertical profile outlines of the trunks of the trees. After 1912 Mondrian sought to simplify nature to those quintessential geometric elements. This became the artist's principal mode of presentation during World War I.

The drawing was acquired in 1962 by the Art Gallery of Ontario. Welsh welcomed its addition to the collection both for its high artistic quality and the contribution it makes to our understanding of Mondrian's evolution. He summarized its significance in Mondrian's artistic development by remarking, "It foreshadows the artist's eventual endeavours to reconcile the world of appearances with an abstractly conceived image of universal balance and harmony."[6] BWO

fig. 1:
Photograph of "Weltevreden" farmhouse at Duivendrecht. Location identified by Robert P. Welsh.
Photo: Courtesy of Bogomila Welsh-Ovcharov

70 GIACOMO BALLA
Turin 1871–1958 Rome
Line of Speed, c. 1913

Gouache and graphite on pressed board
21.9 x 32.0 cm
Signed in gouache l.l.: *BALLA*
Inscribed in coloured pencil on verso: *LINEA DI VELOCITA*
Artist's stamp on verso
Gift of Sam and Ayala Zacks, 1970
71/55

Although Giacomo Balla enjoyed brief stints as an art student in 1891 at the Accademia Albertina di Belle Arti and the Liceo Artistico in Turin, he was largely a self-taught artist. In 1895 he moved to Rome where he worked as an illustrator, portrait painter and landscape artist. His early style was influenced by Italian divisionism, a variation of Georges Seurat's divisionism (more commonly known as pointillism). Around 1903 Balla added teaching to his resume, instructing students in the divisionist technique; two of his pupils, Gino Severini and Umberto Boccioni, would become, like Balla, central figures in the Italian futurist movement. Balla's early work was widely exhibited internationally, culminating with his inclusion in the 1904 Internationale Kunstausstellung in Düsseldorf and the 1909 Salon d'Automne in Paris.

At the beginning of 1910 Balla began his association with the futurist movement, which had been founded the previous year by the symbolist poet F.P. Marinetti. The "Futurist Painting: Technical Manifesto" of 1910, signed by Balla, sought to propel European culture into the modern age. The futurists felt that the arts were not keeping pace with the technological and scientific revolutions of the time. In an age that saw the invention of the wireless, electric lighting, the automobile and the airplane, artists were wallowing in an anachronistic fascination with themes and styles that failed to address what the futurists saw as the "ecstasy of modernity."[1] They felt that European audiences were unresponsive to the excitement of contemporary life. Through provocative works and performances that introduced important innovations in theatre, photography, music, sculpture, poetry and painting, the futurists, or "friends of chaos" as they were dubbed by one critic, succeeded in becoming the irritant they set out to be.[2]

The futurists sought to imbue modern subject matter with the "speed" of the age, or "dynamic sensation." By 1912 they had succeeded in creating distinctive, abstract images that professed to incorporate the essence of movement. Balla undertook a number of studies between 1910 and 1913 that sought to capture the motion of such things as a dog on a leash, a young girl running across a balcony, the flight of a bird, light and automobiles. He produced a series of drawings and paintings in 1913 under the banner *Line of Speed*. They were the culmination of his research on movement and embodied, for him, the essence of motion and his most succinct and poetic images of speed.[3]

Balla became one of futurism's most recognizable and important contributors, nurtured a second generation of futurist artists after World War I, and remained a futurist until his death in 1958. His work expanded to include theatre, interior design and fashion. The level of his commitment to the futurist cause of modernization was so great that he named his two daughters Propeller and Light. JGH

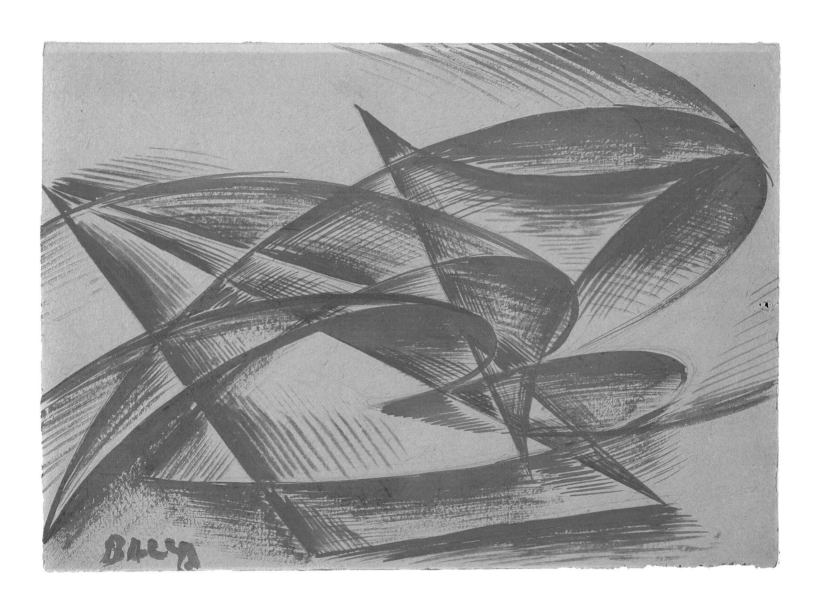

KARL SCHMIDT-ROTTLUFF

Rottluff 1884–1976 West Berlin

Seated Nude, 1913

Watercolour and India ink on laid paper
50.0 × 40.2 cm
Signed in graphite (?) l.r.: *S. Rottluff*
Anonymous gift, 1982
82/230

In 1905 Karl Schmidt moved to Dresden from his birthplace of Rottluff to study architecture and, along with fellow students Erich Heckel, Ernst Ludwig Kirchner and Fritz Bleyl, became a founding member of Künstlergruppe Brücke (Artists' Group Bridge). Die Brücke (The Bridge) was formed as a youthful protest against conservative academic practices and was a call to a radical new kind of creative community. Schmidt-Rottluff[1] is credited with naming the group Die Brücke based on the writings of Friedrich Nietzsche. In reaction to impressionism and naturalistic representation in art, these early German expressionists sought to convey emotional and spiritual states through distortions of form and colour. They found inspiration in the painting of such avant-garde artists as Gauguin, van Gogh and Matisse, but the aggressive directness of their work is often linked to so-called primitive sources, particularly African and Oceanic art.[2]

Schmidt-Rottluff is thought to have first taken up the theme of the single female nude in oil painting in 1905. An experimental and committed printmaker, he explored the subject from 1905 to 1910 in lithography and woodcut exclusively. From 1911 his drawings of nudes increased in number and forcefulness until 1913 when their production stopped. Of the approximately sixty nudes the artist is known to have completed, more than half were made in 1913, in a range of media including oil painting, drawing, watercolour and woodcut.[3]

By 1911, when Schmidt-Rottluff and the other members of Die Brücke moved to Berlin, the artists were developing individual styles and subject preferences. Schmidt-Rottluff's preoccupation with the theme of the female nude was different from the explorations of his friends Kirchner and Heckel. By 1913, the year that Die Brücke disbanded and *Seated Nude* was created, Schmidt-Rottluff had become entranced by the distinctive and exotic elements he found in African sculpture.

In a letter of December 1913 to the Hamburg collector Gustav Schiefler, Schmidt-Rottluff explains that in his nude images he has deliberately exaggerated certain body parts for expressive and conceptual reasons. The head is often enormous because this is where the intellect and psyche are found. The breasts are emphasized because they represent the erotic and earthly. He sees connections with the art of the past, citing Egyptian art and Michelangelo as examples that transcend time and the everyday by melding the metaphysical and the earthly.[4]

This India ink and watercolour *Seated Nude* is surely one of the most shocking manifestations of this theme in the artist's work. Gunther Thiem has remarked that the work is unthinkable without the influence of African art, with its large head and breasts and relatively small body. He has compared the pose, with its striking cross-legged position, one leg tucked under the body and the other pulled up, to funerary statuary from Angola.[5] With the oversized, mask-like face and crudely outlined body coloured in brilliant, jarring washes, the image is one of elemental power and aggressively challenges traditional notions of female beauty.[6] BR

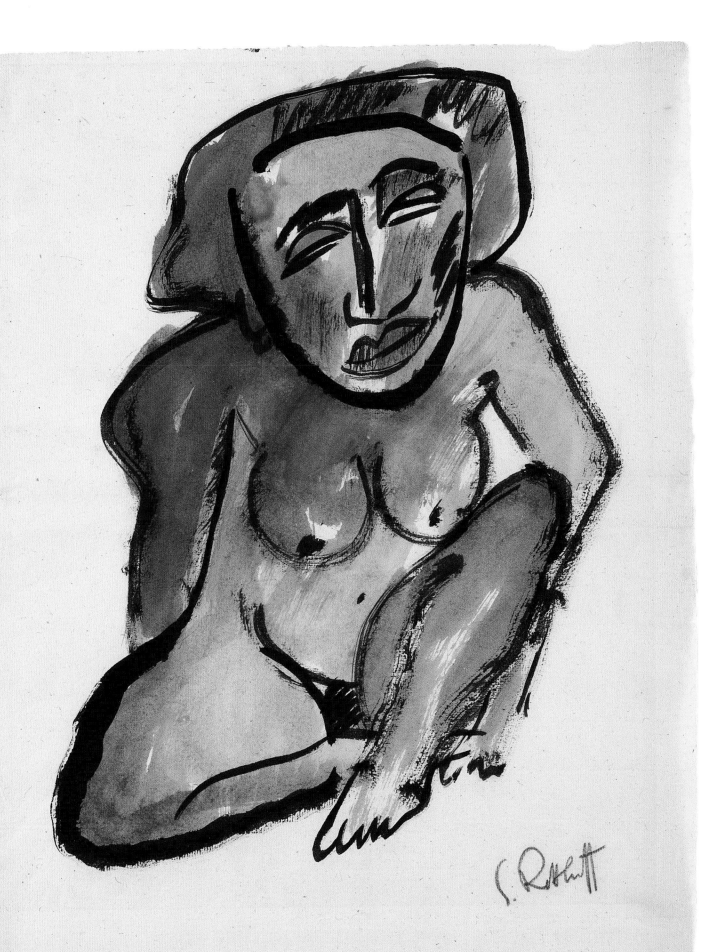

72 EGON SCHIELE

Tulln an der Donau 1890–1918 Vienna

Portrait of a Girl, 1917

Black crayon on wove paper
33.5 × 16.5
Signed and dated l.r.: *Egon/Schiele/1917*
Gift of Herbert Alpert in memory of Patricia Joy Alpert, beloved wife,
mother, grandmother, artist, educator, 2002
2002/9406

Drawing came second nature to Egon Schiele. His mother claimed that he began to draw before the age of two and that as a boy he was rarely without pencil and paper. Early in his career as an artist, Schiele emerged as a skilled draftsman working in an academic manner. By 1910 he had absorbed influences from the Vienna Secession and Gustav Klimt and secured his place among the heirs to *fin-de-siècle* Austrian expressionism.

The distinctive graphic shorthand that characterizes Schiele's expressive style of drawing has led many to conclude that the artist's works on paper are more important than his paintings. Indeed Schiele's brand of expressionism was based not on colour but rather on the distinctive nervous contour line he developed. By 1910 he was employing his taut, linear style to depict distorted and contorted nude bodies that could be interpreted as a disturbing reflection of the artist's state of mind. The young artist's obsession with the naked female form in blatantly sexual poses led to his arrest in 1912 on charges of immorality and seducing a minor.

Portrait of a Girl is a work of Schiele's mature period, 1912–18. At this time his participation in numerous international exhibitions established his artistic reputation and resulted in significant portrait commissions from friends and new patrons. Portraiture would prove to be a major source of income for Schiele, who was reinvigorated by the genre that he had not pursued seriously since 1910.

Schiele's portrait drawings from 1917, a year before his death, demonstrate an increased reliance on strong contour and delicate tonal accents to capture the essence of his subject. The sitter for *Portrait of a Girl* remains unidentified. She may have been related to the family of the Viennese dentist Heinrich Rieger, since four other drawings of her once belonged to him.[1] This portrait presents a carefully composed arrangement of the sitter's head and hands isolated on a blank sheet and balanced at the bottom with the artist's usual way of signing – his name and the date enclosed in a box. Schiele deployed hand gestures as expressive elements that communicate as much as the visage of the sitter. Here the threaded hands of the girl reveal what is going on in her head although she engages the viewer with her direct stare.

The juxtaposition of head and hands against a neutral background may have been inspired partly by the example of Edvard Munch. The Norwegian artist adopted the symbolist motif of the disembodied head in his lithograph *Self-Portrait with Skeleton Arm*, 1895, in which the head floats on a black surface and a skeleton arm forms the lower horizontal border of the composition. Schiele, like Munch, separates the head and hands, thus adhering to the symbolist's belief in the split between the psychological and physical sides of an individual.

MPT

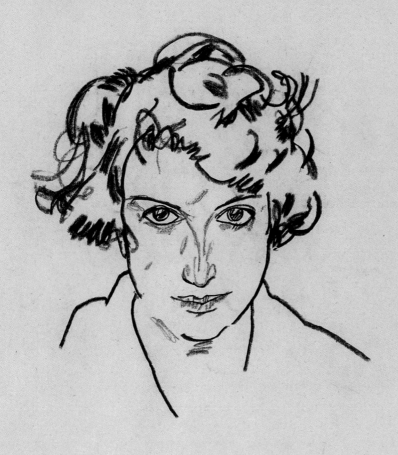

MAX ERNST

Brühl 1891–1976 Paris

Discussion, 1919

Watercolour over graphite, with white gouache highlights on wove paper
27.8 × 22.0 cm
Signed in pen l.r.: *Max Ernst*
Inscribed in pen centre: *Freie/Wirtschaft*; l.l.: *Diskussion*
Purchased with the assistance of the Trier-Fodor Foundation, 2002
2002/9403

Germany was in chaos following World War I. In 1919 the German monarchy was replaced with the Weimar Republic led by President Friedrich Ebert, a Social Democrat. Ebert's government, forced to deal with mass unemployment, crippling inflation and extremist agitation, brutally suppressed riots by the workers, whom the Social Democrats championed.

Allied with radical elements of the Cologne art world, Max Ernst became immersed in this hothouse political environment. By 1919 the disillusion Ernst felt for the government of the new republic found expression in the satirical writings he edited in the suggestively named journal *Der Ventilator*. The left-wing politics of Cologne Dada artists led them to attack the now ruling "establishment" Social Democratic Party, which had already betrayed its socialist followers in 1914 by voting for armaments and thus helping to precipitate war.

The political caricature *Discussion* is uncharacteristic of Ernst's early work, since his revolt against political authority was rarely expressed in visual terms. *Discussion* is a scathing indictment of President Ebert,[1] who is made to look both dangerous and ridiculous. Using devices reminiscent of Vasily Kandinsky's early experiments in abstraction, Ernst presents Ebert not only as two-faced (with eyes in the back of his head), but also as a smiling trickster. Coiled at the waist, Ebert is able to reverse position and strike unexpectedly with nasty talons. The words *Freie Wirtschaft* (free enterprise) that issue from the Social Democrat leader's mouth suggest that the figures trampling each other to gain access to him are middle-class businessmen, whom he woos with promises. But Ebert's duplicity is underscored symbolically by his half-black and half-white suit and by his shoes – one black and one white. Ebert's companions point to the head of a clown on his winged collar. Likewise Ebert is depicted clown-like with a small hat perched on his oversized head. He hovers precariously on a three-legged stool that does not appear able to support his weight.

Ernst's caricature of Ebert's companions is no more flattering. The two in black uniforms are presented like wooden marionettes whose arms appear bolted to their torsos, suggesting that they are puppets of the middle class and no match for the imposing Ebert. The head of the largest of the puppet-like figures calls to mind the work of Marc Chagall, who a few years earlier had shown figures with oval heads dislocated in odd positions.[2]

Discussion, a radical political cartoon in the biting manner of George Grosz, may have been intended for reproduction in a magazine or Dada bulletin. Ernst "corrected" the drawing with white-out, a common practice in publishing.[3] The drawing was among works by Cologne Dada artists rescued by artist Willy Fick (1893–1967) from the residence of his sister Angelika Hoerle following her death from tuberculosis in 1923.[4] The apartment of Angelika and her husband Heinrich Hoerle had been the locus of several Dada publications including Ernst's suite of sardonic lithographs *Fiat Modes Pereat Ars* (Let There Be Fashion, Down with Art) in 1919 and his Dada document *Die Schammade* in 1920.

MPT

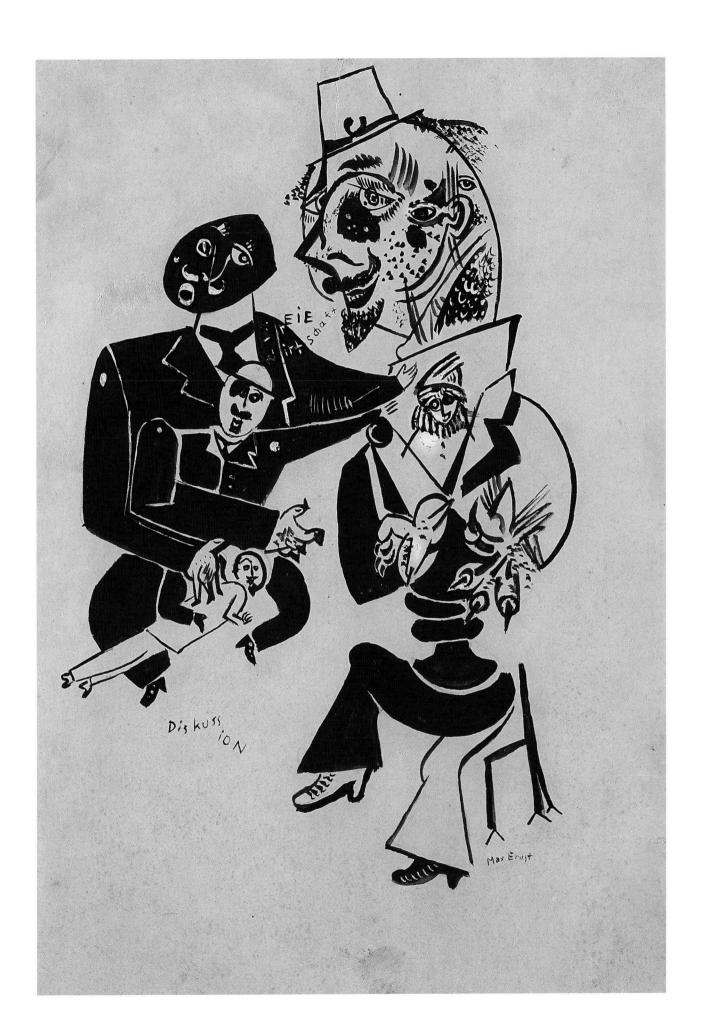

74 GEORGE GROSZ

Berlin 1893–1959 Berlin

City Scene, c. 1917

Brush and black ink on laid paper
48.0 × 31.4 cm
Watermark: "JCA FRANCE ING[RES]"
Signed in graphite l.r.: *GROSZ*
Anonymous gift, 1995
95/339

George Grosz drew incessantly from childhood on. He took an aversion to what he considered "high art," gravitating for subject matter to the sensational stories in cheap American novelettes and for style to the immediacy of children's drawings and the crude graffiti found on the walls of public lavatories.[1] Through the course of a long career and many stylistic changes, his strong draftsmanship, coupled with his cynical unmasking of society's evils, remained the prevailing and most enduring hallmarks of his work.

As a teenager Grosz studied at the Dresden Academy where he learned the traditional and rigorous methods of academic drawing. By the age of nineteen, Grosz found himself in Berlin where he was exposed to the most avant-garde artistic trends – expressionism, cubism and futurism. In 1913, after a brief stint in Paris, he was back in Berlin and immersed in the life of its bars, cafés and brothels. Closely observing the decadence and violence of the city, Grosz drew caricatures for several journals. Inspiration came from the political and social caricatures of artists as diverse as Edvard Munch, Lionel Feininger, Jules Pascin and Paul Klee. He gradually developed the spare shorthand style that is exemplified in drawings such as *City Scene*, made near the end of World War I.

Grosz's posting as a soldier in the German army (from 1914 to 1915, and briefly in 1917) was a traumatic and defining experience for him. Referring to the drawings he made during this period he states, "My art was a sort of safety valve that let the accumulated hot steam escape. Whenever I had time, I would vent my anger in drawings. I sketched what I disliked in my surroundings in notebooks and on stationery: the brutal faces of my fellow soldiers, angry war cripples, arrogant officers, lecherous nurses, etc. My drawings had no purpose, they were just to show how ridiculous and grotesque the busy, cocksure little ants were in the world surrounding me."[2] These satirical illustrations are bitter and rarely humorous, reflecting the anti-war spirit and biting social critique that characterized the work of the Berlin Dadaists.

Grosz's works are full of contradictions and ironies, and *City Scene* is no exception. Like other drawings of around the same date, the image alludes to the frenetic pace of urban life through its tilted perspective and cast of transparent, fragmented figures. The grim-faced bourgeois man wearing a bowler hat, the authority figure (possibly military) with a bald head and jutting chin, and the centrally placed prostitute are recurring types.[3] The armless woman suggests the plight of war amputees and her dehumanized, mannequin-like form is reminiscent of the plaster casts Grosz studied as a student in Dresden. The presence of a bottle, a flowerpot and windows indicates an interior space, perhaps a café or a brothel, while the church and office building in the background suggest city streets. Intersecting lines, representing windowpanes or possibly the crosses found in cemeteries, also reflect the dynamic flux of daily life. The bright, shining orb of the sun, which could be the harbinger of better times ahead, takes on an ominous glare and becomes a symbol of destruction and possibly the end of the world. BR

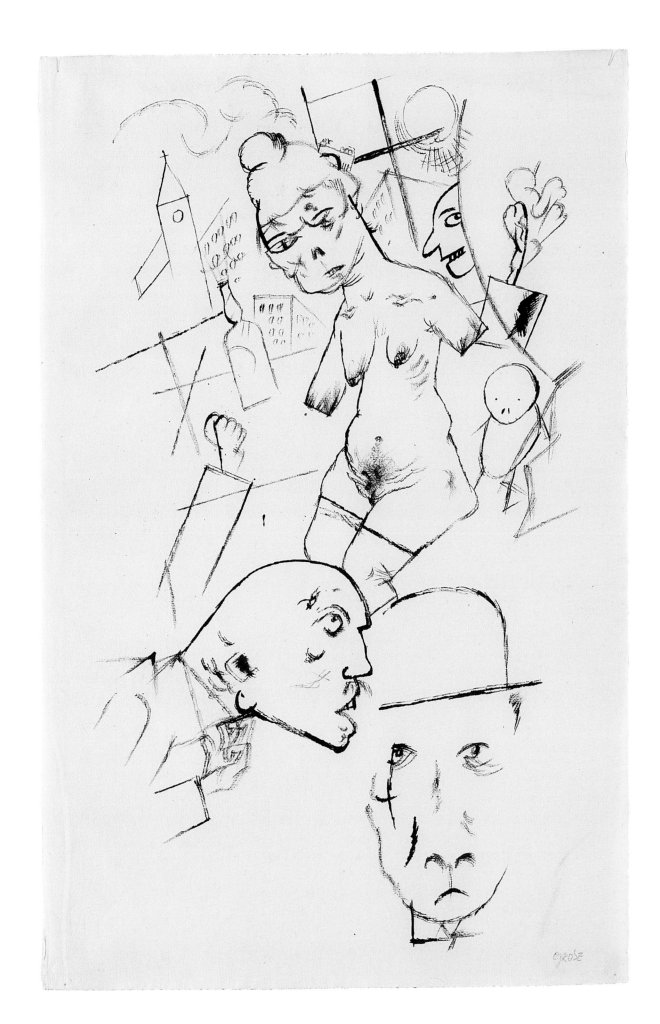

75 FRANTIŠEK KUPKA

Opočno 1871–1957 Paris

Study for Around a Point, 1920–25

Watercolour and gouache over graphite on wove paper
24.3 × 24.3 cm
Signed l.r.: *Kupka*
Purchased as a gift of Norah Lyle Harris and the Marvin Gelber Fund, 2007
2007/16

František Kupka was a pioneer of European abstract painting and one of the great individualist artists of the twentieth century. Working in Paris from 1895, this Czech painter and graphic artist successively absorbed and transformed the mysticism of the Nazarenes, the colouristic freedom of the Fauves, the organic forms of art nouveau, the gestural intensity of the Vienna Secession and the dynamism of the futurists. In spite of his sensitivity to the rapidly shifting artistic currents of the period, Kupka forged a unique style rooted in his own mystical sensibility. At the 1912 Salon d'Automne he showed the first manifesto of abstract art in Paris, *Amorpha: Fugue in Two Colors*, which departed radically from the prevailing cubist idiom. Unsurprisingly, his work was misunderstood – the poet Guillaume Apollinaire linked it to the "Orphism" of Delaunay, which Kupka rejected. As a result of the ornamental quality of his work and its abstruse philosophical foundations, he would remain largely outside avant-garde trends. His critical reappraisal came only with a posthumous exhibition of his work, held at the Musée National d'Art Moderne, Paris, in 1958.[1]

Study for Around a Point is one of the most refined and vibrant of the dozens of studies on paper Kupka made on this theme between 1911 and 1930 for an ambitious two-metre canvas shown in 1936 in the Jeu de Paume, Paris.[2] Watercolour and gouache allowed him to replicate the brilliant hues he sought to capture in oils, but with speed. These studies take up the motif of a central point around which concentric discs, rays and leaf shapes rotate. The AGO sheet dates to around 1920–25 when Kupka moved away from the raw chaos of the early studies toward a more decorative and harmonious style in which the exposed paper emphasizes the luminous, pattern-like effect of the drawing. Here he has achieved a balance between the unity of his design and its apparently infinite expansion. The clover-shaped motif is more or less contained within the frame, while its lines of reverberation and fracture create a wave-like, outward propagation almost suggesting fractal geometry.

Kupka was deeply influenced by theosophy, a syncretic creed melding ancient Neo-platonism and Hindu and Buddhist teachings.[3] The floral imagery of the AGO sheet recalls the Eastern, mystical figure of the lotus blossom that he had employed elsewhere as a symbol of life.[4] A practicing medium, Kupka adapted the theosophical notion of super-consciousness, a sort of self-induced trance, to his artistic practice. This liminal state allowed him to perceive the full intensity, pattern and significance of the objects around him. In practice it unified his work. For example, *Study for Around a Point* relates not only to the abstract paintings pre- and post-dating it, but also to the figurative *The Colored One* (fig. 1), which depicts a woman opening her legs to the disc of the sun.[5] The comparison reveals the elective affinities Kupka sought among religion, biology and astronomy; indeed, he was particularly shaped by the ideas of the Austrian philosopher Rudolf Steiner (1861–1925) whose theosophy blended spirituality with science. For Kupka, artistic creation and natural processes were linked by a kind of erotic communion. RLW

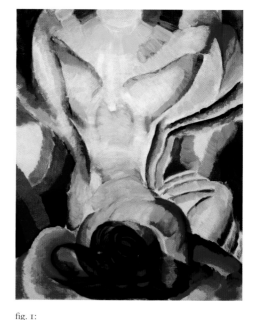

fig. 1:
František Kupka
The Colored One
c. 1919–20
oil on canvas
65.0 × 54.0 cm
Solomon R. Guggenheim Museum, New York,
Gift of Mrs. Andrew P. Fuller, 1966 (66.1810)
© Estate of František Kupka/SODRAC (2007)

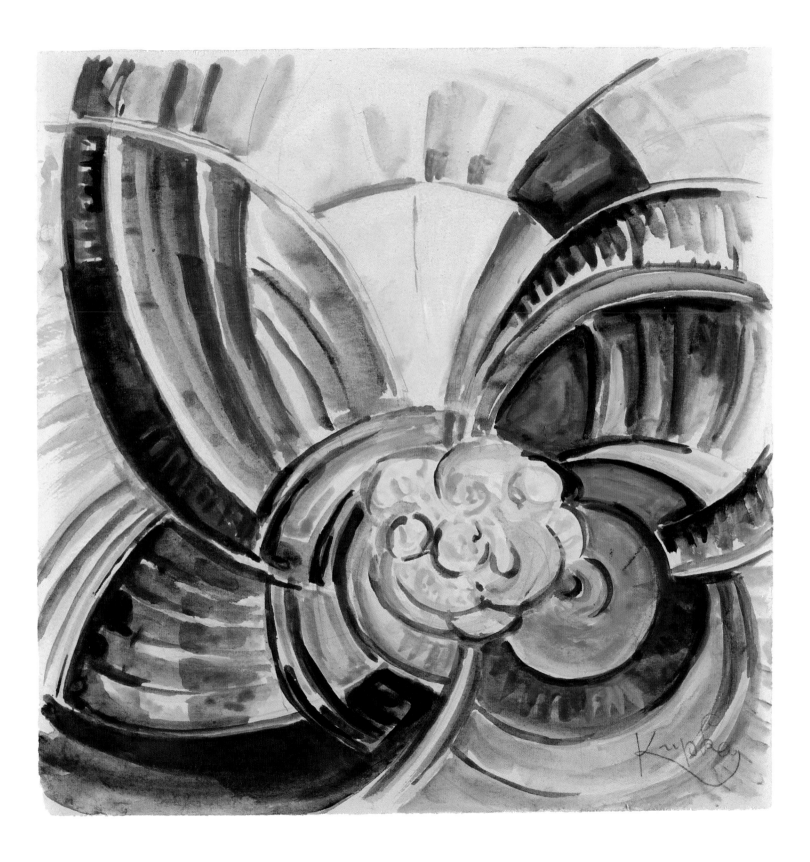

76 VASILY KANDINSKY

Moscow 1866–1944 Neuilly-sur-Seine

Grey Circle, 1923

Watercolour and ink on wove paper
46.8 × 42.0 cm
Signed and dated in ink l.l.: *K/23*
Incribed in pencil on board (verso) u.l.: *K "Grauer Kreis"/No. 68/1923*
Gift of Anne Callahan, 2007
2007/61

Vasily Kandinsky's return to Russia from Germany in late 1914 stimulated a change in the direction of his art from German expressionism to geometric abstraction. Having been involved in the reorganization of Russian cultural life following the 1917 revolution, Kandinsky adopted formal qualities from constructivism with the idea that a universal language for abstraction could be based exclusively on geometric elements. This informed not only his theoretical position and pedagogical work, but also the imagery of his painted and graphic oeuvres, which borrowed Alexander Rodchenko's use of the compass and ruler. Yet Kandinsky's theories differed from the post-revolutionary Russian productivist notion of a rational, utilitarian art stemming from industrial production, positing intuition, rather than geometric calculation, as the basis for artistic creation.

This personal conviction led Kandinsky to leave Russia and return to Germany in late 1921. The following year he was offered a teaching position at the Bauhaus in Weimar. Despite the Bauhaus concern to unite the fine and applied arts into an integrated design environment, Kandinsky's mystical notions about the transcendent qualities of line and colour were not considered contradictory. Rather, a universal formal language was a shared goal among Bauhaus teachers.

The arrival of László Moholy-Nagy at the Bauhaus in 1923 contributed to the school's new focus on geometric abstraction using the compass and ruler – a practice already evident in the work of Rodchenko and El Lissitzky. Kandinsky's paintings and watercolours from this period present the repertoire of geometric forms that he used in *Grey Circle*: triangles, rectangles, squares, zigzags and parallel lines. By 1923 the circle appeared as a dominant element in Kandinsky's work, acquiring symbolic and cosmic overtones, just as it had also assumed iconic status for Rodchenko and Moholy-Nagy. The geometric elements of *Grey Circle* are held in balance by the looming presence of the circle hovering at the top of the composition. Kandinsky asserted that "the circle ... combines the concentric and the eccentric in a single form, and in balance of the three primary forms (triangle, square, circle), it points most clearly to the fourth dimension."[1]

Grey Circle was purchased by Ida Bienert (1870–1965) from Kandinsky's jubilee exhibition held in October 1926 at the Galerie Arnold, Dresden.[2] Bienert (née Suckert) collected modern art with her husband, the Dresden businessman Erwin Bienert (1891–1931). By 1930 she became a member of the Kandinsky Gesellschaft. Since the society provided an opportunity to acquire works by Kandinsky at reduced prices, Bienert was encouraged to become a dedicated patron of the artist at a critical period of his career. In addition to Kandinsky, she collected numerous works by Klee, Chagall, Moholy-Nagy, Mondrian and Picasso. MPT

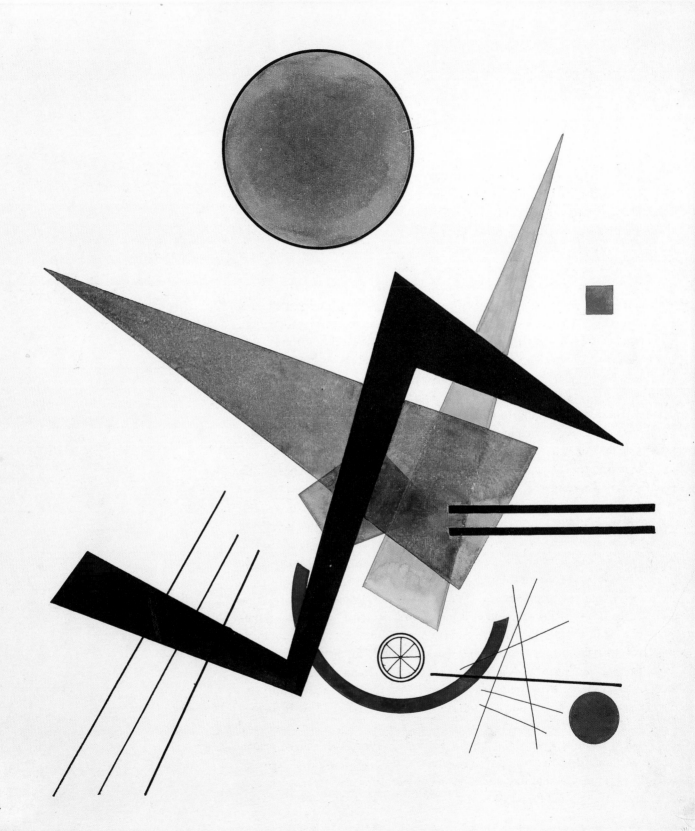

77 SONIA DELAUNAY

Gradizhsk 1885–1979 Paris

Paris, 1915

Coloured wax on laid paper
32.6 × 44.3 cm
Signed in ink l.r.: *Sonia Delaunay 1915/Terk*
Inscribed in ink l.r.:*119*
Gift of Sam and Ayala Zacks, 1970
71/117

Originally from the Ukraine, Sonia Delaunay trained in Moscow before being drawn to Paris in 1905 to continue her studies. In this cosmopolitan capital of the art world she met painter Robert Delaunay, with whom she formed a fruitful professional and personal partnership anchored by a mutual commitment to experimental modern art and design.

This large, vibrant work exemplifies the fascination they shared with colour and with the play of light, particularly in urban spaces. Unlike many of her predecessors, Sonia Delaunay had a passion not for the effect of light on objects, but for the sources of light itself and the way in which light is distorted through prisms. The interlacing discs of colour seen here dominate most of her work and were the basis of an abstract vocabulary of soft-edged geometry that is echoed in later American abstraction. In 1912 the famed critic Guillaume Apollinaire devised the term "Orphism" to distinguish the lyrical abstraction of the Delaunays' circle of artists from the harder edges and muted colours of cubism.

Contrary to its embedded text, this wax drawing was actually made in Iberia where the Delaunays quite happily found themselves marooned after World War I broke out during a family vacation. From the Mexican painter Angel Zárraga, the Delaunays had learned the technique of mixing hot wax with aspic and pigment, but they did not employ the technique until they found themselves basking in the intense light of Portugal in 1915. As Sonia wrote, "What was important to us about this technique was the great purity and force of color. These pictures have not changed, their colors are as bright as the day they were painted."[1]

Preserving colour was so crucial to Delaunay because it was the anchor of meaning in her work. After her first abstract picture in 1912, she never turned back to substantive figuration. Instead, she and Robert experimented with the possibility of representing modernity as simultaneous spaces and forms. This painted wax image is part of a preparatory series for the catalogue cover of a 1916 solo exhibition in Stockholm.[2] In its final design, the front and back covers are clearly divided like a diptych, but in the AGO drawing the merged abstract forms at the top confuse the clear division of each space. In this work, she tries to balance the front and back of the cover into a united design with two distinct focal points. One side integrates text familiar to commercial design, while the other suggests a woman's head in a very abstracted form.

Although this work is part of a series, the number 119 inscribed at the edge of the image is too high to refer to its place in that sequence.[3] It more likely relates to the drawing's place in Delaunay's inventory of her work. SP

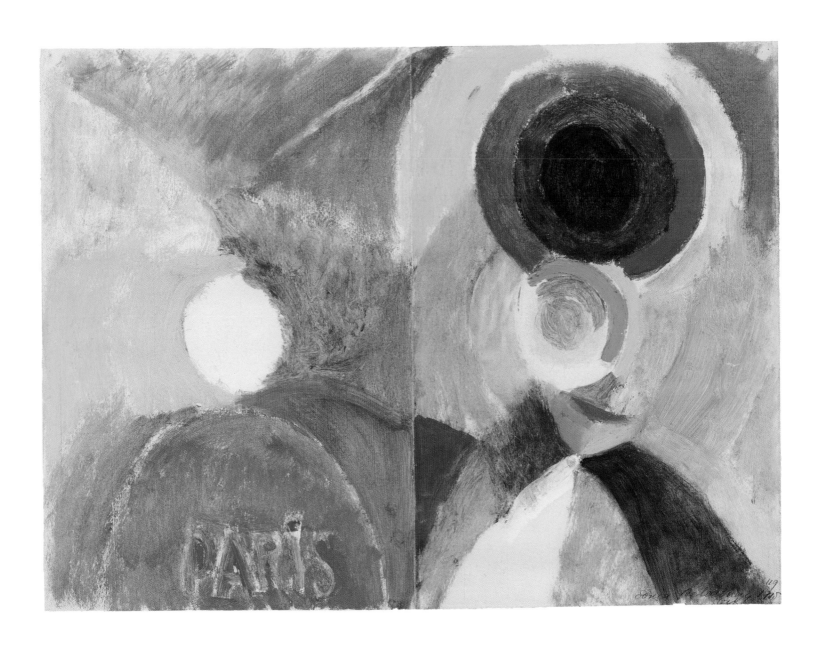

78 MARC CHAGALL

Vitebsk 1887–1985 Saint-Paul de Vence
The Temptation, 1911

Gouache over brush and black ink on wove paper
23.6 × 34.0 cm
Signed l.c.: *1911 ChAgAll*
Anonymous bequest, 1991
91/416

By the time Marc Chagall arrived in Paris in May 1911 he had already received training in his native Vitebsk and St. Petersburg, and was able to express his Russian-Jewish heritage in highly original works of art. Now Paris offered the language of modernism. Until his return to Russia in 1914, Chagall absorbed the lessons of cubism, futurism, Orphism and expressionism. *The Temptation* is one of a series of small gouaches that Chagall made in his first Paris studio, at 18 Impasse du Maine, which anticipate in both subject and style the unique blend of modernist influences that were to characterize his larger oil paintings.

This is one of several works from Chagall's Paris period depicting Adam and Eve. Given that Jewish law as practised in Eastern Europe did not permit the representation of religious imagery, it is remarkable that the young Chagall chose Adam and Eve and other subjects from the Old and New Testaments. His selection of biblical themes also went against the grain of avant-garde modernism, which generally repudiated narrative scenarios in favour of landscape, portrait and still-life subjects that lent themselves more readily to formalist abstraction.

The Temptation follows neither a specific iconographic tradition nor the account of Adam and Eve in Genesis. While the Bible reads, "[God] created them male and female . . ." (Genesis 5:2), Chagall depicts two androgynous-looking figures who appear to be in flagrante delicto. The more aggressive Adam occupies an odd spatial territory, being both on top and to the side of the recumbent Eve. The impossible anatomical position of Adam's legs, in rhythmic parallel to Eve's, further complicates their union. Adam has a swollen belly, perhaps foreshadowing Eve's pregnancy, while Eve derives a male appearance from the size of her frame and powerful facial features. The symbolic dual sexuality of Adam and Eve clearly fascinated Chagall, who treated the theme again in preparatory studies in gouache for his major cubist-style painting *Homage to Apollinaire* of 1911–12 (Van Abbemuseum, Eindhoven). There Chagall represents the couple as one hermaphroditic figure joined at the waist like Siamese twins.

This sheet reflects Chagall's wide-ranging knowledge of mysterious and esoteric symbolism. Its palette and style derive in part from his observation of the high-keyed colours favoured by Fauve artists such as Matisse, Derain and Vlaminck, and cubist tendencies found in Léger. But while Chagall's work responds to French modernism, it remains linked to indigenous Russian culture. The floral-vegetal decoration on the wall behind the figures is reminiscent of designs painted on the walls of Russian homes. And Chagall's use of crude, bright colours, perspectival distortion and wilful anatomical dislocation call to mind Russian naive and folk-art forms. The artist's ability to adapt these elements from outside the traditional realm of fine arts and absorb them into a modernist idiom is what distinguishes his work from that of the mainstream avant-garde. MPT

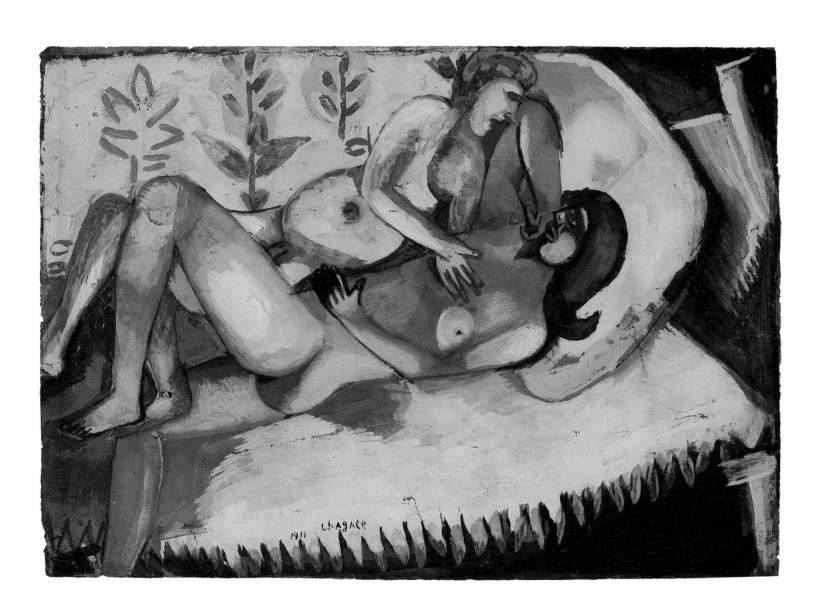

79 LIUBOV POPOVA
Ivanovskoye 1889–1924 Moscow
Cubist Man (Standing Figure), 1915

Graphite on wove paper
25.4 × 20.3 cm
Inscribed in graphite (verso) u.l.: *L. Popova 1915/Collection G. Costakis/Moscow*;
(verso) u.r.: *To Mr. and Mrs. A. Smith/with love/G. Costakis*
Purchased as a gift of the Master Print and Drawing Society of Ontario with the assistance
of the Department of Canadian Heritage under the terms of the Cultural Property Export
and Import Act, 2002
2002/9402

Liubov Popova, one of the talented "Amazons" of the Russian avant-garde, is celebrated for her astonishing versatility in a range of media: drawing, painting, relief work and designs for books, textiles and the theatre. By 1915 Popova's life drawings and paintings established her as one of the main progenitors of a Russian type of cubo-futurism. She remained at the forefront of Russian art until her death from scarlet fever at age thirty-five.

Before the Russian Revolution of 1917, Popova travelled extensively in Europe thanks to her wealthy family's connections. In 1912 she worked in the Parisian studios of Henri Le Fauconnier and Jean Metzinger, where she gained a first-hand knowledge of French cubism. (It was in 1912 that Metzinger and Albert Gleizes published *Du Cubisme*, in which they theorized that the expressive quality of a work of art must be based on the conjunction of straight lines and curves.) The young Popova may also have seen works by the Italian futurist Umberto Boccioni that were exhibited in Paris during the summer of 1913. By 1914, when Boccioni's *Technical Manifesto of Futurist Sculpture* (first published in 1912) appeared in Russian translation, the Italian artist's ideas on dynamism, the structure of movement and the relationship of an object to its surrounding space had implications for Popova's drawing.

In 1913 Popova returned to Moscow where she renewed her working relationship with Vladimir Tatlin. The two artists, unlike many of their contemporaries, felt that figure drawing was a key to understanding the inherent structural elements of the human body. Popova drew inspiration from Tatlin's figure drawings and their abstraction of the body's mechanical structure. *Cubist Man (Standing Figure)* is a quintessential example of her drawing style from that period, in which the composition fills the sheet from top to bottom. Popova's figure is boldly rendered as intersecting shaded planes juxtaposed with circular swirls that create movement around the form and a sense of three-dimensional space. In the spirit of Boccioni, Popova connects the nude to its surroundings by means of a planar treatment of lines that extend beyond the frame of the figure. Along with Tatlin and Boccioni, another artist who may have influenced Popova's treatment of the human figure was the sculptor Alexander Archipenko, whom Popova met with frequently in Paris from 1912 to 1913. Archipenko's sculpture *Medrano I*, 1912, used geometric elements such as cones and cylinders with circular forms for knee and elbow joints.

While *Cubist Man (Standing Figure)* appears rapidly executed, it is the product of a calculated understanding of the architectonic elements of the human form. At first the female figure is difficult to decipher because her head is cropped at the neck. But soon the various body parts become clearly readable as they emerge from the complicated nexus of lines.

This drawing belonged to George Costakis, the foremost private collector of Russian avant-garde art.[1] Costakis, who worked for the Canadian embassy in Moscow, gave the bulk of his collection to Soviet museums before his forced departure from Russia in 1978. He gave *Cubist Man (Standing Figure)* to Arnold Smith, who was Canadian ambassador to Russia in the early 1960s and would later become first secretary-general of the Commonwealth. MPT

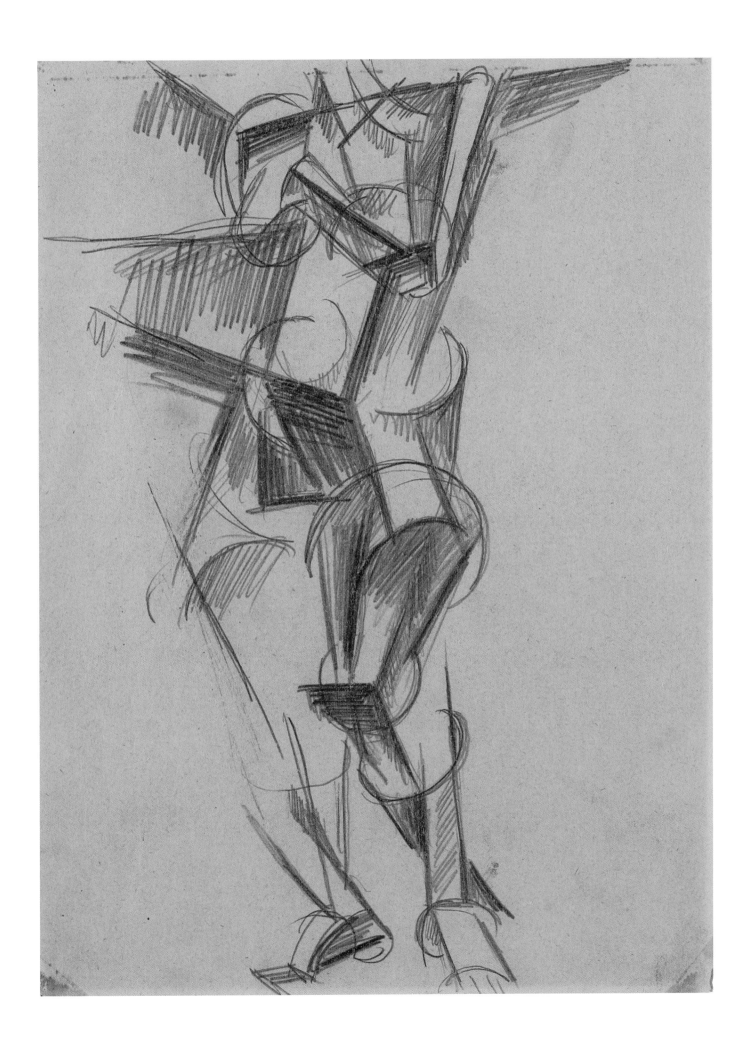

80 ELIEZER MARKOVITCH (EL) LISSITZKY

Pochinok 1890–1941 Moscow

Study for "Proun" 8 Stellungen, 1923

Watercolour and gouache over graphite on laid paper
24.5 × 24.8 cm
Signed and dated l.l.: *El Lissitzky/Hanover 23*
Signed, inscribed and dated around perimeter of diamond, clockwise from u.r.:
Whz/HERRN/1923/HANNOVER '23/EL LISSITSKY/OE...
Gift of Sam and Ayala Zacks, 1970
71/228

Constraints against Jews in Russia temporarily curtailed El Lissitzky's interest in art, leading him to pursue a career in architecture outside Russia. He studied at the Technische Hochschule in Darmstadt, Germany, from 1909 to 1914, but was forced to return to Russia prematurely after the outbreak of World War I. In 1916, after receiving a diploma in engineering and architecture from the Riga Polytechnicum, he began working as an assistant in architectural firms.

Lissitzky's interest in art was rekindled after the repeal of Russia's anti-Semitic laws by the provisional government in 1917, which led to an interest in the revival of Jewish culture. In 1919 he received an invitation from Marc Chagall to teach graphic arts, printing and architecture at the newly formed People's Art School in Vitebsk that Chagall had founded in 1918.

It was there that Lissitzky met the Russian painter Kazimir Malevich. After seeing his work in 1919, El Lissitzky became one of the most articulate proponents of Malevich's "Suprematism." In 1920 he wrote, "SUPREMATISM (. . .) revealed for the first time in all its purity the clear sign and plan for a definite new world never before experienced – a world which issues forth from our inner being and which is only now in the first stage of its formation."[1]

Ironically, Malevich had brought Suprematism to a close in 1918; Lissitzky, however, felt that its objectives had yet to be fully realized and undertook to continue the work Malevich had begun. He began a series of abstract paintings entitled *Proun,* an acronym for "project for the affirmation of the new."[2] The *Proun* paintings were in the simplest terms blueprints for a new society fed by the euphoria that followed in the wake of the Russian Revolution. They were intended, as Lissitzky explained, "as an interchange station between painting and architecture."[3] The *Prouns* were studies of form and space articulated within a multi-dimensional framework. Paralleling the work of the Russian constructivists, they were a primer that took into consideration the most recent advances in mathematics and physics – a point that Lissitzky made in his "Proun" text of 1920–21 and "A. and Pangeometry" of 1925.[4]

Study for "Proun" 8 Stellungen consists of a visual dialogue between the three dimensions that make up our reality (while suggesting the possibility of a fourth, as in some of the later *Prouns*).[5] The confusing play of dimensions generated by the articulation and rearticulation of lines and planes is designed to heighten our awareness of the intricacies of form and space. The artist recommended that the work be turned and viewed from different directions to draw attention to the interplay between dimensions. This appears to be the preliminary study for the closely related painting of the same title in the collection of the National Gallery of Canada (fig. 1). By the end of 1925 Lissitzky's interest had shifted to the design of interior spaces, which gave him the opportunity to put into practice some of the ideas explored in the *Prouns.* JGH

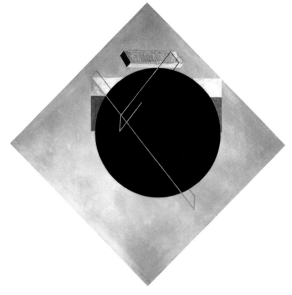

fig. 1:
El Lissitzky
"Proun" 8 Stellungen
c. 1923
oil and gouache with metal foil on canvas
139.3 × 139.3 cm
National Gallery of Canada, Ottawa
Purchased 1973 (17640)
© Estate of El Lissitzky/SODRAC (2007)

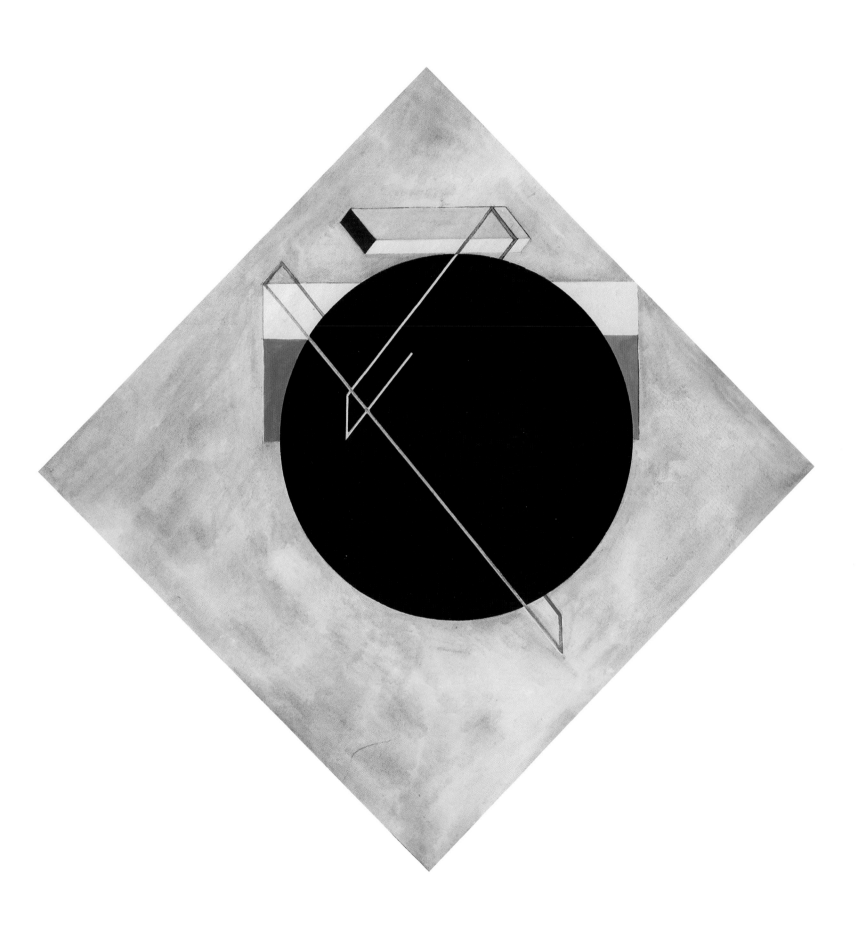

81 ÉDOUARD VUILLARD

Cuiseaux 1868–1940 La Baule

In the Studio of the Rue de Calais, c. 1920

Pastel and charcoal on laid paper
24.2 × 31.2 cm
Watermark: "INGRES/FRANCE"
Studio stamp in violet ink l.r.: *EV* (Lugt 909a)
Gift from the estate of R. Fraser Elliott, 2005
2005/266

Édouard Vuillard, a leading post-impressionist artist, was associated with Paul Gauguin (cat. 40) and the Nabis in his youth. In addition to being a great painter he believed in the fundamental importance of drawing, and his pastels are among the most startling and original graphic expressions of the period.

Vuillard, a bachelor, lived in an apartment on the rue de Calais in Paris at the corner of the Place Vintimille with his mother, a seamstress, until her death in 1928. His work focused on their domestic life and the *mundus mulieribus* (world of women) recommended by the critic Charles Baudelaire as an appropriate modern life subject for artists.

Vuillard was dubbed an *intimiste* in the 1890s because of his compact depictions of claustrophobic bourgeois interiors. He deliberately distorted the perspective of his interiors, creating ambiguous planes and introducing disquieting physical elements into his compositions. Following World War I his work developed greater breadth, his palette lightened, and he began to employ chalky colours in his oil paintings inspired by the *à la colle* technique he had learned in designing theatrical sets. These characteristics are also to be found in his pastels of this period.

The focal point of the drawing-room, which doubled as a studio, was a grey marble mantelpiece with a gilt overmantel mirror. On it was perched a plaster cast of the Venus de Milo that the artist owned and had carted from place to place since the turn of the century. The life-sized bust towers over the scene and appears to be perched precariously on the edge of the mantelpiece. The bizarre disparity of scale, the fragility of the plaster and the precipitous drop create visual and psychological tensions. The Venus is the surrogate female presence in this work and engages in a visual dialogue with the other components of the still life.

Like the symbolist poetry of Vuillard's friend Stéphane Mallarmé, this work is laced with references. Salomon and Cogeval have observed that the Venus was Vuillard's "synecdoche for the Louvre,"[1] where the famous original resides, and appears in at least thirty of his portraits and studio views. The pastel references masterpieces by two artists Vuillard greatly admired, Jean-Auguste-Dominique Ingres (cat. 33) and James McNeill Whistler, both of whom idealized the Venus de Milo. In his portrait *Mme Inèz Moitessier*, 1856, Ingres posed his model in front of a mirror. Whistler, quoting Ingres, did the same thing in *Symphony in White, No. 2: The Little White Girl*, 1864. By alluding to these two works, Vuillard pays homage to these forebears and positions himself in this line of artistic descent. They believed that the artist's role was to hold a mirror up to nature: the flowers represent nature, and the portfolio of sketches, studies. This pastel can be read, therefore, as an allegory of beauty.

KL

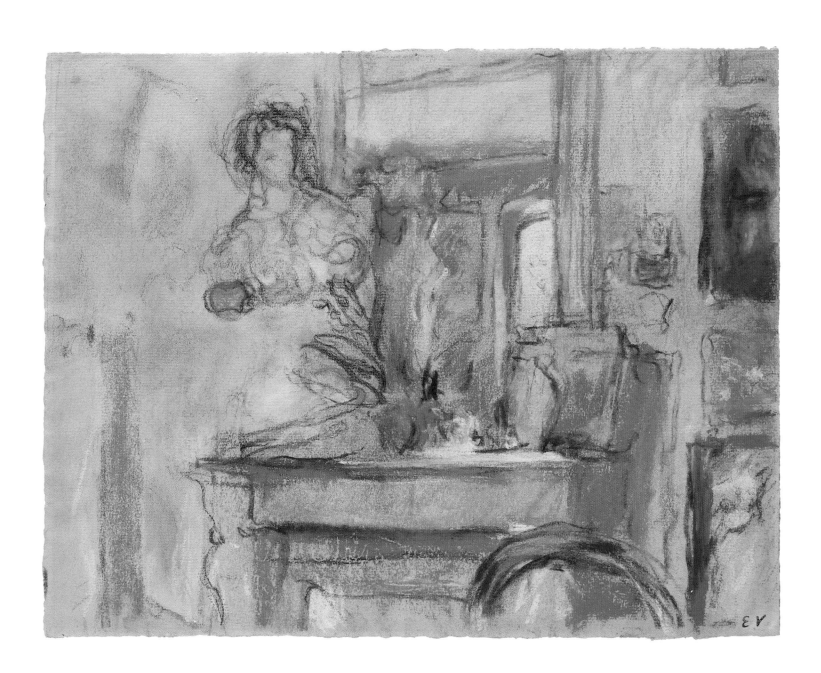

82 HENRI MATISSE

Le Cateau-Cambrésis 1869–1954 Nice
Seated Model with a Guitar, 1922–23

Charcoal and stump on laid paper
47.4 × 31.5 cm
Signed l.r.: *Henri Matisse*
Gift of Sam and Ayala Zacks, 1970
71/250

Craving peace, pleasure and beauty in the wake of World War I, Henri Matisse sought refuge in "the safety and relaxation of 'classicism', 'humanism', and 'traditionalism.'"[1] From 1917 to 1929 he found a personal paradise in the south of France. He was much criticized in Paris for what was perceived as his defection from the more serious concerns of the artistic community in the capital.[2]

After vacationing in Nice, Matisse decided to rent an apartment in Place Charles-Félix where he could devote himself to capturing the soft, warm light and the sybaritic pleasures induced by the warm climate and lush vegetation of the French Riviera. At the Studios de la Victorine, he saw Henriette Darricarrère performing as a ballerina in front of a camera. She began posing for him and was his favourite model from 1920 to 1927. He encouraged her to continue her study of piano, violin and ballet.

Although Matisse was primarily interested in working toward the integration of figure and ground, he explored a more three-dimensional space in this drawing. It references the works of Delacroix (cat. 34), Courbet and Manet, the leading nineteenth-century French romantic and realist artists. Matisse owned a number of works by the realist leader Gustave Courbet, which he hung on the walls of his studio. Matisse regarded Courbet as a "yardstick."[3] The scale, technique and style of this drawing recall those of Courbet and his followers. In 1923 critics noted that Matisse "sometimes seems descended from Velásquez by way of Manet,"[4] and the inclusion of the guitar in this work recalls the realist admiration for Spanish art and in particular the work of Courbet's successor Manet. The exotic textiles, brought back from a trip to Morocco, reference Delacroix's Moroccan trip and pay homage to the artist regarded by the realists as a father figure.

The realists often employed musical themes as a commentary on human relation-ships. This *intimiste* image incorporates psychological tensions not found in the many decorative, two-dimensional odalisques executed by Matisse at that time. Henriette is per-sonalized here as a chic French girl of the 1920s. Her pose and her vacant stare project feelings of ennui, while an indefinable malaise appears to hang in the air. Although she is a musician, she does not appear to be interested in the guitar, an instrument closely asso-ciated with romance and courtship, which looks like a self-conscious prop. The shadows hovering around her contribute to the suggestion that all is not well between the artist and his model.

This work belongs to a group of drawings executed during 1923–24 depicting Henri-ette with musical themes. Although the pose has changed here, in an earlier related drawing, *Seated Model with a Guitar*, c. 1921–23, the model appears equally bored.[5] KL

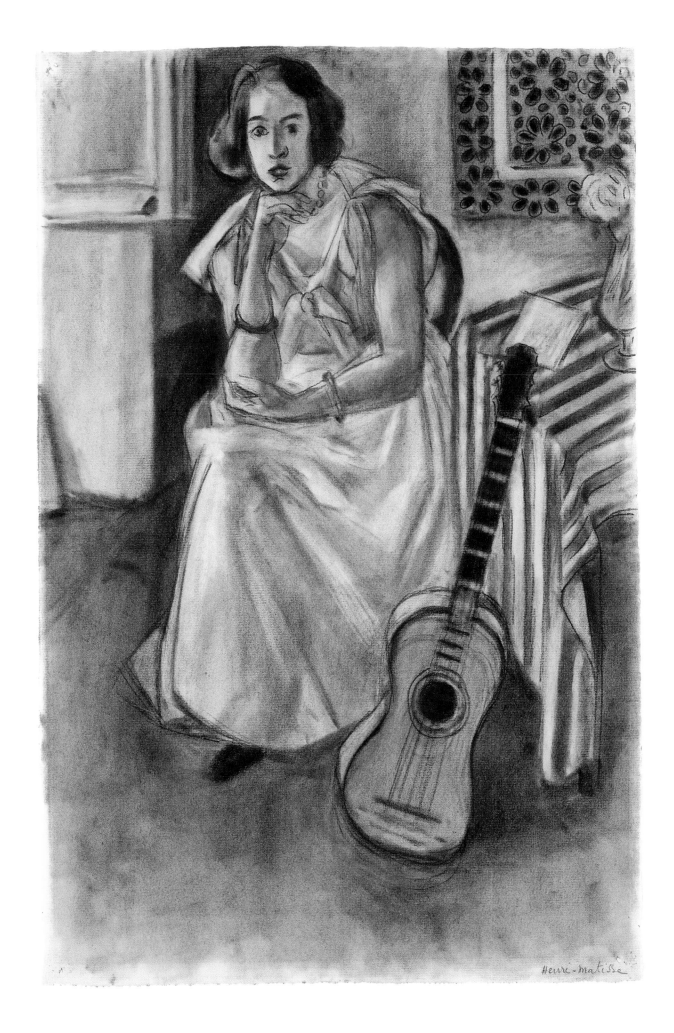

Henri-matisse

GEORGES ROUAULT

Paris 1871–1958 Paris

Idyll, 1929

Ink and brush, watercolour, gouache and pastel on wove paper
51.4 × 37.4 cm
Inscribed in ink l.r.: *G.Rouault 1929*
Formerly in the collection of Dr. and Mrs. Harold Murchison Tovell and purchased from their son
Dr. H.M.M. Tovell of New York with the assistance of the Department of Canadian Heritage under the
terms of the Cultural Property Export and Import Act, 1987
88/87

As a youth Georges Rouault studied with the symbolist painter Gustave Moreau at the École des Beaux-Arts in Paris. Under Moreau's guidance he was taught to trust his imagination for ideas and to develop an intimate knowledge of his materials. Stylistically, Rouault's work was linked to the Fauves, a group of artists that included his former classmates Henri Matisse and Albert Marquet. The Fauves created highly charged images using flat patterns, distortions of form and pure, bright colours. Rouault's work varied from that of his friends in his preference for religious themes, deep, rich hues and heavy dark outlines that encompassed his forms. In the 1904 Salon d'Automne exhibition, his paintings were criticized for their overwhelming "blackness" and were considered "nightmares."[1]

Although Rouault's art is associated primarily with the human figure, he conveyed equally powerful and symbolic truths through his landscapes. Like his Catholic writer friends Léon Bloy and André Suarès, Rouault believed that religion and art should be intertwined; he sought to expose social injustice and to explore humanity's need for redemption through all his work. He was zealous about conveying spiritual messages in every medium – oil paint, watercolour, printmaking and ceramics.

In 1929 Rouault was designing scenery for Serge Diaghilev's ballet *The Prodigal Son*, and this activity appears to have focused his attention on the possibilities of landscape subjects and urban views. That same year, he completed a series of lithographs, *La Petite Banlieue (Little Suburbs)*, and a group of watercolours devoted primarily to the urban landscape.[2] In *La Petite Banlieue*, five of six images are entitled *Faubourg des Longues Peines (Suburbs of the Long-suffering)*, suggesting a place of deep sorrow.[3] The watercolour *Idyll* may have been a preparatory study for *Faubourg des Longues Peines (Impasse)* (fig. 1). In both works two figures stand in a vacant street or alley; there is a dark doorway on the right with a sign on the wall above, the buildings close in oppressively, and the vast emptiness in the background and in the space that separates the two figures speaks of profound loneliness. The ironic title *Idyll*, which suggests a poetic or pastoral scene, lends poignancy to the image.

Rouault reworked his oil paintings extensively over many years. Although watercolour allowed no opportunity to "rework" the image, Rouault could still combine it with other media to create a result that was haunting and technically sophisticated. This serene yet vibrant work, with its vivid blue and red watercolour washes, sweeping black ink strokes and areas of gouache and pastel, shows the artist at the height of his powers. It is perhaps in watercolour that Rouault came closest to imitating the luminosity and dark lead lines characteristic of stained glass, a source frequently cited for his oil painting.[4] BR

fig. 1:
Georges Rouault
Faubourg des Longues Peines (Impasse)
no. 3 in *La Petite Banlieue (Little Suburbs)*
1929
lithograph
32.0 × 22.0 cm
© Estate of Georges Rouault/SODRAC (2007)
Digital image © The Museum of Modern Art/
Licensed by SCALA/Art Resource, NY

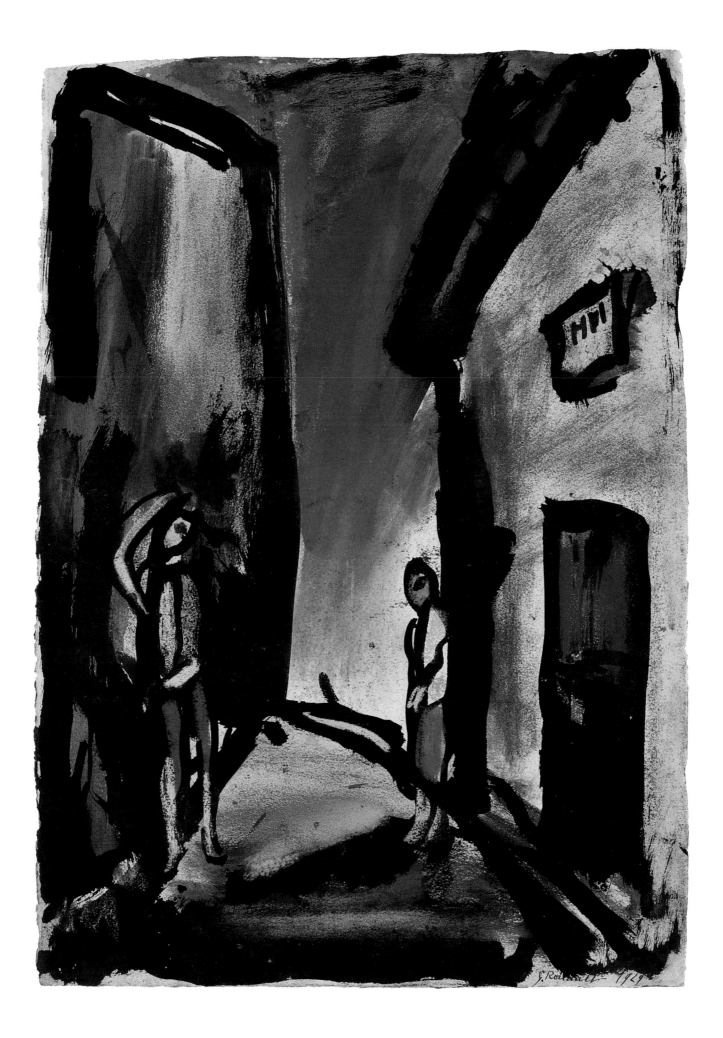

RAOUL DUFY
Le Havre 1877–1953 Forcalquier
The Mosque of Marrakesh, 1926

Watercolour and gouache over graphite on wove paper
49.2 × 64.7 cm
Signed l.r.: *Raoul Dufy*
Gift of Sam and Ayala Zacks, 1970
71/135

In the years preceding World War I, Raoul Dufy experimented with cubism and fauvism. After being discharged from the army, he left Paris to search for his own artistic voice. The "war to end all wars" was followed by a decade of unbridled optimism, and Dufy captures the joie de vivre of the 1920s in the glorious watercolours he made in the Mediterranean, which are full of light and rich colours.

In 1926 Dufy travelled to Morocco with the Paris fashion designer Paul Poiret, for whom he had created textile designs. They were overwhelmed by the visual richness and sensual beauty of Marrakesh – the exotic patterns and shapes; the beauty of Islamic architecture, ornament and calligraphy – and by the festivities organized in their honour by the pasha, Glaoui.

Dufy would have known of the profound influence Morocco had had on Delacroix in 1832. It was there that the great romantic encountered the complementary colour combinations that were to underpin his colour theories, which he recorded in watercolour in his sketchbooks. The French art critic Charles Baudelaire pointed out that Delacroix's colour "thinks for itself, independently of the objects which it clothes. Further, these wonderful chords of colour often give one ideas of melody and harmony."[1] Dufy echoed these words when, after returning to Paris following his Moroccan sojourn, he told Zervos, "In painting and in music, everything depends on harmony. When the painter chooses colours, they seem to resonate and multiply like the chords of a violin."[2] Dufy believed that by striking the right chords, art, like music, could raise the viewer to a higher spiritual plane.

Given his desire to combine light with colour, it is not surprising that watercolour became Dufy's favourite medium. After wetting a large sheet of paper, he quickly brushed in the areas of translucent wash to indicate the planes and to signal shifts in colour. As the paper began to dry, he added strong touches of colour to draw attention to the line and ornament that were, for him, the centre of interest.

Dufy greatly admired the twelfth-century Koutoubia Mosque, one of the largest in North Africa, which is modelled on the Great Mosque of Cordoba in Spain.[3] For this work, he positioned himself well above ground level facing toward the end of an aisle. He framed the composition with one of the pointed arches that springs transversely from the piers and included a pair of the lobed arches that frame each aisle where it terminates at the perimeter wall. As the interior of the mosque is white, it would seem that the colours used were symbolic. By concentrating detail and strong colour toward the top of the composition, Dufy guides the viewer's gaze upward, evoking a floating sensation and a range of aesthetic and spiritual emotions.

In 1921 the artist had entered into a three-year agreement with Bernheim-Jeune and Vildrac that was extended in 1925 for a year, and gave the dealers first choice of his work. This was one of the sheets that they selected from the approximately forty Moroccan watercolours that Dufy made during the twelve-month period. KL

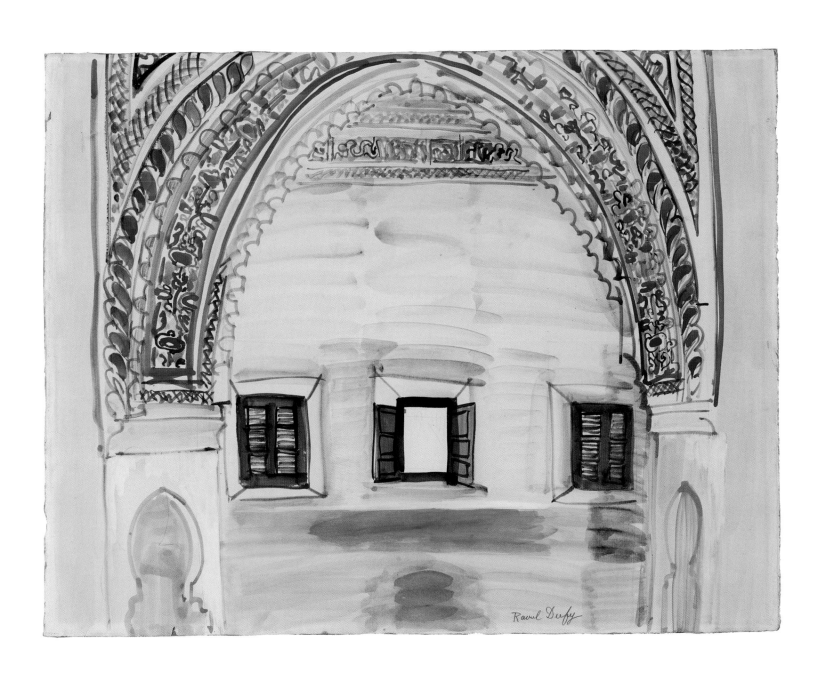

Raoul Dufy

FERNAND LÉGER

Argentan 1881–1955 Gif-sur-Yvette

Two Figures, 1922

Graphite on wove paper squared for transfer in cut copper mount
30.1 × 19.3 cm
Signed and dated in ink l.r.: *F.L. 22*
Gift of Sam and Ayala Zacks, 1970
71/224

Fernand Léger was known for his pioneering drive to create art that captured the dynamism of the machine age. By the time he started a painting, Léger claimed, he was eighty percent certain of where he was going. His ideas were so carefully worked out in preparatory drawings that there was little need to improvise on canvas. Hence, preliminary drawings in pencil on paper are often as complete artistic statements as Léger's oil paintings. Such is the case with *Two Figures*, which is a detailed squared-for-transfer guide-drawing for the painting *Nudes against a Red Background*, 1923 (Öffentliche Kunstsammlung, Basel).[1] In the much larger painting (145 × 97 cm), Léger has isolated the nude figures against an undifferentiated red ground, whereas in the relatively small drawing the figures are enclosed in a frame cut from copper, imparting a precious quality to the work, not unlike that of a religious icon.

In 1922, when he drew *Two Figures*, Léger faced the challenge of wedding two seemingly contrary traditions: the classical and the modern. Léger mined the classical past for formal antecedents, just like other artists in the era following World War I who sought a *retour à l'ordre* through classicism. Still he wished to be stylistically independent of his predecessors, for his goal was to be absolutely contemporary and to invent an art that would express the power of modern life. According to Léger and the purist artists with whom he associated in Paris in the early twenties, the experience of modernity should reflect precision and balance – values associated with the classical world.

The subject matter – female nudes, silent and monumental – speaks to classical concerns. Léger's friend, the great publisher Tériade, noted in a 1928 monograph on Léger that similar static figures are found in Greek art. The two massive figures in the Toronto drawing, silhouetted against a neutral ground, have also been compared to Roman mosaics from the Baths of Caracalla depicting muscular athletes. Images of the mosaics were published in December 1921 in *L'Esprit Nouveau*, a journal read by Léger.

Two Figures is decidedly modern. By drawing the heavy contour lines in lead pencil and adding shading around them, leaving the blank paper to create highlights, the artist gives flesh the sheen of cold metal. This is accentuated by his choice of textured watercolour paper, which imparts a chased metallic look to the graphite, making the figures appear as if they have been constructed from highly polished pieces of interlocking steel. The geometric body parts of the two figures have a factory-made look to them, like pieces mass-produced on an assembly line. Drained of any sensuality, Léger's nudes seem more akin to the photographically enhanced engine parts that were illustrated in the motor magazines he enjoyed reading. His focus was so attuned to the machine that at a dance hall in 1923, while utterly transfixed by one of the dancers, Léger is said to have exclaimed, "Look at that woman, she's beautiful! Like a gas meter!" MPT

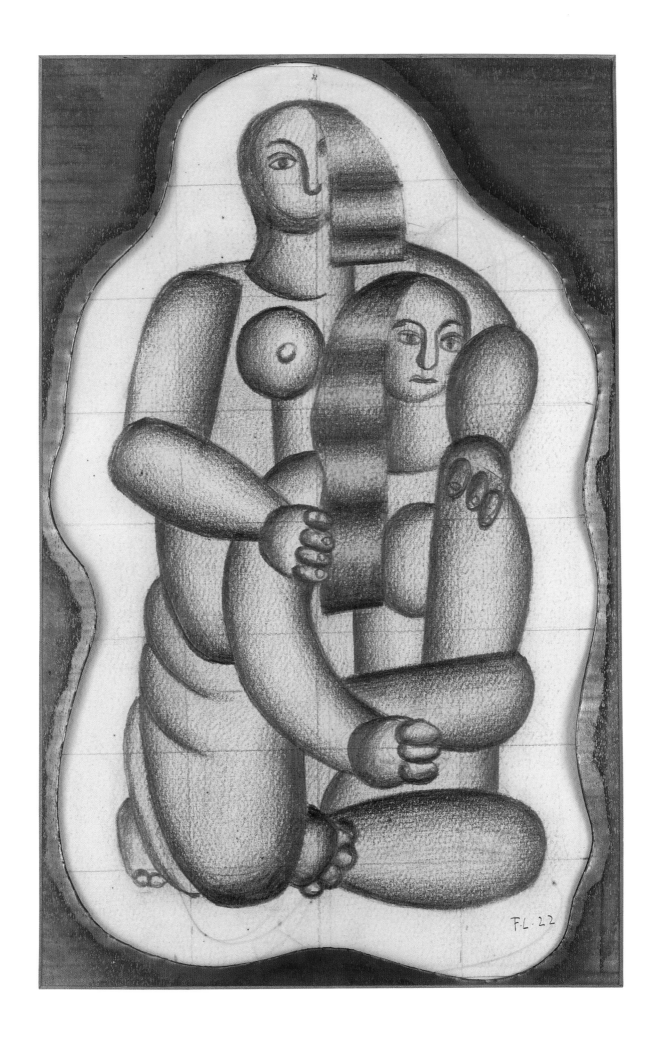

86 ANDRÉ MASSON

Balagny-sur-Thérain 1896–1987 Paris

The Legend of Corn, 1942

Watercolour and gouache on wove paper
56.2 × 76.3 cm
Signed and dated in pencil l.l.: *André Masson 1942*
Gift of Sondra and Allan Gotlieb, 1999
99/784

During the 1920s André Masson experimented with automatic drawing and biomorphic abstraction in collaboration with a number of surrealist poets. He thus contributed the visual means to further surrealism's goal of subverting reason and investigating the workings of the unconscious. Masson's preoccupation with eroticism and his fascination with metamorphosis in all its forms not only informed much surrealist thought, but also provided the fuel for a lifetime of creativity that was to propel him well beyond surrealism.

After the occupation of France in 1939, Masson and his family fled to New Preston, Connecticut, through the assistance of the American Emergency Rescue Committee. During his American exile from 1941 to 1945, Masson became fascinated with American Indian nature myths. He realized that parallels could be perceived between the mythology of the ancient Greeks and the legends of the Iroquois, whom he believed (erroneously) were indigenous to Connecticut. Masson was also interested in the elemental forces of growth and germination that he observed in the American landscape. *The Telluric Landscapes (Peinture Tellurique)*, as he called his brilliantly coloured paintings of this period, are based on an abstract treatment of plant and animal life transformed through metamorphosis. One of Masson's most successful fusions of the creation myth with anthropomorphic imagery is the Toronto watercolour *The Legend of Corn*.

Masson saw a relationship between the so-called Iroquois legend of the Corn Maiden and the classical metamorphosis myth of Apollo and Daphne.[1] The artist is known to have made at least three related works.[2] In each, two figures appear to grow out of a recumbent form that is pregnant with kernels shown as miniature heads (with eyes, noses and mouths) of corn. The vibrantly painted figure rising at left represents the sun god, who has fallen in love with the divine maiden who emerges from the underworld at right. Attempting to escape, she is transformed by his rays into the first cornstalk. Since corn is central to many American Indian fertility cults, Masson's interpretation of the legend is consistent with his vision of America as a symbol of gestating energy and abundance.

MPT

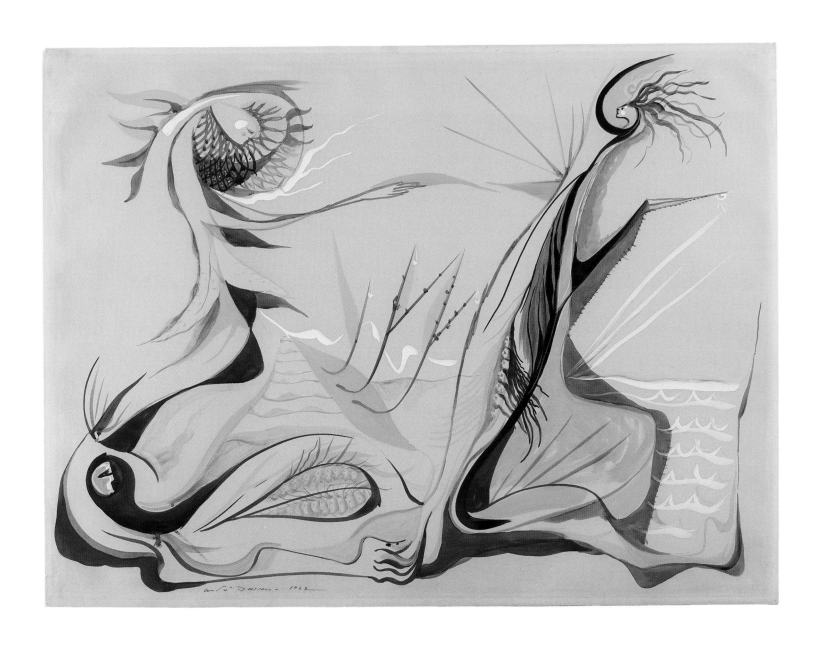

87 PABLO PICASSO

Málaga 1881–1973 Mougins
Head of a Man, 1967

Brush and black ink on wove paper
74.9 × 56.5 cm
Signed and dated u.l.: *31.7.67/Picasso*
Watermark: "Picasso"
Gift of Mr. and Mrs. Sidney Bregman, 1988
88/360

Between 1966 and 1968 Pablo Picasso created thousands of drawings that revisited themes and styles explored in the course of a long and prolific career. In this drawing, the eighty-five-year-old Picasso reveals his renewed interest in the art of the past, particularly ancient art and classical antiquity. The square head, angular profile and pattern of dots used to render the hair and beard in *Head of a Man* recall conventions of Assyrian bas-relief (1500–612 BC) and Archaic Greek sculpture (c. 600–480 BC). Picasso said in 1923, "The art of the Greeks, of the Egyptians, of the great painters who lived in other times, is not an art of the past; perhaps it is more alive today than it ever was."[1] During the so-called *retour à l'ordre* of the 1920s, Picasso, like many of his contemporaries, looked to classical sources and mythology. The lessons he learned remained with him for the rest of his career. He stated his admiration for antiquity once again in 1932: "Raphael is a great master, Velázquez is a great master. El Greco is a great master, but the secret of plastic beauty is located at a greater distance: in the Greeks at the time of Pericles [c. 495–429 BC]."[2]

Although Picasso never visited Greece, being Spanish by birth he was steeped in Mediterranean culture. He was also well acquainted with ancient art from visits to the Louvre and museums in the south of France, and trips to Rome, Naples and Pompeii. In 1927 he met the Greek art historian Christian Zervos, who founded *Cahiers d'Art* during the 1930s and later published books on neolithic and Minoan art in Crete, Cycladic sculpture, and early Greek art.[3] Antiquity was not, however, something that Picasso pursued on its own. It was one of many sources. The artist's genius lay in his ability to assimilate all styles without being enslaved to any of them.

The Toronto drawing belongs to a series of eight large-format ink sketches of a male head that Picasso made from 30 July to 3 August 1967.[4] This one is dated 31 July 1967. Working with the paper attached vertically to his easel – a method that can be detected in our drawing through the vertical drip of a brush loaded with ink – Picasso explored possibilities in seemingly rapid succession. Whether the artist was inspired by a sculpture or a studio model, a reproduction of a work of art, or his imagination, we do not know. With economy of line Picasso created a complex image that requires the viewer to piece together the facial components. This is reminiscent of his cubist manner of simultaneously presenting frontal and profile views of the head. He uses a convention – a simple U-shaped stroke and dot – for the eye seen in profile found frequently in his paintings of the same decade. While the dotted pattern of the hair and beard recall both Assyrian and Archaic Greek sculpture, whether Picasso's source can ever be identified is moot. As Cowling and Mundy observed, "The classical tradition remained for him a stimulus and a resource; but his immersion in it never involved uncritical imitation, and his own powers of creativity were never crippled by the weight of its authority."[5] MPT

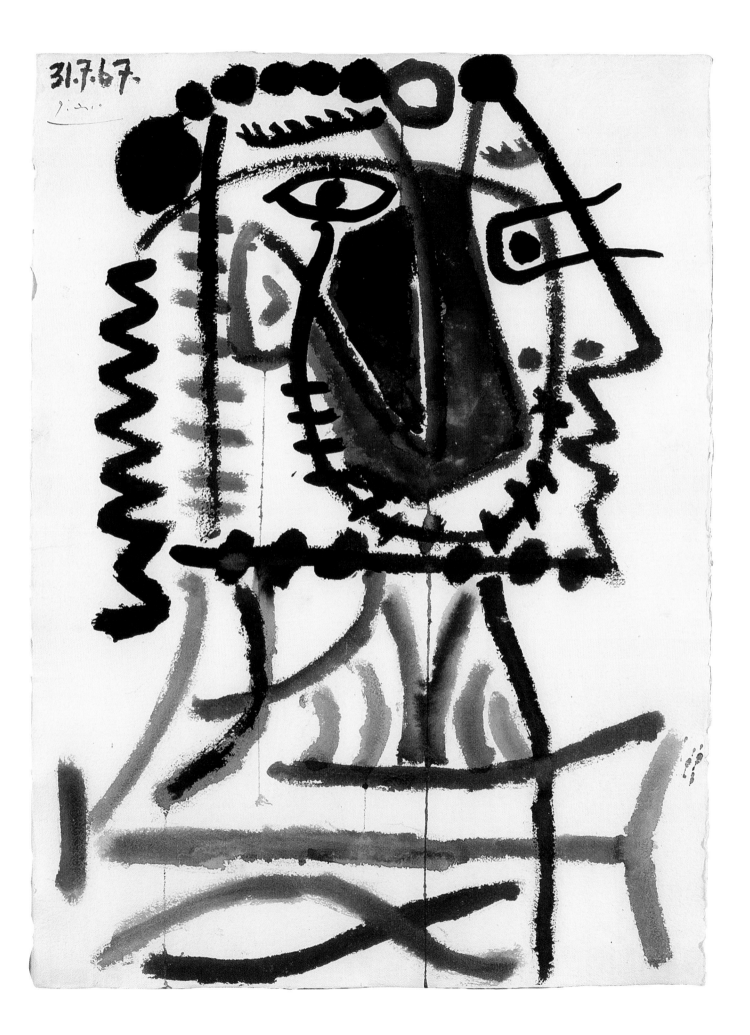

88 VANESSA BELL

London 1879–1961 Charleston, Sussex

Design for Small Screen, c. 1920

55.2 × 25.1 cm (each panel)
Watercolour and gouache, with chalk, charcoal and graphite, and with paper collage
elements including printed wallpaper on wove paper
Purchased with donations from AGO members, 1991
91/152

Along with Roger Fry and her long-time partner, Duncan Grant, Vanessa Bell was one of the key visual artists of the Bloomsbury group that also included Bell's sister, Virginia Woolf, John Maynard Keynes and the art critic Clive Bell. Together they extolled an anti-utilitarian approach to art inspired by the colours, lines and forms of French postimpressionism and ethnic and decorative art.

It was in this group context of exchange and experimentation that Bell's art developed. Although her earlier naturalistic works had been praised by Walter Sickert in 1909, her painting took a dramatic turn after Fry's exhibitions of French postimpressionism in 1911. With Fry's encouragement, Bell experimented wildly with vibrant colours and increasingly abstract designs over the next decade. Working closely with Grant during this period, she eventually toned down her palette, became deeply interested in design and widened her sources of inspiration, as this Japanese-inspired folding screen attests.

Fry, Bell and Grant started the Omega Workshops in 1913, and Bell worked steadily on projects there until the Workshops closed in 1919. Omega was described as a "co-operative workshop-cum-showroom" in which artists directed their interest in abstraction and colour toward projects like fabric, wall panels, lighting and screens. For Bell and Grant, like their Arts and Crafts predecessors in Great Britain, it was the integration of art with daily life that made it meaningful. It was in these forms that Bell and Grant produced some of their most original work, much to the chagrin of more traditional modernists like Roger Fry. In 1920 Fry wrote to Bell lamenting, "I wish you wouldn't always paint your best things just to decorate odd corners of your house . . ."[1]

Bell's designs were more abstract and less riddled with figuration than Grant's. That delicate restraint is evident in this folding screen, which is essentially an ambitious three-dimensional collage. Although there are representational aspects, including a sketch of a vase and some floral imagery, the overall effect is of linear, lyrical abstraction in rich, if muted, tones of burnt sienna and lavender. Perhaps because of her interest in art *and* design, Bell saw no material limits to the means she could use to achieve her layered, rich effect. In this case, she has used papers bought in Italy in 1920 to animate the surface. While some of the papers are left untouched, others are overpainted with a simplified version of their own graphic design, suggesting that these papers may have originally been intended as sources of inspiration. In this piece, one can see the process by which Bell created her livable modern art of clear but not rigid abstract designs. SP

89 STANLEY SPENCER

Cookham-on-Thames 1891–1959 Clivedon

Head of a Girl, 1925

Graphite on wove paper
35.2 × 25.1 cm
Signed and dated in graphite l.r.: *Stanley Spencer/1925*
Purchased with donations from AGO members, 1991
91/154

Stanley Spencer's contribution to British figurative art, and particularly portraiture, transcends both the artist's eccentric imagination and the insular British tradition from which he emerged. Affinities may be established with a range of artists from Otto Dix and Max Beckmann to Thomas Hart Benton and John Curry. In the field of portrait drawing, Spencer's legacy is found in the work of British artists from Francis Bacon to Lucian Freud.

Born in the quaint Berkshire village of Cookham-on-Thames, Spencer nurtured a love and knowledge of local places and colourful types that would assume paramount importance in his oeuvre. As a teenager, he travelled twenty-five miles to London each day to study at the prestigious Slade School of Art. At that time the Slade considered draftsmanship, rather than painting, the most important element in an artist's development. Spencer's course of instruction from 1908 to 1912 focused almost exclusively on drawing from life – a cornerstone of the Slade's teaching method ever since its founding in 1871, based on the French academic system.

Under the rigorous tutelage of Henry Tonks, students were trained to look at the essential lines of their subject and to communicate its basic form. Above all, Tonks taught Spencer how to use a pencil to render the human figure in light and shade. For Tonks, drawing carried an almost religious significance. Indeed he would lecture his students on the privilege of being an artist and impress upon them "that to do a bad drawing was like living with a lie." He believed that the true purpose of art was to record nature objectively. A belief in the moral probity of drawing would inform Spencer's work throughout his career.

While serving with the Royal Army Medical Corps in Macedonia during World War I, Spencer began to sketch informal portraits of fellow soldiers and nurses in military hospitals. His concern for his fellow man was fostered by an empathy for the human condition that gave him insight into a sitter's personality. After the war, these attributes would help confirm Spencer's choice to portray the working-class subjects that he had observed in Cookham.

Spencer's fascination with unidealized types was captured brilliantly in an extensive number of pencil portrait "heads" made during the twenties. He often started, as in *Head of a Girl*, by concentrating on the sitter's eyes. Here he utilizes the hard pencil outline and delicate shading learned at the Slade. The angular eyes and faceted shadows between the nose and lips of the unidentified sitter suggest a stylistic familiarity with Wyndham Lewis's vorticism, Britain's own version of cubo-futurism. The immediacy that Spencer generated in his pencil portraits through the direct observation of his subject was not often equalled in his commissioned oil portraits of the forties and fifties.

In recent years Spencer's work has received growing attention, with retrospective exhibitions mounted in the United Kingdom, Canada and the United States. Toronto is now a prime centre in North America to study the artist, and since 1992 local collectors have given the Art Gallery of Ontario almost two hundred Spencer drawings. MPT

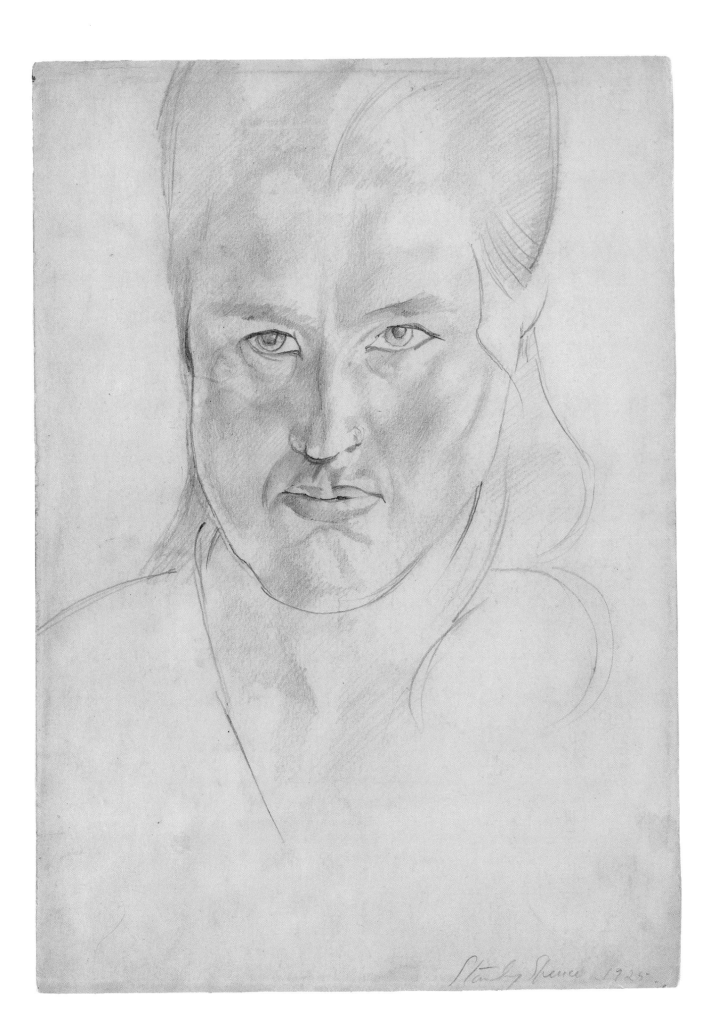

HENRY MOORE
Castleford 1898–1986 Much Hadham
Group of Shelterers During an Air Raid, 1941

AG 41.62; HMF 1808
Graphite, pen and ink, brush and ink, wax crayon, chalks, and scraping out on wove paper
36.8 × 53.3 cm
Gift of the Contemporary Art Society, 1951
50/64

Henry Moore is remembered primarily as one of the greatest sculptors of the twentieth century. But drawing was also such a significant activity for the artist that from time to time it overshadowed his work in three dimensions. Moore considered draftsmanship "a second string in one's bow," and it was through the process of drawing that he understood how to transform the human form into sculpture.

When World War II disrupted his activity as a sculptor from 1940 to 1942, Moore employed drawing as his primary medium. During the Blitz, which began in September 1940, about 100,000 people sought refuge from the nighttime bombing raids on the platforms of the London Underground. For Moore art and life seemed to merge – he saw Londoners taking shelter as "hundreds of Henry Moore reclining figures stretched along the platform." According to Moore, "even the holes out of which the trains were coming seemed to me to be like the holes in my sculpture." In this sheet, five ghostly figures huddle in a tunnel illuminated by a foreground light.

Moore was appointed an official British war artist in 1940 after he showed Kenneth Clark the drawings in his "First Shelter Sketchbook." Working from memory, between autumn 1940 and summer 1941 Moore executed some three hundred drawings in two separate sketchbooks along with eighty loose sheets from other sketchbooks. From these he selected about sixty-five, squared them for transfer and used them as the basis for larger finished drawings for the War Artists' Advisory Committee. This sheet, which comes from this group of drawings, was based on the lower section of a page from the Second Shelter Sketchbook.[1]

Close examination of the drawing reveals a grid of pencil lines beneath a complex mixed-media overlay of pencil, chalk, pen and ink, wash, watercolour and wax crayon. By accident, Moore discovered the unconventional modus operandi of wax-resist when he made a drawing for his niece using wax crayon stumps. Exploiting the repulsion of wax and watercolour, Moore created a dark wash background for his waxy figures. To give detail to the group, he added India ink, which could be scraped down with a knife if the greasy buildup was too great.

There is a remarkable relationship between Moore's drawing and sculpture. While the protective hood of one of the seated figures in *Group of Shelterers During an Air Raid* recalls small bronze helmet-heads Moore made between 1939 and 1940, the axe-like head of the figure at the far right has been shown to prefigure the head of the bronze *Warrior with Shield*, 1953–54.[2] These links are a reminder that the drawing combines observation and memory with abstract elements drawn from the imagination. Moreover the texture of the drawing was also carried over into sculpture. The grainy, pitted and scumbled surface treatment that gives the figures their three-dimensional appearance anticipates the rough patination found on the artist's plaster sculptures made after 1950, which are held in the Art Gallery of Ontario's collection, now the world's most comprehensive public repository of his work. MPT

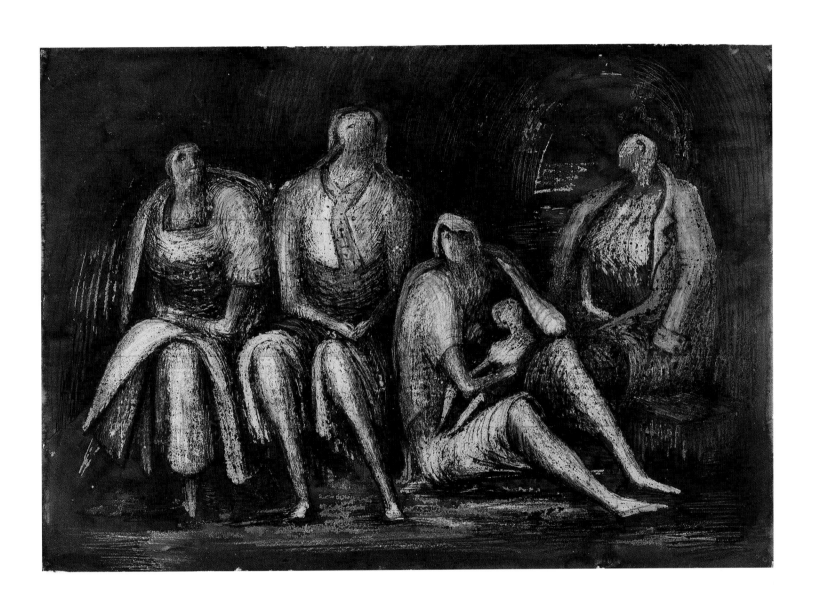

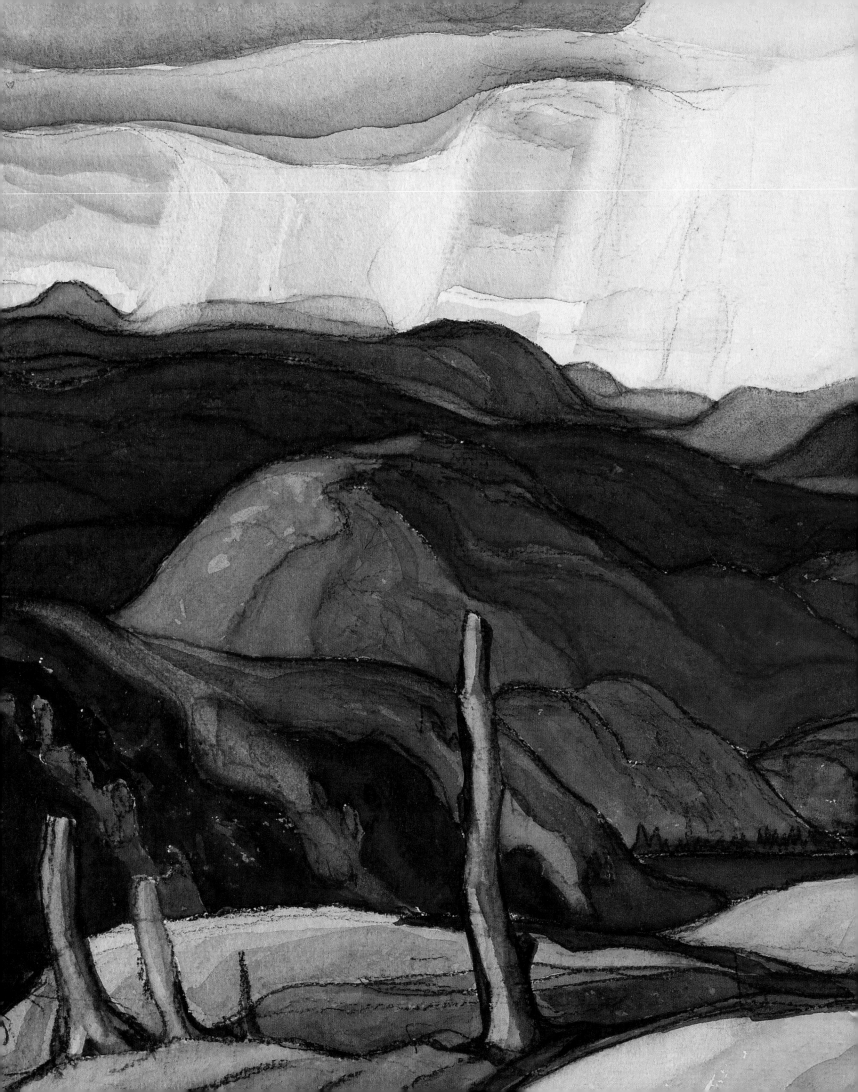

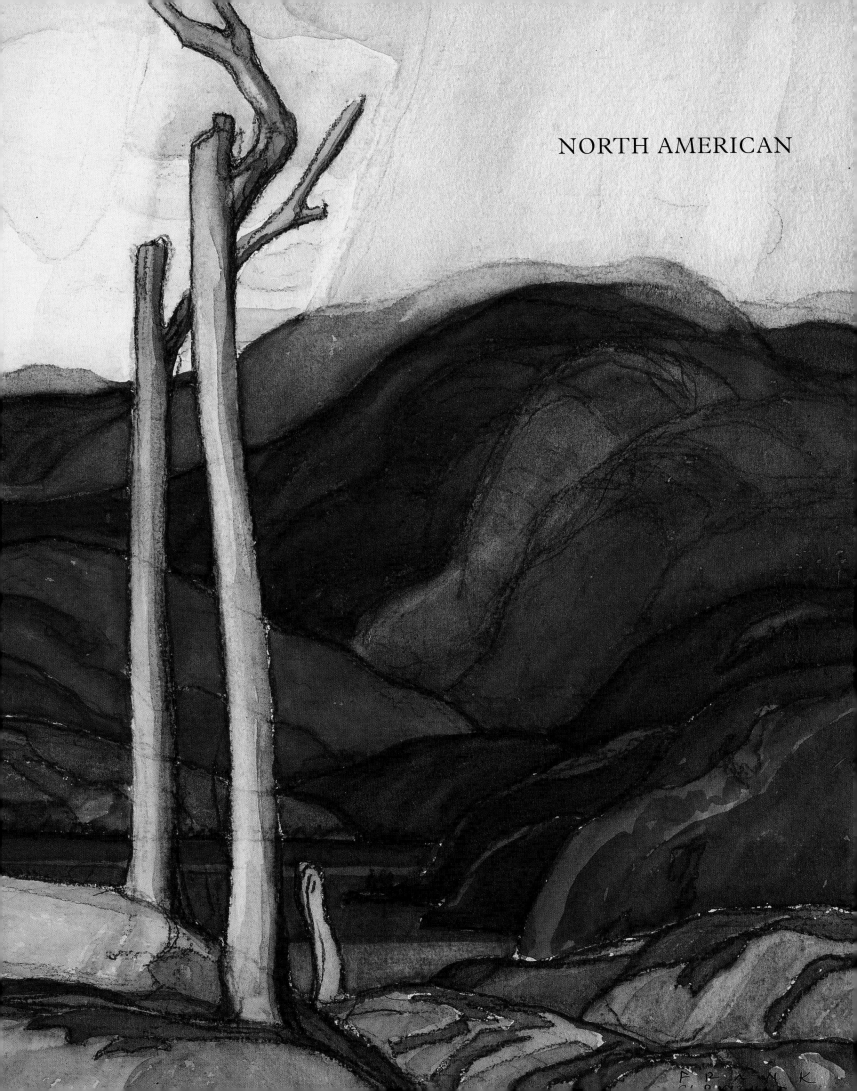

91 JAMES WILSON MORRICE

Montreal 1865–1924 Tunis

Casino by the Sea, c. 1921

Graphite and watercolour on wove paper mounted on board
26.6 × 36.5 cm
Signed in graphite l.r.: *Morrice*
Inscribed in graphite on verso: *Nice*
Studio stamp on verso
Purchase, 1925
776

A pioneer of modernism in Canada, James Wilson Morrice was an international figure. He was born in Montreal but used Paris as his base throughout his career. He painted in France, North Africa, Canada and the Caribbean, and exhibited regularly in Canada, Paris and London. His friend and sometime painting companion Henri Matisse (cat. 82) remarked shortly after Morrice's death that the Canadian artist "was always over hill and dale, a little like a migrating bird but without any very fixed landing-place."[1]

While Morrice worked almost exclusively in watercolour when he started painting seriously in the mid-1880s, he had largely abandoned the medium by the early nineties in favour of sketches in oils on small wooden panels. These *pochades* were informed in their turn by drawings in pocket sketchbooks when worked up to exhibition canvases in his Paris studio. Around 1910 he began to use watercolour again (while continuing to make oil sketches), and the bulk of his production in this medium, principally North African and Caribbean subjects, dates from that time to shortly before his death.[2] The translucent washes of his late watercolours inspired a new fluidity in his oil paintings. At the same time, he reached a level of freedom and spontaneity in these watercolours that was never achieved in his oils.

Judging by a preparatory drawing in a sketchbook Morrice carried on the trip, *Casino by the Sea* was likely painted in the winter of 1921–22 while he was travelling via Nice and Corsica to Algiers and Tunis.[3] The subject, the Casino de la Jetée-Promenade, one of two casinos then in Nice, was destroyed by bombing during World War II.[4] Morrice seems to have been anticipating his North African destination in this choice of subject, featuring the Moresque elements of the casino's architecture and the startling contrasts of azure blue and dark green against delicate pink and yellow so characteristic of a Mediterranean setting. This fauve colouring is skilfully presented within the simplified dynamic composition that is the hallmark of his mature style, the whole scene brought to life with washes and suffused with brilliant light and the sensual delicacy of the dancing shadows of trees.

During the 1920s the south of France, and Nice in particular, was a mecca for French artists who were eager to escape the hothouse postwar Paris scene. They included Matisse and Dufy, whose watercolour *The Mosque at Marrakesh* (cat. 84) demonstrates the similar style and subject matter of the three artists.

The North African connection is significant as well. Morrice's friendship with Matisse grew deeper when they spent two months together in Tangier early in 1913, and then another six weeks or so the following winter when they were joined by Charles Camoin.[5] Morrice did not go back to North Africa until March 1922. At the end of the following year, he returned to Tunis, where three weeks later he died. DR

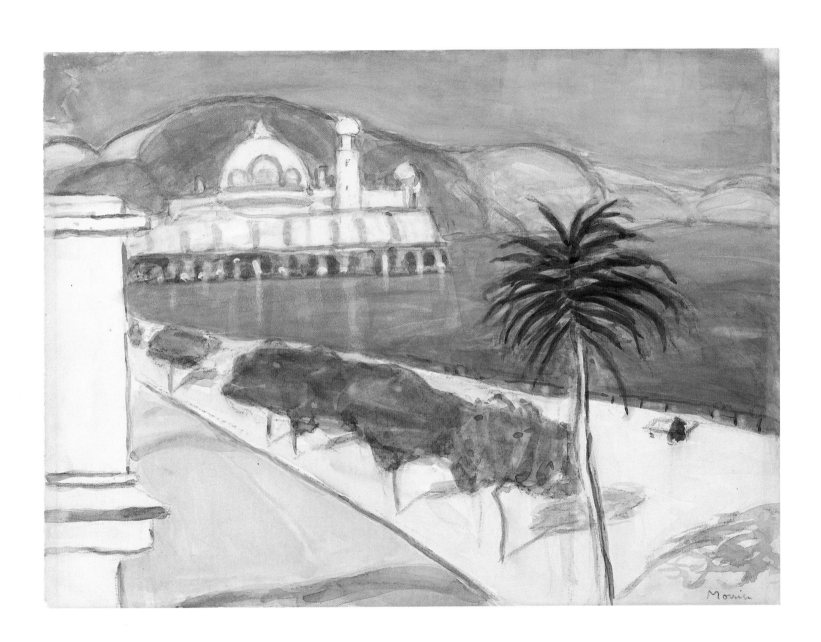

Victoria 1871–1945 Victoria

Stumps and Sky, c. 1935

Oil on wove paper
Signed l.r.: *M E CARR*
58.4 × 90.2 cm
Gift from the Douglas M. Duncan Collection, 1970
70/31

One of Canada's most celebrated and influential artists, Emily Carr has had a profound effect on Canadian art and imagination. Born in 1871 in Victoria, BC, she travelled to the United States and Europe for her artistic training. During her stay in France from 1910 to 1911, Carr encountered, absorbed and made her own the innovations of postimpressionism, in particular the art of Gauguin (cat. 40), Cézanne, van Gogh (cat. 23) and the Fauves.[1] She returned to her beloved British Columbia where First Nations villages, forests, beaches and sky continued to inspire her until the end of her life in 1945. *Stumps and Sky* is one of Carr's best examples of "fresh" landscape painting. She wrote, "Even sketches to me are canned food. I like it fresh, carry it right home and use it."[2]

In the early 1930s, after a hiatus from painting between 1914 and 1927, Carr developed a unique oil-on-paper technique that led to the creation of some of her most sophisticated and highly original works of art. Partly driven by finances, she experimented by thinning her oil paints with gasoline. This allowed her to work outdoors with the speed and facility that watercolour permits, but with the permanence and luminosity of oils. As a result, Carr was able to develop her splendid vision of wide open skies, beaches and forests. Fluid and dynamic, these fantastical portraits of the BC landscape are vivid investigations of rhythm and movement in colour and line.

Carr described the process: "Those are not watercolours. It is a kind of sketching medium I have used the last 3 or 4 years. Oil paint used thin on paper. I feel I have gained a lot by its use. It is inexpensive. Light to carry and allows great freedom of thought and action. Woods and skies out west are *big* you *can't* squeeze them down . . . What I'm after is out there in the woods."[3]

Carr's use of exposed paper is an essential part of the painting's composition. She accurately described the paper as "mechanical woodpulp construction paper,"[4] a crude wood pulp that was not intended to be durable. This kind of paper typically becomes brittle and discolours from a light tone to a dark yellow or light brown when exposed to light and air. The use of gasoline further exacerbated the inevitable discoloration; however, this process freed Carr to pursue what "she was after."

Most likely painted on the spot, *Stumps and Sky* is complete in its delivery of a powerful image of the transcendental qualities of nature. This dramatic view seems to bend at its sides. The sky curves down, the land curves up, while the intense light in the centre is the life force of the work. Three highly energetic white swirls that dominate and intensify the vast blue sky are set in contrast with the dense and chaotic yellows, greens and browns of the forest and earth. Carr is able to make forest and sky breathe with energy. Her dynamic work engulfs the viewer in its hypnotic, ethereal rhythms. GU

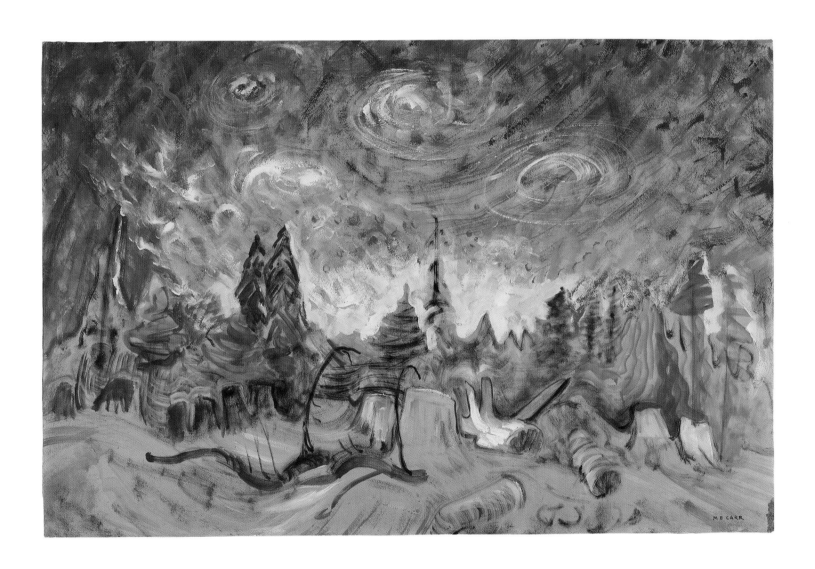

93 TOM THOMSON

Claremont 1877–1917 Canoe Lake
Study for "Northern River," 1914–15

Gouache, brush and ink over graphite on illustration board
30.0 × 26.7 cm
Estate stamp l.l.; estate stamp (verso)
Purchase, 1982
82/176

Tom Thomson is a legendary figure in Canadian art. He was tutored by a band of Toronto painters who later exhibited together as the Group of Seven, and perfectly embodied their vision for a national landscape school, free of European affectation. Thomson had been exhibiting for only four years, but was in his prime when he drowned in Canoe Lake, Algonquin Park, in 1917. The rapidity of his development, the assuredness of his vision, and his tragic death have only added lustre to his reputation and have become integral to his enduring legend.

The canvas *Northern River* (fig. 1), based on the present study, was painted in Thomson's Toronto studio over the winter of 1914–15 and exhibited in March 1915 at the annual exhibition of the Ontario Society of Artists. One review pointed out that it was one of a number of canvases in the exhibition "that revels in what the rest of the world might consider the country's defects," collectively asserting the position "that a landscape is not beautiful in proportion as it is reminiscent of Europe."[1] It is now seen as a nexus of the converging interests, values, influences and sources that united the emerging Toronto Group, ranging from contemporary Scandinavian painting and decorative art through art nouveau and the Arts and Crafts movement to practices inherent to commercial design of the period.[2] The painting, which was purchased from the exhibition by the National Gallery of Canada, has become an icon of Canadian art.

This gouache is the only known sketch for a canvas in a water-based medium. For five years Thomson had made preparatory sketches in oils on small wooden panels, working from nature. It is evident from the medium employed and the level of detail that this work was not made in the field. It is, rather, an idealized concept of the unspoiled "North" that, while it may have been based on recollections of a specific site,[3] is nonetheless "an invention, an amalgam of the important issues then swirling about, an ideal."[4] While narrower, darker and less detailed than the canvas, it is in every sense a "finished" work. Thomson had worked in graphic design for ten years before devoting himself to painting full-time, and the manipulation of the heavy gouache is a tribute to his skill in this commercial medium.

The drawing was acquired from Thomson's estate in 1916 by Sir Edmund Walker through the intervention of Dr. James MacCallum, an early patron and close friend of Thomson.[5] A prominent Toronto banker, Walker played a critical role in the founding of the Art Museum of Toronto (now the Art Gallery of Ontario) in 1900. As chairman of the board of the National Gallery of Canada in 1915, he played an active part in the purchase of the canvas of *Northern River*. One can imagine the pleasure he derived from the possession of this study, a link both to the revered artist and the heady swirl of ideas and aspirations that had informed Canada's first national school of artists. DR

fig. 1:
Tom Thomson
Northern River
1914–15
oil on canvas
115.1 × 102.0 cm
National Gallery of Canada, Ottawa,
purchased 1915 (1055)

94 DAVID BROWN MILNE

Burgoyne 1882–1953 Bancroft

Reflections, Bishop's Pond, 22 August 1920

Watercolour over graphite on wove paper
38.1 × 56.1 cm
Watermark: "J WHATMA[N]"
Signed l.l.: *David B. Milne/Aug 22 '20*
Gift from the J.S. McLean Collection, Toronto, 1969;
donated by the Ontario Heritage Foundation, 1988
L69.45

Born to Scottish immigrant parents in a log cabin in Burgoyne, Ontario, Milne was raised in the nearby village of Paisley. After teaching school for a year, he left for New York in 1903 to study art. There he attended the Art Students' League, haunted commercial galleries, museums and libraries, and supported himself by making show cards for shop windows.

Milne achieved major recognition for his brilliant, staccato watercolours, three of which were included in the landmark Armory Show of 1913. However, he abhorred the commercial aspects of the art world and crumbled under the stress of life in New York. He longed to return to a simple life close to nature where he could devote himself exclusively to painting. In 1916 he discovered Boston Corners, a tranquil hamlet in the Berkshire hills situated at the intersection of the New York, Connecticut and Massachusetts state lines. He rented a seventeenth-century farmhouse and began to develop a new style, palette and subject matter.

He was drawn to the American Transcendentalist philosophy articulated by Ralph Waldo Emerson, Walt Whitman and William Henry Thoreau. Emerson encouraged artists to live close to nature, seek "correspondences" to human emotions, and transform them into works of art. Thoreau's *Walden*, one of Milne's two favourite books, was to be another major source of inspiration.

Bishop's Pond, a small body of water close to the farmhouse, was to become Milne's Walden Pond. There he began work on a series of "reflections" inspired by his favourite artists, James McNeill Whistler and Claude Monet. He flattened the picture space, raised the horizon line, and started to create a series of variations on the theme. He was technically innovative, dragging a sable brush loaded with clear water over areas of dry pigment to create reflections. His artistic program was interrupted by World War I when, in 1917, he enlisted in the Canadian Army. While serving as a Canadian war artist he developed a new "dry brush" technique by dragging a damp hog's hair brush through cakes of dry watercolour.

After returning to Boston Corners in 1920 Milne recommenced the series, combining these new techniques. This poetic work encapsulates layers of metaphors: it pays homage to his artistic, philosophical and literary forebears, and invites the viewer to reflect on vision and reality, the beauty of Creation and the role of the artist. It illustrates perfectly his method and goal: "the painter gets an impression from some phase of nature … he simplifies and eliminates until he knows exactly what stirred him, sets this down in colour and line … and so translates his impression into an aesthetic emotion."[1]

When Milne returned to Canada in 1929 he did not fit into the Canadian national school either programmatically or stylistically. Believing that artists should focus on aesthetic problems, he distanced himself from the Group of Seven (cats. 93 and 95) and declared that he never wanted to be more than "one of one." He continued to look for ways to live a simple life close to nature, and created an independent body of evocative and poetic watercolours that is unique in the history of the medium. KL

95 FRANKLIN CARMICHAEL

Orillia 1890–1945 Toronto

Snow Clouds, 1927

Watercolour and gouache over graphite on wove paper
43.7 × 57.2 cm
Signed and dated l.r.: *FRANK/CARMICHAEL/1927*
Gift from the Reuben and Kate Leonard Canadian Fund, 1928
1278

Born in Orillia, Ontario, Franklin Carmichael studied drawing and painting at the Académie Royale des Beaux-Arts in Antwerp in 1913–14. During that year he combined his formal study of drawing with landscape watercolours. Draftsmen whose works inspired him included R.G. Hatton and John Sell Cotman (cat. 55).

Following his return to Canada in September 1914, Carmichael became an active member of the Toronto art scene. He spent much of the first winter with his friend Tom Thomson (cat. 93) who died in 1917. In the aftermath of World War I, a Toronto-based national landscape movement emerged. Known as the Group of Seven, it was committed to developing an approach to the Canadian landscape that would express its topographic peculiarities. Carmichael was a founding member and was affiliated with the Group until it disbanded in 1932.

While most of the members focused on oil painting, Carmichael returned to watercolour in 1924 following a trip to the Upper Ottawa River. He went on to explore Lake Superior in 1925, 1926 and 1928. On all of these trips, watercolour was an important medium of expression. Drawing served as his starting point, a graphic underlay to guide the subsequent application of paint. The impressive scale of his watercolours, and his unique juxtaposition of flat coloured washes, distinguished them from watercolours produced by other members of the Group.

It was in the mid-1920s that Carmichael commenced what would become an ongoing series of larger-scale "finished" watercolours (approximately 43 × 56 cm). He considered them complete works of art in their own right, not studies for oil paintings. He deliberately allowed the underdrawing to show through the transparent, semi-transparent and, at times, almost opaque washes.

At the same time Carmichael was reading spiritual and theosophical writings and scientific theories related to reincarnation and afterlife. In much the same way as it did for his friend and fellow Group member Lawren S. Harris, nature became for Carmichael a metaphor for transcendental experiences, and the raw wilderness a metaphor for spiritual concepts. *Snow Clouds* demonstrates Carmichael's preference for the essential forms, dramatic skies, stark contrasts of light and dark, and sense of infinite space found in barren landscapes. It was probably conceived during a trip with Harris to the north shore of Lake Superior in 1926 and may have been shown in the 1927 exhibition of the Canadian Society of Painters in Water Colour. Carmichael co-founded this organization in 1925 in a successful effort to enhance the status of the medium in Canadian art.

Although Carmichael had a successful practice as a commercial designer and played an important role in the Toronto art scene as head of the commercial art department at the Ontario College of Art, Toronto (1932–45), he continued to paint the Canadian landscape throughout his career. CM

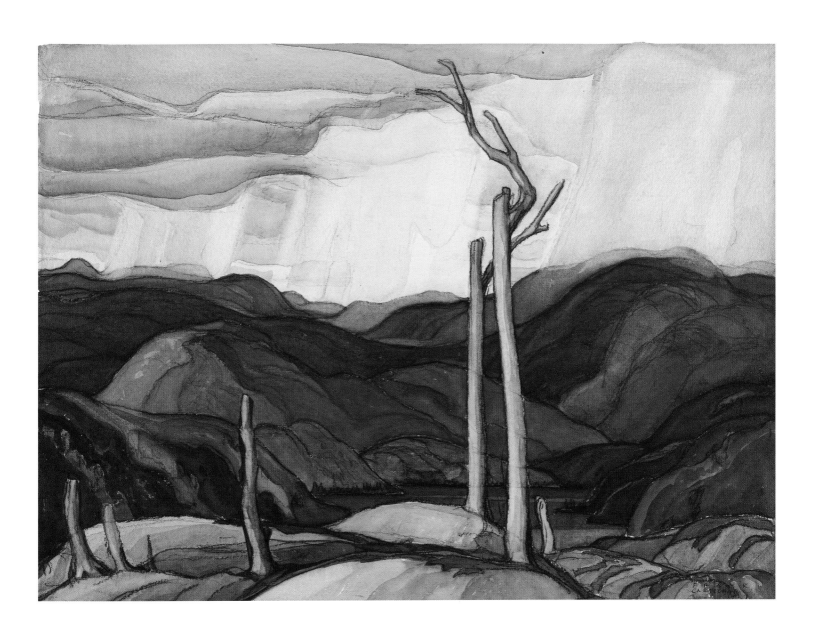

96 CARL SCHAEFER

Hanover 1903–1995 Toronto

Storm over the Fields, 1937

Watercolour over graphite on wove paper
38.1 × 57.1 cm
Blind stamp on verso: *Dixon's/David Cox/Drawing*
Signed and dated l.l.: *Carl Schaefer 1937*
Inscribed on verso: *Dark Rough/July 11, 1937/JS McLean/Storm over the fields*
Gift from the J.S. McLean Collection, 1969; donated by the Ontario Heritage Foundation, 1988
L69.46

The rolling and rhythmic landscape of Carl Schaefer's childhood home in the farming community of Hanover, Grey County, Ontario, inspired his most powerful paintings.

The artist made his career in Toronto where he emerged in the early 1930s as the most promising young member of the Canadian Society of Painters in Water Colour. Through this medium he perfected quick and direct depictions of the rural countryside. Community life, lived in harmony with nature, was a new subject in Canadian art. In contrast to the robust wilderness landscapes of the Toronto-based Group of Seven, Schaefer brought a fresh, young interest to what Graham McInnes, a critic for the Toronto weekly *Saturday Night*, described as "the land as it looks after Canadians have tilled it, lived by it and died in it."[1]

Like his colleagues in a small, but intense, circle of painters in Depression-era Toronto, Schaefer was a socially conscious artist who believed the arts were seriously undervalued. For a painter who, in 1937, lacked full-time work and whose family struggled to make ends meet, his insistence on the social relevance of art was a call for respect. When the Spanish Civil War began in 1936, raising fears that democracy would soon be threatened by a global conflict, Schaefer's painting grew more symbolic and solemn.

Schaefer often returned to Hanover, where he painted this watercolour "in the field" on 11 July 1937. Between the two world wars, Grey County developed into an industrial and agricultural hub on the Great Lakes. *Storm over the Fields* was made prior to Schaefer's oil painting (fig. 1) of the same year. Of the two, the watercolour is the more passionate depiction of home. He employed his favourite palette of brown, green and gold to convey the heavy atmosphere of an approaching summer storm. The high vantage point provides a comprehensive picture of the rich, moist earth and the magnificent patterning of the farmlands threatened by the first crack of thunder. The artist understood the moment to presage World War II.

Schaefer met and befriended David Milne (cat. 94) in 1936. Milne admired Schaefer's "splendid watercolours" and in 1937 returned to the medium he had abandoned for twelve years. Each artist carefully crafted his paintings so as to exploit the immediacy and fluidity of the medium. In the flash of a watercolour brush stroke, Schaefer and Milne caught the rich simplicity of compositional balance, order and harmony.

Schaefer sold *Storm over the Fields* in 1938 to the Toronto industrialist J.S. (Stanley) McLean. "Ever since you first came to my place to look at my work . . . in the fall of 1936," wrote the grateful Schaefer, "I felt you were truly a friend and sincere appreciator, and as you say, artists are the most approachable of people."[2] AH

fig. 1:
Carl Schaefer
Storm over the Fields
1937
oil on canvas
68.7 × 94.0 cm
Art Gallery of Ontario, Toronto, gift from the
J.S. McLean Canadian Fund, 1954
(53/51)

97 PAUL-ÉMILE BORDUAS

Saint-Hilaire 1905–1960 Paris

Abstraction, 1942

Gouache over charcoal on wove paper
59.2 × 43.5 cm
Signed and dated l.r.: *Borduas/42*
Gift from the Junior Volunteer Fund, 1977
77/18

This is one of forty-five gouaches that Paul-Émile Borduas showed in his first solo exhibition, *Les Œuvres surréalistes de Paul-Émile Borduas*, in Montreal in 1942. The event not only constituted Borduas's personal artistic breakthrough, but was also the first time in Canada that, as François-Marc Gagnon notes, "a painter dared to evoke the authority of surrealism in the title of an exhibition."[1]

Borduas's gouaches provided the basis for the formation of the Automatiste movement in Montreal: he and his colleagues were the first Canadian artists to be true avant-garde innovators rather than followers, and their discoveries were, for that time, as groundbreaking as current international developments in Paris and New York.

In the gouaches Borduas sought to work with the total freedom promised by the surrealist technique of automatic writing. As he explained at the time, "I begin with no preconceived idea. Faced with the white sheet, my mind free of any literary ideas, I respond to my first impulse."[2] First he laid down the drawing, working instinctively in terms of movement, rhythm, volume and light, and then he proceeded to apply the colour with similar freedom. He was careful, however, to distance himself from European "psychic automatism," which, in the work of such artists as Dali and Tanguy, always ended up evolving into literary ideas.

His own "superational automatism," in contrast, was a process that gave no thought to expressing content. In the gouaches, meaning was not so much conveyed by the artist as directly evoked in the viewer by the abstract formal values of the work itself. Although Borduas did not speak in Jungian terms, unlike the abstract expressionists in New York, he believed that automatism allowed him to tap into an "acute knowledge of the psychological content of any form, of the human universe – in short, the universe itself."[3]

With any automatically generated work, however, it is impossible to be quite sure where uninhibited spontaneity stops and when conscious decision-making intervenes to bring the work to formal completion. In a broader historical context this gouache – given its biomorphic forms, its fluid line, its flattened colours, its intertwined surface patterns and its ambivalent semi-figurative subject matter – unquestionably owes something to Miró's paintings of the 1930s.[4]

Like the Europeans, Borduas could not always resist discovering intimations of representation in his automatically derived doodlings – the disembodied Picassoid eye in the upper right and the bird-fish in the bottom middle – but his conviction lay on the side of unmediated formal expression. For this reason the gouaches were not originally titled but merely numbered 1 to 45. When literary titles were added, it was after the fact and often in collaboration with collectors. The title of this work, *Abstraction*, is probably a latter-day misnomer. Borduas never described the gouaches as "abstractions," because in both Montreal and Paris during the early 1940s this terminology was used exclusively by members of the alternative European tradition of geometric abstraction. RN

Guanajuato 1886–1957 Mexico City
Day of the Dead, c. 1936

Watercolour with ink and pastel on brown laid paper
48.3 × 62.4 cm
Watermark: "INGRES"
Signed in ink l.l.: *Diego Rivera*
Gift from the J.S. McLean Collection, by Canada Packers, 1990
89/904

Mexico's Day of the Dead festival is celebrated annually on the first two days of November. It is a time when Mexican families remember their dead by visiting, cleaning and decorating the graves of departed loved ones, and keeping an all-night vigil at the gravesites to greet the spirits when they return. Diego Rivera's watercolour depicts a peasant woman keeping vigil in a simple country cemetery.

Consistent with his interest in depicting the colourful local customs and practices of the Mexican people, Rivera treated this subject a number of times in a variety of media. He was one of a triumvirate of Mexican muralists, along with José Clemente Orozco and David Alfaro Siqueiros, who painted important public murals in both Mexico and the United States in the 1920s and 1930s.

Despite its relatively small scale, *Day of the Dead*, like Rivera's enormous murals, demonstrates the artist's interest in the modernist simplification of forms, flattening of pictorial space, use of indigenous motifs and the dry, fresco-like quality of the painted surface. The solitary form of the woman wrapped in a shawl against the cold night is silhouetted against the high burial mounds in the background that are illuminated by large torches. The negative spaces, such as the area between the woman's back and the tree trunk, carry as much visual weight as the solid forms themselves, creating surface tension. The forms, with their dark contour lines, are treated simply, using a minimum of descriptive brushwork.

It is significant to the understanding of Canadian art that *Day of the Dead*, bought from a dealer in Mexico City, found its way into the private collection of Toronto businessman J.S. McLean, president of Canada Packers, in 1946. Since the 1930s McLean had been a collector of Canadian art, especially art that could be classified as "socially engaged modernism."[1] His interest in socially engaged Mexican art demonstrates its relevance to Canadians at that time. The Mexican school was held up as an exemplar of a strongly national, modern and revolutionary school of painting that addressed the people directly. This appealed to many Canadian artists searching for a more humanistic alternative to the nationalist landscape idiom that had prevailed since the 1920s.

From the early 1930s, Rivera was well known to young Canadian artists, many of whom travelled to Mexico. An exhibition entitled *Mexican Art Today* was shown at the National Gallery of Canada, the Montreal Art Association and the Art Gallery of Toronto between July and November 1943, indicating the level of official recognition awarded to the Mexican school in Canada by that time and the desire to make Mexican art accessible to a wider public. This watercolour was included in a smaller exhibition held at the National Gallery in October 1946, *Contemporary Mexican Painting and Furniture*, along with many of McLean's other recent Mexican acquisitions. It signifies the tremendous impact that the Mexican school had on Canadian art and artists in the 1940s and beyond.

CB

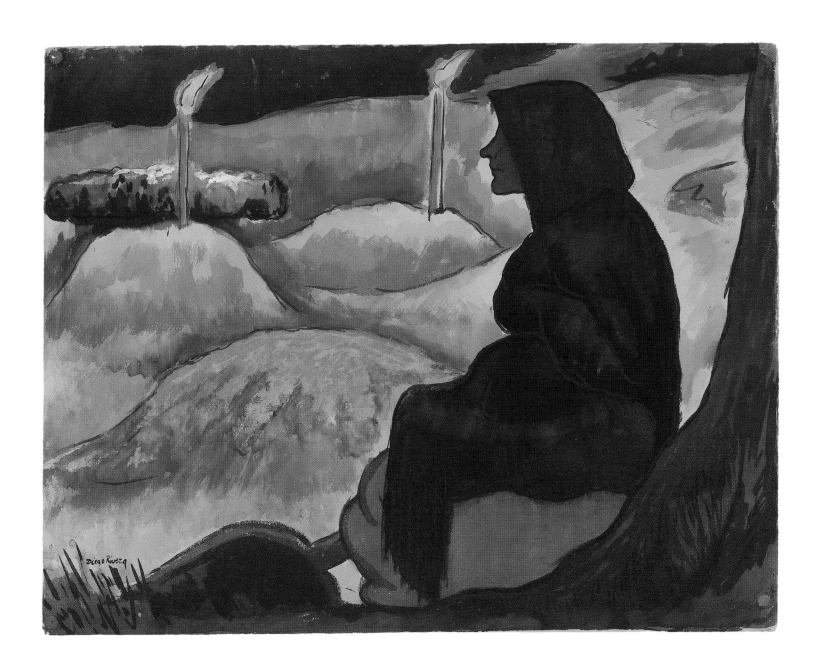

99 WILLEM DE KOONING

Rotterdam 1904–1997 East Hampton
Two Women on a Wharf, 1949

Oil, enamel, graphite and collage on wove paper
62.1 × 62.4 cm
Signed l.r.: *de Kooning*
Purchase, Membership Endowment Fund, 1977
77/68

Of all the major artists of the abstract expressionist generation in New York, Willem de Kooning really stood alone in never completely abandoning representation. He painted his most abstract pictures between 1948 and 1950, but they too are always haunted by vestiges of human anatomy, even as we see only biomorphic shards jostling one another in the shallow space of analytic cubism. *Two Women on a Wharf*, from the same years, anticipates the great series of female figures he began working on in 1950, which stands at the core of his long artistic production.[1]

Two Women on a Wharf has been much exhibited and reproduced but only rarely commented on, which is curious given its concentrated power and, despite its small size, its monumental authority. The catalogue of de Kooning's retrospective at the Whitney Museum in 1975 classified it as a "painting" rather than a "drawing." It is violently aggressive, the drawing agitated and fractured and the paint robustly slashed and smeared. Nevertheless, the bodies of the two women remain largely intact: the woman on the left with one arm roughly sketched in pencil, and the other a long mauve paint streak. The left-hand figure's small head, a composite of face-on and profile view, recalls Picasso. The figure on the right in comparison seems all head, with shiny black, blank enamel eyes and stick legs. She wears a collaged-on hat inscribed with yet another figure. The paint is juicy and the palette voluptuous, if not frankly erotic. In places, notably in the lower centre-right, are some intimations of the wharf structure, and in the upper left some brush strokes of green suggest a group of trees providing a background to this charming summer lakefront or seaside scene.

Also striking is de Kooning's use of collage. Parts of the composition are covered with pieces of thin, smooth and partially translucent paper, like a thick tracing paper, which is held in place by dots of adhesive and torn pieces of masking tape. De Kooning often used collage as a working technique, trying out changes or new ideas before permanently committing to them. The sense of transience embodied in this process, along with the bare paper surrounds and brusque technique, suspends the drawing/painting as if in an ongoing state of creative struggle, a naked look, so to speak, that de Kooning preferred in contradistinction to modern French painting's predilection for finish and perfection.

The subject matter of these "savage dissections," as Clement Greenberg once called them, of the female figure has long been a subject for debate. They have been read as hostile and misogynist, as admiring embodiments of earth mothers or pagan idols, as sexual avengers, or as parodies of the postwar idealizations of the all-American girl depicted in magazine ads, whose smiling mouths de Kooning often cut out and occasionally collaged into his paintings. Whichever, there is as much hilarity as *gravitas* in this full-frontal depiction of the two women on the wharf. RN

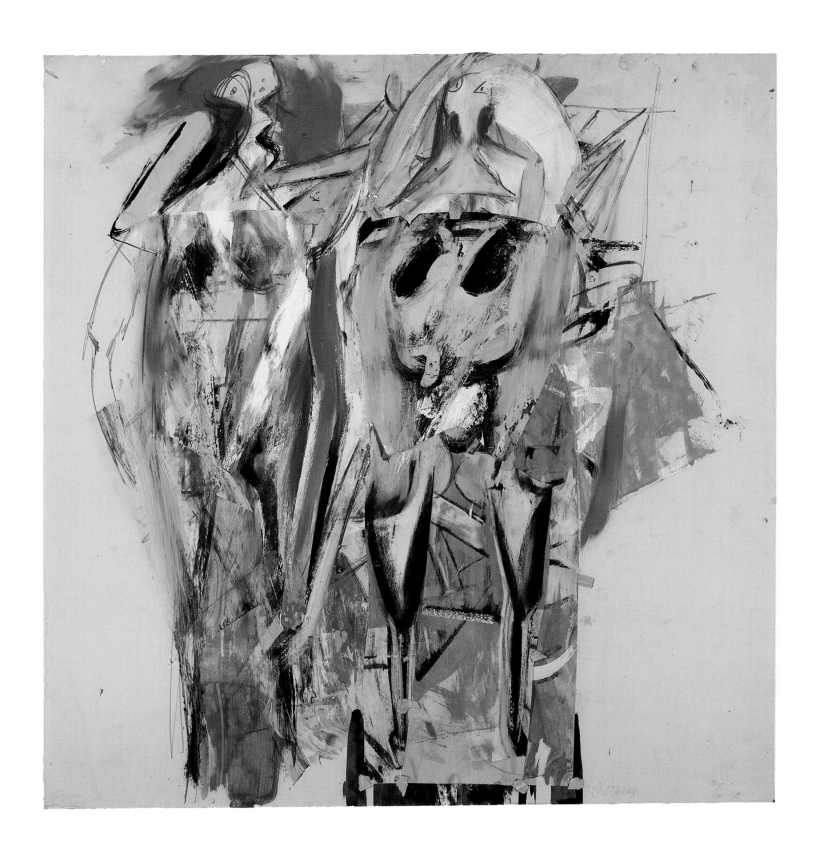

100 JACKSON POLLOCK

Cody 1912–1956 East Hampton

Untitled, 1946

Spatter, pen and black and coloured inks, gouache, watercolour and sgraffito
on heavyweight watercolour paper
56.2 × 76.8 cm
Signed and dated l.l.: *Jackson Pollock/46*
Gift of the Volunteer Committee Fund, 1976
76/199

This remarkable work is unique for Jackson Pollock in the mid-1940s. He more commonly atomized his drawing style into whirlwinds of calligraphic scratches and graffiti scribbles filling up the frame in ways that anticipate his abstract all-over "classic" drip paintings, the first of which appeared in 1946. This drawing, by contrast, is unusual for its dedication to imagery, enclosed forms, powerful local colour and taut structure. Highly finished, it is thought through in detail and, with its technical virtuosity, stands as monumentally self-sufficient.

What do we make of its strange collage of images: the yellow sgraffito-bodied, big-eyed biomorph – both sad surrealist bird and grotesque Picassoid face – about to be squashed by a huge red handbag, or is it by one of those one-ton cartoon weights that fall out of the heavens onto hapless victims? The three black uprights – which grew wispy, ciliated edges when the black ink soaked into the blue wash background – echo the crude stickmen found elsewhere in Pollock's drawings. But they are elegantly rendered, like ornamental coat racks or andirons or ceremonial lances, or perhaps the cooking hardware that carries the spit that skewers the bird. Middle right, from one of the uprights, sprouts the weightless and feathery, tattered wing of a butterfly or the petals of a flower. Or do we see emblematic smoke and fire? The arrow that flies across the blue happy-face moon may have been shot from New York's Museum of Natural History where Pollock had avidly studied the Northwest Coast and Inuit collections.

What have we but an existentialist psychodrama of uncertain interpretation? It is cast in the imagery of surrealism and of tribal art, reflecting the interest of American artists of the time in Jungian archetypes and in the collective unconsciousness (Pollock himself had undergone Jungian psychotherapy during the early 1940s). But Kirk Varnedoe has warned us against interpreting Pollock too specifically. His images may "trumpet their connection to myth, archetype and things primordial," Varnedoe writes, but their use of the unconscious finally "seems more impersonally of its time than revelatory of something unique to Pollock."[1]

Whatever role surrealist automatist techniques may have played in inciting Pollock's symbolic images, in *Untitled* he exults in them, whereas in other drawings and paintings of 1946 he began the process of burying the representational under the maze of his linear pours. Nevertheless, if this is the most imagistic of the drawings he created in 1946, it is perhaps also the least illusionistic. He has flattened his images onto a squared-off, centralized scaffolding that tautly aligns itself with the edges of the paper. This is abstract structure iterated for its own sake, and it is emphasized in just the way that Pollock would on later occasions draw a grid into his all-over pour-generated drawings. It was necessary perhaps to remind the viewer that, although it is not overtly visible in the classic drip paintings, the grid is always their substructure, hiding somewhere in their depths and ensuring their pictorial coherence. RN

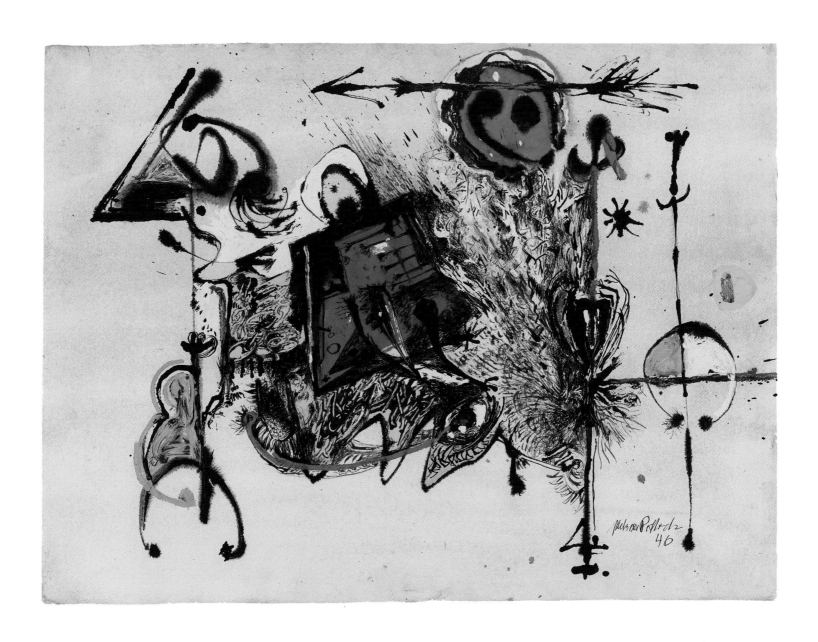

ENDNOTES TO THE CATALOGUE ENTRIES

ITALIAN SCHOOL

cat. 1

1 Crispian Riley-Smith has pointed out that Rizzo proposed that Donnino may be identified with the so-called Master of Santo Spirito, an artist whose work reflects the influence of Ghirlandaio, Filippino Lippi and Perugino, although Fahy does not agree. She has since attributed another drawing in the Berlin Kupferstichkabinett to him: "Agnolo di Donnino: Nuovi Documenti, le Fonti e la possibile identificazione con il 'Maestro di Santo Spirito,'" *Rivista di Arte* 4 (1988): pp. 125–68, figs. 3, 4. The attribution is based on an old, possibly contemporary, inscription found on a silverpoint drawing of a male nude in the British Museum and a study of a head in the Uffizi.

2 Francis Ames-Lewis, *Drawing in Early Renaissance Italy* (London: Yale University Press, 1981), p. 169.

3 Vasari 1906, vol. 7, pp. 174–75.

4 A.B. Hinds's translation in Vasari 1970, vol. 2, p. 55.

cat. 2

1 Michael Hirst, *Michelangelo and his Drawings* (New Haven, Conn.: Yale University Press, 1988), p. 8.

2 Sotheby's London, 9 July 2003, lot 9, p. 16. Michelangelo's drawing of the male torso recently appeared at auction, Christie's New York, 24 January 2006, lot 18.

3 Hirst 1988, p. 40. Regarding the drawing formerly in the Gathorne-Hardy collection, Hirst 1988, p. 69, has also pointed out "the tremulous handling of the chalk, now almost like charcoal, and a kind of translucence in the surface of the forms, all pointing to a date closer to 1560 than 1550."

4 See his magnificent drawings of the risen Christ from the early 1530s and the frescoed figure of Charon at the lower right of the *Last Judgement* in the Sistine Chapel, completed in 1541. Rarely, though, did he show the knee bone (patella) so far from the side that it projects beyond the outline of the leg, as in the present drawing. For the right knee seen from behind, see his presentation drawing *The Archers* from about 1530 and certain figures in his *Last Judgement*, especially those on the left-hand side.

5 K.T. Parker, *Catalogue of the Collection of Drawings in the Ashmolean Museum, Volume II, Italian Schools* (Oxford, 1956), cat. 339; Johannes Wilde, *Italian Drawings in the Department of Prints and Drawings in the British Museum: Michelangelo and His Studio* (London, 1953), pp. 116–18.

cat. 3

1 John Shearman, "Die Loggia der Psyche in der Villa Farnesina und die Probleme der letzten Phase von Raffaels graphischem Stil," *Jahrbuch der Kunsthistorischen Sammlungen in Wien* 24 (1964): pp. 67–70.

2 John Shearman, *Raphael in Early Modern Sources 1483–1602* (New Haven, Conn., and London: Yale University Press, 2003), pp. 385–86, cat. 1519/1.

3 Paul Joannides, "The Giulio Romano Exhibition in Mantua," *Paragone* 40 (Sept. 1989): p. 67. Joannides points out that the

diamante, the Medici device of three diamond rings, appears to be represented at the bottom of the verso.

4 Istituto Nazionale per la Grafica, Rome, inv. no. F.N. 2838. Kristina Herrmann Fiore, *Disegni degli Alberti* (Villa Farnesina, Rome: Gabinetto Nazionale delle Stampe, 1983), p. 176, cat. 108.

5 Respectively, National Galleries of Scotland, Edinburgh, inv. no. D.5145; and Musée du Louvre, Paris, inv. no. MI 1120 verso.

6 An engraving by Giulio Bonasone of approximately the same scene (but in reverse) further testifies to the composition's initial renown. Adam von Bartsch, *Le peintre graveur*, Walter L. Strauss, ed. (New York: Abaris Books, 1854–67), vol. 15, p. 153, cat. 167.

7 It has been proposed that the figure was intended for a scene of Psyche bathing, but there is no supporting evidence of this. Bernice Davidson, "A Study for the Farnesina 'Toilet of Psyche,'" *The Burlington Magazine* 129 (1987): pp. 510–13. Oberhuber in Mantua 1989, p. 348, dates the drawing to Romano's early years in Mantua (c. 1526–28), but this proposal has not met with subsequent support; see especially Paul Joannides, "Raphael and his Circle," *Paragone* 51 (March 2000): pp. 36–37.

cat. 4

1 Vasari's entry on Salviati in his *Lives of the Most Excellent Painters, Sculptors and Architects* (2nd ed., 1568) is among the most well-informed of his famous biography. Vasari was unconditionally supportive of Salviati's work, not only as a friend but also as a staunch advocate of Tuscan artists.

2 See David McTavish et al., *The Arts of Italy in Toronto Collections 1300–1800*, exh. cat. (Art Gallery of Ontario, 1981–82), p. 35.

3 Overall, the painting reverses the drawing's general composition; the number and deportment of attending figures has also been altered, as has the pose of the angel.

4 For instance, Salviati reused aspects of this Lamentation group in later works, such as a *Pietà* painted for Cosimo de' Medici (1545–46) now in the Palazzo Pitti.

5 Michael Hirst has linked the eccentric, dance-like pose of a resurrected Christ appearing in Salviati's tapestry design for Cardinal Benedetto Accolti (1545) to antique sources such as those found in mosaic pavements ("Francesco Salviati: Some Additions and Reflections," in *Francesco Salviati et la Bella Maniera: Actes des colloques de Rome et de Paris (1998)* (École française de Rome, 2001), pp. 69–89). This element of iconographic capriciousness within Salviati's oeuvre has led some to characterize his work as "burlesque," although his choice of allusion is always highly nuanced and apposite, albeit unconventional.

cat. 5

1 Roberto Paolo Ciardi, ed., *Gian Paolo Lomazzo: Scritti sulle Arti* (Florence: Marchi & Bertolli, 1973), vol. 2, p. 315.

cat. 6

1 Kupferstichkabinett, inv. no. KR 5716. Naldini's drawing in Berlin is noted in *Old Master Drawings*, exh. cat. (P. & D. Colnaghi & Co., London, 1986), cat. 10. It seems that Naldini also wished to explore the pose in reverse, as the outlines of the head and body have been indented with a stylus so that they appear in the opposite direction on the verso of the drawing. The verso also contains a detailed red chalk study of a length of drapery tied in the middle in a knot, and a black chalk study of a young man wearing a cap, which has been squared for transfer in both red and black chalk.

2 Leon Battista Alberti, *On Painting and On Sculpture: The Latin Texts of De Pictura and De Statua*, bk. 2, part 36, Cecil Grayson, trans. and ed. (London: Phaidon, 1972), p. 75.

3 For example, London, British Museum, inv. no. 1893-7-31-16, for Naldini's study of a young male studio assistant posing for the figure of an old woman; Nicholas Turner, *Florentine Drawings of the Sixteenth Century*, exh. cat. (British Museum, London, 1986), p. 211, cat. 160.

cat. 7

1 Janet Cox, "Pontormo's Drawings for the Destroyed Vault of the Capponi Chapel," *The Burlington Magazine* 98, no. 634 (January 1956), pp. 17–18; and John Shearman, *Pontormo's Altarpiece in S. Felicita* (Charlton Lectures Series: University of Newcastle upon Tyne, 1971).

2 Milwaukee 1989–90, p. 187.

3 Christ Church, Oxford, inv. no. 0651; James Byam Shaw, *Drawings by Old Masters at Christ Church, Oxford* (Oxford: Clarendon Press, 1976), cat. 533. Taddeo also devised a related pose for Elymas in his fresco in San Marcello al Corso, Rome; for which see J.A. Gere, *Taddeo Zuccaro: His Development Studied in His Drawings* (Chicago, 1969), pl. 89.

4 This connection was first made by Mundy in Milwaukee 1989–90, p. 187. The altarpiece is now in the Museo dell'Opera del Duomo, Orvieto.

5 Respectively, inv. no. 1895-9-15-573, John A. Gere and Philip Pouncey with Rosalind Wood, *Italian Drawings in the Department of Prints and Drawings in the British Museum: Artists Working in Rome c. 1550 to c. 1640* (London, 1983), pp. 189–90, cat. 297; and inv. no. 613, Veronika Birk and Janine Kertész, *Die italienischen Zeichnungen der Albertina: Generalverzeichnis* (Vienna: Böhlau, 1992–97), pp. 333–34, cat. 613. For a discussion of the preparatory drawings, see Gere and Pouncey 1983, pp. 189–90; and Cristina Acidini Luchinat, *Taddeo e Federico Zuccari, fratelli pittori del Cinquecento* (Rome: Jandi Sapi Editori, 1998–99), p. 42, note 92.

cat. 8

1 P. Bjurstrom, C. Loisel and E. Pilliod, *Italian Drawings: Florence, Siena, Modena, Bologna* (Stockholm: Nationalmuseum, 2002), cat. 1388, col. pl. 22.

cat. 9

1 Herwarth Röttgen, ed., *Il Cavaliere d'Arpino* (Rome: Palazzo Venezia, 1973), p. 155, cat. 39.

2 Ibid. This sculpture was originally intended for the tomb of Pope Julius II, but it had long since left Italy by Cesari's lifetime, having been transported to France in the mid-1540s. Cesari may have become familiar with the pose of the original through such reproductive formats as prints, drawings or a *modello* copy. All these sources were commonly used in sixteenth-century studio practice.

3 Unearthed in Rome in 1506, this antique work continued to exert a powerful imaginative hold upon artists throughout the century.

4 The church was demolished in the late nineteenth century: Herwarth Röttgen, *Il Cavaliere Giuseppe Cesari d'Arpino: un grande pittore nello splendore della fama e nell'incostanza della fortuna* (Rome: U. Bozzi, 2002), p. 290.

5 One caveat to this proposal is that Michelangelo's *Bound Slave*, another sculpture from the Julius II tomb, assumes a like mien in its struggle against bondage. Although this does not prevent the AGO drawing from being a preparatory work for the lost painting, it is possible that Cesari turned to multiple sources from within the same artist's oeuvre as the initial inspiration for this work.

6 Cesari employed drawing at every stage in his artistic practice. First he developed poses and attitudes for his figures through a process of experimentation, as this work demonstrates. He then combined these studies into increasingly complex narrative compositions. Finally, in keeping with the standard practice of the time, Cesari created large-scale cartoons in order to transfer his images onto the monumental formats in which he so often worked.

cat. 10

1 See Denis Mahon and Nicholas Turner, *The Drawings of Guercino in the Collection of Her Majesty the Queen at Windsor Castle* (1989), cats. 338 and 339.

2 See Maria Mrozinska, *I Disegni del Codice Bonola del Museo di Varsavia* (Venice: Fondazione Giorgio Cini, 1959), cat. 78. Ryan Whyte kindly pointed out Barbara Haeger's reference that "the spider symbolizes both the devil and heretics" in her article "Rubens's *Adoration of the Magi* and the program for the high altar of St Michael's Abbey in Antwerp," *Simiolus* 25 (1997): p. 59, footnote 1. See also Richard Spear's chapter on witches in *The "Divine" Guido* (1997), pp. 44–50.

3 *Perosa* implies stony and was an adjective used in the Renaissance to indicate Perugia. I am grateful to Dr. Giordano Berti for this suggestion.

cat. 11

1 For example, "*Raphael interpretatur Curatio vel Medicina Dei*," in Guillaume Durand's thirteenth-century *Rationale divinorum officiorum*, cited by Louis Réau,

Iconographie de l'Art Chrétien (Paris: Presses universitaires de France, 1956), vol. 2, p. 53. Mrs. Jameson in the mid-nineteenth century called Raphael "the prince of guardian spirits, the guardian angel of all humanity," Mrs. [Anna B.] Jameson, *Sacred and Legendary Art* (London: Longman, Brown, Green, Longmans, & Roberts, 1848), vol. 1, p. 92.

2 Giuliano Briganti, *Pietro da Cortona o della pittura barocca* (Florence: Sansoni, 1962), pp. 147, 258, cat. 127, pl. 274. An accompanying painting of the archangel Michael, now lost, was paid for at the same time.

3 Christie's London, 30 March 1971, lot 8. For the drawing, see Blunt and Cooke 1960, p. 79, cat. 604, inv. no. 4519.

4 J.M. Merz, "Cortona-Studien" (Ph.D. dissertation, Universität Tübingen, 1985), p. 290. Bonacina's engraving (21.5 × 15.3 cm) is in the same direction as the Toronto drawing, whereas Cassart's (21.8 × 15.8 cm) is in reverse. Both engravings are slightly smaller than the Toronto drawing, but they repeat the composition with only minor variations, such as the drapery around the waists of the two protagonists and the angle of Raphael's wings. It is almost certain, then, that Cortona made the drawing specifically as the model for an engraving.

5 He specifically compares it to a drawing by Cortona (inscribed *1647*) of the return of Hagar (Louvre, inv. no. 474), which Jacob Bean, *Dessins romains du XVIIe siècle* (Paris: Musée du Louvre, 1959), p. 25, cat. 25, characterized as "*fait pour être présenté à un amateur.*"

6 John Milton, *Paradise Lost* (1667), bk. 5, lines 221–22.

cat. 12

1 Filippo Baldinucci, *Notizie dei professori del disegni da Cimabue in qua*, F. Ranalli, ed. (Florence: 1845–47), vol. 5, p. 162.

2 F.M.N. Gabburri, cited by G. Ewald in *The Twilight of the Medici: Late Baroque Art in Florence, 1670–1743*, exh. cat. (The Detroit Institute of Arts; Palazzo Pitti, Florence, 1974), p. 318.

3 Baldinucci 1681–1728, vol. 5, pp. 180–89; Maria Cecilia Fabbri in *Il Seicento Fiorentino, Arte a Firenze da Ferdinando I a Cosimo III*, exh. cat. (Palazzo Strozzi, Florence, 1986), vol. 2, pp. 347–50.

4 Baldinucci 1681–1728, p. 186.

5 Louvre, Paris, inv. no. 0499; Arthur Ewart Popham, *Correggio's Drawings* (London: Oxford University Press, 1957), p. 160, cat. 53.

6 Albertina, Vienna, inv. cat. 23997; Alfred Stix and L. Fröhlich-Bum, *Die Zeichnungen der toskanischen, umbrischen und römischen Schulen, beschreibender Katalog der Handzeichnungen in der graphischen Sammlung Albertina* (Vienna: Schroll, 1932), p. 69, cat. 669. For other drawings for the dome frescoes, see M.C.F. in Florence 1986, vol. 2, pp. 348–50.

cat. 13

1 Mahoney suggests Rosa could have absorbed Riberesque influences second-hand – from his brother-in-law and veritable follower, Francesco Fracanzano; see Michael Mahoney, *The Drawings of Salvator Rosa* (Outstanding Dissertations

in the Fine Arts), 2 vols. (New York and London: Garland, 1977), pp. 40–42.

2 Jonathan Scott, *Salvator Rosa: His Life and Times* (New Haven, Conn., and London: Yale University Press, 1995), p. 216. Scott asserts that Rosa's drawings were acquired en bloc by Queen Christina after Rosa's death. For a complete history of this collection, see Mahoney 1977, pp. 24–25.

3 There are several studies of figures wearing cypress boughs both with and without caps: Rosa's allegorical etching, *Genius of the Artist*, from about 1662, in Scott 1995, pp. 158–61, fig. 165; his painted *Self-Portrait* from the mid-1650s (Metropolitan Museum, New York), including the attendant preparatory sketches; and his *Portrait of Riccardi* (Metropolitan Museum, New York); see Mahoney 1977, figs. 24.6–24.10.

cat. 14

1 Roger de Piles, *Cours de peinture par principes*, Jacques Thuillier, ed. (Paris: Gallimard, 1989), p. 169.

2 Martin Folkes, *Journal*, Oxford, Bodleian Library, MS Eng. misc c.444, 22, cited by Bruce Redford, *Venice and the Grand Tour* (New Haven, Conn., and London: Yale University Press, 1996), p. 93.

cat. 15

1 There exists a painting quite similar in composition, now in Leipzig, which is dated to 1727, the year preceding that inscribed on this sheet. It appears that Panini revisited the motifs of an earlier painting in order to create this drawing, doing so perhaps at the request of a client. In the process, he modified the architectural surround of the source image, creating a less enclosed composition (Toronto 1981–82, p. 94). In the eighteenth century, such drawings as this were considered works of art in themselves and were accordingly allotted permanent means of display, rather than being consigned to portfolios for periodic contemplation, as had largely been the case in the past.

cat. 16

1 The Beurdeley album in the Hermitage measures 44.0 × 30.0 cm; the Quaderno Gatteri in the Civico Museo Correr measures 44.5 × 28.5 cm; George Knox, *Giambattista and Domenico Tiepolo: A Study and Catalogue Raisonné of the Chalk Drawings* (Oxford: Clarendon Press, 1980), sections A and C.

2 For these dates, see George Knox, "G.B. Tiepolo and the Ceiling of the Scalzi," *The Burlington Magazine* 110 (July 1968): p. 397.

3 For a good reproduction, see George Knox, *Tiepolo: A Bicentenary Exhibition, 1770–1970. Drawings, Mainly from American Collections*, exh. cat. (Fogg Art Museum, Harvard University, Cambridge, Mass., 1970), fig. 3.

4 George Knox, "Some early chalk drawings by Giambattista Tiepolo," in *L'Arte del Disegno: Christel Thiem zum 3. Januar 1997* (Berlin: 1997), pp. 181–89.

5 For a discussion of this date, about which opinions differ, see Knox 1980, p. 14.

6 Antonio Morassi, *G.B. Tiepolo: His Life and Work* (London: Phaidon Press, 1955), p. 77.

7 Morassi 1955, p. 84.

8 This was very rightly rejected by James Byam Shaw, "Tiepolo Celebrations: Three Catalogues," *Master Drawings* 3 (1971), p. 269.

9 Some are still sceptical. See George Knox, "Review: Tiepolo, in Würzburg," *Apollo* (April 1996): p. 62; Knox in *Giambattista Tiepolo: Forme e colori: La pittura del Settecento in Friuli*, exh. cat. (Milan: Electa, 1996), pp. 39–40; Knox, "Review: Tiepolo and his Circle," *Drawing* (Spring 1997): pp. 110–13; Knox, "Tiepolo in Warsaw," Vancouver 1990.

10 For further details, see George Knox, "Tiepolo Drawings from the Saint-Saphorin Collection," in *Atti del Congresso Tiepolo*, E. Quargnal, ed. (Milan: Electa, 1970), pp. 58–62; Knox 1980, pp. 191, 192; Édith Carey, "Deux collectioneurs : Édouard et René de Cérenville," in *Cinq siècles de dessins*, Vevey, 1997, pp. xxv–xxxi, 78–95.

cat. 17

1 Four items from the group are first noted in the sale in 1883 of Louis-Auguste, Baron de Schwiter (1805–1889), and nine came to the British Museum as early as 1885. Since then most of the drawings have emerged in France, including the present example. At present the largest groups are the set of eleven in the Metropolitan Museum of Art from the Biron collection, and the set of fifteen recorded in a private collection in Rome. None found their way into the large groups of pen drawings that became separated at an early stage: the Beauchamp album, broken up in 1965, and those in the Bossi-Beyerlen group which were sold at Stuttgart in 1882: Gutekunst, 27 March 1882, lots 612–79. The study of these drawings by Jean Cailleux in 1974 listed 100 items and reproduced 77 of them; Jean Cailleux, "Centaurs, Fauns, Female Fauns and Satyrs among the Drawings of Domenico Tiepolo," *The Burlington Magazine* 116 (June 1974). Cailleux arranged the drawings in a number of categories. Most of them involved centaurs, often with satyrs (cats. 1–76), but the rest depict satyrs and female satyrs without centaurs (cats. 77–100) and this section included the present drawing.

2 Knox 1975, no. 1; Massimo Gemin and Filippo Pedrocco, *Giambattista Tiepolo: I dipinti* (Venice, 1993), cat. 67.

3 George Knox, *Tiepolo Drawings in the Victoria and Albert Museum* (London: HMSO, 1975), cat. 24; George Knox, "The Tasso Cycles of Giambattista Tiepolo and Gianantonio Guardi," *Museum Studies* 9 (1978), pp. 49–95, cats. 12–14; Gemin and Pedrocco 1993, cats. 292–94. These emphasize the female satyr.

4 Aldo Rizzi, *The Etchings of the Tiepolos* (London: Phaidon, 1971), cats. 13, 14, 26, 33. These also emphasize the female satyr.

5 For the drawings, see Jacob Bean & William Griswold, *18th Century Italian Drawings in the Metropolitan Museum of Art* (New York: Metropolitan Museum of Art, distributed by H.N. Abrams, 1990), cats. 195–98; also two drawings in the Horne album, II.25, 26, Detlev, Baron von Hadeln, *Handzeichnungen von G.B. Tiepolo* (Leipzig: H. Schmidt and C. Günther, Pantheon Vlg für Kunstwissenschaft, 1927), cat. 61; Licia Ragghianti Collobi, *Disegni della*

Fondazione Horne in Firenze, exh. cat. (Palazzo Strozzi, Florence, 1963), cat. 88.

6 Gemin and Pedrocco 1993. The set of thirteen fine drawings in the Horne album in Florence, listed but not all reproduced in the catalogue by Collobi, cats. 148–59, are loosely related.

7 Anna Pallucchini, *L'opera completa di Giambattista Tiepolo* (Milan, 1968), cat. 277. For the drawings, see George Knox and Christel Thiem, *Tiepolo: Zeichnungen von Giambattista, Domenico und Lorenzo Tiepolo*, exh. cat. (Staatsgalerie, Stuttgart, 1970), cats. 161–64; Knox 1980, cats. 209–12.

8 She is particularly close in pose and lighting to a male satyr in the Horne album, 6346, II.46. She also appears in very similar form in one of the drawings in the Lehman Collection: James Byam Shaw and George Knox, *The Robert Lehman Collection, VI: Italian Eighteenth-Century Drawings* (New York: Metropolitan Museum of Art; Princeton: The University Press, 1987), cat. 141.

9 Painted by Domenico for the Villa Tiepolo near Mirano, and now transferred to Ca' Rezzonico: Terisio Pignatti, *Il Museo Correr di Venezia* (Venice: N. Pozza, 1960); Adriano Mariuz, *Giandomenico Tiepolo* (Venice: Alfieri, 1971), cats. 240–44.

10 Mariuz 1971, p. 141.

11 Cailleux 1974, cats. 14, 21, 49, 51, 63, 84.

12 James Byam Shaw, *The Drawings of Domenico Tiepolo* (Boston: Boston Book and Art Shop, 1962), pp. 41–42, in a warm discussion of these drawings – calling them "the most delightful and original of all Domenico's allegorical and mythological subjects" – claims a date of 1759 for this part of the decoration of the Villa Tiepolo. An old photograph seems to rule against this date. Cailleux favours an earlier dating in the 1750s for most of these drawings. Byam Shaw and Knox 1987, p. 171, modifies the date to between 1771 and 1791. Byam Shaw goes on: "The drawings of this series are perhaps the most charming and original of all Domenico's drawings – original because less dependent on the inventions of other artists than some of his other series, and catching exactly the charm and gaiety of the pagan mythology."

13 Mariuz 1971, cat. 352.

DUTCH & FLEMISH SCHOOLS
cat. 18

1 N. Dacos's contention that he is Dirck Hendricsz. Centen (also known as Teodoro d'Errico), a Netherlandish artist active in Rome and Naples, has not been accepted by all scholars. For a summary of debates, see Eiche 2000.

2 Egbert Haverkamp-Begemann and Anne-Marie Logan, *European Drawings and Watercolors in the Yale University Art Gallery 1500–1900* (New Haven, Conn., and London: Yale University Press, 1970), vol. 1, pp. 265–67, cats. 496–99. They are now in the Yale University Art Gallery.

3 Haverkamp-Begemann and Logan 1970, vol. 1, p. 266.

4 B. Meijer, "De Spranger à Rubens : vers une nouvelle équivalence," in N. Dacos, B. Meijer et al., *Fiamminghi a Roma, 1508–1608. Artistes des Pays-Bas et de la Principauté de Liège à Rome à la Renaissance*, exh. cat. (Palais des

Beaux-Arts, Brussels; Palazzo delle Esposizioni, Rome, 1995), pp. 32–47.

5 A group of black chalk drawings attributed to the artist especially exhibit the influence of Taddeo Zuccaro; see M. Schapelhouman, *Netherlandish Drawings circa 1600* (Amsterdam, 1987), no. 106, and Sabine Eiche, Gert Jan van der Sman and Jeanne van Waadenoijen, eds., *Fiamminghi a Roma, 1508–1608*. Proceedings of the symposium held at Museum Catharijneconvent, Utrecht, 13 March 1995 (Florence: Centro Di, under the auspices of the Istituto Universitario Olandese di Storia dell'Arte, 2000), p. 48.

6 T. Connolly, "The Cult and Iconography of St. Cecilia before Raphael," in C. Bernardini et al., *La Santa Cecilia di Raffaello* (Bologna, 1983), p. 135. The portative organ is medieval in origin (although based on ancient Roman designs) and was widely used from the fourteenth and fifteenth centuries.

7 Jacob Matham after Hendrick Goltzius, engraving, Adam von Bartsch, *Le peintre graveur*. Walter L. Strauss, ed. (New York: Abaris Books, 1854–67), p. 261.

8 K.G. Boon, *The Netherlandish and German Drawings of the XVth and XVIth Centuries of the Frits Lugt Collections* (Paris: Waanders, 1992), vol. 1, p. 425; Eiche 2000, p. 52.

9 Inv. no. C 1976-184, pen and brown ink and black chalk, 35.1 × 28.4 cm. C. Dittrich, *Van Eyck, Bruegel, Rembrandt. Niederländische Zeichnungen des 15. bis 17. Jahrhunderts aus dem Kupferstich-Kabinett Dresden* (Dresden: Albertinum; Vienna: Kunstforum, 1997–98), cat. 21.

cat. 19

1 Private collection: M. Roethlisberger, *Abraham Bloemaert and his Sons: Paintings and Prints* (Doornspijk: Davaco, 1993), cat. 17.

2 Roethlisberger 1993, cat. 21. Sadly, this painting was destroyed in World War II and no colour photograph exists.

3 Other drawings from the early and mid-1590s include *Mars and Venus* in the J. Paul Getty Museum, Los Angeles; *Venus and Amor* in the National Gallery of Scotland, Edinburgh; *Acis and Galatea* from the Woodner family collection, New York; the *Annunciation*, of which there are two versions, one in the Kunstsammlungen zu Weimar dated 1593 and the other in the Museum Boymans-van Beuningen, Rotterdam; *Apollo and Daphne* in the Albertina, Vienna; and *Christ and the Canaanite Woman* in the Metropolitan Museum of Art, New York. A smaller, sketchier variant of the Toronto drawing is in the Louvre.

4 Bartsch, vol. 14, p. 197, cat. 245. Minerva's identity is more obvious in the painting, in which she holds a lance.

5 Anne W. Lowenthal, *Joachim Wtewael and Dutch Mannerism* (Doornspijk: Davaco, 1986), nos. A21, A25, A26.

6 Roethlisberger 1993, cat. 545.

7 T. Schrevelius, *Harlemias* (Haarlem, 1648), p. 375.

8 E.J. Sluijter, *De "Heydensche Fabulen" in de Noordnederlandse schilderkunst, circa 1590–1670* (The Hague, 1986).

cat. 20

1 On this group, see B. Albach, "Rembrandt en het toneel," *De Kroniek van het*

Rembrandthuis 31 (1979): p. 4.

2 Berlin, Staatliche Museen zu Berlin, Kupferstichkabinett, inv. no. 5268. Pen and brown ink, corrections in white, 20.0 × 14.7 cm. Otto Benesch, *The Drawings of Rembrandt*, 6 vols. (London: Phaidon, 1954–57), cat. 416; Holm Bevers, *Rembrandt. Die Zeichnungen im Berliner Kupferstichkabinett* (Berlin: Staatliche Museen zu Berlin, 2006), cat. 19.

3 C.J. Fresia, "Quacksalvers, quack doctors," in *Dutch Art: An Encyclopedia*, S.D. Muller, ed. (New York, 1997), pp. 309–10.

4 Benesch 1954–57, cats. 293, 294a, 295, 296, 297. On this group, see W.R. Valentiner, "Komödiantendarstellungen Rembrandts," *Zeitschrift für bildende Kunst* 59 (1925–26): pp. 265–77.

5 Hamburg, Kunsthalle, inv. no. 22417; Benesch 1954–57, cat. 296. On the similarity in clothing, see Bisanz-Prakken in K.A. Schroder and M. Bisanz-Prakken, eds. *Rembrandt*, exh. cat. (Vienna, Albertina, 2004), cats. 39–40.

6 Rotterdam, Museum Boymans-van Beuningen. See I. Gaskell, "Gerrit Dou, his Patrons, and the Art of Painting," in *Oxford Art Journal* 5 (1982): pp. 15–23.

7 W.W. Robinson, verbal communication with the author.

8 For example, Benesch 1954–57, cats. 115, 293, 411, 416.

cat. 21

1 Berlin, Staatliche Museen, Kupferstichkabinett, inv. no. 4348. Elfried Bock and Jakob Rosenberg, *Die Niederländischen Meister. Beschreibendes Verzeichnis sämtlicher Zeichnungen. Staatlichen Museen zu Berlin*, 2 vols. (Berlin: J. Bard, 1930), no. 4348; Wolfgang Schulz, "Schellinks, Doomer und Jan Steen," *Pantheon* 28 (1970): pp. 415–25, fig. 7. Schulz corrected Lugt's opinion that the drawing represents the Old Testament subject *The Arrival of Abraham and Lot at the City of Haran* (Gen. 11:31).

2 Schellinks kept a diary of their travels (Copenhagen). On their route, see Wolfgang Schulz, *Lambert Doomer, Sämtliche Zeichnungen* (Berlin and New York: Walter de Gruyter, 1974), p. 16 and P. Schatborn, review of Schulz 1974, *Simiolus* 9 (1977): pp. 50–52. On the drawings for van der Hem, see Schulz 1974, pp. 30–31, nos. 44–49; Schatborn 1977, p. 51, figs. 4, 52. Although van der Hem's encyclopedic atlas of the world included views of Asia, this sheet does not stem from his collection.

3 Compare to the following landscapes by Doomer: W. Sumowski, *Drawings of the Rembrandt School* (New York: Abaris Books, 1979–92), vol. 2, cats. 432, 434, both signed and dated 1692, and cat. 433.

4 Sumowski and Schulz suggested that both artists used the same printed model: Sumowski 1979–92, vol. 2, cat. 437; Schulz 1970, p. 418. In any case, Doomer could have been familiar with Schellinks's drawing as well, as proposed in Wolfgang Schulz, "Lambert Doomer 1624–1700, Leben und Werke" (Ph.D. thesis, Berlin, 1972), p. 70.

cat. 22

1 W.W. Robinson, "Preparatory Drawings by Adriaen van de Velde," *Master Drawings* 17, no. 1 (1979): p. 10; P. Schatborn, *Dutch*

Figure Drawings from the Seventeenth Century, exh. cat. (Rijksprentenkabinet, Rijksmuseum, Amsterdam; National Gallery of Art, Washington, D.C., 1981–82), pp. 28, 116.

2 For van de Velde's preparatory method, see Robinson 1979. For his studies of nudes, see W.W. Robinson, "Some Studies of Nude Models by Adriaen van de Velde," *Nationalmuseum Bulletin* (Stockholm) 17 (1993): pp. 53–66.

3 Robinson 1979, p. 10.

4 A similar old man, but in a different pose, appears as St. Jerome in a painting signed and dated 1668 in Schwerin, Staatliche Museen.

cat. 23

1 See Jacob Baart de la Faille, *The Works of Vincent van Gogh: His Paintings and Drawings* (New York: Reynal and Co., 1970), cats. F182, F183, F185, F1127–28, F1130–33.

2 Elizabeth Huberta du Quesne-van Gogh, *Vincent van Gogh: persoonlijke herinneringen aangaande een kunstenaar* (Baarn: Van de Ven, 1910), p. 55.

FRENCH SCHOOL
cat. 24

1 While he was partly an engineer in the modern sense – for instance, when directing fortifications in the regions of Champagne and Brie – Rabel also applied his visual ingenuity to a wide range of tasks including garden and costume design.

2 The highly finished drawings (Musée du Louvre, inv. nos. 32602–93) commemorate the *Ballet des Fées de la Forest de Saint Germain* (1625), the *Grand Bal de la Duchesse Billebahaut* (1626) and the *Ballet du Chasteau de Bicesstre* (1632). Some of these sheets are illustrated throughout Christout 1987. The same Rothschild collection in the Louvre contains unpublished drawings that seem close to Rabel's designs, including costumes for a hermaphrodite (inv. no. 3196 DR 13) and two women (inv. nos. 3257, 3258). I discuss the *livret* for the *Ballet de la Délivrance de Renaud*, in Sue Welsh Reed et al., *French Prints from the Age of the Musketeers* (Boston: Museum of Fine Arts, 1998), cat. 29.

3 Most of these drawings, found in an album in a private library in Germany, are reproduced in McGowan 1986. For a description of the album, which has been reordered more than once and which initially included no fewer than 239 items, see her unpaginated introduction.

4 The present drawing is cat. 110 in McGowan 1986. The other AGO drawings include cats. 1, 12, 17, 21, 28–29, 31–32, 36, 44, 57, 62, 81, 95–98, 100, 113, 123, 128, 131, 155, 158–59, 160–61, 164–65, 171–72, 174, 181 and 183, and five designs for men's costumes not reproduced in McGowan's catalogue (AGO accession nos. 87/308, 87/309, 87/310, 87/311, 90/189).

5 McGowan 1986, unpaginated introduction.

6 For an overview of the burlesque ballet, see Margaret M. McGowan, *L'Art du ballet de cour en France, 1581–1643* (Paris: Éditions du Centre national de la recherche scientifique, 1963), pp. 133–53.

7 See the respective *livrets* reprinted in Paul

Lacroix, *Ballets et mascarades de cour, de Henri III à Louis XIV (1581–1652)* (Geneva: J. Gay et fils, 1868–70, vol. 2, pp. 315–16; vol. 3, pp. 44–46; vol. 3, p. 161; vol. 5, p. 62). Rabel's costumes for the second and third of these roles are reproduced as Christout 1987, plates 80 and 118.

8 For the ballets as carnival reversal, see Graham Larkin, "Serious Play: Daniel Rabel's Classical and Burlesque Costume Designs for the Court Ballet of Louis XIII" (master's thesis, Queen's University, Kingston, Canada, 1993), pp. 48–51. A typical Rabel drawing of a *grand ballet* entry is reproduced in Christout 1987, fig. 39.

9 In medieval and early modern Europe, stripes and other *mi-parti* fabrics were generally reserved for clowns, heretics, prostitutes and other embodiments of deviance or indecorousness. See Michel Pastoureau, *The Devil's Cloth: A History of Stripes and Striped Fabric*, Jody Gladding, trans. (New York: Columbia University Press, 2001).

10 McGowan 1986 associates twenty-one drawings, cats. 98–118, with this performance. For the difficulties of matching the working drawings to specific performances, see Larkin 1993, pp. 14–20. Even though very few of Rabel's drawings can be ascribed to a particular performance with any confidence, they provide vivid evidence for the look of these diversions.

11 The *livret* for this ballet is reproduced in Lacroix 1868–70, vol. 3, pp. 299–321.

12 Ibid., pp. 304–5.

13 Ibid., p. 311.

cat. 25

1 Jacques Thuillier, "Poussin et ses premiers compagnons français à Rome," in André Castel, ed., *Nicolas Poussin, actes du colloque international tenu à Paris les 19, 20, 21, et 22 septembre, 1958* (Paris: Éditions du Centre national de la recherche scientifique, 1960), vol. 1, pp. 71–89, 96–114. For Richelieu's policy of using art for both religious and dynastic propaganda, see Hilliard T. Goldfarb, "Richelieu and Contemporary Art. 'Raison d'État' and Personal Taste," and Marc Fumaroli, "Richelieu Patron of the Arts," in Hilliard T. Goldfarb, ed., *Richelieu: Art and Power*, exh. cat. (Montreal Museum of Fine Arts; Wallraf-Richartz Museum, Cologne, 2002–3), pp. 1–13, 15–47.

2 Now in the Church of Notre-Dame, Les Andelys. See Michel Hilaire in Hilaire et al., *Century of Splendour: Seventeenth-Century French Painting in French Public Collections*, exh. cat. (Montreal Museum of Fine Arts; Musée des Beaux-Arts de Rennes; Musée Fabre de Montpellier, 1993), pp. 242–45, cat. 78, pp. 243–44, repr., and Goldfarb in Montreal 2002–2003, pp. 170–72, cat. 66, p. 171, repr.

3 Thuillier 1960, pp. 105–7; Thuillier, "Seventeenth Century French Painting and Art History, Problems and Methods," in Montreal 1993, p. 219; and Michel Hilaire in Montreal 1993, p. 242, cat. 78, fig. 1, Poussin's *The Miracle of Saint-François-Xavier* in the Louvre, and fig. 2, Michel Dorigny's engraving of Vouet's *Virgin Taking the Jesuits under her Protection* (destroyed in 1944).

4 Goldfarb in Montreal 2002–2003, p. 172. Bernini placed them in the crossing of St. Peter's in 1633. See William Chandler Kirwin, *Powers Matchless, the Pontificate of Urban VIII, the Baldacchin, and Gian Lorenzo Bernini* (New York, 1997), pp. 248–50.

5 For their history, see André Félibien, *Entretiens sur les vies et sur les ouvrages des plus excellents peintres anciens et modernes* (Paris, 1688; Geneva, 1972), vol. 5, pp. 271–72, and Anthony Blunt, "Jacques Stella, the de Masso Family and Falsifications of Poussin," *The Burlington Magazine* 116, no. 861 (1974): pp. 744–51. Blunt's provenance is the most accurate since he had access to documents in the archives of Penrice Castle. Half of the drawings were sold at Christie's New York, 13 January 1987, pp. 58–65, cats. 102–12, and the other half at Christie's London, 9 December 1986, pp. 86–93, cats. 122–32. *The Massacre of the Innocents*, in the earlier sale, p. 108, cat. 107, repr., is in the Princeton University Art Museum, Princeton, New Jersey.

6 Several other drawings in the series have the same watermark. See Christie's New York, 13 January 1987, cats. 102, 109, and Christie's London, 9 December 1986, cats. 126, 132. The series is dated by Rosenberg to late in Stella's life in *French Master Drawings*, exh. cat. (AGO; National Gallery of Canada, Ottawa; Palace of the Legion of Honor, San Francisco; the New York Cultural Center, New York, 1972–73), p. 211; by Chomer, c. 1650–55 in *Les Étapes de la Création : Esquisses et dessins de Boucher à Isabey* (Galerie Cailleux, 1989), pp. 84–85; by Sylvain Kerspern, 1655–57 in Kerspern, "« Jésus retrouvé par ses parents dans le temple » (1654) par Jacques Stella (Provins, Église Saint-Ayoul)," *Gazette des beaux-arts* 114, nos. 1446–47 (1989), p. 9, note 23; by Goldfarb, early 1640s in Cleveland 1989, p. 142; and by Goldfarb, 1655–57 in Montreal 2002–2003, pp. 172, 186. For Stella's later, very different painting and drawing style, see Kerspern 1989, p. 2, fig. 2 and p. 3, fig. 4. In the 1650s, Stella used a more nervous outline and his figures are more agitated and more expressive.

7 For the frontispiece, see Goldfarb in Montreal 2002–2003, pp. 153–55, p. 154, cat. 54, repr., and Maxime Préaud, "L'imprimerie royale and the Cardinal de Richelieu," in Montreal 2002–2003, p. 216; and for the preparatory drawing in the Biblioteca di Archeologia e Storia dell'Arte in Rome, see Thuillier 1960, p. 103, note 121, fig. 79 (unpaginated), signed "J. Stella f." on the reverse.

8 See also Thuillier 1960, pp. 103–04, figs. 76–78 (unpaginated); Préaud in Montreal 2002–2003, pp. 210–17; and Goldfarb in Montreal 2002–2003, p. 186, cat. 76, repr., signed "Stella" lower right, for the engraved title page by Claude Mellan of *De imitatione Christi libri IV* by Thomas à Kempis (Paris: Imprimerie royale, 1640).

9 For Jacques Callot's (1592–1635) earlier *Vitae et historiae beatae Mariae virginis matris dei* (Paris: Israël Henriet, 1632–33), see Jacques Lieure, *Jacques Callot*, part 2: *Catalogue de l'œuvre gravé*, vol. 3 (Paris, 1927), pp. 78–82, nos. 1357–70. The fourteen etchings each measure 7.0 × 4.4 cm.

10 Several other drawings of this series were executed on sheets of paper with a different watermark, a crowned shield with three fleurs-de-lys. See Christie's New York, 1987, cats. 104, 106, 108 and 110; and Christie's London, 1986, cats. 123, 125, 127, 128, 129 and 131. See W.A. Churchill, *Watermarks in Paper in Holland, England, and France in the XVIIth and XVIIIth Centuries and their Interconnection* (Amsterdam: M. Hertzberger, 1935), pp. 82–83, cat. 386, France, 1636.

11 In both cases, the etchings were wrongly inscribed as being after drawings by Poussin. See Blunt 1974, p. 748, and etchings after this drawing, Alessandro Mocchetti, p. 749, fig. 44; Felice Polanzani, p. 749, fig. 45, now in the AGO, accession no. 88/332.

cat. 26

1 Thuillier 1982, pp. 351–55, and Toronto 1970, cat. 27. I would like to thank Margaret Haupt for identifying the metalpoint in this drawing.

2 Toronto 1970, cat. 27. See also Hermona Alisah Dayag in *Origins of Italian Veduta*, exh. cat. (Bell Art Gallery, Brown University, Providence, Rhode Island, 1978), p. 59, cat. 45, and Toronto 1981–82, cat. 58. For the woodcut by Reeuwich, see Kathe Misch Tuttman in Providence 1978, cat. 3, fig. 3.

3 For an identification of the buildings in the foreground in paintings by Canaletto, see André Corboz, *Canaletto: una Venezia immaginaria* (Milan, 1985), vol. 1, pp. 47–51, and vol. 2, p. 601, pl. 111, *The Molo Looking West*, 1743, Windsor Castle, Her Majesty the Queen; p. 577, pl. 46, *The Fonteghetto della Farina*, 1724–30, Count Alvise Giustiniani, Venice; and p. 569, pl. 21, *The Riva degli Schiavoni*, 1724–30, Toledo Museum of Art, Toledo.

4 For other drawings in the album, see Granville Fell, "Drawings by Israël Silvestre (1621–1691)," *The Connoisseur* 97 (Jan. 1936): pp. 18–22; Agnes Mongan and Paul Sachs, *Drawings in the Fogg Museum of Art* (Cambridge, 1946), vol. 1, p. 315, cat. 595, and vol. 2, fig. 303, *The Villa Ludovisi, Rome*, Fogg Art Museum, Cambridge; Millon 1962, *The Piazza San Pietro, Rome*, Fogg Art Museum, Cambridge; and Denison in Cara D. Denison, *French Master Drawings from the Pierpont Morgan Library*, exh. cat. (Musée du Louvre, Paris; Pierpont Morgan Library, New York, 1993–94), pp. 74–75, cat. 31, repr. p. 75, *Panoramic View of Loreto*, the Pierpont Morgan Library, New York.

5 François Avril in *Collections de Louis XIV. Dessins, albums, manuscrits*, exh. cat. (Orangerie des Tuileries, Paris, 1977), cat. 302, repr. p. 289.

cat. 27

1 *A View of the Park at Arcueil*, in *Old Master Drawings. Autumn 1995*, exh. cat. (London: Thomas Williams Fine Art; New York: W.M. Brady and Co., 1995), cat. 36 repr.; *Vue du bout du canal du parc d'Arcueil*, d. 1747 and annotated "Arqueil," sold Paris, 25 June 1990, lot 110.

2 See Hal Opperman, *J.-B. Oudry, 1686–1755* (Paris: Réunion des Musées Nationaux, 1982–83), p. 242, no. 136, repr. This drawing is in a private collection.

3 Opperman 1983, p. 233.

4 See Julie Anne Plax, *Watteau and the Cultural Politics of Eighteenth-Century France* (Cambridge University Press, 2000); Thomas Crow, *Painters and Public Life in Eighteenth-Century Paris* (Yale University Press, 1986). Rococo taste persisted in the followers of Watteau, and in Natoire, Boucher, Fragonard and their followers. However, it lost its oppositional status thanks to the royal house's public preference for the rococo style, the new public context of the Salon du Louvre (periodic since 1737) and the explosion of reproductive printmaking after mid-century. I am grateful to Ryan Whyte for his help with this footnote.

5 Lise Duclaux, *Charles Natoire, 1700–1777* (Cahiers du Dessin Français. nº 8) (Paris: Galerie de Bayser; Boston: Ars Libri, 1991), p. 8.

cat. 28

1 Robin Ironside, trans., *French XVIII Century Painters* (London: Phaidon, 1948), p. 55. Edmond and Jules de Goncourt, *L'art du dix-huitième siècle et autres textes sur l'art*, J.-P. Bouillon, éd. (Paris: Hermann, 1967), p. 93.

2 An attribution which was supported from the outset by Colin Bailey, Pierre Rosenberg and Jean-François Méjanès.

3 Alastair Laing to Katharine Lochnan, 30 April 1998, AGO, accession file.

4 Colin Bailey to Kathryn Zedde, 29 January 1998, AGO, accession file.

5 *Réflexions sur quelques causes de l'état présent de la peinture en France. Avec un examen des principaux ouvrages exposés au Louvre le mois d'août 1746* (La Haye, 1747).

cat. 29

1 For further details of his early training, stylistic influences and tenure in Rome at the French Academy, see Richard P. Wunder, "Charles Michel-Ange Challe: A Study of his Life and Work," *Apollo* 87 (1968): pp. 22–33.

2 For more on the cut marks and a brief overview of the temple's architectural history, see Eric Fulford, "A Temple Through Time," *Archaeology* 47 (Sept/Oct. 1994): pp. 54–59.

3 The present façade was built in 1602. In 1537 the exterior side chapels were torn down, and the entire porch was detached temporarily from the church proper to clear the way for the triumphal procession of Charles V; however, to my knowledge the complete structure (*cella* and church) was intact in the mid-eighteenth century, when Challe made this sketch. There are other contemporary works that include the Roman temple without the later medieval, Christian additions; for example, Sébastien Bourdon's painting *Landscape with a Ford*, c. 1640, and an eighteenth-century watercolour (Albertina, Vienna) by French artist L.F. Cassas (1756–1827). Other artists have also represented this ruined temple-church, among them Piranesi and R.L.M. de Chancourtois.

cat. 30

1 Marie-Anne Dupuy-Vachey, *Fragonard et le Roland furieux* (Paris: Les Éditions de l'Amateur, 2003), pp. 6–7. See Christian Michel, *Charles-Nicolas Cochin et le livre illustré au XVIIIe siècle : avec un catalogue raisonné des livres illustrés par Cochin, 1735–1790* (Geneva: Droz, 1987), cats. 148, 155, for a detailed description of two editions (1773 and 1775–83) in which the plates were engraved by Charles-Nicolas Cochin le Jeune (1735–90).

2 Eunice Williams, *Drawings by Fragonard in North American Collections* (Washington: National Gallery of Art, 1978), p. 153.

3 Dupuy-Vachey 2003, p. 36.

4 Ibid., cat. 3.

cat. 31

1 See Hans Küng, *The Catholic Church: A Short History*, John Bowden, trans. (New York: Random House, 2001), p. 10, for the origin of this statement.

2 I would like to thank Pierre Rosenberg for making this observation.

cat. 32

1 Bottineau 1980, "Dessins de Pierre Guérin," in *Etudes de la revue du Louvre et des Musées de France: La donation Suzanne et Henri Baderou au musée de Rouen* (1980), vol. 1, p. 112, note 32, points out that Guérin owned Flaxman's book of *Compositions d'après les tragédies d'Eschile* (Paris, 1803) and compares one of the plates with this composition.

2 Walter Friedlaender, *David to Delacroix* (Cambridge: Harvard University Press, 1952), p. 45.

3 *The Age of Neoclassicism* (London: Royal Academy, 1972), p. 83.

4 Bottineau 1980, p. 108.

5 21 February 1873, nos. 151–81, including Rouen inv. no. 975-4-2532; see Bottineau 1980, p. 110, and Paris 1989, cat. 65. There were several compositional studies in the Bodinier sale, lots 168, 169, 174 and 175.

6 V. Huchard and A. Laing, *The Finest Drawings from the Museums of Angers* (London: Heim Gallery, 1978), cats. 53–55.

cat. 33

1 Georges Vigne, *Ingres* (New York: Abbeville Press, 1995), pp. 106–9.

2 In the past it may have been framed together with a third Ingres drawing titled *Head of a Woman, Study for "Virgil Reading the Aeneid to Augustus."* Ann Dumas, with contributions by Françoise Cachin, *The Private Collection of Edgar Degas*, Mark Polizzotti, trans., exh. cat. (Metropolitan Museum of Art, New York, 1997), cats. 708–09.

3 Ibid.

4 Sonia Couturier, *French Drawings from the National Gallery of Canada* (Ottawa, 2004), cat. 48, p. 120.

5 Ibid., p. 121, fig. 75.

cat. 34

1 I would like to acknowledge the inspiring lectures on Delacroix given by the late Professor Lee Johnson at the University of Toronto and his support of the acquisition of this watercolour.

2 Patrick Noon, *Constable to Delacroix: British Art and the French Romantics*, exh. cat. (Tate Britain, London; Minneapolis Institute of Arts, Minneapolis; Metropolitan Museum of Art, New York, 2003–04), pp. 235–36.

3 Delacroix to Soulier, 21 April 1826, and "Lundi matin," May 1826, *Correspondance générale d'Eugène Delacroix, 1858–1863*

(Paris: André Joubin, 1938), vol. 1,
pp. 177–80.

4 Delacroix, *Journal* 1, 20 February 1824,
p. 52.

5 London 2003, p. 272.

6 Sir Walter Scott, *The Bride of Lammermoor*
(London: Everyman's Library, 1966), p. 322.

7 See Katharine Lochnan, "Les lithographies
de Delacroix pour Faust et le théâtre des
années 1820," in *Nouvelles de l'Estampes*
(July 1986), cat. 87, pp. 6–13.

cat. 36

1 See Gabriel Weisberg, *Bonvin: La Vie et
L'Œuvre* (Paris, 1979), p. 68.

cat. 38

1 Ambroise Vollard, *En écoutant Cézanne,
Degas, Renoir* (Paris: B. Grasset, 1938),
p. 202; Jean Renoir, *Renoir* (Paris: Hachette,
1962), p. 225.

2 Colin B. Bailey, *Renoir's Portraits: Impressions
of an Age* (New Haven, Conn.,
and London: Yale University Press in
association with the National Gallery
of Canada, Ottawa, 1977), p. 212.

3 Denis Rouart, *Renoir* (Paris: Nathan, 1985),
p. 73.

4 Gotz Adriani, *Renoir*, exh. cat. (Tübingen
Kunsthalle, 1996), p. 249, cat. 77 repr.

5 Barbara Ehrlich White, *Renoir: His Life, Art,
and Letters* (New York: Harry N. Abrams,
1984), p. 160 repr.

6 *Mother and Child*, 1886, Sir Chester Beatty,
London (c. 1960), repr. in Walter Pach,
Pierre Auguste Renoir (New York: Abrams,
n.d.), pp. 90–91; *La Maternité*, 1885, Musée
d'Orsay; and *The Child at the Breast* (known
as *Maternity*), 1886, anonymous loan,
Museum of Fine Arts, St. Petersburg,
Florida (1985).

7 White 1984, p. 160, footnote 39. See Rouart
1985, p. 128.

8 Joseph Stella, *The Graphic Works of Renoir:
Catalogue Raisonné* (Bradford: Lund
Humphries, 1975), cat. 59.

9 BNF. Rés. 450 (Fol.) Tome II. Don Lucien
Vollard, 1946. See Francois Fossier, "Une
pointe-sèche inconnue de Renoir entre dans
les collections nationales," *Nouvelles de
l'Estampes* 139 (March 1995), p. 16, cat. 31.

10 Jean Leymarie and Michel Melot,
*Les gravures des impressionnistes: Manet,
Pissarro, Renoir, Cézanne, Sisley* (Paris: Arts
et Métiers Graphiques, 1971), cat. 56, repr.

cat. 39

1 Gracia Dorel-Ferré, "Le Peintre Léon
Lhermitte: une gloire méconnue de l'Aisne,
1844–1925," *Mémoires – Fédération des
sociétés d'histoire et d'archéologie de l'Aisne* 43
(1998): pp. 135–36.

2 André Theuriet, *La Vie Rustique*
(Paris, 1888), p. vi.

3 Dorel-Ferré, "Le Peintre Léon Lhermitte,"
p. 144.

4 Ibid., p. 130.

cat. 40

1 Quoted in Douglas Druick and Peter
Zegers, *Paul Gauguin: Pages from the Pacific*,
exh. cat. (Auckland, 1995), p. 22.

2 See Peter Zegers, "In the Kitchen with Paul
Gauguin: Devising Recipes for a Symbolist
Graphic Aesthetic," in Harriet Stratis and
Britt Salvesen, eds. *The Broad Spectrum:
Studies in the Materials, Techniques, and
Conservation of Color on Paper* (London,
2002), pp. 138–44.

3 See John Rewald, "Paul Gauguin – Letters
to Ambroise Vollard and André Fontainas,"
in Irene Gordon and Frances Weitzenhoffer,
eds. *Studies in Post-Impressionism* (New York,
1986), p. 183.

SWISS, GERMAN & AUSTRIAN
SCHOOLS
cat. 41

1 Kobell's brother to Jean-Georg Wille in Paris
in 1771.

2 *Goethes Werke: herausgegeben im Auftrage der
Grossherzogin Sophie von Sachsen* (Weimar,
1889; reprinted München: Deutscher
Taschenbuch Verlag, 1987), sec. 4, vol. 5,
p. 12, quoted in Heinrich Sieveking, *Fuseli to
Menzel: Drawings and Watercolors in the Age
of Goethe from a German Private Collection*
(Munich and New York: Prestel Verlag,
1998), p. 42.

cat. 42

1 L.D. Ettlinger, "Winckelmann," in
Arts Council of Great Britain, *The Age
of Neo-Classicism*, exh. cat. (Royal Academy
of Arts and Victoria and Albert Museum,
London, 1972), p. xxx.

2 Hugh Honour, "Neo-Classicism,"
in London 1972, p. xxiii.

3 Honour, "Neo-Classicism," p. xxv.

cat. 43

1 Related drawings are in the Städelsches
Kunstinstitut, Frankfurt (*Abhang mit
Felsblöcken und Ölbäumen*, inv. no. 16017,
repr. in Inge Feuchtmayr, *Johann Christian
Reinhart 1761–1847. Monographie und
Werkverzeichnis* (Munich: Prestel Verlag,
1975), cat. 98); the Stadtarchiv Schweinfurt
(*Geröll une Felsen*, repr. in Feuchtmayr 1975,
cat. 241); Museum der bildenden Künste,
Leipzig (*Felsen und Bäume*, inv. no. 3118,
repr. in Feuchtmayr 1975, cat. 197).

cat. 44

1 Menzel quoted in Marcie Ursula Riemann-
Reyher, "The Draughtsman – and
Master of the Glance," in *Adolph Menzel
1815–1905. Between Romanticism and
Impressionism* (New Haven, Conn., and
London: Yale University Press in association
with the National Gallery of Art,
Washington, 1996), p. 125.

2 The reunification of East and West Berlin
allowed increased access to the large
cache of Menzel drawings held in the
Nationalgalerie in East Berlin (now stored in
the Kupferstichkabinett in West Berlin).
Several exhibitions and major studies of
the artist's life and work in both German
and English have been undertaken in the
past fifteen years.

3 Françoise Forster-Hahn, "Authenticity
into Ambivalence: The Evolution of
Menzel's Drawings," *Master Drawings* 16,
no. 3, p. 257.

4 In his later years Menzel often exhibited
his drawings as independent works of art.

5 Max Liebermann quoted in Heinrich
Sieveking, *Fuseli to Menzel. Drawings and
Watercolors in the Age of Goethe from a
German Private Collection* (Munich and
New York: Prestel Verlag, 1998), p. 196.

cat. 45

1 *The Diary and Letters of Kaethe Kollwitz*,
Hans Kollwitz, ed., Richard and Clara
Winston, trans. (1955; Evanston, Ill.:

Northwestern University Press, 1988).
"In Retrospect 1941," p. 40.

2 Alexandra von dem Knesebeck, *Käthe
Kollwitz: Werkverzeichnis der Graphik*, 2
vols. (Bern, 2002), cats. 10, 11 and 19
respectively. Kollwitz abandoned the
planned *Germinal* print series when she took
up the dramatic themes of *A Weavers'
Rebellion* in 1893.

3 *Diary and Letters*, "In Retrospect 1941,"
p. 41. See also Käthe Kollwitz, *Briefe der
Freundschaft* (Munich, 1966), p. 205f,
letter to Paul Hey, 26 February 1891.

4 For example, Gretchen from Goethe's
Faust appears in several works.

5 Otto Nagel and Werner Timm, *Käthe
Kollwitz. Die Handzeichnungen*. Unter
Mitarbeit v. S. Schallenberg-Nagel. Bearb.
v. W. Timm (Berlin: Henschel, 1972),
cat. 99 (redated to 1903–04) and Ketterer
Kunst auction 282, May 2003, *The Tremmel
Collection*, cat. 514. The entry in this
auction catalogue dates these two drawings
to 1903–04 and relates them to the etching
Fight in the Tavern (Knesebeck 2002,
cat. 84) of 1904.

BRITISH SCHOOL
cat. 46

1 Cited by Hugh Belsey, "'A Picture Ought to
be Like a Tune': Gainsborough Drawings,"
in *Thomas Gainsborough, Themes and
Variations: The Art of Landscape* (London:
Lowell Libson, 2003), p. 10. I wish to thank
Mr. Belsey for kindly reading the draft of
this entry and offering valuable comments.

2 Cited by John Hayes and Lindsay Stainton,
Gainsborough Drawings (Washington, D.C.:
International Exhibitions Foundation,
1983), p. 2.

3 Cited by Leslie Parris, *Landscape in
Britain c. 1750–1850* (London: Tate
Gallery, 1973), p. 59.

4 Hayes and Stainton, *Drawings*, p. 126.

5 Reproduced in Ellis Waterhouse,
Gainsborough (London: Spring Books,
1958), cat. 935, pl. 193.

cat. 47

1 See Victor Chin-keung Chan, "Pictorial
Image and Social Reality: George
Romney's Late Drawings of John Howard
Visiting Prisoners" (Ph.D. dissertation,
Stanford University, 1983). Chan does
not discuss this particular sheet.

2 Although Hayley in his *Life of George
Romney* (London: T. Payne, 1809),
pp. 86–87, states that Romney's sketch
dates from 1780, he himself wrote a letter
in December 1779 referring to Romney's
promise to "make some designs"; cited by
Alex Kidson, *George Romney 1734–1802*
(London: National Portrait Gallery
Publications, 2002), cat. 131, p. 212.

3 John Romney, *Memoirs of the Life and Works
of George Romney...* (London: Baldwin
and Cradock, 1830), p. 266.

4 Victor Chan, *"Leader of My Angels":
William Hayley and His Circle* (Edmonton:
Edmonton Art Gallery, 1982), p. 65.

cat. 50

1 Quoted in Kim Sloan, "Cozens, John
Robert (1752–1797)," in *Oxford Dictionary
of National Biography*, H.C.G. Matthew
and Brian Harrison, eds. (Oxford: Oxford
University Press, 2004).

cat. 51

1 Quoted in David Bindman, ed. *John
Flaxman, R.A.*, exh. cat. (Royal Academy,
London, 1979), p. 80.

cat. 52

1 The Art Gallery of Ontario owns a copy
of *The Miseries of Human Life* published
by R. Ackermann in 1808 with fifty hand-
coloured etchings by Rowlandson.

cat. 53

1 G. Finley, *Angel in the Sun: Turner's Vision of
History* (Montreal and Kingston: McGill-
Queen's University Press, 1999), p. 190.

2 A.J. Finberg, *Complete Inventory of the
Drawings of the Turner Bequest*, 2 vols.
(London: His Majesty's Stationery Office,
1909), cat. 263.

cat. 54

1 See Joan Weir's essay in this catalogue on
Constable's use of "fixative" (appendix,
pp. 260–61).

2 R.B. Beckett, ed. *John Constable's
Correspondence: Early Friends and Maria
Bicknell (Mrs. Constable)* (London: Her
Majesty's Stationery Office, 1964),
vol. 2, p. 33.

3 Graham Reynolds, *The Early Paintings and
Drawings of John Constable* (New Haven,
Conn.: Paul Mellon Center for Studies
in British Art, 1996), cats. 03.11–03.22.

4 Beckett 1964, vol. 2, pp. 33–34.

5 The AGO also owns Constable's other two
studies of the *Victory: Stern View of H.M.S.
Victory in the Medway* and *Broadside View
of H.M.S. Victory in the Medway*.

6 The three drawings were discovered by
Sotheby's in a private collection in Scotland
and sold in London, 19 March 2003,
lots 138–140.

cat. 55

1 Andrew Moore, *John Sell Cotman,
1782–1842* (Norfolk Museums, 1982),
p. 43. A list of numbered drawing copies
was established by S.D. Kitson (present
location unknown).

2 Adele M. Holcomb, *John Sell Cotman*
(British Museum Publications, 1978),
cat. 44.

cat. 56

1 Quoted in Martin Hardie, *Water-colour
Painting in Britain* (London: Batsford,
1967–69), vol. 3, p. 213.

2 Harriet De Wint, "Memoir of Peter De
Wint," in Hammond Smith, *Peter De Wint:
1784–1849* (London: F. Lewis, 1982),
p. 114.

3 See Paul Spencer-Longhurst and Janet M.
Brooke, *Thomas Gainsborough: The Harvest
Wagon*, exh. cat. (Birmingham Museum
and Art Gallery; AGO, Toronto, 1995)
for illustrations of works by Gainsborough,
such as cats. 30–38, with related subjects
and formats. See Smith 1982, pp. 58–59
for a discussion about De Wint's
relationship with Gainsborough.

4 Kim Sloan, *Preferred Places: A Selection
of British Landscape Watercolours from the
Collection of the Art Gallery of Ontario*,
exh. cat. (AGO; Glendon Gallery, Toronto;
Kitchener-Waterloo Art Gallery; Sarnia
Public Library and Art Gallery; Toronto
1987a), p. 31.

5 Quoted in Hardie 1966–69, vol. 3, p. 218
(also in Smith 1982, p. 94).

cat. 57

1 By 1821 Haydon's eyesight had deteriorated to such an extent that he could no longer see his paintings as a whole but only focus on parts. This further accentuated the awkwardness of their design and tended to reduce their complexity but not to great effect.

2 See *A Method to Learn to Design the Passions* (Los Angeles: University of California, 1980), p. 38.

3 The deliberate awkwardness of the pose and schematization of the muscles is characteristic of the Fuseli circle.

4 Letter of 11 August 1992 in AGO files. Sloan makes the link based on notes Haydon made in his diary about head studies for the painting, but she notes that the drawn head does not closely resemble Uriel as known from prints after the assumed-to-be lost painting.

cat. 58

1 John Ruskin, *The Works of John Ruskin* (London, 1903), vol. 3, p. 472, quoted by Sloan in Toronto 1987a, p. 34.

2 He used gamboge, Indian yellow, Prussian blue, rose madder with cobalt and brown madder for sky, and Smith's warm grey. Martin Hardie, "William Turner of Oxford," in *The Old Watercolour Society's Club 1931–1932*, Randall Davies, ed. (1932), vol. 9, p. 6.

3 Timothy Wilcox and Christopher Titterington, *William Turner of Oxford* (Oxfordshire County Museum, 1984), p. 68.

4 Ibid., p. 10.

5 See Allen Staley and Christopher Newall, *Pre-Raphaelite Vision: Truth to Nature* (London: Tate Publishing, 2004).

cat. 59

1 Pamela Dunbar, *William Blake's Illustrations to the Poetry of Milton* (Oxford: Clarendon Press, 1980), p. 36.

2 Raymond Lister, *Catalogue Raisonné of the Work of Samuel Palmer* (Cambridge: Cambridge University Press, 1988), p. 54, cat. 61, repr. An ink, watercolour and body colour version of the subject was sold at Christie's, 2 March 1976, lot 161, attributed to "Samuel Palmer Circle." This work reveals an even greater debt to Blake.

3 Christiana Payne, *Toil and Plenty: Images of the Agricultural Landscape in England, 1780–1890* (New Haven, Conn.: Yale Center for British Art and Yale University Press, 1993), p. 135.

4 Edward Malins, *Samuel Palmer's Italian Honeymoon* (London: Oxford University Press, 1968), p. 50, pl. 8a and 8b. Linnell used Palmer's profile in *The Journey to Emmaus*, 1838.

5 Martin Butlin, *The Paintings and Drawings of William Blake* (London: Yale University Press, 1981), cat. 537, p. 389.

6 David Linnell to Martyn Gregory, 6 March 1992, with photocopy of a letter from Louis Huth to John Linnell, 11 December 1860. As this work is a good deal larger than those intended for the scrapbook, it seems likely that it was not made with this project in mind and may have been made years earlier.

cat. 60

1 Recorded by Joseph Farington in his diary, 28 February 1808, quoted in Louis Hawes,

Presences of Nature: British Landscape 1780–1830, exh. cat. (Yale Center for British Art, New Haven, 1982), p. 175.

2 Andrew Wilton, *British Watercolours 1750 to 1850* (Oxford: Phaidon; New York: E.P. Dutton, 1977), p. 183.

cat. 61

1 See London 2003–04, cat. 7, p. 57. Also Stephen Bann in London 2003–04, p. 29, calls Bonington "the paradigm case of a British-born artist ... who profoundly affected the development of the Romantic generation of French artists."

2 See Patrick Noon, *Richard Parkes Bonington: On the Pleasure of Painting*, exh. cat. (Yale Center for British Art, New Haven; Musée du Petit Palais, Paris, 1991–92), p. 12.

3 New Haven 1991–92, cat. 43, p. 140.

4 David Cordingly, *The Art of the Van de Veldes* (London: National Maritime Museum, 1982), cat. 124, p. 118.

5 *The Victory Returning from Trafalgar*, Yale Center for British Art, New Haven, and *A First-Rate Taking in Stores*, Cecil Higgins Museum and Art Gallery, Bedford.

6 On devices used by marine artists, see David Cordingly, *Painters of the Sea: A Survey of Dutch and English Marine Paintings from British Collections* (London: Lund Humphries in association with the Royal Pavilion, Art Gallery and Museums, Brighton, 1979), p. 13.

7 Eugène Delacroix to Théophile Thoré, quoted in New Haven 1991–92, p. 12.

cat. 62

1 See, for example, Palmer's *Rome from the Via Sistina*, 1839, Victoria and Albert Museum, London.

2 Scott Wilcox, "Poetic Feeling and Chromatic Madness: Palmer and Victorian Watercolour Painting," in William Vaughan, Elizabeth E. Barker and Colin Harrison, *Samuel Palmer 1805–1881: Vision and Landscape*, exh. cat. (British Museum, London; Metropolitan Museum of Art, New York, 2005), pp. 43–46.

cat. 63

1 Margaret Flanders Darby, "The Conservatory in St. Johns Wood," in *Seductive Surfaces: The Art of Tissot*, Katharine Lochnan, ed. (New Haven, Conn., and London: Yale University Press, 1999), p. 162.

2 Anonymous, "The Fine Arts in Ontario," *The Canadian Monthly* 3 (1873): pp. 545–46.

cat. 64

1 John Ruskin, *John Ruskin's Letters to William Ward* (Boston: Marshall Jones, 1922), pp. 53–57.

2 E.T. Cook and Alexander Wedderburn, eds. *The Works of John Ruskin*, 15 vols. (London: George Allen, 1904), p. 49.

cat. 65

1 Mary Lago, ed. *Burne-Jones Talking: His Conversations 1895–1898 Preserved by his Studio Assistant Thomas Rooke* (London: John Murray, 1981), p. 142.

2 The culminating work was *The Merciful Knight* (1863, Birmingham Museums and Art Gallery). See Stephen Wildman and John Christian, *Burne-Jones: Victorian

Artist-Dreamer, exh. cat. (Metropolitan Museum of Art, New York, 1998), cat. 26, pp. 93–95.

3 The last great project they worked on together was the famous Kelmscott Press Chaucer (1896), which contained Burne-Jones's illustrations for *The Legend of Good Women*, including three for the story of Ariadne.

4 Richard and Hilary Myers, *William Morris Tiles: The Tile Designs of Morris and his Fellow-Workers* (Shepton Beauchamp, Somerset: Richard Dennis, 1996), pp. 21–25, pl. 8–9, pp. 40–41. It is possible that the present watercolour reflects this first tile design, now lost. When Burne-Jones recycled a motif from his design work to his easel art, which he did frequently, he usually followed the motif closely.

5 When Burne-Jones came to design the Ariadne cartoon for Ruskin's embroidery (1863–64, National Gallery of Art, Washington, D.C.), he completely changed the figure, and it is this new design that he repeated in the second series of *Good Women* stained glass and tiles (see Myers 1996, pp. 78–79, pl. 35b, p. 91, cat. 80, p. 144). It is sometimes said that Chaucer's "Good Women" were loosely adapted for an ambitious embroidery project to decorate the dining room at Red House, but Morris ignored Chaucer's list and chose his own heroines, including Saint Catherine, Penelope and Guinevere. See A.R. Dufty, *Morris Embroideries: The Prototypes* (London: Society of Antiquaries, 1985), pp. 8–9, 13–31.

6 Malcolm Bell, *Sir Edward Burne-Jones: A Record and Review*, 4th ed. (London: George Bell and Sons, 1903), appendix 1, p. 129. In 1862 Burne-Jones did a delightful tile design, *Theseus and the Minotaur*, which shows the hero seeking to kill the Minotaur in the labyrinth, Ariadne's ball of thread in his hand (see Myers 1996, fig. 34, p. 21).

7 It was painted over an unidentified cartoon, apparently for stained glass, as a wedding gift for Charles Augustus Howell – since Lucretia committed suicide after being raped, she was the archetype of a faithful wife. See John Christian, Elisa Korb and Tessa Sidey, *Hidden Burne-Jones: Works on Paper by Edward Burne-Jones from the Birmingham Museums and Art Gallery*, exh. cat. (Birmingham Museums and Art Gallery, 2007), cat. 30, p. 54, illus. p. 42).

8 Dr. Elisa Korb, who has written her Ph.D. dissertation on Burne-Jones and Zambaco for the University of Birmingham, compares *Ariadne* (which she dates "c. 1868") to *Cassandra* (1870, Victoria and Albert Museum, London), for which Zambaco sat.

9 *A Harmony in Blue* is usually associated with the lost *Viridis of Milan*. Burne-Jones went on to paint his *A Harmony in Red* watercolour for the Dalziel brothers, *The Annunciation ("The Flower of God")* (1863, Lord Lloyd-Webber collection [see New York 1998, cat. 27, pp. 95–96]).

10 Whistler exhibited, in fact, four *Nocturnes* at the Grosvenor Gallery in 1877, including two entitled *A Nocturne in Blue and Silver* (nos. 5 and 6a [Christopher Newall, *The Grosvenor Gallery Exhibitions: Change and Continuity in the Victorian Art World* (Cambridge: Cambridge University Press, 2004), p. 135]).

cat. 66

1 See Donato Esposito, "From Ancient Egypt to Victorian London: The Impact of Ancient Egyptian Furniture on British Art and Design 1850–1900," *The Decorative Arts Society Journal* 27 (2003): pp. 85–86.

cat. 68

1 Rodney Engen, *A Country Paradise: The British Countryside of Helen and William Allingham, 1846–1926*, typescript, n.d., p. 89.

2 Marcus B. Huish, *The Happy England of Helen Allingham* (1903; London: Bracken Books, 1985), p. 171.

3 Engen, *Country Paradise*, p. 90.

4 Charles Tennyson, *Farringford, Home of Alfred, Lord Tennyson* (London: LSG Printers, 1976), p. 11.

5 Helen Allingham and Arthur Paterson, *The Homes of Tennyson* (London: Adam and Charles Black, 1905), note to *The Dairy Door, Farringford* opposite p. 46.

MODERN EUROPEAN SCHOOLS

cat. 69

1 Robert P. Welsh, *Piet Mondrian: The Amsterdam Years, 1892–1912* (Amsterdam: Gemeentearchief; Bussum: Thoth, 1994), p. 118.

2 See Joop M. Joosten and Robert P. Welsh, *Piet Mondrian: Catalogue Raisonné* (New York: Harry N. Abrams; Blaricum, the Netherlands: V+K Publishing, 1998), vol. 1, pp. 310–11, cat. A392.

3 Ibid., cat. A391.

4 Ibid., pp. 308–12, cats. A392–96, A396a.

5 Robert P. Welsh, "Farm Near Duivendrecht," *News and Notes – Art Gallery of Toronto* 7, no. 2 (April 1963), p. 3.

6 Ibid.

cat. 70

1 Umberto Boccioni, *Pittura, Scultura Futuriste* (Milan, 1914), cited in Emily Braun, ed., *Italian Art in the 20th Century: Painting and Sculpture, 1900–1988* (Munich: Prestel Verlag; London: Royal Academy of Arts, 1989), p. 53.

2 "Friends of chaos" was the term used by the French critic André Warnod to describe the futurists; see Ester Coen, "The Violent Urge Towards Modernity: Futurism and the International Avant-garde," in Braun, *Italian Art*, p. 53. Marinetti was himself referred to as "the Caffeine of Europe"; see Caroline Tisdall and Angelo Bozzolla, *Futurism* (London: Thames and Hudson, 1977), p. 8.

3 Maurizio Fagiolo dell'Arco, *Balla, The Futurist* (New York: Rizzoli, 1987), p. 90. Dell'Arco mentions a painting from the Art Gallery of Ontario that he dates to 1913 in his discussion of the *Line of Speed* works.

cat. 71

1 In 1906 the artist added the name of his birthplace Rottluff to his own name.

2 By 1905 African and Oceanic art could be viewed in the Dresden Ethnological Museum.

3 For an extensive exploration of the theme, see Gunther Thiem, *Die Verwandlungen der Venus. Schmidt-Rottluffs Akt-Zeichnungen von 1909 bis 1913* (Munich/Berlin: Deutscher Kunstverlag, 2003), p. 11; the artist's drawings of nudes (1909–10) are

not known except through images on four picture postcards.

4 Quoted in Thiem 2003, p. 113.

5 Thiem 2003; see cat. 73 for entry on the Toronto drawing. Thiem illustrates a statue from the Musées royaux des Beaux-Arts de Belgique.

6 Thiem 2003, cat. 73. He titles the drawing *Frontal Hochkende (Frontally Seated [Figure])*. For other watercolours from 1913 of similar nudes, see Thiem 2003, cats. 64, 67 and 74.

cat. 72

1 Jane Kallir, *Egon Schiele: The Complete Works* (New York: Abrams, 1990), cats. 1892–96.

cat. 73

1 Angelika Littlefield, *The Dada Period in Cologne: Selections from the Fick-Eggert Collection*, exh. cat. (AGO, 1988), p. 20.

2 William A. Camfield, *Max Ernst: Dada and the Dawn of Surrealism* (Munich: Prestel Verlag, 1993), pp. 50–51, note 33. Ernst exhibited with Chagall in 1913 along with Klee, Delaunay, Macke and Kandinsky in the Erster Deutscher Herbstsalon (First German Autumn Salon) in Berlin.

3 Stephen C. Foster, ed., *Crisis in the Arts: The History of Dada* (New York: G.K. Hall; London: Prentice Hall International, 1996–), vol. 3, p. 19.

4 This important archive of Cologne Dada material known as the Fick-Eggert Collection is in the collection of the AGO. Angelika Littlefield found the hundreds of works of art, documents and periodicals "buried under piles of debris, wet, and badly stuck together" in her great-uncle Willy's shed in Cologne in 1967 and brought the collection to Canada. See Toronto 1988, p. 5.

cat. 74

1 Grosz was so enamoured with American culture that in 1916 he anglicized his name by changing it from Georg Groß to George Grosz.

2 Nora Hodges, trans., *George Grosz: An Autobiography* (New York: MacMillan, 1983), p. 111.

3 Based on the dry, scratchy ink-line and the figure "types" who reappear in other drawings dated to 1917, Stephanie Dales (Art Institute of Chicago) has dated this drawing to c. 1917 in recent correspondence with the author.

cat. 75

1 See Friedemann Malsch, "Sur la réception de l'œuvre de František Kupka," in *František Kupka. La collection du Centre Georges Pompidou*, exh. cat. (Centre Georges Pompidou; Vaduz; Lausanne; Strasbourg; Montpellier; Münster, 2003–04), pp. 30–33; Dorothy Kosinski, "Kupka's Reception: Identity and Otherness," in *Painting the Universe: František Kupka Pioneer in Abstraction*, exh. cat. (The Dallas Museum of Art, Dallas; Wolfsburg; Prague, 1997–98), pp. 99–112.

2 Salon 1936, cat. 36. Now in the Musée National d'Art Moderne, Paris, inv. no. AM 3213-P.

3 See Margit Rowell, "František Kupka: A Metaphysics of Abstraction," in *František Kupka 1871–1957: A Retrospective* (New York: Solomon

R. Guggenheim Museum, 1975), pp. 47–80.

4 For example, *The Beginning of Life, the Waterlilies*, Centre Georges Pompidou, Paris, inv. no. AM 10889-Gr.

5 The Solomon R. Guggenheim Museum, New York, inv. no. 66.181.

cat. 76

1 Vasily Kandinsky to Will Grohmann, 12 October 1930, quoted in Vivian Endicott Barnett, *Vasily Kandinsky: A Colorful Life* (Munich: Lenbachhaus, 1995), p. 539.

2 Vivian Endicott Barnett, *Kandinsky Watercolours 1922–1944* (London: Sotheby's Publications, 1994), vol. 2, p. 58.

cat. 77

1 In Paulo Ferreira, *Correspondance de quatre artistes portugais…avec Robert et Sonia Delaunay : contribution à l'histoire de l'art moderne* (1915–17), p. 42.

2 This work is very similar to one from the following year in the collection of the Centre Georges Pompidou that also includes just the word "Paris" on the left side. The design for the final cover is in the collection of the Musée National d'Art Moderne, Paris, inv. no. AM 2609-D.

3 Theodore Allen Heinrich in Toronto 1971, cat. 114.

cat. 79

1 Costakis may have acquired the drawing from the collection of Pavel Popova (brother of the artist) since many drawings by Popova in the Costakis collection came from that source.

cat. 80

1 El Lissitzky, "Suprematism in World Reconstruction" (1920), in Sophie Lissitzky-Küppers, ed., *El Lissitzky. Life, Letters, Texts* (London: Thames and Hudson, 1968), p. 327.

2 "Proun" has been translated in various ways, although its meaning does not change substantially; see Alan C. Birnholz, "El Lissitzky" (Ph.D. dissertation, Yale University, 1973), pp. 70–71.

3 El Lissitzky, "The Film of El's Life" (1928), in Lissitzky 1968, p. 325.

4 El Lissitzky, "Proun" (1920–21), in *El Lissitzky* (Cologne: Galerie Gmurzynska, 1976), pp. 60–61; El Lissitzky, "A. and Pangeometry" (1925), in Lissitzky 1968, pp. 348–51.

5 Peter Nisbet believes that *Study for "Proun" 8 Stellungen* is the work listed as number 46 in the inventory Lissitzky put together in 1923–24, while the finished version found in Ottawa is listed as item 1. See Nisbet's comments for number 47 of the inventory in Cambridge 1987, p. 166.

cat. 81

1 Antoine Salomon and Guy Cogeval, *Vuillard: The Inexhaustible Glance. Critical Catalogue of Paintings and Pastels*, 3 vols. (Milan: Skira, 2003), cat. X-180.

cat. 82

1 Alfred Barr, *Matisse: His Art and His Public* (New York: Museum of Modern Art, 1951), p. 204.

2 Vincent Rousseau, "Au-delà des odalisques," in *Matisse: La Période Niçoise*, exh. cat. (RMN, Musée des Beaux-Arts de Nantes, 2003), p. 17.

3 Grautoff in Jack Flam, ed., *Matisse: A Retrospective* (New York: Park Lane, 1990), p. 199.

4 Lhote in Flam 1990, p. 216.

5 Sotheby's New York, 11 May 1988, lot 154.

cat. 83

1 The critic Péladan quoted in Pierre Courthion, *Georges Rouault* (New York: Abrams, 1961), p. 102.

2 See several watercolours illustrated in Courthion 1961, pp. 222, 227–29, and pp. 422–23, cats. 178–85. *L'Église pauvre* (cat. 178) for example, which is now in the collection of the Art Institute of Chicago, is of the same technique as *Idyll*, approximately the same size and also signed in ink "G. Rouault 1929" (Art Institute of Chicago, Charles H. and Mary F.S. Worcester Collection, inv. no. 1947.107).

3 The same title appears on a painting now in the Louvre and on pl. 10 in the *Miserere* series.

4 As a boy Rouault worked in the shop of a glass painter where he had the opportunity to repair and study medieval stained glass.

cat. 84

1 Charles Baudelaire, "The Exposition Universelle, III Eugène Delacroix," in *Baudelaire: Art in Paris, 1845–62*, Jonathan Mayne, ed. and trans. (New York: Phaidon, 1965), p. 141.

2 Christian Zervos, "Les gouaches marocaines de Raoul Dufy," in *Cahiers d'Art 5* (June 1926): p. 99.

3 The Great Mosque of Cordoba has seventeen aisles and can accommodate 20,000 worshippers.

cat. 85

1 Reproduced in colour in Elizabeth Cowling and Jennifer Mundy, *On Classic Ground: Picasso, Léger, de Chirico and the New Classicism 1910–1930* (London: Tate Gallery, 1990), p. 143.

cat. 86

1 To date, Masson scholars have not been able to connect the iconography of *The Legend of Corn* to a specific Iroquois legend, and in fact Evan Mauer ("Dada and Surrealism," in *"Primitivism" in 20th Century Art: Affinity of the Tribal and the Modern* (New York: Museum of Modern Art, 1984), vol. 2, p. 549) asserts that the source for the myth is from Masson's favourite study of primitive magic and religion, James George Frazer's *The Golden Bough*.

2 In addition to the AGO's watercolour, there is a smaller, probably preparatory gouache now in the Drukier Collection: see Nancy Green, *Surrealist Drawings from the Drukier Collection* (Ithaca: Herbert F. Johnson Museum of Art, 2003), p. 122. A related painting, *The Legend of Maize*, is in a private Tokyo collection: see Dawn Ades, *André Masson* (Barcelona: Ediciones Poligrafa, 1994), cat. 89.

cat. 87

1 Pablo Picasso, *Picasso on Art: A Selection of Views*, Dore Ashton, ed. (New York: Viking Press, 1972), p. 4. The quote was originally recorded in Marius de Zayas, "Picasso Speaks," *The Arts* (May 1923).

2 Picasso 1972, p. 165. Quoted by Felipe Cossio del Pomar in 1932.

3 See Zervos's publications *L'art en Grèce des temps préhistoriques au début du XVIIIe siècle*, 1933; *L'art de la Crète néolithique et minoenne*, 1956; and *L'art des Cyclades du début à la fin de l'âge du bronze, 2500–1100 avant notre ère*, 1957. Zervos 1932–78 is the authoritative Picasso catalogue raisonné in 33 volumes.

4 Zervos 1932–78, vol. 27, cats. 90–97.

5 Elizabeth Cowling and Jennifer Mundy, *On Classic Ground*, p. 202.

cat. 88

1 Roger Fry to Vanessa Bell, Morbihan, 3 or 4 September 1920, in *Bloomsbury: The Artists, Authors, and Designers*, Gillian Naylor, ed. (Great Britain: Pyramid Books, 1990), p. 151.

cat. 90

1 Second Shelter Sketchbook, p. 17 (HMF 1642), reproduced in David Mitchinson et al., *Celebrating Moore: Works from the Collection of the Henry Moore Foundation* (Berkeley; London; Los Angeles: University of California Press, 1998), p. 189.

2 Alan G. Wilkinson, *The Drawings of Henry Moore* (London: Tate Gallery, 1977), p. 107.

NORTH AMERICAN SCHOOLS
cat. 91

1 Donald W. Buchanan, *James Wilson Morrice, A Biography* (Toronto: Ryerson Press, 1936), p. 111.

2 Irene Szylinger, "A Brief Analysis of the Watercolours," in Nicole Cloutier, *James Wilson Morrice 1865–1924*, exh. cat. (Montreal Museum of Fine Arts, 1985), p. 79.

3 Ibid., p. 85. The sketchbook, no. 21, is in the Montreal Museum of Fine Arts, inv. no. Dr.973.44.

4 First identified by William R.M. Johnston in *James Wilson Morrice, 1865–1924*, exh. cat. (Montreal Museum of Fine Arts; National Gallery of Canada, Ottawa, 1965), p. 73; corroborated by photographs located by Adam Welch, E.P. Taylor Research Library and Archives, Art Gallery of Ontario.

5 See Laura Coyle, "Chronology," in Jack Cowart et al., *Matisse in Morocco: The Paintings and Drawings, 1912–1913* (Washington: National Gallery of Art, 1990), pp. 257–62.

cat. 92

1 Her exposure in France to "new art," as she called it, was filtered through her expatriate instructors and friends, primarily Henry Phelan Gibb, John Duncan Fergusson and Frances Hodgkins.

2 Emily Carr to Eric Brown, director, National Gallery of Canada, 4 March 1937, in Emily Carr Papers, National Gallery of Canada, reprinted in part in David Alexander and John O'Brian, *Gasoline, Oil, and Paper: The 1930s Oil-on-Paper Paintings of Emily Carr*, exh. cat. (Mendel Art Gallery, Saskatoon, 1995), p. 29.

3 Ibid.

4 Barry Byers, "Conservation Report on the Oil-on-Paper Paintings," in Saskatoon 1995, p. 35. Byers is the former chief conservator at British Columbia Archives

and Records Service, and an expert on Carr's works on paper.

cat. 93

1 *Christian Science Monitor* (Boston), 1915. It specifically described Thomson's canvas as "a virile rendering of the tangled confusion of the fringe of the forest, the still surface of a river, the serrated purple silhouette of woods in the middle distance and a salient curve of the river bank, touched with the ruddy glow of the setting sun."

2 Charles C. Hill, "Painter," in Hill et al., *Tom Thomson*, exh. cat. (National Gallery of Canada, Ottawa, 2002), pp. 130–31; in the same publication, Robert Stacey, "Tom Thomson as Applied Artist," p. 60; and Dennis Reid, "Tom Thomson and the Arts and Crafts Movement in Toronto," p. 79; Dennis Reid, *Tom Thomson: The Jack Pine* (Ottawa: National Gallery of Canada, 1975), p. 11.

3 A close friend of Thomson's at the time, Winifred Trainor, is reported to have later said that it was painted outside Algonquin Park (see Joan Murray, *Tom Thomson: Trees* [Toronto: McArthur and Company, 1999], p. 46). Thomson, however, never suggested a specific location, referring to it simply as his "swamp picture." Tom Thomson, Algonquin Park, to Dr. James MacCallum, Toronto, 22 April 1915, in MacCallum Papers, National Gallery of Canada Archives.

4 Dennis Reid, "Tom Thomson," in Ottawa 2002, p. 79.

5 Mrs. Margaret Twaddle [Thomson] to Martin Baldwin, curator, Art Gallery of Toronto (now the AGO), 2 March 1936, in Edward P. Taylor Research Library and Archives, AGO, Toronto.

cat. 94

1 David Brown Milne to Alice and Vincent Massey, 20 August 1934, in Massey Papers, Massey College, University of Toronto.

cat. 96

1 G. Campbell McInnes, "New Horizons in Canadian Art," *New Frontier* 2 (June 1937): p. 20.

2 Carl Schaefer, Toronto, to J.S. McLean, Toronto, 10 December 1952, in J.S. McLean Papers, Archives of the Art Gallery of Ontario, Toronto.

cat. 97

1 François-Marc Gagnon, *Chronique du mouvement automatiste québécois 1941–1954* (Outremont, QC: Lanctôt, 1998), p. 67.

2 Ibid., p. 103.

3 Paul-Émile Borduas, *Écrits/Writings 1942–1958*, François-Marc Gagnon, ed., François-Marc Gagnon and Dennis Young, trans. (Halifax: Nova Scotia College of Art and Design, 1978), p. 71.

4 There are strong family resemblances to Bram van Velde's more Picasso-derived gouaches also from the early 1940s, but Borduas surely could not have known these works.

cat. 98

1 See Anna Hudson, *A Collector's Vision: J.S. McLean and Modern Painting in Canada* (Toronto: AGO, 1999).

cat. 99

1 The series began with *Woman I, 1950–52* (Museum of Modern Art, New York).

cat. 100

1 Kirk Varnedoe, "Comet: Jackson Pollock's Life and Work," in Kirk Varnedoe, with Pepe Karmel, *Jackson Pollock* (New York: Museum of Modern Art, 1998), p. 29.

cat. 1 (see pp. 28–29)

AGNOLO DI DOMENICO DI DONNINO (Attributed to)

A Standing Draped Youth

PROVENANCE: François Desmarais (or Des Marais), Nantes; part of an album assembled before 1729 (inscribed "*Dessins originaux des plus fameux Peintres, Rassemblez Par M. Des Marais: 1729*" on the title page); the album broken up and sold, Nouveau Drouot, Paris, March 1984 (as studio of Filippo Lippi), for 52,000 francs (sale stamp "D," not in Lugt, at the lower right); Michèle Moatti, Paris; Ian Woodner, New York; his sale, Christie's London, 1991, as "Agnolo di Donnino"; Colnaghi Drawings, London, 1992; purchased 1994, R. Fraser Elliott, Toronto; AGO

LITERATURE: Giampaolo 1994, p. 71, repr.; Goguel 1994, p. 127, note 74

cat. 2 (see pp. 30–31)

MICHELANGELO

Studies of a Left Thigh and Knee, a Right Knee, and a Right Foot

PROVENANCE: Sir Joshua Reynolds (Lugt 2364); Christie's London, 9 December 1982, lot 144; Stanhope Shelton, Suffolk; purchased by an anonymous owner; Sotheby's London, 9 July 2003, lot 9; Kenneth Thomson, Toronto; AGO

LITERATURE: *Apollo* 157 (July 2003), p. 60, repr.

EXHIBITION: Shizuoka 1991, cats. 1–4

cat. 3 (see pp. 32–33)

GIULIO ROMANO

Study for the Toilet of Psyche; Study for Psyche Bathing (?)

PROVENANCE: Arnold Brigden, Winnipeg; Louise Comfort, Ottawa; AGO

LITERATURE: Davidson 1987, pp. 510–13; Joannides 1989, p. 67; Macandrew 1990, p. 30, cat. 5; Weston-Lewis in Edinburgh 1994, p. 103, cat. 49 (as attributed to Giulio Romano); Wolk-Simon and Bambach 1999, p. 166; Joannides 2000, pp. 15, 36–37; Wolk-Simon 2000, pp. 25–26

EXHIBITIONS: Mantua 1989; New York 1999, cat. 2; Kingston 2004 (exhibited at the Kingston venue only)

cat. 4 (see pp. 34–35)

FRANCESCO SALVIATI

Lamentation over the Dead Christ

PROVENANCE: Incorrectly attributed to the collection of P. Crozat; private collection, U.S.; Harlow, McDonald & Co., New York; Ruth Heidsieck, New York; Agnews, London, 1980; AGO

LITERATURE: Sale catalogue, Agnews, London, 1980, cat. 28, repr.; AGO 1990, p. 77; Zeri 1992, pp. 35–37; Mortari 1992, p. 274, cat. 547, repr.

EXHIBITIONS: Milan 1981, cat. 24; Toronto 1981–82, cat. 21; Kingston 2004 (exhibited at the Kingston venue only)

cat. 5 (see pp. 36–37)

AURELIO LUINI

St. John the Baptist in a Landscape

PROVENANCE: Biblioteca Reale, Turin; Sotheby's London, 4 July 1975, lot 187; Paul Drey Gallery, New York; Esther and Malcolm Bick, Massachusetts; Sotheby's New York, 16 January 1986, lot 30 (as attributed to Aurelio

Luini); Frank and Marianne Seger, Toronto; AGO

EXHIBITION: Milwaukee 1981, cat. 14; Kingston 2004 (exhibited at the Fredericton venue only)

cat. 6 (see pp. 38–39)

GIOVANNI BATTISTA NALDINI

Study of a Kneeling Youth, Looking to the Left; Studies of Drapery and a Bust-Length Youth

PROVENANCE: William Mayor (Lugt 2799); Colnaghi, London; purchased in 1986 by R. Fraser Elliott, Toronto; AGO

EXHIBITION: London 1986, cat. 10

cat. 7 (see pp. 40–41)

FEDERICO ZUCCARO

Seated Youth with his Arms Raised

PROVENANCE: Dr. Victor Bloch, London; Colnaghi, London, 1965; R. Fraser Elliott, Toronto; AGO

LITERATURE: Cox 1956, pp. 15, 18, fig. 16 (as a copy after Pontormo); Shearman 1971, pp. 18–20; Luchinat 1999, pp. 39, 42; Cocke 2001, p. 135

EXHIBITIONS: Regina 1970, cat. 13; Toronto 1981–82, cat. 30; Milwaukee 1989–90, cat. 58

cat. 8 (see pp. 42–43)

ANNIBALE CARRACCI

Studies for the Hand of an Angel Holding a Violin Bow; Study for the Figure of St. Jerome Reading

PROVENANCE: From an album of drawings in a family collection, Europe, since 1880s; art market, England; Kate Ganz Ltd., London, 1987, cat. 14; Arthur Gelber, Toronto, 1987; AGO

LITERATURE: Benati and Peruzzi 1987, p. 71, fig. 19; Bull 1987, pp. 549–50; Brogi 1989, p. 18, cat. 3; AGO 1990, p. 83; Benati et al., 1991, cat. 9.5; Legrand 1995, p. 8; Benati 1996, p. 108; Bohn 1996, p. 171; Benati and Peruzzi 1997, p. 56, fig. 21; Robertson 1997, p. 28, fig. 37

EXHIBITION: Washington 1999–2000, cat. 9

cat. 9 (see pp. 44–45)

GIUSEPPE CESARI
called **CAVALIERE D'ARPINO**

Study of a Standing Male Nude

PROVENANCE: Christie's London, 28 June 1966, lot 105 (as Testa); Sotheby's London, 21 November 1974, lot 26, repr.; Marvin Gelber, Toronto; AGO

LITERATURE: Röttgen 1973, p. 155; AGO 1990, p. 82; Röttgen 2002, p. 290, cat. 61, repr. p. 291

EXHIBITION: Toronto 1981–82, cat. 39

cat. 10 (see pp. 46–47)

GIOVANNI FRANCESCO BARBIERI
called **GUERCINO**

A Witch, Two Bats, and a Demon in Flight

PROVENANCE: Christie's London, 9 December 1986, lot 42; AGO

EXHIBITION: Ottawa 1991, appendix, no. 169, pl. I

cat. 11 (see pp. 48–49)

PIETRO BERRETTINI
called **PIETRO DA CORTONA**

Tobias and the Archangel Raphael

PROVENANCE: Said to have been purchased at the Strawberry Hill sale, 1842; Miss E. Carnegy-Arbuthnott, OBE; Christie's London,

30 March 1971, lot 8, repr.; Seiferheld and Co., New York; AGO

LITERATURE: *Art Quarterly* 35 (Summer 1972), p. 199, repr.; Merz 1985, p. 290; AGO 1990, p. 105

EXHIBITION: Toronto 1981–82, cat. 68

cat. 12 (see pp. 50–51)

BALDASSARE FRANCESCHINI
called **IL VOLTERRANO**

Studies for the Head of the Virgin; Right Arm and Hand

PROVENANCE: Sale of 410 drawings, Paris (Hôtel Drouot), 8 November 1922, lot 214; Kate de Rothschild, London;[1] AGO

EXHIBITIONS: Detroit 1974; Florence 1986

1. Kate de Rothschild believes that the drawing came from an album that was split up in Italy by art dealers before Sotheby's obtained the bulk of the drawings and sold them in London, 3 July 1980. The sale included drawings for *The Assumption and Coronation of the Virgin, with Prophets, Saints and Angels*, Florence, SS. Annunziata, tribune cupola, 1681–83 (cats. 46–48). None of the drawings matches the AGO sheet in size. However, its dimensions are similar to many of the drawings in the group for SS. Annunziata.

cat. 13 (see pp. 52–53)

SALVATOR ROSA

A Poet Seated by a Tree

PROVENANCE: Queen Christina of Sweden; Livio Odescalchi (1652–1713); by inheritance to Prince Ladislav Odescalchi; Christie's London, 30 March 1976, cat. 55; Adolphe Stein, Paris; AGO

LITERATURE: Mahoney 1977, cat. 25.1; RACAR 1977, repr. p. 127; AGO 1990, p. 102

EXHIBITIONS: London 1976, cat. 27; Toronto 1981–82, cat. 76 (as *A Poet Seated by a Tree Holding a Pen in One Hand, a Half Open Book in the Other*)

cat. 14 (see pp. 54–55)

ROSALBA CARRIERA

Portrait of a Woman

PROVENANCE: Private collection, Switzerland; Thomas Williams Fine Art Ltd., London, 1995; AGO

LITERATURE: Burns 2002, pp. 356–57, 360 and 365, figs. 77, 78, 81 and 82; Burns 2007

cat. 15 (see pp. 56–57)

GIOVANNI PAOLO PANINI

Roman Ruin with Figures

PROVENANCE: Miss M. Tonucci; Sotheby's London, 9 April 1970, cat. 55; G.C. Baroni, Florence, 1971; AGO

LITERATURE: Arisi 1986, p. 323

EXHIBITIONS: Ottawa 1976, cat. 22; Toronto 1981–82, cat. 114

cat. 16 (see pp. 58–59)

GIAMBATTISTA TIEPOLO

A Reclining Male Nude

PROVENANCE: Armand-Louis de Mestral de Saint-Saphorin; Édouard de Cérenville; René de Cérenville; Colnaghi, London, 1965; R. Fraser Elliott, Toronto; AGO

LITERATURE: Knox 1968 (as by Domenico); Knox 1970, p. 59 (as by Giambattista); Byam Shaw 1971; Knox 1980, p. 48, cat. K.1

EXHIBITIONS: Cambridge 1970, cat. 42; Toronto 1981–82, cat. 130; Vancouver 1990, cat. 55

cat. 17 (see pp. 60–61)

GIOVANNI DOMENICO TIEPOLO

Satyrs and Satyresses in a Landscape

PROVENANCE: Palais Galliera, Paris, 11 March 1967, cat. 16; Charles E. Slatkin Galleries, New York; Arnoldi-Livie, Munich; Christie's New York, July 1988, cat. 89; Hill-Stone, New York; AGO

LITERATURE: Cailleux 1974, p. 81

EXHIBITIONS: New York 1967, p. 17; Munich 1982, cat. 25; New York 1989, cat. 16

cat. 18 (see pp. 64–65)

MASTER OF THE EGMONT ALBUMS

St. Cecilia and the Heavenly Chorus

PROVENANCE: N. Chaikin, New York, 1962 (formerly with *The Good Samaritan Paying the Innkeeper*, which was in the Woodner collection until his sale, Christie's London, 7 July 1992, lot 82); Colnaghi's, London, 1965; Charles E. Slatkin Galleries, New York; Marjorie Bronfman, Montreal; AGO

LITERATURE: Haverkamp-Begemann and Logan 1970, vol. 1, p. 266; Boon 1980–81, p. 23, note 6; Goldner 1983–84, p. 120; Piel 1986, p. 165; Lucassen-Mackert in Kloek 1986, p. 429; Bevers 1989–90, p. 53, note 1; Dacos 1990, p. 65, 68, note 26; Boon 1992, vol. 1, p. 426, note 11; Dittrich 1997, p. 60; van der Sman in Eiche 2000, pp. 57, 65, note 68

EXHIBITION: Ottawa 1976, cat. 6

cat. 19 (see pp. 66–67)

ABRAHAM BLOEMAERT

The Judgment of Paris

PROVENANCE: Randall Davies, London (as Spranger); his sale, Sotheby's London, 10 February 1947, lot 154 (as Bloemaert); Benedict Nicolson, London; Arcade Gallery, London; Theodore Heinrich, 1951; from 1951 to 1983 in the same hands as the painting; AGO

LITERATURE: *Art News* 50 (Sept. 1951): p. 33; Lowenthal 1986, pp. 101, 104; Robinson in Hand 1986, p. 70, note 1; Roethlisberger 1993, cat. D2, pp. 69, 421, fig. 41; Christie's, November 1998, p. 28; Bolten 2007, vol. 1, p. 190, cat. 537, repr. vol. 2, p. 248

EXHIBITIONS: London 1950, cat. 27; Montreal 1953, cat. 122, repr.; Vancouver 1964, cat. 35; Toronto 1968, cat. 165; Poughkeepsie 1970, cat. 10; Ottawa 1976, cat. 7

cat. 20 (see pp. 68–69)

REMBRANDT HARMENSZ. VAN RIJN

A Quack

PROVENANCE: John, Lord Northwick; Sotheby's London, 1–4 November 1920, lot 176; Sotheby's London, 5–6 July 1921, lot 95 (on the same mount with *Two Studies of the Head of an Old Woman*); Captain E.G. Spencer-Churchill, Northwick Park, Brockley, Gloucestershire; The Rt. Hon. Earl of Harewood, Harewood House, Yorkshire; Christie's London, 6 July 1965, lot 135; Herbert Bier, 1965; R. Fraser Elliott, Toronto; AGO

LITERATURE: Valentiner 1925–26, p. 272; Valentiner 1925–34, vol. 2, cat. 751a; Bock and Rosenberg 1930, cat. 5268; Benesch 1935, pp. 15, 28; Benesch 1954–57, vol. 2, cat. 418; Bevers 2006, cat. 19

EXHIBITION: Berlin 2002–03, cat. 76

cat. 21 (see pp. 70–71)

LAMBERT DOOMER

Noah's Ark on Mount Ararat, a Camel Train outside the City of Yerevan in the Foreground

PROVENANCE: Cornelis Hofstede de Groot, The Hague (Lugt 561); C.G. Boerner, Leipzig, 4 November 1931, cat. 82; purchased by Meijer Elte, The Hague; Curt Otto, Leipzig (Lugt 611c); Carl Robert Rudolf, London; Sotheby's London, 18 April 1977, cat 46; David Tunick, New York; AGO

LITERATURE: Hofstede de Groot 1926, p. 191; Schulz 1970, pp. 418, 420, 423, pl. 9; Schulz 1972, cat. 383, pp. 70, 439; Schulz 1974, cat. 270, pl. 146, pp. 33, 105; Sumowski 1979–92, vol. 2, cat. 437; AGO 1990, p. 97

EXHIBITIONS: The Hague 1930, cat. 39; London 1953, cat. 356

cat. 22 (see pp. 72–73)

ADRIAEN VAN DE VELDE

Seated Old Man

PROVENANCE: Mrs. Stewart Bagnani, Port Hope, Ontario; AGO

cat. 23 (see pp. 74–75)

VINCENT VAN GOGH

The Vicarage at Neunen: Seen from the Back, with the Artist's Studio on the Right

PROVENANCE: Elizabeth Huberta du Quesne-van Gogh, in her possession prior to 1913 until 1936; by inheritance to her son Félix du Quesne-van Bruchem, 1936–82, Montreal; Sotheby's Toronto, 31 March 1982, lot 612; AGO

LITERATURE: Du Quesne-van Gogh 1910, p. 55; de la Faille 1970, cat. F1343; AGO 1990, pp. 152–53; Hulsker 1996, cat. 475, repr. p. 111 (as *Parsonage, Seen from the Back*)

EXHIBITIONS: Toronto 1984; S'Hertogenbosch 1988, cat. 85; Otterloo 1990, cat. 95; Toronto 1998–99

cat. 24 (see pp. 78–79)

DANIEL RABEL

Grotesque Musician from the Ballet du Sérieux et du Grotesque

PROVENANCE: Private collection, Germany (discovered mid-1980s[1]); Wheelock Whitney & Co., New York, 1986; AGO

LITERATURE: McGowan 1986, cat. 110

1. See Margaret M. McGowan, *The Court Ballets of Louis XIII: A Collection of Working Designs for Costumes 1615–33* (London: Victoria and Albert Museum, 1986)

cat. 25 (see pp. 80–81)

JACQUES STELLA

The Presentation of Jesus to Simeon in the Temple

PROVENANCE: Bequeathed by the artist to his niece, Claudine Bouzonnet-Stella (1636–1697); left by Bouzonnet-Stella to her cousin Michel de Masson in 1697; by 1756 owned by Gaetano Minossi, Rome; acquired in Rome in the eighteenth century by Thomas Talbot (1747–1806) of Margam Abbey; by descent to Christopher Methuen-Campbell of Penrice Castle, Glamorgan; his sale, Christie's New York, 13 January 1987, lot 105, p. 60;[1] Margot Gordon, New York, 1987; AGO

LITERATURE: Blunt 1974, pp. 748, 749, pl. 47; Davidson 1975, p. 155, note 9

EXHIBITIONS: Paris 1989, p. 85; Cleveland 1989

1. The actual illustration is that of the *Sacrifice of Anna*. See Christie's London, 9 December 1986, p.86, cat. 123.

cat. 26 (see pp. 82–83)

ISRAËL SILVESTRE

View of Venice from the Campanile of San Giorgio Maggiore

PROVENANCE: Earl of Abingdon; his sale, Sotheby's London, 17 July 1935, part of lot 5, an album of drawings; P. and D. Colnaghi, London, 1935, cat. 3; Sir Bruce S. Ingram, Chesham, his collector's mark (Lugt 1405a), from 1935; Mrs. J.C. Prost; J. Seligman, New York; AGO

LITERATURE: *The Illustrated London News*, 10 December 1949, p. 898, repr.; *Art Quarterly* 33, no. 3 (1970): p. 324, repr.; Thuillier 1982, pp. 352, 362–63, 369, 370, repr.; Corboz 1985, vol. 1, p. 49, fig. 26; Laureati 2002, p. 52

EXHIBITIONS: London 1949, cat. 526; Toronto 1970, cat. 27; Toronto 1972–73, cat. 134; Providence, Rhode Island 1978, cat. 45; Toronto 1981–82, cat. 58; Cleveland 1989, cats. 43, 91

cat. 27 (see pp. 84–85)

CHARLES-JOSEPH NATOIRE

The Park at Arcueil

PROVENANCE: Vente Natoire, 1778, lot 287 (?);[1] private collection, Rouen; Palais des Congrès, Rouen, 15 December 1985, lot 48; Christopher Comer, Amherst, Massachusetts, 1987; AGO

LITERATURE: Turcic 1987, pp. 210–11; AGO 1990, p.121

1. Included in Natoire's estate sale (Paris, 14 December 1778 and following days) were fourteen views of Arcueil (lot 287); see *Charles-Joseph Natoire. Nîmes, 1700–Castel Gandolfo, 1777 : peintures, dessins, estampes et tapisseries des collections publiques françaises*, exh. cat. (Troyes; Nîmes; Rome, 1977), p. 102; Jean-François Méjanès, "A Spontaneous Feeling for Nature: French Eighteenth-Century Landscape Drawings," *Apollo* 104 (Nov. 1976): p. 404, note 5.

cat. 28 (see pp. 86–87)

FRANÇOIS BOUCHER

Young Country Girl Dancing

PROVENANCE: Daniel Saint; his sale, Hôtel des Ventes, Paris, 4–8 May 1846, lot 27 (as *Jeune paysanne dansant tenant son tablier des deux mains le corps gracieusement incliné*), sold with its pendant to Delessert Fils; separated from its pendant by 20 January 1851; probably framed by Thomas Ponsonby, London, before 1861;[1] probably sold by Colnaghi before 1911;[2] Mr. Popper, London, then Montreal, c. 1939; by descent to Ritchies Toronto, 2–4 December 1997, lot 4120; Hazlitt, Gooden and Fox, London; AGO

LITERATURE: Souillé et Masson 1906, cat. 2340; Ananoff 1966, cat. 266

EXHIBITIONS: London 2003–04, cat. 54; New York 2003–04

1. The frame is typical of the British idea of a rococo frame of the late 1840s or 1850s according to Thomas Williams who says that the frame has not been modified, and could well have been made for the drawing in London. The label of Thomas Ponsonby on the frame predates the death of Prince Albert in 1861.

2. Fragment of Colnaghi label on the frame bears its address pre-1911. Stephen Ongpin to Katharine Lochnan, 12 June 1998, wrote, "While Colnaghi's has very full records and documentation for paintings, drawings and prints sold by the firm after its move to New Bond Street in 1911, there is only a very little amount of information on any material sold before then." He was unable to find a record of this drawing.

cat. 29 (see pp. 88–89)

CHARLES MICHEL-ANGE CHALLE

The Ruins of the Temple of Antoninus and Faustina in Rome

PROVENANCE: Galerie Jean-François Baroni, Paris; AGO

cat. 30 (see pp. 90–91)

JEAN-HONORÉ FRAGONARD

Charlemagne Leads Angelica away from Roland; Illustration for *Orlando Furioso* Canto 1 (6–9) by Ariosto

PROVENANCE: Fragonard family, by inheritance; Hippolyte Walferdin (1795–1880); Walferdin sale, Hôtel Drouot, Paris, 12–16 April 1880, cat. 228; Louis Roederer, Rheims; Orly-Roederer, Rheims; purchased 1923 by Dr. A.S.W. Rosenbach, Philadelphia; purchased 1947 by Arthur Houghton, United States; by December 1977, Thos. Agnew and Sons Limited, London (as *Melissa Leads Astolfo and Ruggiero to Logistilla*); AGO

LITERATURE: Seznec 1945, pl. 63; Janin 1979, p. 28; AGO 1990, p. 120; Dupuy-Vachey 2003, pp. 36–37 and 377, cat. 3

EXHIBITION: Ottawa 2004, cat. 40

cat. 31 (see pp. 92–93)

HUBERT ROBERT

View of the Vaulting of St. Peter's Taken from an Upper Cornice

PROVENANCE: Sotheby's New York, 18 January 1984, cat. 81; AGO

LITERATURE: *Sotheby's Newsletter* (March 1984), p. 5, repr. (reversed); *Gazette des beaux-arts: Chronique des Arts* (March 1985), p. 22, no. 121, repr.; Cayeux 1985, p. 172; AGO 1990, p. 117

EXHIBITIONS: Ottawa 1986 (*hors catalogue*; exhibited at the Toronto venue only); Rome 1990–91, cat. 131; Philadelphia 2000, cat. 398

cat. 32 (see pp. 94–95)

PIERRE NARCISSE GUÉRIN

Clytemnestra Urges Aegistes to Kill the Sleeping Agamemnon

PROVENANCE: Georges Danyau, second half of 19th century (Lugt 720); possibly Guillaume Bodinier sale, Angers, 12–21 February 1873 (Lugt 33668); Hôtel Drouot, Paris, 22 March 1983; Galerie Cailleux, Paris, 1983–89; AGO

EXHIBITION: Paris 1989, cat. 65

cat. 33 (see pp. 96–97)

JEAN-AUGUSTE-DOMINIQUE INGRES

Study of a Drapery

PROVENANCE: Collection of the artist; Hôtel Drouot (?); collection of Edgar Degas; collection sale II: 207.3; purchased Carré, lot 3; Huguette Berès, Paris; purchased 1968, R. Fraser Elliott, Toronto; AGO

EXHIBITION: New York 1997, cat. 709

cat. 34 (see pp. 98–99)

EUGÈNE DELACROIX

The Bride of Lammermoor

PROVENANCE: Artist's studio; Frédéric Villot; Vente Villot, 6 December 1875, lot 61; Jean Joseph Marie Anatole Marquet de Vasselot, Hôtel Drouot, 1891; with André Piccitti in 1954; Lucien Goldschmidt, New York by 1978; AGO

LITERATURE: Robaut 1885, p. 33, cat. 104; Sérullaz 1963, p. 32, cat. 58; Kemp 1973, p. 215, footnote 11; Wilton 1984–85, fig. 3, pp. 350–51

EXHIBITIONS: Tours 1998, cat. S.8; London 2003–04, cat. 179

cat. 35 (see pp. 100–01)

JEAN-FRANÇOIS MILLET

Women Carrying Loads of Dried Grasses at the Entrance to a Village; *Sketch of the Plain of Chailly*

PROVENANCE: Émile Gavet (1830–1904), Paris; Hôtel Drouot, Paris, 11–12 June 1875, cat. 44 (as *Ramasseurs des bois mort*); collection of Comte Doria, 1887 (as *Femme(s) portant des faix d'herbes à l'entrée d'un village*); probably Vente Armand Doria, Galerie Georges Petit, Paris, 4–5 May 1899; James Staats Forbes, London, until 1906; Frits Meyer, Zurich; collection of F. Meyer, Zurich; Fred. Muller, Amsterdam, 13 July 1926; E.J. van Wisselingh and Co., Amsterdam; purchased 1926 by Mrs. F.R. Douglas, Montreal or Ottawa; estate of Mildred Douglas; Miss Florence Forman, Vancouver, BC; consigned to sale with Sotheby's New York, through Sotheby's Toronto, 1989; AGO

LITERATURE: Gay 1950, cat. 29 (as *Femmes portant des faix d'herbes*)

EXHIBITION: Paris 1887, cat. 118 (as *Femmes portant des faix d'herbes à l'entrée d'un village* [*dessin rehaussé*])

cat. 36 (see pp. 102–03)

FRANÇOIS BONVIN

A Woman Knitting

PROVENANCE: Stoppenbach and Delestre Ltd., London, through Waddington and Schiell Galleries Ltd., Toronto; AGO

LITERATURE: AGO 1990, p. 139

cat. 37 (see pp. 104–05)

EDGAR DEGAS

Portrait of a Woman

PROVENANCE: The artist's studio, third sale, Galerie Georges Petit, Paris, 7–9 April 1919, lot 50 (3) (as *Tête de femme âgée*); Georges Bernheim, Paris; anonymous sale, Hôtel Drouot, Paris, 9 June 1928, cat. 3; Duc de Trévise, Paris; anonymous sale, Plaza Art Galleries, New York, 11 April 1940, lot 74, repr.; anonymous sale, Parke-Bernet, New York, 16 March 1944, lot 56, repr.; Joseph Rosenberg, Milwaukee; Hirschl and Adler Galleries, New York; Vivian and David Campbell, Toronto; AGO

LITERATURE: Lemoisne 1946, vol. 2, cat. 675

EXHIBITIONS: Paris 1931; New York 1963–64, cat. 67; Toronto 2003–04

cat. 38 (see pp. 106–07)

PIERRE AUGUSTE RENOIR

Studies for Mother and Child

PROVENANCE: Ambroise Vollard, Paris; Robert de Galea, Paris; Theodore Schempps and Company, Paris; M. Knoedler and Co., New York, June 1951; purchased 1951 by Sam and Ayala Zacks, Toronto; AGO

LITERATURE: AGO 1990, p. 145

EXHIBITIONS: Jerusalem 1955, cat. 66; Toronto 1956–57, cat. 96 (as *Mother and Child*); Toronto 1960; Toronto 1971, cat. 100

cat. 39 (see pp. 108–09)

LÉON-AUGUSTIN LHERMITTE

Watering the Garden

PROVENANCE: Boussod, Valadon and Cie; Bergand; H.C. Cox (father); Mr. and Mrs. H.C. Cox (son); AGO

LITERATURE: Hamel 1974, cat. 194; Fonteny 1991, cat. 83, p. 178

EXHIBITION: Oshkosh 1974, cat. 43

cat. 40 (see pp. 110–11)
PAUL GAUGUIN
Tahitian Girl in Pink Pareu
PROVENANCE: Francisco Durrio (?);
Marcel Gobin, Paris; Harold and Ruth Tovell,
Toronto, 1929; Vincent Tovell, Toronto; AGO
LITERATURE: Tovell 1932, p. 271; Field 1973,
cat. 21
EXHIBITIONS: Paris 1926, cat. 27; Basel 1928,
cat. 225; Berlin 1928, cat. 221; Toronto 1973,
cat. 21; Toronto 1981–82, cat. 24

cat. 41 (see pp. 114–15)
FRANZ INNOCENZ KOBELL
Colosseum
PROVENANCE: Arturo Cuéllar, Zurich, 2004;
AGO

cat. 42 (see pp. 116–17)
**JOHANN CRESCENTIUS
SEYDELMAN**
Portrait of a Man
PROVENANCE: Robert Frank (Charlotte
Frank), London; AGO

cat. 43 (see pp. 118–19)
JOHANN CHRISTIAN REINHART
In the Park of the Palazzo Chigi, Ariccia
PROVENANCE: Galerie Arnoldi-Livie,
Munich, 2005; AGO

cat. 44 (see pp. 120–21)
**ADOLPH FRIEDRICH ERDMANN
VON MENZEL**
Head of a Young Man
PROVENANCE: Galerie Grünwald,
Munich, 1985; AGO
LITERATURE: AGO 1990, p. 156

cat. 45 (see pp. 122–23)
KÄTHE KOLLWITZ
*Tavern in Königsberg;
Studies of Women's Clothing*
PROVENANCE: Gutekunst und Klipstein,
1958, auction 90, cat. 519, repr. pl. 38;
Galerie St. Étienne, New York, 1959,
cat. 3, repr. p. 6, 1961, cat. 2, repr. p. 8,
1965, cat. 3; Karl and Faber, 1971, auction 130,
cat. 895; Galerie St. Étienne and Kennedy
Galleries, New York, 1976, cat. 2, repr. p. 8;
Galerie Dresdnere, Toronto, 1983; AGO
LITERATURE: Nagel/Timm 1972, cat. 51
EXHIBITION: Toronto 2003, cat. 4

cat. 46 (see pp. 126–27)
THOMAS GAINSBOROUGH
Wooded Landscape with Herdsman and Cattle
PROVENANCE: Earl Spencer, Althorp
(Lugt 2341a), then by descent; Agnews, 1979;
private collection, U. S., 1983; Agnews, 1985;
AGO
LITERATURE: Woodall 1939, cat. 292;
Hayes 1971a, vol. 1, cat. 389, vol. 2, pl. 139
(as mid-1770s); AGO 1990, repr. colour p. 124
EXHIBITIONS: Oxford 1935, cat. 18;
London 1936, cat. 69; Washington 1983,
cat. 53; Toronto 1987; Toronto 1987a, cat. 1;
Fredericton 1991, cat. 17, repr.

cat. 47 (see pp. 128–29)
GEORGE ROMNEY
John Howard Visiting a Prison or Lazaretto
PROVENANCE: By descent to the artist's
granddaughter Elizabeth Romney; her sale,
Christie's London, 24–25 May 1894; Xavier
Haas, early 1900s;[1] Marie Grey; Theodore
Allen Heinrich, 1947; AGO
LITERATURE: Moskowitz 1962, cat. 979,
repr. colour (as *Episode from the Revelations*

of Darius);[2] Black 1996, repr. p. 167
EXHIBITIONS: Pasadena 1952; Scottsdale
1953, cat. 21; Toronto 1983, cat. 2 (as c. 1790);
Kitchener 1985, cat. 37 (as *John Howard
Visiting a Prison*, 1790–92)
1. The circular "GEORGE ROMNEY" stamp
 inside the drawing's mat is a collector's mark
 of Xavier Haas of the Galerie Haas and Gross,
 Paris. Haas was a dealer who, according to
 Patricia Milne-Henderson, formed "the greatest
 collection of Romney drawings … since the
 break-up of the artist's studio." Patricia Milne-
 Henderson, *The Drawings of George Romney*
 (Northampton, Mass.: Smith College Museum
 of Art, 1962). This collector's mark was placed
 on drawings in the Haas collection probably
 shortly after World War II.
2. The identification as Darius may stem from
 Haas, as Galerie Haas and Gross's *Romney et
 Shakespeare* exhibition in 1913 included twelve
 drawings called *Le spectre de Darius (Perses
 d'Eschyle)*. According to Milne-Henderson 1962,
 cat. 80, there were at least twenty-three such
 sheets in the Haas collection, and the subject
 was later correctly identified as John Howard
 in the Haas papers.

cat. 48 (see pp. 130–31)
HENRY FUSELI
A Standing Nude Figure, Seen from Behind
PROVENANCE: Harriet Jane Moore
(1801–1884); Christie's London,
14 April 1992, lot 42; Martyn Gregory,
London; AGO

cat. 49 (see pp. 132–33)
THOMAS KERRICH
*Portrait of William Heath M.A., Fellow of
Magdalene College*
PROVENANCE: Sotheby's London, 21 March
1989, lot 82; Christopher Powney, Shrewsbury;
AGO

cat. 50 (see pp. 134–35)
JOHN ROBERT COZENS
The Lake of Albano and Castel Gandolfo
PROVENANCE: Trimbridge Galleries, Bath;
Martyn Gregory, London, cat. 43; AGO
LITERATURE: Clark 1956, cat. 68, p. 71;
AGO 1990, p. 125
EXHIBITION: Toronto 1986, cat. 201

cat. 51 (see pp. 136–37)
JOHN FLAXMAN
Paternal Affection
PROVENANCE: Christopher Powney,
dealer in drawings, Faversham; AGO
EXHIBITION: Toronto 1983

cat. 52 (see pp. 138–39)
THOMAS ROWLANDSON
After Dinner
PROVENANCE: Frost and Reed, London;
Mellors Fine Arts, Toronto, 1937; AGO
EXHIBITIONS: Toronto 1967, cat. 5;
Toronto 1987, cat. 6

cat. 53 (see pp. 140–41)
**JOSEPH MALLORD WILLIAM
TURNER**
Stormy Landscape with a Rainbow
PROVENANCE: Given by the artist to H.A.J.
Munro of Novar, 1836; Allon Dawson;
by descent to his granddaughter;
Agnews AG (Swiss subsidiary of Agnews
London); Alan Flacks, 1987; estate of Alan
Flacks; AGO

cat. 54 (see pp. 142–43)
JOHN CONSTABLE
Bow View of H.M.S. Victory in the Medway
PROVENANCE: Captain Charles Golding
Constable; Clifford Constable, 1900;
descendants of the artist; Sotheby's
London, 19 March 2003, lot 139;
Kenneth Thomson, Toronto; AGO
LITERATURE: Beckett 1964, pp. 33–34;
Reynolds 1996, p. 46, cat. 03.7

cat. 55 (see pp. 144–45)
JOHN SELL COTMAN
Rustic Cottage
PROVENANCE: Independent Gallery, London,
May 1928; Martyn Gregory, London; AGO

cat. 56 (see pp. 146–47)
PETER DE WINT
An Oxcart on a Country Road
PROVENANCE: J. and W. Volkins; Charles
Frederick Huth, Christie's London, 6 July
1895, lot 65; Martyn Gregory, 1983, cat. 52;
Andrew Wyld, 1983; AGO
EXHIBITIONS: Toronto 1987a, no. 16;
Minneapolis 1996

cat. 57 (see pp. 148–49)
BENJAMIN ROBERT HAYDON
Head of a Young Man
PROVENANCE: Frederick Cummings;
private collection, U. S., until 1991; Thomas
Williams Fine Art, London; AGO

cat. 58 (see pp. 150–51)
WILLIAM TURNER OF OXFORD
Bournemouth Common
PROVENANCE: Sotheby's London, 12 July 1984
("Property of a Gentleman"), lot 31; Martyn
Gregory, London, 1985, cat. 131; AGO
EXHIBITION: Toronto 1987a, cat. 19

cat. 59 (see pp. 152–53)
JOHN LINNELL
Eve Offering the Forbidden Fruit to Adam
PROVENANCE: By descent from the artist to
J.S. Linnell; his sale, Christie's London, 10 June
1964, lot 1; Ruskin Gallery; Alan Rowe and
Geoffrey Bayldon; Alister Mathews,
Bournemouth; Mrs. Mathews; Spink and Son;
AGO
LITERATURE: Firestone 1971, pp. 112–13

cat. 60 (see pp. 154–55)
FRANCIS DANBY
*The Avon Gorge with Clifton and the Hotwells,
Bristol*
PROVENANCE: Private collection;
Thomas Agnew and Sons, London, 1988;
AGO
EXHIBITIONS: London 1988–89, cat. 75;
London 1996, cat. 94

cat. 61 (see pp. 156–57)
RICHARD PARKES BONINGTON
Dutch Fishing Vessels near the French Coast
PROVENANCE: Charles Russell; Sotheby's
London, 30 November 1960, cat. 64 (as
Fishing Boats off the Normandy Coast), where
Agnews purchased for W.B. Dalton; AGO
LITERATURE: Brooke 1966, repr.; AGO 1990,
p. 136
EXHIBITIONS: Toronto 1970, cat. 42; Toronto
1987a, cat. 17; New Haven 1991–92, cat. 43

cat. 62 (see pp. 158–59)
SAMUEL PALMER
Sunset
PROVENANCE: Mrs. William Foster; Christie's
London, 22 March 1946, lot 42, to Fine Art
Society; Mrs. Robert Skinner; Thomas Agnew
and Sons, London; AGO
LITERATURE: Lister 1988, p. 211, cat. 683
EXHIBITIONS: London 1946, cat. 5;
Sheffield 1961, cat. 82; London 1977, cat. 99;
Toronto 1987a, cat. 20

cat. 63 (see pp. 160–61)
DANIEL FOWLER
Cactus
PROVENANCE: Sir Edmund Osler, 1918; AGO
LITERATURE: AGO 1970, p. 124
EXHIBITIONS: Toronto 1875, cat. 60; Toronto
1911, cat. 43; Kitchener 1967, cat. 10; Toronto
1972a, cat. 39, Toronto 1978, cat. 11; Kingston
2006, cat. 22

cat. 64 (see pp. 162–63)
JOHN RUSKIN
*Study of a Feather, Flanked by Two Studies
of a Gentian*
PROVENANCE: Brantwood sale, Sotheby's
London, 20 May 1931, no identifiable lot;
Sir Michael Sadler;[1] Christie's London,
14 November 1989, lot 159; Martyn
Gregory, London; AGO
EXHIBITIONS: London 1991, cat. 107;
New York 1996, cat. 25
1. Not in his sale, Christie's London, 25 May 1945.

cat. 65 (see pp. 164–65)
EDWARD BURNE-JONES
Ariadne
PROVENANCE: Gift of the artist to
Euphrosyne Ionides Cassavetti;[1] her
daughter, Maria Zambaco; by family
descent to A.J.S. Cassavetti; his sale, Christie's
London, 19 November 1965, lot 31; bought by
Thomas Agnew and Sons, London (190
guineas); Foster family collection, Kent;
Galerie Arnoldi-Livie, Munich (c. 1975);
Schulz-Dornburg collection, Munich;
Sotheby's London, 14 December 2006,
lot 110; Galerie Arnoldi-Livie, Munich; AGO
LITERATURE: Fitzgerald 1975, p. 134
1. According to Penelope Fitzgerald's notebooks for
 her Burne-Jones biography recording information
 from Helen Cassavetti Milligan, the sister of
 A.J.S. Cassavetti (Harry Ransom Humanities
 Research Center, University of Texas at Austin),
 Euphrosyne was given this work as a gift
 (information kindly supplied by Dr. Elisa Korb,
 whom I would like to thank along with Dr. John
 Collins and Dr. Dennis T. Lanigan for their help
 with this entry).

cat. 66 (see pp. 166–67)
EDWARD JOHN POYNTER
The Snake Charmer
PROVENANCE: M. de Salvador sale, London,
25 April 1899; Christie's London, 23 March
1928, lot 67, to Sampson, 15 guineas; Christie's
London, 8 April 1929, lot 81, to Pollock, 19
guineas; Thomas Agnew, Manchester; Carroll
Galleries, Toronto; private collector, Toronto;
Waddington's, Toronto; Sheldon Fish; AGO
LITERATURE: Anonymous 1867a, p. 87;
Anonymous 1867b, p. 195; Anonymous 1867c,
p. 143; Lanigan 2003, p. 89
EXHIBITIONS: London 1867, cat. 586;
Toronto 2000

cat. 67 (see pp. 168–69)
SIMEON SOLOMON
Profile Head
PROVENANCE: Jerrold Morris Gallery,
Toronto; AGO
EXHIBITION: Toronto 2000

cat. 68 (see pp. 170–71)
HELEN ALLINGHAM
*The Dairy Door, Farringford,
Lord Tennyson's Home*
PROVENANCE: Christopher Wood, London;
Chris Beetles, London; AGO
LITERATURE: Wood 1988

cat. 69 (see pp. 174–75)
PIET MONDRIAN
Farm at Duivendrecht
PROVENANCE: By c. 1910, J.F.S. Esser and
heirs (Miss C. Esser); Alan Frumkin Gallery,
New York, 1960; Laidlaw Foundation, Toronto,
1962; AGO
LITERATURE: Welsh 1963, p. 3; Buenger 1984,
repr.; AGO 1990, p. 168; Joosten and Welsh
1998, vol. 1, cat. A391
EXHIBITIONS: New York 1964, cat. 8; Toronto
1966, cat. 28; Regina 1969, cat. 68; Amsterdam
1994, cat. 40 (as *The Farm Weltevreden at
Duivendrecht*, 1905)

cat. 70 (see pp. 176–77)
GIACOMO BALLA
Line of Speed
PROVENANCE: Acquired Rome, from the
artist's daughter, Lucia, 1956; Rose Fried
Gallery, New York; Sam and Ayala Zacks,
Toronto, 1960; AGO
LITERATURE: AGO 1990, p. 177
EXHIBITIONS: Hartford 1961 (as *Futurist
Composition*, 1914); Edmonton 1978, cat. 2 (as
Movement in Space, 1914); Toronto 1990–92,
cat. 4

cat. 71 (see pp. 178–79)
KARL SCHMIDT-ROTTLUFF
Seated Nude
PROVENANCE: Hanna Bekker vom Rath,
1920s (?); private collection, Toronto; AGO
LITERATURE: AGO 1990, p. 192; Thiem
2003, cat. 73, repr. p. 134
EXHIBITION: Toronto 1981, cat. 92

cat. 72 (see pp. 180–81)
EGON SCHIELE
Portrait of a Girl
PROVENANCE: W. Ketterer, Munich, 9 June
1970, sale 3, lot 1473c; Helen Serger, La
Boetie, New York; Herb Alpert, Toronto, 1977;
AGO
LITERATURE: Kallir 1990, cat. 1895, p. 570

cat. 73 (see pp. 182–83)
MAX ERNST
Discussion
PROVENANCE: Willy Fick, Cologne; Frank
and Suse Eggert, Whitby, 1967; Angelika
Littlefield and Michael Eggert; AGO
LITERATURE: Herzogenrath, Teuber and
Littlefield 1986, repr. p. 19; Camfield 1993,
fig. 21, p. 50; Foster 1996
EXHIBITION: Toronto 1988

cat. 74 (see pp. 184–85)
GEORGE GROSZ
City Scene
PROVENANCE: Herbert Tannenbaum,
1920s (?); private collection, Toronto; AGO
EXHIBITION: Mannheim 1994, cat. 173

cat. 75 (see pp. 186–87)
FRANTIŠEK KUPKA
Study for Around a Point
PROVENANCE: Pierre Brullé; Galerie
Normand, Paris, March 2007; AGO
EXHIBITION: Paris 2007

cat. 76 (see pp. 188–89)
VASILY KANDINSKY
Grey Circle
PROVENANCE: Ida Bienert, Dresden, October
1926; Marlborough Fine Art, London
(by 1966); Anne Callahan, Toronto, 1967;
AGO
LITERATURE: Grohmann 1933, p. 21;
Overy 1969, repr. pl. 44; Roethel and Benjamin
1982–84, vol. 2, p. 676; Barnett 1994, vol 2,
cat. 619, p. 58
EXHIBITIONS: Berlin 1923; Vienna 1924;
Dresden 1927; Munich 1950, cat. 97; London
1966, cat. 24

cat. 77 (see pp. 190–91)
SONIA DELAUNAY
Paris
PROVENANCE: Rose Fried Gallery, New York,
by May 1956; Sam and Ayala Zacks, Toronto,
1956; AGO
LITERATURE: AGO 1990, p. 179
EXHIBITIONS: Toronto 1956–57, cat. 22;
Toronto 1971, cat. 114; Regina 1979; Toronto
1990–92, cat. 30; Barcelona 2001, cat. 55

cat. 78 (see pp. 192–93)
MARC CHAGALL
The Temptation
PROVENANCE: Nell Walden, Berlin;
Schick, Paris; Galerie Motadert, Paris;
E.J. van Wisselingh and Company, Amsterdam,
1951; Dr. M.J. van Tussenbroek, Haarlem,
1953; E.J. van Wisselingh and Company,
Amsterdam, cat. 7942, 1958; Mrs. Murray
Vaughan, Montreal, 3 December 1958; AGO
LITERATURE: Meyer 1961, cat. 87, repr.
p. 747 (as *Le couple sur le lit*); Sorlier 1982,
cat. 135 (as *Couple on a Bed*)
EXHIBITIONS: Montreal 1952, cat. 3;
Amsterdam 1952, cat. 4

cat. 79 (see pp. 194–95)
LIUBOV POPOVA
Cubist Man (Standing Figure)
PROVENANCE: George Costakis, Moscow;
Mr. and Mrs. Arnold Smith, Toronto, 1972;
Stewart Smith, Toronto; AGO

cat. 80 (see pp. 196–97)
**ELIEZER MARKOVITCH
(EL) LISSITZKY**
Study for "Proun" 8 Stellungen
PROVENANCE: Moscow, 1965;
Sam and Ayala Zacks, Toronto; AGO
LITERATURE: AGO 1990, p. 200
EXHIBITIONS: Eindhoven 1965–66,
hors catalogue; Toronto 1971, cat. 137 (as
Abstraction [*Victory over the Sun*]); Los Angeles
1980, cat. 157; Cambridge 1987; Toronto
1990–92, cat. 16

cat. 81 (see pp. 198–99)
ÉDOUARD VUILLARD
In the Studio of the Rue de Calais
PROVENANCE: Private collection; Galerie
Bellier, Paris, 1969; David Findlay Galleries,
New York, 1979; Jerrold Morris Gallery,
Toronto; R. Fraser Elliott, Toronto, 1979; AGO
LITERATURE: Salomon and Cogeval 2003,
cat. X-180

cat. 82 (see pp. 200–01)
HENRI MATISSE
Seated Model with a Guitar
PROVENANCE: M. George Levy, Paris; M.
Lemare, Paris; Carroll Carstairs, New York;
Stanley N. Barbee, Beverly Hills, California;
Mrs. L. Schwan; M. Knoedler and
Company, New York, 1953; Sam and Ayala
Zacks, Toronto; AGO
LITERATURE: Faure 1923, repr. pl. 53;
Escholier 1937, repr. p. 89; Carlson 1971,
cat. 40, repr. p. 100; AGO 1990, p. 199
(as *Seated Model with Guitar*)
EXHIBITIONS: New York 1931, cat. 93 (?);
New York 1944; Jerusalem 1955, cat. 48;
Toronto 1956–57, cat. 72; Toronto 1969,
cat. 6; Toronto 1971, cat. 107; Baltimore 1971,
cat. 40; Paris 1975, cat. 67; New York 1985,
cat. 60

cat. 83 (see pp. 202–03)
GEORGES ROUAULT
Idyll
PROVENANCE: Brummer Gallery, New York,
1930; Harold and Ruth Tovell, Toronto, 1934;
Dr. H.M.M. Tovell, New York; AGO
EXHIBITION: Toronto 1935, cat. 191

cat. 84 (see pp. 204–05)
RAOUL DUFY
The Mosque of Marrakesh
PROVENANCE: Galerie Bernheim-Jeune, Paris;
Galerie Motte, Geneva; Galerie Art Moderne,
Lucerne; Galerie Moos, Geneva, 1958;
Sam and Ayala Zacks, Toronto, to 1970; AGO
LITERATURE: Berr de Turique 1930, repr.
p. 120; Guillon-Laffaille 1981, p. 119, cat. 328
EXHIBITIONS: Geneva 1952, cat. 152; Toronto
1956–57, cat. 31; Toronto 1971, cat. 119

cat. 85 (see pp. 206–07)
FERNAND LÉGER
Two Figures
PROVENANCE: Molesworth, London, by 1957;
Sam and Ayala Zacks, Toronto, 1957; AGO
EXHIBITIONS: Toronto 1956–57, cat. 57;
Toronto 1971, cat. 113

cat. 86 (see pp. 208–09)
ANDRÉ MASSON
The Legend of Corn
PROVENANCE: Buchholz Gallery, New York;
Galerie Louise Leiris, Paris; Galerie du Perron,
Geneva, by 1963; Allan Gotlieb, Toronto,
by 1964; AGO
LITERATURE: Clébert 1971, repr. pl. 136
EXHIBITIONS: Geneva 1963, cat. 13;
Toronto 2002, cat. 22

cat. 87 (see pp. 210–11)
PABLO PICASSO
Head of a Man
PROVENANCE: Galerie Louise Leiris, Paris;
Dunkelman Gallery, Toronto; Mr. and Mrs.
Sidney Bregman, Toronto; AGO
LITERATURE: Zervos 1932–78, vol. 27, p. 28,
cat. 92; AGO 1990, p. 198; Chipp and Wofsy
1995, vol. 13, repr. 376, cats. 67–318
EXHIBITIONS: Paris 1968, cat. 53; Toronto
1972, cat. 25; Toronto 1988a, cat. 39

cat. 88 (see pp. 212–13)
VANESSA BELL
Design for Small Screen
PROVENANCE: Spink and Son, London, 1991;
AGO
EXHIBITION: London 1991a, cat. 38

cat. 89 (see pp. 214–15)
STANLEY SPENCER
Head of a Girl
PROVENANCE: Christopher Powney,
London; AGO
EXHIBITION: London 2001 (*hors catalogue*;
shown only in Toronto)

cat. 90 (see pp. 216–17)
HENRY MOORE
Group of Shelterers During an Air Raid
PROVENANCE: Contemporary Art Society,
London; AGO
LITERATURE: *Poetry* (London), vol. 2, no. 7
(Oct.–Nov. 1942), repr. facing p. 32; Read 1957,
vol. 1, pl. 191b; Melville 1972, repr. p. 95;
Wilkinson 1979, cat. 48, repr. p. 73; Lieberman
1983, repr. p. 52; Wilkinson 1984, pl. 258;
Wilkinson 1987, cat. 48, repr. p. 99; Finlay 1987,
repr. fig. 2; Garrould 1994–2003, vol. 3, cat.
41.62, repr. p. 95; Andrews 2002, pl. 80, repr.
p. 138
EXHIBITIONS: London 1948, cat. 35; Toronto
1977–78, cat. 151; Iwaki-shi 1978, cat. 124;
Toronto 1985–86, cat. 8; London 1988,
cat. 151; Dallas 2001–02, cat. 162

cat. 91 (see pp. 220–21)
JAMES WILSON MORRICE
Casino by the Sea
PROVENANCE: Estate of the artist, W. Scott and
Sons, Montreal; AGO
LITERATURE: Duval 1954, repr. pl. 25
(as c. 1922); AGO 1970, pp. 322–23, repr.
(as c. 1920)
EXHIBITIONS: Ottawa 1937, cat. 14;
Montreal 1965, cat. 106; Montreal 1985

cat. 92 (see pp. 222–23)
EMILY CARR
Stumps and Sky
PROVENANCE: Douglas Duncan,
Picture Loan Society; AGO
LITERATURE: Barwick 1975, repr. p. 13;
Shadbolt 1979, fig. 148, p. 163; Tippett 1979,
repr. p. 228; AGO 1990, repr. p. 286
EXHIBITIONS: Vancouver 1971, cat. 99;
Sackville 1978; Saskatoon 1980; Victoria 1982,
cat. 2; Ottawa 2006–08, cat. 130

cat. 93 (see pp. 224–25)
TOM THOMSON
Study for "Northern River"
PROVENANCE: Estate of the artist;
Sir Edmund Walker, Toronto, 1918;
Mrs. Carl Hunter, Toronto, 1924, by bequest;
Dr. Harold Hunter, Toronto, 1966, by descent;
AGO
LITERATURE: Addison 1969, p. 36; Reid 1970,
p. 83; Reid 1975, pp. 11, 15; Town and Silcox
1977, p. 94, repr. colour; Gamester 1983;
Murray 1986, p. 32, repr. colour p. 33; Murray
1994, p. 54, repr. colour; Murray 1999, p. 46;
Silcox 2002, p. 58, repr. colour
EXHIBITIONS: Toronto 1941; Toronto 1971a,
cat. 36; London 1991b; Ottawa 2002–03, cat. 39

cat. 94 (see pp. 226–27)
DAVID BROWN MILNE
Reflections, Bishop's Pond
PROVENANCE: Douglas Duncan, Picture Loan
Society; J.S. McLean, Toronto, 1938; AGO
LITERATURE: AGO 1970, cat. 8; Jordan 1975,
p. 28, cat. 51 repr.; Silcox 1996, p. 126; Milne
and Silcox 1998, vol. 1, p. 287, cat. 201:112;
Lochnan 2005, pp. 101–21
EXHIBITIONS: Ottawa 1952, cat. 57;
Toronto 1968a, cat. 54; Toronto 1975–76,
cat. 51; West Palm Beach 1984

cat. 95 (see pp. 228–29)
FRANKLIN CARMICHAEL
Snow Clouds
PROVENANCE: Purchased directly from the
artist, 1928
LITERATURE: AGT 1928, p. 18; Brooker
1929, p. 77
EXHIBITIONS: Toronto 1927, cat. 18;
Toronto 1928, cat. 8; Toronto 1947, cat. 25;
Orillia 1961, cat. 10; Toronto 1967a; Toronto
1969–70, cat. 7; Victoria 1981, cat. 13;
St. Thomas 1989, cat. 4

cat. 96 (see pp. 230–31)
CARL SCHAEFER
Storm over the Fields
PROVENANCE: J.S. McLean, Toronto 1938;
AGO
LITERATURE: Hudson 1999, repr. p. 62
EXHIBITION: Hamilton 1986, cat. 20

cat. 97 (see pp. 232–33)
PAUL-ÉMILE BORDUAS
Abstraction
PROVENANCE: Galerie B, Montreal; AGO
LITERATURE: AGO 1990, p. 314
EXHIBITION: Timmins 1987, cat. 13

cat. 98 (see pp. 234–35)
DIEGO RIVERA
Day of the Dead
PROVENANCE: Galeria de Arte Mexicano,
Mexico City; J.S. McLean Collection, Toronto;
AGO
EXHIBITIONS: Ottawa 1946; Toronto 1992,
cat. 48

cat. 99 (see pp. 236–37)
WILLEM DE KOONING
Two Women on a Wharf
PROVENANCE: Edward F. Dragon, East
Hampton; Aquavella, New York; AGO
LITERATURE: Hess 1959, pl. 110; Rosenberg
1974, pl. 99; Waldman 1988, pp. 79–80 repr.;
AGO 1990, p. 306
EXHIBITIONS: Venice 1954; New York
1968–69; New York 1983–84; Newport
1988–89; Los Angeles 2002–03

cat. 100 (see pp. 238–39)
JACKSON POLLOCK
Untitled
PROVENANCE: Peggy Guggenheim Collection,
New York; estate of Dwight Ripley, New York;
Jeffrey Loria Collection, New York; AGO
LITERATURE: O'Connor and Thaw 1978,
vol. 4, cat. 1011; Marchesseau 1979, p. 58 repr.;
AGO 1990, p. 304
EXHIBITIONS: New York 1979, cat. 29; New
York 1980; Timmins 1987, cat. 11; Berlin 2005,
cat. 45

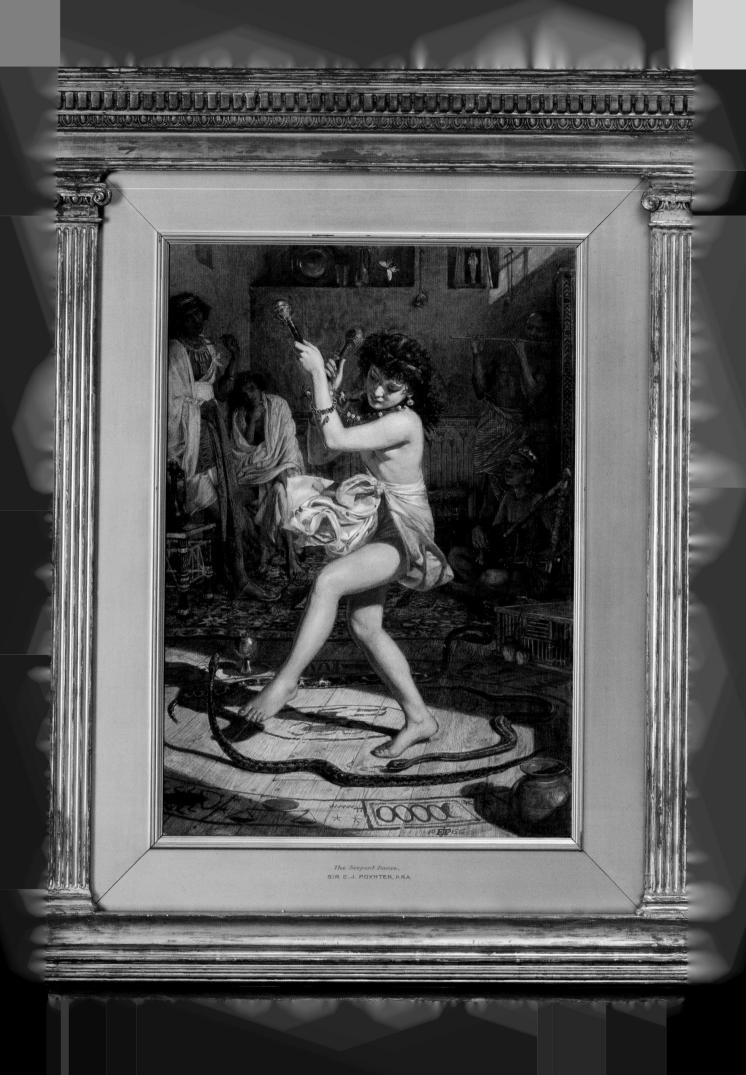

The Serpent Dance.
SIR E. J. POYNTER, P.R.A.

THE ART OF FRAMING DRAWINGS

Frames around paintings have existed since they were movable, but this is not so with works on paper. While drawings have been prized by collectors since the Renaissance, they were not regarded until the eighteenth century as having the necessary visual presence to be framed and exhibited with paintings. Instead they were viewed as precious objects for study by connoisseurs interested in their aesthetic properties.

The traditional way of keeping individual sheets together was in albums or portfolios, which protected the drawings and allowed collectors easy access to them. By the sixteenth century works on paper were often pasted onto sheets and given decorative borders that served the same purpose as a frame by focusing attention on the drawing and creating a sense of perspective. In perhaps the earliest example, sixteenth-century Italian artist and historiographer Giorgio Vasari (1511–1574) employed distinctive *trompe l'oeil* borders around the drawings he collected. He surrounded each work with an elaborately drawn frame of his own design and would often insert into it a portrait of the artist. By framing the drawings in this manner, he intended to create the illusion of a finished work of art, thus giving each a distinctive and definitive character.[1]

The practice of drawn or painted borders around works on paper continued into the eighteenth century. Drawings were still kept in elaborate portfolios, but a new device was introduced by the French collector Pierre-Jean Mariette (1694–1774), who instead of pasting his Old Master drawings into an album mounted them individually on sheets of coloured cardboard. A gold line framed each drawing, with the name of the artist inscribed in a cartouche below. These are referred to as "Mariette" mountings, a testament to his exquisite taste.[2] This practice of devising a distinctive collector's mount was adopted by many renowned connoisseurs of the eighteenth century, and these decorative borders are invaluable today when establishing the provenance of a drawing.

While there are instances of drawings being framed and hung on the wall by the end of the sixteenth century, a practice that increased during the seventeenth century, it was only the more highly prized sheets that were framed. In the eighteenth century, carved frames were required for physical, aesthetic and symbolic purposes. Installed only on more finished drawings, such as pastels and watercolours, they were similar in style to the contemporary gilt frames designed for paintings.

The conscious decision to frame works on paper signified that they were regarded as being on an equal aesthetic footing with paintings. The style of frame selected had more to do with the taste of the collector and the interior in which the work was displayed than with the work itself. For example, the pastels of Venetian portraitist Rosalba Carriera (1675–1757) (cat. 14) were avidly collected by Frederick Augustus III, King of Poland and Elector of Saxony (1696–1763), for his palace in Dresden. Inventories of the period indicate that they were displayed in a cabinet room with elaborate gilt frames that became part of the room's overall decorative character.[3]

In the eighteenth century watercolours and pastels were also mounted on card with pen and ink borders with coloured washes (cats. 31 and 52). Continental artists executing works for wealthy British aristocrats on the Grand Tour often drew such borders to give them a finished appearance and enhance their commercial viability. Many British artists of the period also embraced this practice, including Thomas Rowlandson (cat. 52), Richard Wilson, Francis Towne and Alexander Cozens. These devices not only gave watercolours and pastels more visual prominence, but, more importantly, signalled their newly perceived artistic importance. By the nineteenth century, when watercolour reached its apogee, artists created larger and more technically accomplished works for exhibition and placed them in highly ornamental gilt frames, which enabled them to hold their own next to oil paintings.

Today we are accustomed to museums and private collectors framing their drawings for display. Many of the same principles still apply. Not only does the frame protect the work, it also focuses the viewer's attention. The Art Gallery of Ontario has a comprehensive inventory of over 1,500 European frames with extraordinary examples dating from the Renaissance, baroque, rococo, neoclassical, Biedermeier, Empire, and early-twentieth-century periods. Originating from Italy, France, Spain, the Netherlands, Germany and England, the frames range from the modest to the magnificent, and possess distinctive types of ornament, materials, finishes and techniques. As illustrated by selected examples from the AGO's holdings, many wood frames are enhanced by such materials as gilt, ivory, stucco, glass, metals, tortoiseshell, mother-of-pearl, *pastiglia* and papier mâché.

While a frame is primarily chosen for its aesthetic compatibility, considerations of date, country of origin and historical significance, as well as nuances of form, tonality and detail, are equally relevant. A successful pairing between the frame and object is an art form in itself. A sympathetic union between the two can transform the work and enable the viewer to experience it anew.

Martha Kelleher

Edward John Poynter (cat. 66) in original frame designed by the artist.

1 See Charles de Tolnay, *History and Technique of Old Master Drawings* (New York: Hacker Art Books, 1972), pp. 5–6.
2 Ibid., p. 81.
3 See Nancy Bell, ed., *Historic Framing and Presentation of Watercolours, Drawings and Prints* (Institute of Paper Conservation, 1996), pp. 17–18.

1

4

2

5

3

6

fig. 1:
Germany, mid-19th century, veneered wood.
Anonymous gift, 1994, Art Gallery of Ontario
(94/1079)

fig. 2:
France or Continent, early 19th century,
parcel water gilt. Anonymous gift, 1994, Art
Gallery of Ontario (94/1008)

fig. 3:
England, early 18th century, water gilt.
Anonymous gift, 1994, Art Gallery of Ontario
(94/989)

fig. 4:
Netherlands, 17th century, ebonized and
veneered in tortoiseshell. Anonymous gift,
1994, Art Gallery of Ontario (94/1003)

fig. 5:
Netherlands, mid-17th century, ebonized and
veneered in tortoiseshell. Anonymous gift,
1994, Art Gallery of Ontario (94/1181)

fig. 6:
Italy, late 18th century, stained and polished
wood. Anonymous gift, 1994, Art Gallery of
Ontario (94/1010)

fig. 7:
Spain, 17th century, water gilt. Anonymous
gift, 1994, Art Gallery of Ontario (94/1104)

fig. 8:
France, c. 1725–50, water gilt. Anonymous
gift, 1994, Art Gallery of Ontario (94/1140)

fig. 9:
England, late 19th century, water gilt.
Anonymous gift, 1994, Art Gallery of Ontario
(94/1158)

fig. 10:
Italy, early 17th century, water gilt.
Anonymous gift, 1994, Art Gallery of Ontario
(94/1155)